The Techniques of Sprang

BY THE SAME AUTHOR

The Techniques of Rug Weaving

THE TECHNIQUES OF
SPRANG

Plaiting on Stretched Threads

Peter Collingwood

WATSON-GUPTILL PUBLICATIONS

New York

First published in the United States 1974 by Watson-Guptill Publications,
a division of Billboard Publications, Inc.,
One Astor Plaza, New York, New York 10036

Copyright © 1974 by Peter Collingwood
First published in 1974 in Great Britain by Faber and Faber Ltd.,
3 Queen Square, London WC1H 3AU

Manufactured in Great Britain

Library of Congress
Catalog Card Number 73–17319
ISBN 0–8230–5220–6

For Elizabeth

Foreword

This is a detailed book intended for those who want to learn about sprang, a fabric making process that has been used for at least three thousand years. It is not a historical or ethnographical study of the subject, but as it tries to deal with most of the historical material, it may prove of use in museum circles. The techniques described cover those found in historical fabrics together with many developments and inventions made by the author and other contemporary workers in the medium. Although the descriptions of the old and new techniques are not in any way segregated, each occurring in the place appropriate to the classification adopted, it is generally made clear in the text when an old or traditional technique is being described.

The classification arranges the techniques in a sequence which moves from simple to complex thread structures. But it should be realised that the actual making of a simple structure may be more difficult for the hands to master or the mind to grasp than that of a complex structure. So the reader should choose his own route through the book, according to his abilities. As no established nomenclature exists for sprang, every technique both old and new has had to be christened. The aim has been to make such names, essential for easy reference, as simple and descriptive as possible.

Sprang is an entirely finger-controlled technique and an attempt has been made to describe in detail the finger and hand movements involved. These descriptions, in the interests of accuracy often tediously long, should be taken as showing only one possible way to achieve any desired result. Hands vary greatly in their proportions and in what they can do and each reader should search for the movements that come most easily to him.

Sprang fabrics have usually been strictly functional fabrics or decorative additions to functional fabrics. Released from this restraint, hangings and three-dimensional fabrics made by the sprang process can explore in a much freer and more adventurous way the thread structures involved. It is the author's belief that it is sensible to base any such creative effort on knowledge gleaned from historical fabrics. The latter were after all made by experts in the method who, although they may have been working within a limiting tradition, had a far deeper understanding of at least one technique than is possessed by anyone today.

The photographed samples made by the author were worked in a heavy rug wool. Some were slightly stretched to help show the structure. The diagrams, also by the author, often distort nature in the interests of clarity.

I am greatly indebted to the West Surrey College of Art and Design, Farnham Centre,

whose enlightened policy of granting Research Fellowships in the field of crafts gave me the time for much of the research that has gone into this book.

I wish to thank Irmgaard Weitlaner Johnson, Marianne Cardale-Schrimpff and Regina von Bültzingslöwen for allowing me to see their unpublished manuscripts, Karen Rush, Mrs. Barrett and Mrs. Schonberg for help in translating Danish and Swedish texts, Pat Bull for much tedious typing, Cora van Helfteren for almost all the photography, Jason for his rubber and Rachel for her pencil.

But my chief thanks must go to Noemi Speiser who has contributed so much and so unselfishly to the substance of this book that it should by rights also bear her name. I would especially mention her detailed analysis of Coptic and other sprang fabrics, her tireless search for literary references which has resulted in the very extensive bibliography, and her constant development of new techniques, especially in intertwined sprang. But in fact her help and influence have been too extensive to itemise. Moreover, if this book has any significance in the eyes of textile experts, it is largely her doing.

Since the rediscovery of sprang nearly a century ago, no account has appeared which tries both to record its past and to explore its creative possibilities. It is the author's hope that this book will help to fill that gap.

Contents

8. Intertwined Sprang

Plates

After page 292

All photographs not followed by a name in brackets are by *Cora van Helfteren*

1. Making shaped head-dresses on free-standing frames, Moravia, 1954 (Ema Markova)
2. Putting warp in figure of eight formation on a portable frame, Yugoslavia, 1958 (Paula Gabric)
3. Nahua woman working a sprang fabric on a back-strap loom (weaver-tensioned warp), Ichcateopan, Guerrero, Mexico, 1948 (Bodil Christensen)
4. Interlinked sprang with warp colour sequences of (A,B,A,B), (A,A,B,B) and (A,A,A,A,B,B,B,B)
5. Interlinked sprang with a warp colour sequence of (A,A,B) and (A,B,B)
6. Double twist interlinking. Screen made from horsehair and nylon (Charles Seeley)
7. Double twist interlinking using a striped warp (Stanland Photography)
8. Double twist interlinking used selectively to give a block of cross stripes on a background of diagonal lines. Chained meeting line
9. Double twist interlinking used selectively to give a diamond of diagonal lines on a background of cross stripes. Meeting line secured by a thread in the final shed
10. Double twist interlinking used selectively to give a diagonal band of interlocking triangles on a background of cross stripes. Meeting line secured with wefts in the three final sheds
11. Double twist interlinking used selectively to give two different central areas
12. Horizontal stripes of S- and Z-twist interlinking
13. Areas of S- and Z-twist interlinking with angled boundaries showing the three-dimensional effect
14. S- and Z-twist interlinking used so that every edge of a diamond stands above the background

15. Vertical stripes of S- and Z-twist interlinking. Three rows of chaining at bottom edge
16. Alternating blocks of S- and Z-twist interlinking giving an undulating surface
17. Vertical stripes of S- and Z-twist interlinking on a warp with an (A,A,B,B) colour sequence
18. Triangle of S-twist on a background of Z-twist interlinking, using a warp with an (A,A,B) colour sequence
19. Combination of S- and Z-twist interlinking using a warp with an (A,A,B,B) colour sequence
20. Same structure as in plate 19, but using a warp of one colour to show the textured surface
21. Inserting extra rows of interlinking in selected places
22. Omitting rows of interlinking in selected places on a nylon warp: detail of a hanging by Noemi Speiser (Hinz)
23. Alternate rows of 2/2 and 1/1 interlinking used all across the warp to give holes (Stanland Photography)
24. Long holes separated by two threads: detail of a bag by Noemi Speiser
25. Combination of holes with warp transposition to give a three-dimensional fabric (Stanland Photography)
26. Woollen Coptic bag with red extra twining threads on a blue inter-linked background. Partly destroyed so both inside and outside can be seen. Woven band of red wool at top to which the ends of the drawstring are tied. Meeting line secured with a continuous line of chaining on outside and inside of bag. Side panels in orange, green, red and white (Museum für Volker-kunde, Basel; photograph, Helen Sager)
27. Sample showing three typical Coptic motifs produced by extra threads twining on the interlinked background
28. Threads changing from twining to interlinking along a diagonal line
29. Sample showing a Coptic design in which threads change regularly from interlinking to twining and back again
30. Three sets of extra threads twining vertically. At intervals the central and left-hand sets float at the back so that spots are formed, the right-hand set forms a continuous vertical stripe
31. Hair-net found at Borum-Eshöj, Denmark, and dated to Danish Bronze Age. Shows multiple twists, chained ridges and a chained meeting line (arrowed) (National Museum, Copenhagen)
32. Single, double and triple chained ridges (Stanland Photography)

33. Twisted and chained ridge (Stanland Photography)
34. Double interlinked sprang
35. Two areas of double interlinked sprang on a background of single interlinked sprang
36. Converting the back fabric of double interlinked sprang into a stripe
37. Triple interlinked sprang: small sample stretched to show structure
38. Over one, under one interlaced sprang: loosely made sample to show structure
39. Over two, under two interlaced sprang with horizontal ribs
40. Over three, under three interlaced sprang with vertical ribs
41. Over two, under two, over one interlacing with one row of inter-linking
42. Area of over one, under one interlacing on a background of 1/1 interlinking
43. Double intertwined sprang. Two woollen tassels connected by long woven cord. Outer panels red and yellow, central panel blue and white. Each piece folded in half along the meeting line and the sides then sewn up. Near the meeting line, an area of cross knit loop stitch. Peru, probably Nazca valley, before A.D. 900 (Courtesy of the Textile Museum, Washington, D.C.)
44. Over one, under one double interlaced sprang
45. Intertwined sprang. In upper half a single pair of threads is the unit, in the lower half two pairs are the unit
46. Intertwined sprang: combining the two types of crossing on a warp of one colour to give a zig-zag stripe
47. Intertwined sprang: combining the two types of crossing on a warp of two colours
48. Intertwined sprang: braids made by repeating a row several times
49. Intertwined sprang: extra twining threads coming to the surface to form three chevrons
50. Diamond of intertwined on a background of interlinked sprang
51. Woollen cap made by Noemi Speiser which combines intertwined and interlinked sprang (Stanland Photography)
52. Interlinked fabric with narrow diagonal stripes of intertwining
53. Intertwined fabric by Noemi Speiser, made of horsehair and nylon and mounted in a frame (Werner Nefflen)
54. Intertwined fabric made of grey wool and white synthetic by Noemi Speizer (Werner Nefflen)
55. Detail of an intertwined fabric made by Noemi Speiser of grey synthetic and dark wools. Note rod securing the meeting line (Werner Nefflen)

Text Figures

1 · Introduction

Sprang is a method of making fabric by manipulating the parallel threads of a warp that is fixed at both ends. The manipulation can take the form of interlinking, interlacing or intertwining of adjacent threads or groups of threads, see Fig. 1. Such structures do not require the addition of any other threads to stabilise them. The work is carried out row by row at one end of the warp. As an inevitable result of the warp being fixed at both ends, corresponding but contrary movements of the threads appear simultaneously at its other end.

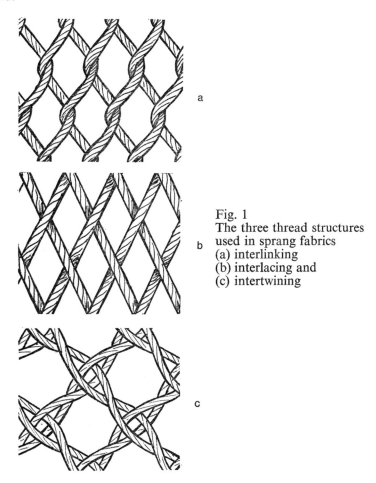

a

b

Fig. 1
The three thread structures
used in sprang fabrics
(a) interlinking
(b) interlacing and
(c) intertwining

c

So the fabric is produced in two halves at the same time, one starting at the upper end, one at the lower end of the warp, and both growing towards its centre. A sword or beater is generally used to force the twists evenly to both ends. Eventually a point is reached when only a short length of untwisted threads remains at the centre and there is no more space for the fingers to work between the upper and lower halves of the fabric. At this central meeting line some form of fastening is essential in order to lock in place the contrary twists of the two halves of the fabric and so prevent them undoing.

Perhaps those unfamiliar with the technique can most simply grasp its principles in the following practical way.

Tie three threads so that they are fixed at both ends, as in Fig. 2(a). Now begin braiding (plaiting) at the top of this little warp. First cross thread 1 over thread 2, near the upper end, as in Fig. 2(b). Inevitably thread 1 will also cross thread 2 below the hands, but the crossing will be in the opposite direction. Then cross thread 3 over thread 1, as in Fig. 2(c), and again the mirror image of this crossing will take place below. So two braids are being produced at the same time, one growing downwards from the top, one growing upwards

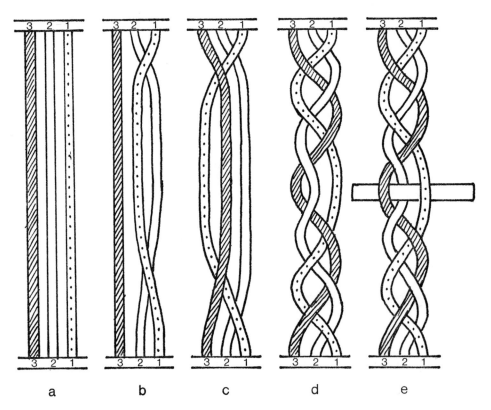

a b c d e

Fig. 2 (a) to (e). Stages in braiding three threads fixed at both ends

from the bottom. Continue braiding thus until a moment is reached when the two braids meet and lack of space stops any more threads crossing, as in Fig. 2(d). If the lower crossings have been well pushed down, this point will be at the centre of the warp. It will be seen that if the work is now abandoned, it will untwist itself, simply reversing the steps taken in its making. So to preserve the structure the central point must be locked in some way, such as by sliding in a rod as shown in Fig. 2(e). A very small piece of Interlaced Sprang has now been made.

Because of the dual method of production, it will be understood that any design in the upper fabric will of necessity be exactly mirror-imaged in the lower fabric. If in the upper fabric threads cross right over left, then in the lower they will cross left over right. Also any mistakes made in the upper fabric will inevitably appear in the lower.

The above description shows that sprang fabrics are made exclusively from warp. They result from thread movements within this one set of elements, and do not rely on other elements, in the way weaving relies on weft, to complete them. The effect of these movements is almost always to make the threads lie diagonally in relation to the selvage of the fabric, see Fig. 1. As a result the fabric has great elasticity both across its width and along its length, a characteristic that has in the past led to its use in many types of clothing. In fact before the advent of knitting, sprang represented the quickest way of making a stretch fabric. (Linking and vantsöm, the other available techniques, involve the manipulation of thread ends and are therefore much slower, though lending themselves better to shaping a fabric.) Apart from this physical property, sprang has many possibilities in the field of design. The three basic structures, with their numerous variations, can be used separately or in combination to give useful or purely decorative articles. These show designs which are usually geometric and often beautiful, and their description makes up the bulk of this book.

Sprang fabrics can be made on two distinct types of warp, a *flat* warp as already described and a *circular* warp. The threads of the latter are arranged as a tube, not as a flat sheet, and they are only manipulated on the front half of the warp. The resulting thread twists are periodically carried round to the back half of the warp by means of small sticks. Chapters 2–10 deal with Flat Warp Sprang and Chapter 11 deals with Circular Warp Sprang.

1. TERMINOLOGY

It will be seen from the preceding section that the word sprang is here used to mean a fabric-making process, involving the manipulation of a set of stretched threads. So this book deals with certain fabrics which are grouped together because, basically, they are all made in the same way. For convenience the group is subdivided by referring to the thread structures employed. As these are interlinking, interlacing and intertwining, the terms Interlinked Sprang, Interlaced Sprang and Intertwined Sprang are used. But it is

Fig. 3
Constructing a fabric by linking

very important to realise that each of these structures can be, and indeed still is, made by other methods. For instance, interlinking can be worked with a needle (see Fig. 3), interlacing can be worked on hanging threads fixed at only one end, and intertwining can be worked in the bobbin lace method. So it can never be deduced from the thread structure alone whether or not a fabric was made by the sprang method.

Sprang is a word of Scandinavian origin. Sprangning, an old Swedish word, originally meant any openwork textile, but has more recently been used to specify the plaiting-on-stretched-threads technique. In old Swedish dialects and in common use in Norwegian and Danish, there is also the form, Sprang, which is the word generally used today. In old records, Sprang seems to be treated as a verb, with *Sprangade* (made by the sprang process, 'spranged') and *Sprangning* (a piece of sprang work or the process itself) as the corresponding adjective and noun. It is a matter of personal opinion whether sprang is to be completely anglicised. If it is, then forms such as spranged, spranger and spranging could be used. In this book, only the word sprang is used, except where a word like *sprangade* is being directly translated. In Swedish the word is accented thus, språng, making the pronunciation sprong.

Other words, such as the Norwegian *bregding* and the Danish *slynging*, occur in old Norse sagas and may refer to sprang. The Danish woman, Ane Jacobsen, called the process, *linkning* (Hald, 1935, 1950).

Much confusion exists, especially in the earlier literature, due to the use of other words for sprang. Examples are twine-plaiting (O'Neale and Kroeber, 1930; Johnson, 1958), knotless netting (van Gennep, 1909), openwork fabric (Schinnerer, n.d.), Egyptian plaiting (Reesema, 1926), Coptic plaiting (Ensslin, 1933), twining (O'Neale, 1942), plaiting (Walterstorff, 1925) and even Egypto-Ruthenian lace (Whiting, 1928). Most of these refer to the structure rather than the method. Other terms, such as plaiting on stretched threads, frame-plaiting and loom-braiding, are more accurate as they include a reference to the way the fabric is made. But plaiting and braiding have indistinct meanings and what meanings they have do not cover all the structures that can be made.

The search for one self-explanatory term that covers both the method and all the possible structures only leads to something unwieldy like stretched-thread-interworking, which is hardly acceptable.

Confusion also arises from an imprecise use of the word sprang itself, in that some writers label as sprang any fabric, no matter how it is made, as long as it has an inter-linked structure. To avoid altogether the use of the word sprang, which is admittedly not accepted by everyone, the terms frame-interlinking, oblique frame-interlacing and oblique frame-intertwining have been suggested (Emery, 1966). These are accurate and unambiguous and therefore well suited for use in museum and research circles. However, sprang is already in the vocabulary of the textile artist and of a large number of textile specialists and will probably remain their word of choice for this technique, prefixed appropriately if they wish to specify the structure.

Other words for sprang still used in Europe today include the following:

Egyptisch Vlechtwerk, or simply *Vlechten*, in Holland.

Stäbchenflechterei in Germany.

Pinnbandsflätning in Sweden. This refers to the process. The fabric is *Pinnbandsspets* when it shows the typical hole designs (*spets* meaning lace), and *Pinnband* when it is a simple narrow undecorated band. There is also a S. Swedish dialect word for the fabric, *Spedeband*.

2. HISTORY

A. The rediscovery of sprang

Although it is now realised that sprang has a wide distribution both in time and space, at the end of the last century it seems to have been unknown to European textile specialists. This ignorance was ended by two archaeological discoveries.

The first was the unearthing at Borum Eshöj, Jutland, Denmark, in 1871, of a woman's hair-net made of fine 2-ply wool (Broholm and Hald, 1935, 1940; Hald, 1950; Müller, 1891, 1897). With the other clothes found in the oak coffin burial, it was dated to the Early Danish Bronze Age, that is, to about 1400 B.C. Being well preserved, this net-like fabric could be examined in detail and it proved to be of a then unknown type (see Plate 31). A Danish student, Petra Godskesen, studied it carefully and noticed that two small faults in the patterning occurred symmetrically on either side of the central line of the fabric. This led her to the discovery of the method which was indeed the sprang technique. She mastered it sufficiently to make, around 1880, an exact copy of the hair-net which was shown at the Paris World Fair of 1889, where it aroused considerable interest.

At almost the same time, archaeologists working on the Coptic graves (A.D. 400–700) in Egypt were discovering bags and caps made of wool and linen in a strange technique (see Plate 26). In 1882, Theodor Graf, a Viennese merchant, brought some of these to Austria where they were examined by textile experts. The first of these to mention the Coptic finds in print was Tina Frauberger. Her chief interest was in lace and she had collected much information on linking, as she regarded it as a forerunner of lace. She had even found a rope-making factory near Vienna, where hammocks were still made in this primitive technique. In linking, a knotless net is made with a single thread on a needle or

a small shuttle, see Fig. 3. The thread, going from right to left, passes through loops made in the previous row. In so doing, it forms a new set of loops through which the thread passes on its return journey from left to right. Comparison with Fig. 1(a) shows the similarity of structure. In publications of 1893 and 1894, Tina Frauberger wrote of her conviction that the Coptic finds had been made in the linking technique.

But her conclusions did not satisfy Louise Schinnerer, a Viennese teacher of embroidery, for when she tried to copy the Coptic caps in the linking technique, she found she could only reproduce their simplest patterns and on a small scale. There was also the problem of the central meeting line which served no useful purpose when linking was used.

At this time, Schinnerer was studying the textiles of the Ruthenians in Galizia, now part of the Ukraine. There, in the villages of Rude and Svetice, she came across the sprang technique still being practised as a living craft for the making of women's caps. She learnt the method from the women on the spot and realised that it was in this way that the Coptic caps had been made. She published her findings in 1895, also mentioning a Ruthenian man's scarf which was probably made on a circular warp, although the method was not known to her. But her main contribution on sprang was contained in *Antike Handarbeiten* (undated, but probably late 1890s), a small book which also included tablet weaving and vantsöm. This was the first detailed and practical description of sprang to appear, although it naturally only dealt with the variations found in Coptic work. Her photograph of the free-standing Ruthenian frame and her technical diagrams have since been reproduced on many occasions. Her name for sprang fabrics was *Durchbrochene Arbeite*, openwork or filigree fabrics.

Thus as the result of archaeologists' finds, the sprang technique was rediscovered both by Danish and Austrian workers. Surprisingly, neither knew of the existence of the other and for some time they both pursued their research independently. In Denmark the reconstruction of the Borum Eshöj hair-net led to a re-evaluation of certain museum textiles and some which had previously been labelled netting or lace or knitting were seen to be sprang. This spread to other centres in Europe, but even today misnamed and misplaced sprang fabrics can be found in many museums.

The rediscovery of the technique also made textile specialists wonder if it still lingered on in isolated communities, as in Ruthenia. And indeed, over the next few decades, reports (summarised below) came in confirming that the tradition was not broken and that the technique had a wide distribution.

In N. Jutland, an old woman called Ane Jacobsen was found who knew the technique well and her method of work was recorded on film by the National Museum, Copenhagen (Hald, 1936; Dohrenburg, 1936). Hans Dedekam, a Norwegian investigator, travelled through the valleys in the Trondheim region searching for old textiles in the scattered farms and came across districts where sprang was still being used (Dedekam, 1914). A craft exhibition in the late 1890s showed that sprang was still known in Croatia. Schinnerer mentioned that the *faja*, a Spanish version of the military sash, was still being worn by generals as a sign of rank (Schinnerer, n.d.). Van Gennep found descriptions of belt-

making by the circular warp method both in the Caucasus and Algeria (van Gennep, 1912). Romulus Vuia described the making of a similar black girdle by the women in Central Rumania (Vuia, 1914). Smolkova found the method in use in Czechoslovakia on a free-standing frame (Smolkova, 1904).

Since then sprang has been recorded in Estonia (Kurrik, 1935), Finland (Sirelius, 1932), Yugoslavia (Moszynski, 1929), Libya (Ricard, 1925–26), Persia, Tunisia, Afghanistan and Pakistan (Lund, 1970). In the New World, examples of sprang are now known from Arizona (Kent, 1940, 1957), Mexico and Guatemala (Johnson, 1958), Columbia (Cardale-Schrimff, 1972), Peru (Harcourt, 1935), Guyana (Roth, 1916–17) and Venezuela. Where the technique still lingers on today, it is generally for making belts and often uses the circular warp method. Its use for larger articles, such as shirts, hats and other garments, seems to have died out completely, with the notable exception of the big Columbian hammocks. So with a few exceptions it only persists at a technical level far below that present in the earliest finds in Denmark, Egypt and Peru.

B. Chronological lists

The history of any fabric is based on surviving pieces of that fabric and the equipment used in its making, on pictures of the fabric and its making, and on written records referring to the fabric. As the evidence in these three categories is very patchy for sprang fabrics, no continuous story is possible, so three chronological lists have been compiled with notes and references.

Only a very small number of sprang fabrics have chanced to survive. This may be partly because the method was used for useful, everyday fabrics which would be thrown away when worn out, not for luxury fabrics which would be treasured, and partly because its properties make it a fabric with specialised and therefore limited uses. This small number may eventually be swelled by examples which now lie unrecognised in textile collections. The only attempt to list and describe old sprang fabrics in European collections was made by Regina von Bültzingslöwen in her *Nichtgewebte Textilien vor 1400*, which though written around 1951 unfortunately still remains unpublished.

(i) CHRONOLOGICAL LIST OF SPRANG FABRICS AND EQUIPMENT

(See the index for references to many of these fabrics in the general text)

New Stone Age (3000–1500 B.C.)	On the undersides of some neolithic pots from Rietzmeck, Kreis Rosslau, E. Germany, there are impressions of the fabrics they stood on when drying. If some of these are correctly interpreted as interlinked in structure, there is still no evidence that they were made by the sprang method (Schlabow, 1960).

Danish Bronze Age (about 1400 B.C.)	*The Borum Eshöj Hair-net* (see Plate 31) Discovered in 1871, in a woman's grave in Borum Eshöj, a burial mound near Aarhus, Denmark. 158 threads of fine 2-ply wool in warp. Very skilfully made, using multiple twist inter-linking and ridges (Broholm and Hald, 1935, 1940; Collins, 1922; Hald, 1950; Müller, 1891, 1897). Perhaps the only historical examples that can be considered as luxury fabrics are the early Danish finds. As they came from graves in impressive barrows (Borum Eshöj was over 120 feet across and nearly 20 feet high), they probably belonged to chiefs or even royalty. This explains the expertise both in design and manual skill that went into these fabrics. See the hair-net from Haraldskar bog and the Oseberg frame.

The Skrydstrup Cap
Discovered in 1935 in a man's grave in Skrydstrupfield, near Haderslev, Denmark. Made from 2-ply wool, worked in a mixture of interlacing and interlinking. Meeting line closed by two rows of chaining (Broholm and Hald, 1939, 1940; Hald, 1950).

A hair-net made from horsehair and with an intertwined structure was found in the same grave but there is no evidence it was a sprang fabric.

Late Pre-ceramic, Peru (about 1100 B.C.)	*Cylindrical Bags and Fabrics* Excavated in 1957 at Asia, central coast of Peru. Interlinking and interlacing, cotton yarn. ? Meeting lines present (Engel, 1963).

Hallstatt period (800–500 B.C.)	*Hair-net* Discovered in 1835 in the Haraldskar bog at Vejle, Denmark, but not recognised as sprang until a century later. Sometimes called 'Queen Gunhild's Hair-net' as she is known to have been drowned here. Made of single-ply wool, using closely placed holes as the basic structure. Incomplete, one edge sewn to a woven band, meeting line present (Broholm and Hald, 1935, 1940; Hald, 1936).

Woman's Cap or Hood
Discovered in 1942 in a peat bog at Arden, Denmark. Well-preserved, woollen. Stripes of S- and Z-twist interlinking (Hald, 1950).

Paracas Cavernas, Peru (500–300 B.C.)	*Two Pieces, possibly Head-dresses*

Paracas Cavernas, Peru
(500–300 B.C.)

Two Pieces, possibly Head-dresses

Excavated in 1931 in Paracas Cavernas graves, Peru. Both made from orange wool, one 52 inches × 22 inches. Complex hole design depicting fish, birds, serpents, in all-over pattern. Chained meeting line (O'Neale, 1932, 1937, 1942; Harcourt, 1934).

Nazca, Peru
(300 B.C.–A.D. 500)

Four Pieces

Excavated in 1925 at Majoro and Cacatilla, near Nazca, Peru. They show intertwining, but it is not clear whether they are sprang or not. Woollen (O'Neale, 1930, 1937).

Neck Coverings

Also from Nazca come the very elaborate woollen neck coverings using double, and sometimes quadruple, intertwined sprang (see Plate 43). Very complex construction. All-over linear designs. Simple interlaced bags also found (Harcourt, 1934).

La Tène Period
(500–50 B.C.)

A collection of charred textiles, ropes and wooden tablets found in a Spanish grave. One fragment shows interlinking, ? sprang (Hundt, 1968).

Roman Iron Age

A fragment of simple interlinking found in a grave at Blidegn, Denmark, ? sprang (Mackeprang, 1936).

Migration Period

Woollen Stocking

Found in a bog at Tegle, Jaeren, the earliest Norwegian find of sprang. Consists of a tubular fabric with interlocking triangle design done in S- and Z-twist interlinking. Top and bottom edge finished with tablet-woven band, no meeting line (Dedekam, 1925; Hoffmann and Traetteberg, 1959; Hoffmann, 1964).

A.D. 100

? Hair-net

Found in rubbish dump at Vindonissa, Switzerland. Fine wool worked with triple twist interlinking. Incomplete, but meeting line present (Wild, 1970).

A.D. 400–700

Coptic Sprang Fabrics

Discovered from the 1880s onwards, in Coptic graves in Upper Egypt, chiefly at Achmin. Made of undyed linen or dyed wool. Some are pointed and called caps, some are rectangular with drawstrings and called bags (see plate 26), also turbans and other garments. Techniques include hole designs, S- and Z-twist, extra twining threads, 2/2 and 4/4 interlinking and double

interlinked sprang. Very accomplished workmanship. Mentioned and illustrated in catalogues of all main textile collections. Technical analyses in Schinnerer, n.d., and Hald, 1950.

By far the largest number of historical sprang fabrics come from the Coptic burial grounds and for two reasons. Firstly, there is the Coptic habit of burying their dead fully clothed with everyday objects like carrying bags around them; secondly, there is the position of the graves, which were in dry sand, above the level of the Nile's flood water and in a region with practically no rainfall. So there was a profusion of textiles buried in conditions that prevented bacterial decay, with the result that any textile collection has far more examples of Coptic sprang than of sprang fabrics of more recent date.

Viking Period (about A.D. 850)

Wooden Frame

A beech wood frame, 44 inches high × 30 inches wide, found in the ship-burial (? of Queen Aase), at Oseberg, Norway; may possibly have been used for sprang. Lower beam adjusted by pegs fitting into the uprights; narrow rod fitting into a groove on underside of top beam; intended to be free-standing. If used for sprang, then probably for circular warp method (Broholm and Hald, 1940; Hald, 1936, 1950; Hoffmann, 1964; Grieg, 1928.)

Woollen Stocking

Excavated in 1838 at Micklegate Bar, York, England. Worked with 2-ply wool in stripes of S- and Z-twist interlinking. Selvages sewn together to form a tube which tapers slightly, so like the Tegle stocking it has no foot. No meeting line (Henshall, 1951).

Impression inside Brooch

A tortoiseshell brooch, found in the Shetlands, Scotland, bears on its inside the impression of some type of diamond mesh thread work, ? interlinked sprang (Shetelig, 1940; *Proceedings of Society of Antiquaries of Scotland*, XVII).
Small fragments of interlinking found in the graves at Birka, Sweden, ? sprang (Geijer, 1938).

A.D. 1100–1300

Narrow Band

Found at Mule Creek Cave, New Mexico, USA. Made from 2-ply cotton, 10 inches long × 1 inch wide, worked in interlinking with hole designs. No meeting line (Cosgrove, 1947; Kent, 1957).

A.D. 1300–1500	*Shirt* Found at Tonto Monument, Arizona, USA. Measures about 26 inches square, back largely missing, worked with elaborate hole designs. Fringe at bottom edge, warp loops of front and back portion joined along the shoulders. Front and back may be the upper and lower halves of a sprang fabric (Kent, 1957, 1972).
15th century	*White Linen Fabric* 120 inches long × 30 inches wide, with complex hole designs some of which are embroidered with blue thread. Made on a circular warp. Probably from central Switzerland (Bültzingslöwen).
17th century	*Three Woman's Caps* Made of silk and gold thread, bequeathed to Austrian Museum by a woman from Transylvania (Schinnerer, n.d.; Reesema, 1920).
	Woman's Girdle Found in a church at Mediasch, Transylvania. White, with simple hole designs and fringes at both ends. Made on a circular warp (Treiber-Netoliczka, 1970).
About 1700	*Silk Mittens* Norwegian; worked with hole designs (Collins, 1922). These were also made in Holland and France.
1707	*White Linen Piece* Found by Edna Mygdal in a church at Hvalsoe, Jutland, Denmark in 1916. 70 inches long × 18 inches wide, worked with hole designs, forming diamonds, but also the initials M K D and the date 1707. Circular warp method (Mygdal, 1917; Broholm and Hald, 1935; Dohrenburg, 1936).
1700–1850	*Military Sashes* (see Plates 67 and 68) Ceremonial sashes made of silk and worn by army officers, each country having its own colour or striping. Usually simple interlinking, sometimes with hole designs. Up to 12 feet long × 30 inches wide, with long fringes. Also used by officers of town guilds, sometimes being embroidered. Made on circular warp. (Schinnerer, n.d.; Reesema, 1920; Hald, 1950; *Dress Regulations, 1846*; *General Washington's Military Equipment*, 1963).

1797–1835	*Collection of Sprang Fabrics*

About a hundred pieces, many unfinished, such as bonnets, stockings, mittens, collars, cuffs. All made by a woman from Bruges, Belgium, in intricate hole designs. Now in Musée Royaux d'Art, Brussels, which also has a sprang frame (68 inches × 14 inches), with work still on it and a collection of wooden sticks, 10 inches long (Paulis, 1930).

About 1850	*Works of Christine Steeger*

Many pieces survive made by Christine Steeger (1800–59), of Aalen, Württemberg, Germany. These include complete jackets and skirts, but also smaller pieces. All worked with hole designs. Sprang was called 'krabbeln', i.e., crawling like a crab, in Württemberg, probably from the way the right hand moves across the warp (Dohrenburg, 1936).

From more recent times, there are a number of undated pieces in museums, chiefly in Scandinavia and Eastern Europe where the technique persisted for simple articles like garters, mittens, bands for carrying jugs, belts, borders for towels and so on. Old sprang frames are found in Aalborg Museum, Denmark (Mygdal, 1917), at Maihaugen, Norway (Collins, 1915) and at the Textile Museum, Enschede, Holland (Schweizer, 1966). Photographs of frames are found in Schinnerer, 1895; Dedekam, 1925; Whiting, 1928; Vuia, 1914; van Gennep, 1912; Treiber-Netoliczka, 1970.

(ii) CHRONOLOGICAL LIST OF PICTURES

From 500 B.C. onwards	*Greek Vase Paintings*

Two or three vase paintings show a seated woman with a small frame on her lap. The frame is held sideways on, so one hand is behind and one hand in front of the threads. The upper cross bar is longer than the lower, ? to spread the work and give more space for the hands. Between the cross bars, threads and finished work are visible. In one case, the latter is clearly shown as an upper and lower piece separated by unworked threads. Some paintings include, hanging from the wall, fringed scarves whose length, being twice the height of the frame, suggests circular warp sprang; but no small sticks are shown. Many head bands, ribbons and scarves are shown on Greek coins, sculpture and in paintings. Some of them taper at their ends, where there is a knot or a tassel, characteristics not inconsistent with circular warp sprang (Lang, 1908; Six, 1920; Hald; 1950).

300 B.C.	*S. Italian Dish*
	Shows a woman's head wearing a cap, which Reesema considered to be sprang. She reproduced it, using double interlinked sprang, on a frame shaped as on the Greek vase paintings (Reesema, 1920; Six, 1920).
A.D. 1460	*Church Fresco*
	At Crngrob, Yugoslavia, a church fresco shows women spinning and dyeing. One woman sits in front of a free-standing frame on which threads are stretched vertically. A set of sticks cross these threads above the lower fabric. The hands are in the normal working position. Very probably represents sprang (Schweizer, 1966).
A.D. 1520	*Church Fresco*
	At Sveti Primoz, Yugoslavia, a far more detailed fresco shows the Virgin sitting before a frame on which a narrow warp is stretched. No sticks in use. Possibly sprang (Schweizer, 1966).
A.D. 1550	*Belgian Woodcut*
	Shows the Virgin working on threads stretched between cross bars set fairly close together near the top of a small free-standing frame. Not possible to make out more details (Lehmann, 1954).
A.D. 1580	*French Engraving*
	An engraving after a picture by Martin Devos of Anvers, France, shows a woman seated by a frame with vertically stretched threads. She is pulling the front layer of the latter towards herself, exactly as in circular warp sprang. Finished work visible on the back layer of the warp (Paulis, 1933).
A.D. 1800	*French Engraving*
	Shows a woman seated at a frame with vertical threads stretched between two cross cords; two sticks are inserted in the warp below her hands. Beside her sits a man reading a book with 'Le Point de Dentelle' written across it, presumably a French expression for sprang (Paulis, 1930).

(iii) CHRONOLOGICAL LIST OF WRITTEN RECORDS

| 1328 | Mention of sprang tablecloth and towels in a list of taxable chattels, from Bergen, Norway (Hald, 1935). |
| 14th century | Sprang altar cloths mentioned in Bishop Petr's inventory of church textiles, Iceland (Mygdal, 1917; Dohrenburg, 1936). |

15th century	Inventory of Turners' Guild in Hamburg mentions 'spranck', a German word which may be related to sprang (Dohrenburg, 1936).
1483	Finnish document mentions towel with 'stockespragning'. This might mean stick spranging, i.e. sprang using one or more small sticks (Collins, 1922).
1534	An inventory from Svanholm, Denmark, mentions sprang towels and cloths, which may refer to added decorative borders sewn to woven pieces (Mygdal, 1917; Hald, 1936).
1542	In Jens Nielsen's Visitors' Book is this entry: 'Karen Gyldenstjerne (born 1542), when only seven years old, was sent to a convent where she learnt to read and write . . . also to knot, net and sprang and suchlike, which young men appreciate' (Mygdal, 1917; Hald, 1936).
1555	Olaus Magnus in his book, *Historia de Gentibus Septentrionalibus*, praises the handicraft of the Nordic women, especially in 'opere retiario quod spraangning vocant', 'the netlike work which they call spraangning' (Collins, 1922).
1578	The will of Peder Oxe from Gisselfeld mentions a pair of sprang stockings, also a sprang cloth (Mygdal, 1917; Dohrenburg, 1936).
Undated references from the late Middle Ages	'Sprangadum garnadukum' (Spranged cloth with embroidery;) 'Sprangat handkleidi' (Spranged towels); 'Dukr sprangadr' (Spranged cloths); 'Sprangade altarisdukr' (Spranged altar cloths); 'Formadukr med sprang' (Tablecloth ornamented with sprang) (Falk, 1919; Collins, 1922).

Written records of a more indirect nature refer to items of clothing which, on the evidence of more recent examples, are thought to have been sprang fabrics. This applies to the women's belts mentioned in the town records in Transylvania from 1505 onwards (Treiber-Netoliczka, 1970).

Part One

FLAT WARP SPRANG

2 · Equipment

In sprang, as in weaving, a set of warp threads must be held uniformly taut to make possible their easy manipulation. The tension can be achieved in several ways:

 (1) by using a frame (frame-tensioned warp)
 (2) by adding weights to a vertically hanging warp (gravity-tensioned warp)
 (3) by using the backstrap loom principle (weaver-tensioned warp)

In all these methods there has to be a way of adjusting to the gradual shortening of the warp, which is an inevitable part of the sprang process.

Less orthodox methods have been described which were improvised by workers in isolated communities. These include stretching the warp between two branches of a tree (Reesema, 1926), between two chair backs (Collins, 1916), between two fence poles (Walterstorff, 1925) and over a window frame (Dedekam, 1925).

1. FRAME-TENSIONED WARP

Frames can be divided into large frames that stand free on the floor, and small portable frames used on the lap or on a table.

A. Free-standing frames

When sprang was being rediscovered at the end of the last century, it was found that free-standing frames (see Plate 1) were still in use in Ruthenia (Schinnerer, 1895), Norway (Dedekam, 1914) and Czechoslovakia (Smolkova, 1904). But if the frame found in the Oseberg ship burial of about A.D. 900 was intended for sprang, then the material evidence for this type goes back another thousand years (Grieg, 1928). The earliest representations of the frame are found in two N. Yugoslavian church frescoes of 1460 and 1520 (Schweizer, 1966), a Belgian woodcut of 1555 (Lehmann, 1954) and an engraving by Martin Devos dated about 1580 (Paulis, 1930); but it is not absolutely certain that sprang is the technique depicted in some of these cases.

Fig. 4 shows the free-standing frame, which is a simple structure made of wood. It has two uprights of circular cross-section (about $1\frac{1}{2}$ inches diameter) which are joined at top and bottom by cross pieces of square section (about 2 inches across). To the lower cross piece are attached two feet on which the frame stands. Obviously the dimensions of a frame determine the maximum size of the fabric that can be made, but a height of 4 feet

6 inches and a breadth of 2 feet will be found useful. A frame of any size can be used as long as it is strong enough to resist the warp tension without buckling.

WARPING CORDS

The warp itself is stretched vertically between two cords that span the uprights of the frame. In Fig. 4, as in all other diagrams in this chapter, the warp is indicated by an area of dotted lines. Cords rather than sticks are used so that, when the fabric is removed from the frame, the warp loops at both ends are as small as possible. The cords also have some elasticity and make the warp easier to handle. As will be imagined, the cords have to be fixed extremely tightly to prevent the warp curving them unduly. The traditional way of fixing the cords is shown in Fig. 5 and described below.

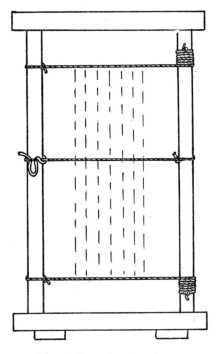

Fig. 4. Free-standing frame

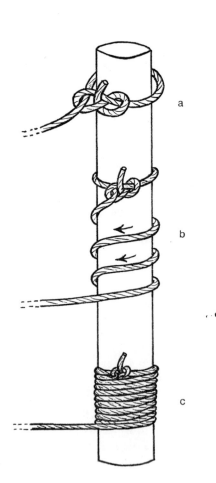

Fig. 5 (a) to (c)
Stages in fixing a warping
cord

Take a strong cord about four yards long. Make a slip knot at one end. Carry the other end around the right-hand upright of the frame and through the loop of the slip-knot, as in Fig. 5(a). Pull the cord tight around the upright. Then wrap the cord around the upright in a downward direction, firmly but not too tightly, as in Fig. 5(b). Wrap it about ten times and make it lie in a close spiral, each turn touching the next, as in Fig 5(c). Tie the other end of the cord to the left-hand upright at the same height and with a secure non-slipping knot. Fix a second cord below and parallel to the first, in exactly the same way except that the cord must spiral upwards from the slip knot, as in Fig. 4.

To tighten or loosen the cords, grasp the whole area of wrapped cord firmly with the right hand and twist it to left or right. It will be found that the cord does not slip back when the hand is removed, but stays in position. This adjustment will not work if the uprights are of anything except circular cross-section. For a very high tension, hold the frame with the left upright against the body and, encircling the frame with both arms, pull hard on the right upright. The two uprights are than slightly bent inwards and the cords can be tightened in this position.

Another way of fixing the cords is between pegs (Dedekam, 1914; Whiting, 1928). These are like the tuning pegs on a violin and four of them fit very tightly into holes drilled into the uprights. The holes can either be drilled on the outer sides of the uprights, as in Fig. 6(a), or on their front surfaces facing the worker. The uprights must of course be drilled with many holes to allow for different lengths of warp.

Fig. 6
(a) Warping cord fixed with a peg
(b) Fine metal rod with butterfly nut

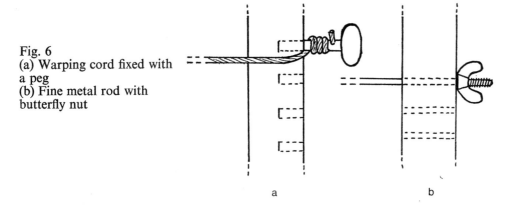

a b

More recently in Scandinavia the warp has been stretched between fine metal rods (Nilsson, 1928; Hald, 1936). The two rods are passed through holes drilled at intervals in the uprights. Butterfly nuts screw on to a threaded portion at each end of the rods, so tension is easy to apply and to adjust. See Fig. 6(b).

In the two latter methods it is obviously not necessary for the uprights to have a circular cross-section.

How the warp is laid between the cords or rods is described in Chapter 4.

SAFETY CORD

Halfway between the two warping cords, the safety cord spans the uprights, as in Fig. 4. It is tied tightly to the right upright but is attached to the left upright with the sort of hitch that can be easily tied and untied, see Fig. 7(a). Alternatively, a cleat can be screwed to the left upright and the cord simply wrapped around it, as in Fig. 7(b). During the course of the work, the safety cord lies in the shed between the two layers of threads. After working each row, it is untied at the left, pulled out of the last shed, inserted into the newly formed shed and retied at the left. Thus the thread twists made in each row cannot be accidentally lost.

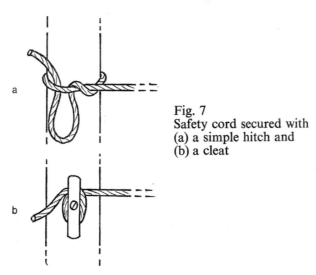

Fig. 7
Safety cord secured with
(a) a simple hitch and
(b) a cleat

Other ways of handling the safety cord, involving the use of a single unattached cord and the alternate use of two cords, are described in Chapter 5, section 4.

SWORD AND STICKS

A flat piece of wood is required for pushing the twists, made in each row, up and down the warp. This sword, or beater, must be at least as long as the frame is wide. It is shaped as in Fig. 8; the handle is an inessential refinement. It should be made of hard wood that can be given a smooth finish. An ordinary wooden or metal ruler makes a perfectly adequate sword for narrow fabrics.

Depending on the exact method of work, other smaller sticks may or may not be needed

Fig. 8. Sword or beater

as temporary shed sticks. These are about as long as the frame is wide. Fine dowels or flat laths are suitable. They must be smooth and splinter-free, so that they can be pushed up and down the warp and pulled out sideways from the shed without catching threads.

USING A CONVENTIONAL LOOM

It will be seen from the above details that the aim is to produce a rectangle of fabric which has four selvages, i.e., it has warp loops at the two ends, not warp fringes. Also a new warp has to be prepared for each piece made. These two characteristics are also found in primitive weaving. But there is nothing against using the warp on a normal floor loom or table loom for sprang. This will make a fabric with fringes at both ends and naturally many such fabrics could be worked on one long warp. Alternatively, a section of sprang can be worked in an otherwise woven piece, while it is still on the loom.

B. Portable frames

Smaller frames have a long history if the two or three Greek vase paintings often cited do actually show sprang being made. (See the Chronological List of Pictures in Chapter 1.) Until recently a small frame was in use in Yugoslavia for the making of an openwork head-dress (Gabric, 1962; Schweizer, 1966). As Plate 2 shows, it consists of a lower cross

Fig. 9
Portable frames
(a) for small fabrics
(b) for larger fabrics

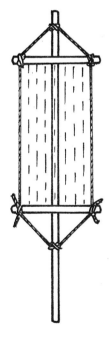

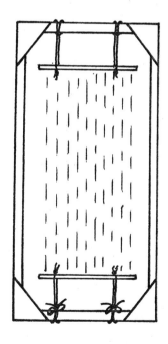

a

b

piece into which are fitted both ends of a thin stick bent into a horseshoe shape. The frame was either supported on the ground with the worker's two feet resting on the cross piece, or held on the lap. The warp was stretched between two cords as in a free-standing frame.

The mechita, a small carrying bag made in Columbia from agave fibre, is still worked today on a very simple portable frame, shown in Fig. 9(a) (Cardale-Schrimpff, 1972). The warp is laid between two short cross pieces which are attached to the central stick solely by means of the cords shown. With its long central stick wedged between the left elbow and the side of the body and the threads held by the hands, the frame is steady enough for the bag to be made while the worker is standing or even walking about.

A portable frame used today is a simple construction made of wood (1 inch cross-section), with the corners of the rectangle strengthened, as in Fig. 9(b). The warp is stretched between rods or wires fastened to the end pieces of the frame by adjustable cords. A height of about 40 inches and a width of about 20 inches is convenient. Such a frame is used with its base either on the floor or in the worker's lap, depending on whether the work is begun at the top or the bottom of the warp. In both cases the top of the frame is leant against something, such as a wall or table. A safety cord is fixed in the usual way between the two uprights.

SAMPLING FRAME

An even smaller frame is very useful for making samples, working out techniques and for demonstrating. Schinnerer describes one made of metal, as in Fig. 10 (Schinnerer, n.d.). The lower cross piece is adjustable.

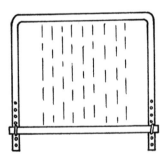

Fig. 10
Louise Schinnerer's
sampling frame made of
metal strip

A very simple and satisfactory frame, invented by the author,[1] is made in the form of an octagon, each side of which is about 8 inches long. Fig. 11(a) shows one made from a single piece of $\frac{1}{8}$ inch diameter stainless steel rod, the two ends of which are joined by fitting tightly into a metal sleeve. The much better version shown in Fig. 11(b) is made from two pieces of the same type of rod which fit into holes drilled in both ends of two lengths of wood (sections of broom handle, about 1 inch diameter). In both cases the

[1] These frames are obtainable from Peter Collingwood, Old School, Nayland, Colchester, Essex.

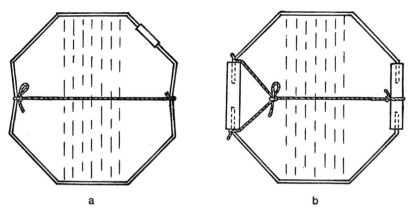

Fig. 11. Sampling frames (a) made entirely of steel rod
(b) made of steel rod and wood

octagon is gradually distorted by the shortening of the warp. The tension of the warp is controlled by the tension at which the safety cord is tied, as it will be found that narrowing the octagon increases its height. The only real limitation of this cheaply made frame is one of size. A bigger frame intended for a longer warp will become twisted out of shape by the warp tension.

On such a sampling frame the warp can be repeatedly worked, undone, reworked, and so on. But if something is made which the worker wants to preserve, the frame in Fig. (11)b can be easily dismantled and the fabric slid off the rods.

FRAME FOR VERY NARROW FABRICS

A type of frame was used in Sweden until recent times for the making of very narrow fabrics, such as garters and straps for carrying jugs (Collins, 1915; Hald, 1936). It consisted of a plank about 80 inches long with a fixed peg at one end and another peg at the other end which could go into any of ten holes drilled about 2 inches apart. The warp was wound between the two pegs. The length of the frame was just right to make one pair of garters; in other words the work stopped short of the centre, where it was cut, so that two pieces were produced. The extra holes were for adjusting the warp tension as the work proceeded.

2. GRAVITY-TENSIONED WARP

The only equipment needed for this method is two sticks between which the warp is stretched. The upper stick is suspended from the wall or in a doorway and the lower stick has a weight attached to it. So as the work proceeds the lower stick gradually rises due to the warp take-up, but the tension stays constant. A refinement of this method is to have two vertical metal rods passing through holes drilled at the ends of the upper and lower

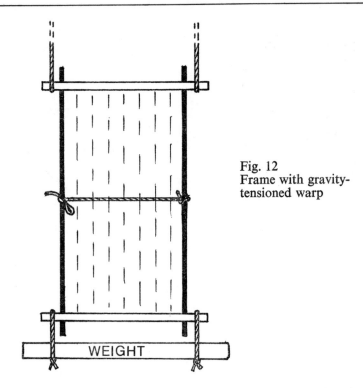

Fig. 12
Frame with gravity-
tensioned warp

WEIGHT

stick, see Fig. 12. The safety cord can be tied between these rods. They also prove useful as attaching points if it is desired to stretch the fabric sideways while working.

3. WEAVER-TENSIONED WARP

This is really a backstrap loom (see Plate 3) but without the shedding devices needed for weaving. It has been described in Guatemala and Mexico (Johnson, 1958). The warp is stretched nearly horizontally between the far stick, attached to a tree or post, and the near stick attached to a strap passing round the back of the sitting worker. The tension of the warp results from the worker learning back against the strap. In this position the work must of necessity start at the near end of the warp. The warp is rolled up on the stick as the work progresses, exactly as in weaving. Sword and temporary shed sticks are used normally.

3 · Yarns

1. CHOICE OF FIBRE

Traditionally the four natural fibres, wool, linen, silk and cotton, have been used for sprang fabrics. Wool has gone chiefly into garments and bags, linen into caps and borders almost always with hole designs, silk into scarves, sashes and gloves, and cotton into belts. Harder bast fibres, such as agave, have also been used for bags and hammocks. The choice has depended partly on availability and partly on the function of the fabric.

Today practically all types of fibre are used from monofilament nylon to coarse sisal. Some are far more difficult to manipulate than others. The characteristics to avoid are the following:

HIGH DEGREE OF TWIST

The more the yarn is twisted, the greater will be the curling effect described below.

SPRINGINESS OR RESILIENCE

A springy hair yarn or harsh wool yarn strongly resists attempts to twist or untwist it, whereas linen or silk does not.

HAIRINESS

A coarse yarn with protruding hairs, such as sisal or horsehair, makes the beating down after each row very tedious. But for the same reason, once it is beaten down it stays in position.

INELASTICITY

This property is a slight nuisance as it means the warp tension increases quickly and so the distance between the two ends of the warp has to be frequently adjusted. It also means that any slight irregularity in warp tension shows very obviously in the finished fabric.

So the ideal thread for a sprang fabric, that is not to be stretched in a frame, is smooth, elastic and with little twist. It must also be constructed soundly enough to survive the various sprang manipulations without disintegrating.

2. SIZE AND SETTING OF YARNS

Any thickness of yarn can be used. However close or openly the warp has been laid, the fabric will find its own width after a few rows. If this proves to be wider or narrower than is wanted, simply undo these rows and remove or add the appropriate number of threads.

Combining yarns of different elasticity and thickness in the same piece will obviously lead to buckling of the surface of the fabric, but this will not happen if the fabric is to be mounted in a frame. Moreover the varying ways the different yarns react to the thread structure being used can in this case be an important contribution to the design.

3. THE CURLING EFFECT

Both interlinking and intertwining involve the twisting of two threads around each other. Assume the yarn is made of two S-twisted singles plied in the Z direction, so the final twist is Z-twist. Now if this yarn is interlinked or intertwined in the same Z direction, its twist will be increased. The threads thus become over-twisted and when the warp tension is released, they all try to return to their original state by untwisting. The net result is a curling up of the edge of the fabric, especially if the yarn is elastic and tightly spun. A narrow fabric will twist into a complete corkscrew.

One way of counteracting the curling is to change to S-twist interlinking at the midline of the warp or to have warpway stripes of S- and Z-twist interlinking, that is, if the design and technique allow it. Where the yarn is treated thus, its twist will be decreased and it will tend to curl the fabric in the opposite direction. The problem then seems to be solved as the two tendencies to curl should cancel each other out. Indeed this is the case with lightly twisted and unresilient yarn. But there is a flaw in the method in that the over-twisted yarn exerts more force in trying to return to its original state, i.e., in trying to untwist itself, than does the under-twisted yarn in trying to retwist itself. So the Z-on-Z-twist areas will have a greater effect in curling the fabric in one direction than the S-on-Z-twist areas will have in the opposite direction, and the result, at least in theory, cannot therefore be a flat fabric. Only the upper fabric has been considered here but the same applies to the lower fabric, where the twists are reversed.

There are two obvious solutions to this problem. One is to use a completely twistless yarn, either a fine synthetic monofilament or a thrown silk yarn, which can be as easily twisted in the S as in the Z direction. This seems to be the ideal solution as not only will the curling effect be overcome, but there will be the same amount of twist in the upper and lower fabric. The other solution is to start with a yarn in both S-twisted and Z-twisted form, then a Z-on-S-twist area will exactly balance a S-on-Z-twist area. The great disadvantage here is that if the twists are as stated in the upper fabric, they will be S-on-S and Z-on-Z in the lower fabric. In other words, the yarns will have much more twist in the lower fabric and so the two fabrics will differ completely.

The curling effect only shows itself when a sprang fabric is hung freely. Mounted in a frame or put under tension in some way, the same piece will lie quite flat. Naturally this

effect can be made use of in hangings; but without making experiments it is very difficult to know the *amount* of curling to expect from a certain yarn worked in a certain technique. Wool, which shows the curling effect to marked degree, has been used traditionally for garments whose design involves the joining of selvage to selvage. Thus for a mitten or stocking, the left selvage is sewn to the right selvage of both upper and lower fabric to make two tubes; for a bag, the right selvages of both fabrics are sewn together and the same done to the left selvages. The usual result is that a selvage curling upwards is sewn to a selvage curling downwards, so the two effects are cancelled out. To this can be added the fact that woollen garments are generally worn in a stretched state and so the curling effect will not be obvious.

Cross stripes of S- and Z-twist interlinking have also been used in woollen fabrics to overcome curling. These give a flat surface especially if the stripes are narrow, but with a little curling at the selvages.

Against wool's tendency to curl in a sprang fabric can be put its thermoplasticity. In other words the fabric can be heat-set either by ironing if a flat fabric is wanted, or by immersing the fabric fitted over a mould in hot water if a three-dimensional shape is wanted. Linen can also be heat-set in this way.

Note—All these remarks on curling only apply to interlinking and intertwining. Interlaced sprang which involves no twisting of threads gives a completely flat fabric.

It will now be understood that at a purely practical level the choice of yarn depends on what thread structure is to be used (whether interlacing, interlinking or intertwining), and on how the resulting fabric is to be used (whether stretched, stitched to itself, hanging freely or stuffed). Naturally the choice is equally a matter of aesthetics. It is in any case a difficult choice and many yarns will be found unsuitable.

4 · Warping

With sprang, as with weaving, the aim in warping is to produce a set of parallel threads all of the same length and at the same tension. Any method that achieves this is legitimate. This chapter describes several methods, some traditional, some not, which are suitable for different types of equipment. The method for a free-standing frame is described in greatest detail and this should be read to understand the process fully, even if the intention is to use simpler equipment.

1. WARPING A FREE-STANDING FRAME

A. Method

The warp is laid vertically between the two horizontal warping cords; therefore their distance apart determines the length of the warp. But it must be realised that the length of the fabric will be less than the length of the warp. This is because as an untreated warp the threads lie in straight parallel lines, but in the finished fabric they take a zigzag or diagonal course. The amount of this warp take-up is variable and depends both on the thickness of the yarn and the thread structure being used, but it is something between 15 and 30 per cent. So if a fabric 30 inches long is wanted, the warping cords are fixed about 30 + 6 = 36 inches apart. If greater accuracy is needed, then experiments must be made with the yarn and structure to be used. It will be understood that the estimation of warp take-up is one of the great problems in sprang. If it is not accurate either the centre of the warp is reached before the design is finished or the design is completed with still some warp to spare.

When fixing the warping cords for a long warp, remember to leave enough space between the upper cord and the upper cross piece, and between the lower cord and the lower cross piece, to allow the easy passage of the ball or spool of warp yarn.

With the safety cord in position and the warp yarn wound in a convenient form, the warping is done in the following way:

Knot the end of the warp to the lower warping cord, labelled C in Fig. 13(a). Do this towards the left and with a knot that can be easily untied. Then take the ball of yarn up the frame, passing *behind* the safety cord, B, and in front and around the upper warping cord, A. Then take it down the frame, passing in *front* of the safety cord, and behind and around the lower warping cord.

Repeat this exactly, always working towards the right and laying the threads evenly side by side, without overlapping. An even number of threads is almost always wanted, so when the required number has been warped, finish by tying the yarn to the lower warping cord at the right with a temporary knot.

Fig. 13(a) shows a very small warp of 12 threads. The cross-section at Fig. 13(b) demonstrates clearly that the over-and-under course taken by the threads in relation to the three cross cords results in two warp crossings, one above the safety cord, one below it. It is as if the warp were being darned into the three cords. A simple way to remember the route taken by the yarn is that as it goes *up* the frame, it goes *under* the safety cord.

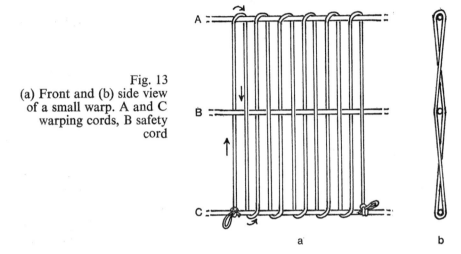

Fig. 13
(a) Front and (b) side view
of a small warp. A and C
warping cords, B safety
cord

If the frame has thin metal rods instead of warping cords, stretch a fine cord by each rod. Then lay the warp around both rod and cord at both ends of the frame. When the fabric is made, the rods can be pulled out leaving the cords in the end loops of the warp.

B. Adjusting the tension

However carefully the warping is done, some inequalities of tension may be discovered when it is completed. Any loose areas can be eliminated by working the slack along the warp towards the nearest selvage in the following manner:

Pick up a loose thread where it crosses the safety cord and pull it forward, taking in the slack. Pick up the next thread to the right (if working towards the right selvage), pull it forward and at the same time release the first thread, so that the slack now passes into the second thread. Proceed thus towards the right selvage, probably pulling forward a larger

loop of slack each time. At the selvage, untie the temporary knot and retie, having taken in the slack. When the warp is uniformly tensioned, tie both end knots in a more permanent manner.

C. Spacing the warp threads

No reed or other warp-spacing device is used in sprang, so the width of the fabric depends partly on the number and thickness of the threads being used, and partly on the thread structure. For a close dense fabric, the warp is laid as closely as possible, so that each thread touches its neighbour as it loops round the warping cords. For a fabric with an openwork design, the warp does not need to lie so close. In any case there are two reasons why it is not very important how the warp is laid on the cords.

(i) The warp loops, if they need to be re-spaced, can be slid from side to side along the warping cords, even after the work has begun. So the spacing of the warp as made need not be the final spacing.

(ii) However the warp is spaced on the cords, the fabric will find its own width when a few rows have been worked.

D. Making a striped warp

A warp can be made with stripes of different colours or of different materials. If the stripes are over half an inch wide, simply cut the yarn at the end of its stripe and knot it to the yarn to be used for the next stripe, using a bow with long ends. Such knots should lie as near as possible to either the upper or lower warping cord. If the threads are shifted in a subsequent adjustment of tension, the knots will be displaced from this position. But the bow can be untied and the two threads retied permanently with the knot correctly placed in relation to the warping cord.

For narrower stripes the warp need not be cut. To make a black and white warp as shown in Fig. 14, a stripe of black is first made, perhaps four threads wide. Then the white warp is tied to the lower cord and a stripe of white is warped. The black thread is then carried across the white and warped for a second stripe; then the white is carried across the black, and so on. Each colour is knotted to the cord after its final stripe. In order to keep an even tension, as each stripe is begun, the slack in the last stripe of that colour should be pulled up. The large loops of yarn at the lower end of the warp may make this method unsuitable for some projects.

E. Correcting mistakes in the warping

After a warp is made, slide the sword into the opening between the warp layers already occupied by the safety cord. Push the sword up to the top of this shed. Any mistakes in warping will at once become obvious. Three such possible mistakes are arrowed in Fig. 15 and the threads concerned are shaded. Mistakes 1 and 2 can only be remedied by cutting

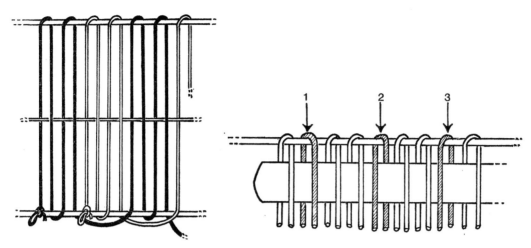

Fig. 14. Making a warp with narrow stripes

Fig. 15. Three possible mistakes in warping

the warp at that point, correcting the course of the thread and retying the ends, trying to alter the warp tension as little as possible. Mistake 3 can be corrected more simply. The safety cord and sword have merely to be re-routed in relation to the two threads involved.

Test for mistakes in a similar way at the lower end of the warp, leaving the sword lying there between the front and back layers of warp. The warp is now ready for one of the sprang techniques to be worked on its threads.

F. Making a warp for a shaped fabric

(i) ADDING SIDE PANELS OF WARP

In certain projects, it is necessary for some sections of the warp to be longer than others. Traditional examples are the making of gloves, mittens and certain head-dresses (see Plate 1), but the principle can be applied to shaped or three-dimensional hangings today.

Assume that a fabric shaped as in Fig. 16(a) is wanted. A warp corresponding to the longer central section is set up between the warping cords. It is worked until the resulting fabric reaches the level at which the side sections should begin. This is the stage shown in Fig. 16(b). Two more warping cords (dotted horizontal lines) are now stretched across at this level, passing through the last shed of the central section, one being put at each end of the warp. The correct number of additional threads (dotted vertical lines) are laid between these cords on either side.

The work then continues but now each row goes right across the increased width of warp. Obviously the second two cords should be as fine as is feasible so that they leave no trace in the central section when they are finally pulled out.

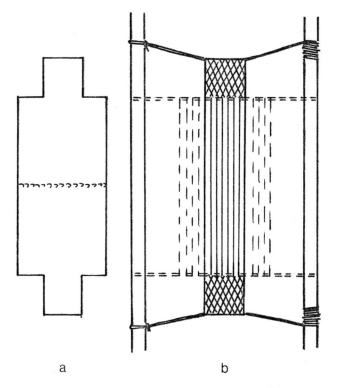

Fig. 16
(a) Shaped fabric
(b) adding side panels of
warp to make this fabric

a b

(ii) INTERSPERSING NEW THREADS AMONG THE ORIGINAL THREADS

New warp threads can be added in another way to increase the width of a sprang fabric. Two cords are stretched across as described above, but the new threads are laid so that a pair of them lies between each pair of the original warp threads. See Fig. 17, where the new warp threads are shaded. The work then proceeds including these new threads in subsequent rows.

The new threads interspersed among the old double the total number and so cause the selvages to curve outwards until the fabric assumes its new width. As described here, this width will naturally be double the starting width, but threads can be added in any numbers to give any desired increase in width. Also by using several sets of extra cords, threads can be added in several stages to give a more gradual and controlled increase in width.

When the piece is finished and the cords removed, the end loops of the new warp threads can be chained into each other, but they are quite secure if left untreated.

G. Alternative methods

A warp can be made between two pegs on a warping board and then be transferred to the sprang frame. If the transferring is done carefully, this is probably the best way to ensure an even tension.

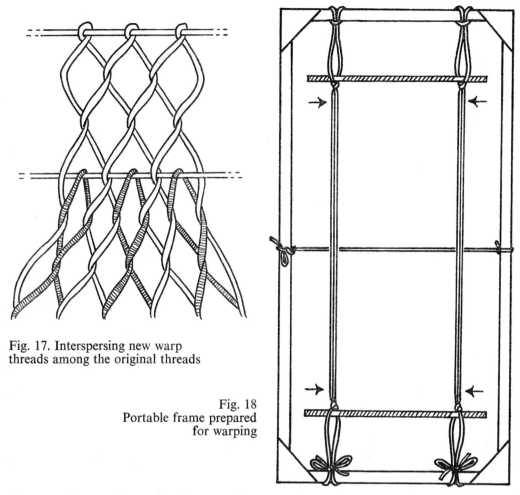

Fig. 17. Interspersing new warp
threads among the original threads

Fig. 18
Portable frame prepared
for warping

Some workers prefer to lay the warp between the cords or cross pieces in a figure of eight formation. This gives a natural shed which it is impossible to lose and so establishes the sequence of the threads beyond any doubt (see Plate 2).

2. WARPING A PORTABLE FRAME

Portable frames which have warping cords are naturally warped exactly as described above for free-standing frames. The portable frame shown in Fig. 9(b) and Fig. 18 is warped as follows:

Take two cords whose length is more than twice the height of the frame. Hitch each cord at its centre to the top cross piece of the frame, as shown in Fig. 18. About 4 inches below the cross piece, tie an overhand knot in each doubled cord, making sure the knots are at

the same level. Tie two more overhand knots, again at exactly the same level, about 4 inches above the lower cross piece of the frame. Then tie each doubled cord to this cross piece with the adjustable knot used for tying the warp to the front stick of a loom.

Now separate the doubled cords above each of the upper overhand knots and slide across a narrow wooden or metal rod (shaded in Fig. 18), so that it rests on the knots. Slide in another rod in a similar way below the two lower overhand knots. Tie a safety cord across between the two uprights of the frame.

The frame is now as shown in Fig. 18, and is ready for the warp to be laid between the rods. This is done exactly as described for a free-standing frame and as shown in Fig. 13.

So tie the end of the warp to the left side of the lower rod. Carry the ball of yarn up the frame, passing behind the safety cord, in front and around the upper rod, then bring it down the frame, passing in front of the safety cord, and behind and around the lower rod. Repeat this, always working towards the right, until the required number of threads has been warped. Then tie the end of the warp to the lower rod.

When the warping is finished, the two side cords can be cut at the four places shown by arrows in Fig. 18, i.e., below the upper overhand knots and above the lower overhand knots. The warp is then slung freely between the two rods as shown in Fig. 9(b). Alternatively, if they do not interfere with the subsequent work, these cords can be left uncut and so be ready for the next warp that is put on. The overall tension can be adjusted by altering the knots at the lower cross piece, but any localised areas of slackness must be corrected as described in section 1B above.

Now insert the sword in the opening occupied by the safety cord. Push it up and down the warp to spot any mistakes. Correct these and leave the sword at the bottom of the warp.

3. WARPING A SAMPLING FRAME

Warping a sampling frame is very simple and quick, as the method is modified to suit the small number of threads involved.

Tie the safety cord across the frame. Tie the end of the warp to the lower part of the frame itself towards the left. Then just wrap the yarn round and round the frame in a circular manner. See Fig. 19(a) and (b) for front and side view. Notice that the warp ignores the safety cord completely, simply lying in a spiral around the frame. Take care that the threads do not overlap each other as they pass round the frame. When sufficient warp has been wound on, tie the end to the lower part of the frame.

Now working from the right, slide a stick or the fingers into the warp, picking up each

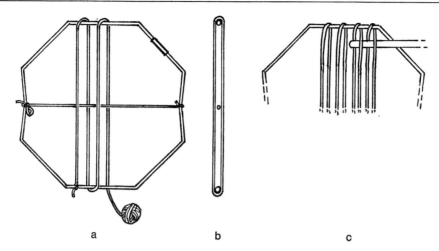

a b c

Fig. 19. (a) Warping a sampling frame, (b) side view to show course taken by warp, (c) picking up the first shed

thread which passes behind the frame, and letting fall to the back each thread which passes in front of the frame, as in Fig. 19(c). When the stick has crossed the warp in this way, untie the safety cord at the left and pull it out of the warp. Then introduce the cord into this newly made opening, passing it from right to left, where it is retied.

The cord now lies in the same relation to the warp as in the methods described above and the warp is ready for the work to begin.

 The warping is even quicker if the sampling frame with wooden side pieces is used. A metal rod (shaded in Fig. 20) is passed through holes drilled in the centre of each wooden

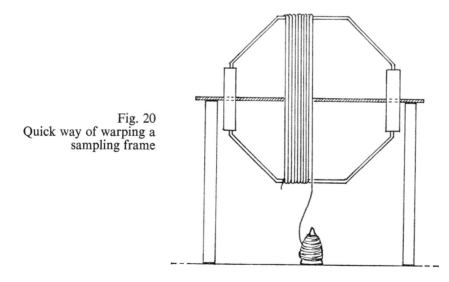

Fig. 20
Quick way of warping a
sampling frame

piece and its ends are rested on two objects, such as tables or chair backs. In this position, the frame can be easily rotated with one hand, while the other hand carefully guides the thread, as it is drawn from a suitably placed cone or spool on to the rotating frame. When the warp is made, a stick is slid in, as described above, to make the opening for the safety cord and the sword.

4. GRAVITY-TENSIONED AND WEAVER-TENSIONED WARPS

For both of these types, a warp stretched between two rods is needed. While the warp is being made, the rods must be immobilised in some way. One method is to follow the description in section 2 above for warping a portable frame, but when the warp has been made on the two rods, lift the latter out of the frame and use them as shown in Fig. 12. Alternatively two rods can be clamped to a table top and the warp laid between them.

Quite a different way is to set up a warp on a normal loom, working as follows:

Weave a few picks of weft, then weave a stick in, followed by a few more weft picks. Then wind forward a length of unwoven warp. On the far side of this, weave a few picks, a stick and a few more picks. Then cut this from the loom, apply tension to the two sticks and work the sprang on the unwoven section of warp between them.

Using this method, one long warp on a loom can quickly provide many warps for sprang fabrics. A possible disadvantage is that the warp setting is fixed and therefore cannot be altered as it can with a normal sprang warp. So the warp setting on the loom must be correct for the sprang fabric. The two sticks and the weft on either side of them are part of the final fabric, so this method is suitable for hangings which in any case probably need a stick at either end.

A development of this idea is to combine both sprang and weaving in the same fabric. A stripe of weaving alternates with a stripe of sprang, worked on warp threads left unwoven for this purpose. The sprang can either be worked on the loom before the cloth is wound on, or off the loom with the fabric stretched on a frame. The idea could be extended to alternating blocks of weaving and sprang.

5. MAKING A WARP WITH WOVEN BORDERS AT BOTH ENDS

A warp of this type has been described only in connection with the finding of a fabric at Tegle, Norway (Hoffmann and Traetteberg, 1959). Though usually referred to as a stocking, it is in fact only a tube of fabric with no foot, so perhaps legging is a better description.

The principle is that two narrow warps (labelled A in Fig. 21) are set up, at a distance apart equal to the required length of the sprang warp. Yarn from a ball is then laid as weft between these two warps, a loop of yarn being inserted in each succeeding shed, as shown in Fig. 21. A thread is passed through the loops of weft at the top to stop them

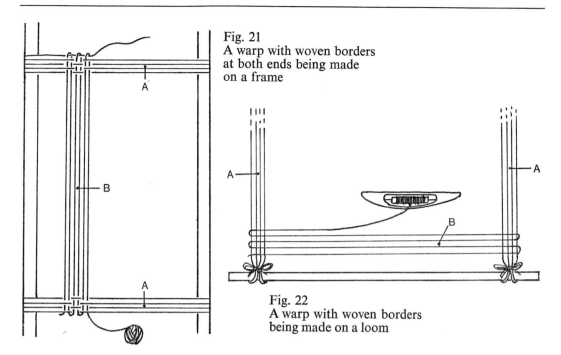

Fig. 21
A warp with woven borders
at both ends being made
on a frame

Fig. 22
A warp with woven borders
being made on a loom

slipping out. It is this weft (labelled B in Fig. 21) which is to be used as warp for the sprang work. The weaving may take the form of plain weave, obtaining the sheds with a rigid heddle, or the form of tablet weave, using tablets or cards. The two narrow warps can be stretched horizontally between the uprights of a sprang frame, as suggested in Fig. 21, and then the sprang warp is in the correct position for its subsequent working.

Alternatively, the two warps can be mounted in a normal loom and tied to the front stick as shown in Fig. 22, provided the loom is wide enough to give the required length of sprang warp. In this case, the weft (labelled B in Fig. 22) can come from a shuttle and can weave normally with the two small warps (labelled A). When sufficient has been woven, it is taken from the loom. Then tension has to be applied in some way to what was weft, but is now to be warp for the sprang process. The two woven borders could be stitched to rods, and then the rods be gravity- or weaver-tensioned or fixed in a frame.

The set of the warp is naturally fixed once the warp is made in either of these ways.

6. MAKING A LONG WARP

A very long warp cannot be accommodated on a frame, even if the circular warp method described in Chapter 11 is used. Therefore it has to be stretched horizontally between two rods, which are fixed by adjustable cords to some substantial supports. The warp is laid by walking up and down between the rods carrying the yarn. For ease of working, the warp should lie at about waist height.

5 · Basic Technique

INTRODUCTION

The various warping methods end with inserting the sword into the central warp opening, or shed, the opening in which the safety cord lies. The sword is pushed down to the lower end of the warp where it lies separating the warp into a front and back layer of threads. Numbering the threads from the right selvage, the odd numbered threads lie in front of the sword, and the even numbered threads lie behind it.

The various sprang structures are achieved by twisting threads all across the warp. So the work proceeds in rows, the edge of the fabric always being at right angles to the warp direction as in weaving. This edge is called the fell of the fabric. Each structure needs a certain number of rows to complete it, after which the sequence is repeated. In 1/1 Interlinking, which is the basic and most simple sprang technique, there are two rows. These are called the *plait row* and the *overplait row*, which are direct translations of *vlechttoer* and *overvlechttoer*, the Dutch words used by Reesema (Reesema, n.d.). They will now be described in detail.

1. 1/1 INTERLINKING

A. Normal method of working

(i) PLAIT ROW

Beginning the row

Insert the fingers of the left hand into the warp opening in which both the safety cord and sword lie and slide them up almost to the top of this shed. The odd numbered, front layer, threads now lie in front of the fingers and the even numbered, back layer, threads lie behind them. Lay the left thumb across the front layer of threads, so in effect the left hand is gripping the front layer.

With the right thumb and index, pick up the first two right-hand threads of the back layer (threads 2 and 4) and bring them forward, so that they lie across the front of the right-hand fingers and under the right thumb. Then from the front layer held in the left hand, release the first thread (thread 1). Just let it slip from between the left fingers and thumb. Push it with the back of the right index so that it comes to lie behind that finger. One interlinking of the plait row has now been worked and the hands are now as in Fig. 23.

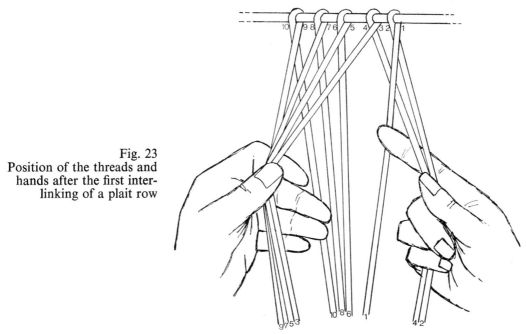

Fig. 23
Position of the threads and
hands after the first inter-
linking of a plait row

Note—That in Fig. 23 the hands are pulling the threads out of their vertical line so that
there is a spreading of the warp between the hands. This is important and is always
done to make the threads easier to see at the actual point of work.

Central section of the row

With the right thumb and index pick up the next thread in the back layer (thread 6) and
take it into the right hand to join the two threads already there. Drop the next thread from
the front layer (thread 3) and again with the right index push it behind this finger. So at
the end of the second interlinking, there are three threads in the right hand and two
threads behind the right index.

Repeat this manœuvre all across the warp, always picking up the next back layer thread
with the right hand and dropping the next front layer thread from the left hand.

Note—That as the row is being worked the left hand moves slowly to the left, holding
progressively fewer threads, while the right hand, also moving slowly to the left,
holds progressively more threads.

Finishing the row

Eventually a point is reached when only three threads remain to be interlinked, two being
front layer threads *in* the left hand and one being a back layer thread lying *behind* the left

hand. Pick up this last back layer thread with the right thumb and index and take it into the right hand and drop off the last two front layer threads and let them go behind the right-hand fingers. The plait row is now completed.

Note—That a plait row begins by picking up the first two back threads and dropping the first front thread, and ends by picking up the last back thread and dropping the last two front threads. Between these two points, it is always *one* back thread (the next in order) that is picked up, and *one* front thread (the next in order) that is dropped.

The net result of the plait row is that the threads which were in the back layer in the initial shed (i.e. behind the left hand to begin with) are now in the front layer (i.e. in front of the right-hand fingers), and the threads which were in the front layer are now in the back layer. This interchange of threads from front to back layer takes place in every row and together with a sideways shift gives rise to the diagonal mesh of 1/1 interlinking. The sideways shift is the result of beginning the row by picking up two back threads.

With the left hand, now free of threads, untie the safety cord from the left-hand upright and draw it out of the previous shed. Now put the left hand into the newly made shed and take out the right hand. With the latter pick up the safety cord and give its free end to the fingers of the left hand. Slide the left hand out of the shed, drawing the cord through the shed after it. Tie the cord once again to the left-hand upright. Withdraw the sword, insert it

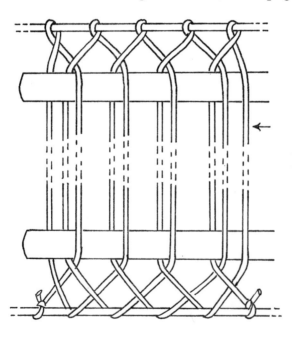

← Fig. 24
Position of the threads at
the top and bottom of the
warp after the first plait row

into the new shed and push it upwards and downwards, driving the new thread crossings to the two ends of the warp. Fig. 24 (top) shows how the threads will lie at the upper end of the warp.

Note—The two threads lying together in front of the sword at the right selvage and the two threads lying together behind the sword at the left selvage. This is how the two selvages must look at the end of a plait row.

As Fig. 24 (bottom) shows, a similar state exists at the lower end of the warp when the sword is pushed down, except that the thread crossings are in the reverse direction.

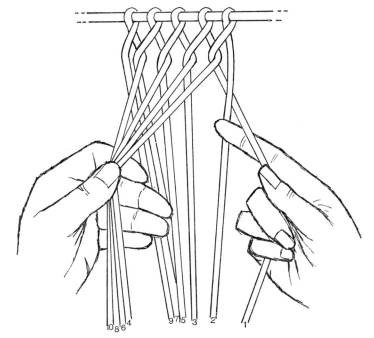

Fig. 25
Position of the threads and
hands after the first inter-
linking of an overplait row

(ii) OVERPLAIT ROW

As before, insert the left hand into the opening in which the safety cord lies, and grip the front layer of threads. Using exactly the same movements as described above, begin by picking up the first back layer thread with the right hand, and dropping the first front layer thread from the left hand. The hands are now as in Fig. 25. So only one back layer thread is picked up at the start of the over-plait row, not two as at the start of the plait row. The front layer thread that is dropped must naturally be the right-hand of the two threads which lie together, i.e. the one arrowed in Fig. 24. These two threads may get crossed, but if they are traced upwards it can easily be decided which is the right-hand one of the two.

Continue the row to the end, always picking up the next back layer thread and dropping the next front layer thread. At the end, be careful that the two back layer threads lying together are taken in their correct order, first picking up the right-hand of the two, then the left-hand one.

Note—That in an overplait row, one back layer thread is picked up and one front layer thread is dropped, all the way across.

Untie the safety cord with the left hand, pull it out of the previous shed and insert it into this new shed. Withdraw the sword and put it into the new shed, pushing it up and down.

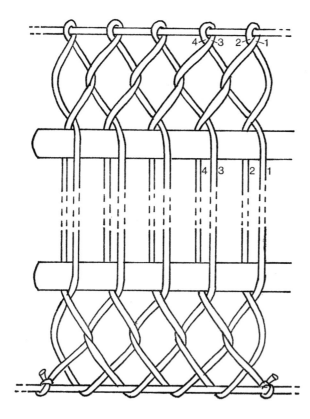

Fig. 26
Position of the threads at the top and bottom of the warp after the first overplait row

With the sword pushed up and the threads spread out, the work will look as in Fig. 26 (top). The diamond-shaped mesh, characteristic of interlinking, is clearly seen to result from each thread linking alternately with its right and left neighbour. This zigzag or, more accurately, spiral movement of each warp thread continues right through the fabric and is

the cause of the warp take-up. If the sword is pushed down, as in Fig. 26 (bottom), a corresponding piece of fabric will be seen at the bottom of the warp.

Note—That the lower fabric is a mirror-image of the upper one, the thread crossings in one fabric being in the reverse direction to those in the other.

—The threads are now back in the same order as on the top rod. See the numbered threads in top half of Fig. 26. So the plait row draws them out of their original sequence and the overplait row returns them to that sequence.

—In both rows, that as each back layer thread is picked up it passes under two front layer threads, thus shifting to the right. See Fig. 25. The only exception is the very first back layer thread in a plait row and the very last back layer thread in an overplait row.

—That if for any reason a warp must contain an odd number of threads, the rows are worked quite normally. But it will be found that a plait row must end by picking up one thread and dropping one, and that an overplait row must end by picking up one thread and dropping two, i.e., exactly the reverse of the normal condition.

To continue the interlinking, another plait row is worked, then another overplait row, and so on. With this constant alternation of plait and overplait rows, the two halves of the fabric will gradually approach the centre of the warp.

There is never any difficulty in deciding which is the next type of row to do. If there are two threads in front at the right selvage, it indicates that a plait row has just been completed so an overplait row must follow. If there is only one thread in front, then an overplait row has been worked and a plait row must follow. This can be reduced to a practical rule as follows. If there are two threads in front at the right selvage, begin the next row by picking up one back layer thread. If there is one thread in front at the right selvage, begin the next row by picking up two back layer threads.

B. Abbreviations for sprang instructions

An abbreviated way of describing the sprang manœuvres is used throughout this book and will now be described.

The letters B and F are used to indicate the *next Back layer thread* and the *next Front layer thread*. B/F indicates 'pick up the next back layer thread and drop off the next front layer thread'. This is the manœuvre that has predominated in the above descriptions of the plait and overplait rows. Similarly 2B/F indicates 'pick up the next two back layer threads and drop off the next front layer thread', the first manœuvre in a plait row. One of the signs in a bracket, i.e. (B/F), indicates it is to be repeated as often as necessary. A number outside the bracket, i.e. (B/F) × 4, indicates it is to be repeated that number of times. A sign without a bracket means that the manœuvre is to be done once only.

So, using these abbreviations, the instructions for a plait and overplait row can be written in the following way.

B/2F ——◄—— (B/F) ——◄—— 2B/F Plait Row

——◄—— (B/F) ——◄—— Overplait Row

Note—That these instructions are read *from right to left*, as shown by the arrows. This is the direction in which the work is done and not the normal left-to-right direction of reading.

The direction of the stroke, /, indicates the direction of twist at the point where the two threads interlink, see Fig. 27(a). The technique described above can be called *1/1 Inter-linking*, as one thread is interlinked with one thread and the twist is in the direction of the stroke. Alternatively, using the convention applied to twist in yarns, it can be called *Z-twist Interlinking*.

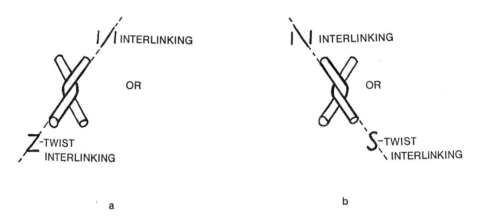

Fig. 27 (a) and (b). Explanation of nomenclature of Z- and S-twist interlinking

The direction of the twist can be in the opposite direction, giving 1\1 *Interlinking* or *S-Twist Interlinking*, see Fig. 27(b). Naturally when the interlinking is 1/1 or Z-twist in the upper fabric, it is 1\1 or S-twist in the lower fabric, see Fig. 26. Several sprang techniques combine S- and Z-twist interlinking in the same piece.

In the descriptions so far, it has always been a back layer thread that is picked up and a front layer thread that is dropped off. But instances will be found later in this book where the opposite is done and it is important to be able to convey this information with the above symbols. So the following convention has been adopted.

With Z-twist interlinking, the thread (or threads in some cases) to be picked up is always written to the *left* of the stroke. This is not an arbitrary choice, as in normal working the back layer thread does in fact lie to the left of the front layer thread with which it is to

interlink. With S-twist interlinking, the thread (or threads) to be picked up is always written to the right of the stroke. Again this is the position in which the thread normally lies.

So F\B indicates pick up the back layer thread and drop the front layer thread, giving an S-twist. But B\F indicates pick up the front layer thread and drop the back layer thread, giving an S-twist, a manœuvre met with in some techniques that combine S- and Z-twist interlinking.

The rule can be memorised thus: if the stroke is tilted a few degrees until it is horizontal, then it is always the thread *above* the stroke that is to be picked up.

Other abbreviations will be explained as they are encountered in the descriptions of techniques.

C. Other methods of working

The way of manipulating the threads to make 1/1 interlinked sprang just described will in this book be regarded as the normal way, and the other techniques will be built on this foundation. But there are other methods of arriving at the same structure and their description now follows.

(i) USING A STICK INSTEAD OF THE RIGHT HAND

In this method, which is not traditional, the left hand behaves normally, but a pointed stick held in the right hand takes the place of the right index finger. So in the plait row, the first two back layer threads are picked up on the point of the stick and then lie in front of it, and the first front layer thread is released by the left hand and pushed backwards by the stick and then lies behind it. The next back layer thread is then picked up and lies in front of the stick and the next front layer thread is released and pushed behind the stick, and so on. This operation, in which the point of the stick moves backwards and forwards as if it were darning its way into the new shed, can be done quite quickly to begin with. But the further the row progresses to the left, the more difficult it is to manipulate the stick, especially if the warp is highly-tensioned and inelastic. Also in the more complicated structures of sprang, it is really essential to have the fingers of both hands involved in the work. So the method has limitations.

(ii) S-TWIST INTERLINKING USING BOTH HANDS

Some methods produce a 1\1 interlinked sprang in the *upper* fabric as the normal basic structure, i.e. at the point of interlinking, the threads make an S-twist with each other, instead of a Z-twist. Schinnerer's diagrams show this so presumably the Ruthenians, who taught her, worked thus (Schinnerer, n.d.). Hald has an exact description of this method, which now follows (Hald, 1935, 1950).

Plait row

Insert the left hand into the warp so that the index, middle and little fingers lie in the shed, the fourth finger behind the back layer of threads and the thumb in front of the front layer of threads, as in Fig. 28. As in the normal method, work begins from the right. With the thumb and *middle* finger of the right hand, pick up the first two front layer threads and make them slide in between the index and middle fingers. Then with the thumb and *index* of the right hand, pick up the first back layer thread and bring it to lie in front of the index. The position reached is shown in Fig. 28.

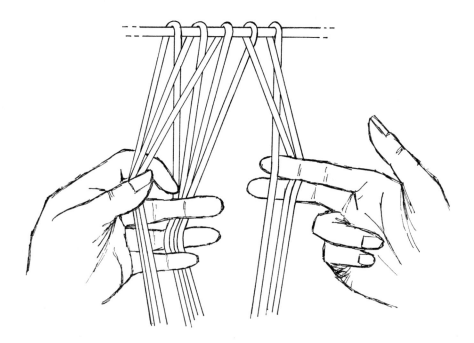

Fig. 28. S-twist interlinking. Position of hands and threads as plait row is begun

Then with the right thumb and middle finger pick up the next front layer thread and let it slide in between the index and middle fingers to join the two threads already there. With the right thumb and index, pick up the next back layer thread and let it lie in front of the index finger. Continue thus, picking up one front layer thread and one back layer thread to the end of the row. There, pick up one front layer thread with the right thumb and middle finger and two back layer threads with the right thumb and index finger.

It will now be found that it is only the right index finger which is in the new shed. The safety cord and sword are put into this shed in the normal way.

Overplait row

Take exactly the same grip with the left hand in the new shed. Work the row as before with the right hand, but picking up *one* front layer thread with the thumb and middle finger and *one* back layer thread with the thumb and index finger all the way across.

Repeat the plait and overplait rows.

Note—Due to the position of the fourth finger of the left hand, the back layer threads can be held as much under control as the front layer threads. Without this special grip, it will be found that the next back layer thread is more difficult to pick up because it wanders over to the right.

(iii) S-TWIST INTERLINKING USING A STICK INSTEAD OF THE RIGHT HAND

S-twist interlinking is also the normal basic structure in a method using a stick held in the right hand. The work goes from right to left. The left hand does not lie in the shed but its fingers do all the selection of threads.

Plait row

Start with a stick (A) in the first shed, and work below it, see Fig. 29(a). Insert the left thumb and index finger between the second and third front layer threads (i.e. the second and third threads from the right lying over the stick), move them to the right, pick up the first back layer thread, pull a loop to the front and slip it over stick B, held in the right hand. See Fig. 29(b). Now insert the left-hand fingers between the third and fourth front layer threads and pick up the second back layer thread and slip it on to stick B.

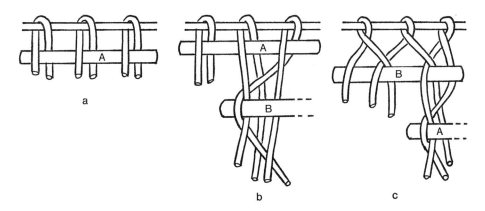

Fig. 29 (a) to (c). Stages in S-twist interlinking using a stick instead of the right hand

Continue thus all across the warp, the point of insertion of the left-hand fingers always being one front layer thread further to the left, and the back layer thread they pick up always being the most right-hand one. At the end of the row, pick up the final two back layer threads and put them on the stick. Pull out stick A and push stick B up. Insert another stick (C) in this new shed and push it downwards. Leave these two sticks, B and C, in position.

Overplait row

Insert the left thumb and index finger between the first and second front layer threads and pick up the right-hand of the two back layer threads which lie together and put it on to stick A. See Fig. 29(c). Insert the fingers between the second and third front layer threads and pick up the next back layer thread, the left-hand of the two which lie together. Continue thus all across the warp. Take out sticks B and C, push A up to the top, insert C into the same shed and push it down to the bottom.

Repeat the plait and overplait row alternately as many times as desired.

Note—Except at the very beginning of the overplait row and the very end of the plait row, each picked up back layer thread is made to pass under two front layer threads before it passes over the stick. See Fig. 29(b).

—That a safety cord is not necessary as there are always two sticks in the shed.

(iv) WORKING AT THE LOWER END OF THE WARP

In all the methods described so far, the threads are manipulated at the upper end of the warp, but there is no reason at all against working at its lower end. Indeed there may be some significance in the fact that two of the few countries that still make flat warp sprang use this method; they are Mexico and Colombia. The method may even be more convenient in some cases. For instance, if a large portable frame is held on the lap, it is tiring to work with the hands raised to the top of the frame. Or with a weaver-tensioned warp, it is impossible to stretch to the far end of the warp.

If the instructions for the normal method of working the plait and overplait rows are followed, then the 1/1 interlinking will result as described. It will be S-twist under the hands, in the lower fabric, and Z-twist in the upper fabric. The sword and safety cord will be above the hands.

Alternatively the sword can be left in the last shed, lying against the fell of the lower fabric, and the next row be made above it. In this case, a different set of finger movements can be used which involve the right hand only and which make for very speedy progress. This method gives Z-twist in the lower fabric and S-twist in the upper. When each row is completed the safety cord is re-positioned. The sword is taken out, put in the new shed and pushed upwards forcing the twists to the top of the warp. It is left at the lower end of

the warp and the next row is worked above it. Having the sword in this position can prove very helpful in the more complicated techniques.

Temporary shed sticks can be used exactly as when working at the top of the warp.

Anyone who works in this way will soon discover how to interpret the diagrams in this book. Some will have to be turned upside down, some mirror-imaged, and some left as they are.

(v) WORKING ON A DIAGONAL

The makers of hammocks and string bags in Columbia work at the lower end of the warp, using the method of interlinking along a diagonal line. Beginning at the bottom left-hand corner, they build up a triangle about six rows high, just as shown in the bottom half of Fig. 36. From then on, they make diagonal lines, each of six interlinkings, securing the final interlinking of each line with a stick, which is gradually slid in from the left. In this way a band, six interlinkings deep, is made all across the warp. The duplicated twists are then pushed to the top end of the warp. The whole process is repeated exactly, adding another band of interlinkings to both ends of the warp, and so on until the upper and lower fabrics meet. Only simple 1/1 interlinking is used and the method is certainly not suited to most of the pattern-making techniques. But simple diagonal stripes using S- and Z-twist interlinking could be worked quite easily.

This method of work has two very useful applications, in correcting a mistake (see section 3B(ii) of this chapter) and in working the final rows of a fabric (see section 7B). It is described in more detail in both of these cases.

2. LEAVING STRINGS IN THE SHED

When first learning sprang or when trying out a new technique, it is a good idea to leave a string or thread in the shed, at intervals in the work; and it is always advisable to leave one in the very first shed of the warp. When a row is completed and the safety cord and sword reinserted in the new shed, a length of string or thread is laid in this shed under the sword at the lower end of the warp. This is repeated a few rows later and so on. If it is decided to keep the piece of sprang fabric, then the threads are all pulled out and no trace is left of their temporary presence. But if it is decided to undo the piece and start again, the fabric is unworked back to one of the threads, which then provides a baseline for the second attempt.

3. MISTAKES

A. Spotting mistakes at the end of a row

At the end of each row and before the safety cord is put in the new shed, it is advisable to push the right hand up to the top of the warp and look for any errors. The commonest

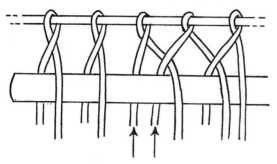

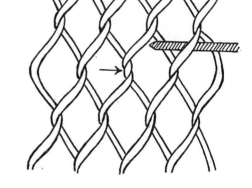

Fig. 30. Spotting the mistakes at the end of
a row

Fig. 31. Correcting mistakes. Inserting a rod
above the mistake

mistake is to pick up or drop off two threads where one should be picked up or dropped off.
This makes the whole of the rest of the row incorrect. At the points arrowed in Fig. 30,
two threads instead of one have been dropped in the first plait row, and it will be seen that
in the rest of the row there is no side-to-side interlinking of the threads. If a mistake is
discovered, slide the right hand out of the shed to that point, slide the left hand into the
initial shed (where the safety cord still lies) up to that point and rework the threads
correctly to the end of the row.

B. Correcting mistakes made in a previous row

When a mistake is discovered in weaving, it is simple to unweave back to the mistake and
correct it. The shafts are just raised in the reverse of their normal sequence and the weft
is withdrawn pick by pick. Sprang is a far less mechanical process and to undo a row may
take longer than doing the row as the fingers are not used to the reversed movements. So
to reach back to a mistake or to undo a sprang fabric for any reason, it is quicker to pull
the work apart in a less ordered manner. Assuming no strings have been left in, there are
two ways of doing this.

(i) BY INSERTING A ROD

In Fig. 31, a double twist (arrowed) has been mistakenly made in the centre of the warp.

Just above it, slide a thin rod such as a knitting needle into the mesh. Make it pass over
each thread moving down to the right, and under each thread moving down to the left.
Continue this over-one-under-one movement right across the warp and the rod will come
to lie in the shed that was being used when the mistake was made. Now remove the safety
cord and pull the work apart until the threads are untwisted back to the rod. Put the cord
in the same shed as the rod, remove the rod and work the row normally without a mistake.

It may be difficult to determine the correct horizontal path for the rod through some thread structures, e.g. in designs with long holes and those combining S- and Z-twist interlinking.

(ii) BY MAKING A TRIANGULAR OPENING

If the warp is wide, the above is a wasteful way of correcting one mistake. In this case, remove the safety cord and let the work come apart in the following controlled manner.

Insert the two hands into the last shed and bring them towards each other so that they meet vertically below the mistake. Grip the front layer of the warp with each hand and pull it sideways so there is a gap in the warp under the mistake. Now from one hand release the two threads nearest this gap, thus undoing an interlinking made in the last row. Then release the similarly placed two threads from the other hand and so on.

As each pair is released, a diagonal line of interlinking will become undone and run upwards into the fabric, first to one side and then to the other of the gradually increasing triangle of unworked threads. Eventually this triangle will reach up to the mistake as shown in Fig. 32, where the mistake is arrowed. Having corrected the mistake, the triangle can be re-worked in one of two ways:

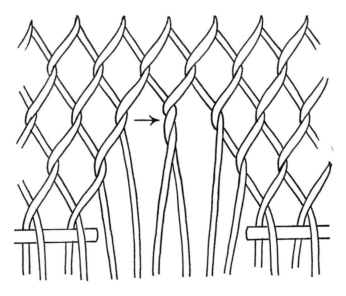

Fig. 32. Correcting mistakes. Making a triangular opening leading up to the mistake

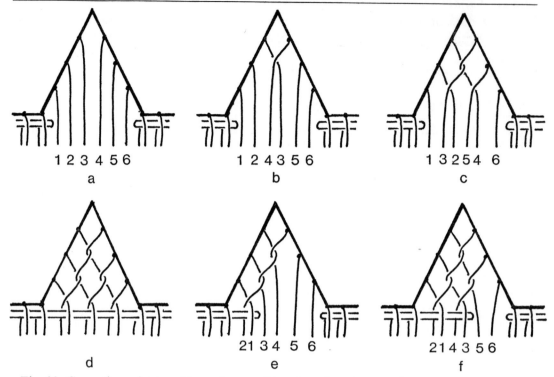

Fig. 33. Correcting mistakes. Stages in reworking the triangular opening. (a) to (d) Working row by row, (e) and (f) working diagonally

(a) Working row by row

Fig. 33(a) represents the triangle in a much simplified form.

Starting at the apex of the triangle, interlink the two highest threads, 4 and 3. See Fig. 33(b). Then for the second row, interlink thread 5 with 4, and thread 3 with 2. See Fig. 33(c). For the third row, interlink thread 6 with 5, 4 with 3, and 3 with 2. See Fig. 33(d).

The mesh in the triangle has now caught up with the surrounding fabric, which has been prevented from undoing by two temporary sticks as shown in Fig. 33(a). A complete shed all across the warp is now re-established and the work can continue.

 This is the method to use if there is any patterning in the fabric, as the pattern can be reconstructed row by row in the normal way.

(b) Working on a diagonal

If however there is only simple 1/1 interlinking in the area concerned, the following method is probably simpler.

Fig. 33(e) shows the principle. Interlink thread 4 with 3, then 3 with 2, then 2 with 1. Slide in the left-hand stick (or the left hand itself) to hold the last interlinking and thus secure the diagonal line of new mesh. This is a simple and quick procedure done with the right hand alone and it will be seen that it reduces the size of the triangle.

Now interlink thread 5 with 4, and 4 with 3, and again slide in the rod or left hand to secure the diagonal line of mesh. See Fig. 33(f) for the position now reached. The triangle has practically disappeared and it only remains to interlink thread 6 with 5 for the correct shed to be established all across the warp, as in Fig. 33(d).

Note—That any diagonal row of interlinking, however long, is always secured or locked by the final interlinking.

 —That this method works well for correcting mistakes at or near the selvage. There is no noticeable complication due to the different beginnings of a plait and overplait row.

 —That this is the same principle as used in correcting mistakes in knitting, where a vertical line, not a triangle, of stitches is first dropped and then reworked.

4. OTHER METHODS OF HANDLING THE SAFETY CORD

Some workers prefer to handle the safety cord in a simpler way than that described in section A(i) above. The cord is not tied to either upright, but just hangs down freely at either side of the warp. At the completion of a row, the cord is pulled out of the warp with the free left hand and its end immediately given to the fingers of the right hand, which then slides to the right out of the shed, drawing the cord into the shed. The sword is removed from the previous shed. One hand then pulls forward the two ends of the safety cord, thus opening the shed into which the other hand then slides the sword.

Another method is to use two cords, both fixed to the right upright of the frame. One is always in the last shed and is tied temporarily to the left upright. The other is drawn into the new shed when the row is completed, or, if the fabric is wide, it is drawn in section by section. So at this point there are two cords across the warp, the upper one in the newly made shed, the lower in the shed from the previous row. The former is tied to the left upright. The latter is untied at the left, pulled out of the warp and allowed to hang free until it is inserted in the shed of the following row.

This is a doubly safe method as at no time is the warp without at least one cord running through it and securing a shed.

5. HOLDING THE WARP OUT

Fig. 26 shows the sprang fabric stretched sideways but in its normal state it will draw in, obliterating the diamond-shaped spaces and appearing as an almost solid fabric. See Fig. 34. The front surface will be composed entirely of threads slanting downwards to the left

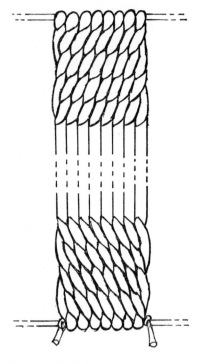

Fig. 34
Close texture of 1/1 inter-
linking in its normal
unstretched state

in the upper fabric, and of threads slanting downwards to the right in the lower fabric. So the surface has a strong diagonal texture. In either the upper or lower fabric, the diagonal is found to be in the same direction when the fabric is turned over.

The fabric can be held in the open state while working by tying loops of string between its edges and the uprights of the frame.

When a sprang fabric is mounted in a frame for use as a wall hanging, it is generally stretched sideways so the diamond mesh is visible. See Plate 6.

6. WORKING WITH A WIDE WARP

It will be obvious that with a wide warp all the front layer threads cannot be held in the left hand at the beginning of a row, nor in the right hand at the completion of a row. Each row is therefore worked in small manageable sections in the following manner.

Insert the left hand into the warp shed at a covenient distance from the right selvage, say about 3 to 4 inches, so that it is gripping the front layer threads between this point and the right selvage. Work the row normally until all the threads in the left hand have been dealt with. Now put a stick (or an extra cord) into the shed where the right hand lies and having thus secured this first section of the new shed, withdraw the right hand. Insert the left hand into the warp another 3 to 4 inches further to the left. When this group of threads has

been worked, the stick or cord is slid across into the new shed, so that this new section of it is also secured.

Continue working thus, section by section, until the row is finished, then pull the safety cord out and insert it into the new shed, occupied by the stick or extra cord. The stick or cord can then be removed, but will of course be needed in the next row.

In this manner a warp of any width can be worked. Care should be taken to avoid mistakes at the junction between two sections of warp.

Naturally if two safety cords are used as described above in section 4, a wide warp presents no problems. One cord lies in the previous shed and the other is drawn into each section of the new shed as it is made. At the end of the row, the lower cord is pulled out and is ready for use in the next row, while the upper cord is pushed down to make room for the work to continue.

7. MAINTAINING EQUAL TEXTURE IN UPPER AND LOWER FABRIC

A. Using two sets of temporary shed sticks

One of the difficulties of sprang is to ensure that the rows are equally packed down in both the upper and lower fabric. Any inequality leads to one fabric being longer than the other and to the meeting line being off-centre, a condition often found in old fabrics. As the sword is kept lying in the shed above the lower fabric, there is a tendency for this to stay better compacted than the upper fabric even though both may be equally well beaten with the sword after each row. Though this tendency can be overcome with practice and a frequent use of a tape measure, it can be avoided altogether by using several small temporary shed sticks. These are thin dowels and are used in the following manner.

After the first row, put two sticks into the new shed, where the safety cord lies. Push one down the warp and one up and leave them there against the fell of the two fabrics. After the second row, which is worked below the upper stick, put another two sticks in the new shed and push them up and down firmly. Do the same after the third and fourth row. After the fifth row, slide out the two sticks which were the first to be inserted, i.e., the highest and the lowest stick, and put these into the new shed. Push the upper sticks upwards, one by one, starting with the top stick, to keep the fabric well compacted and to avoid any looseness where the stick has just been slid out. Push the lower sticks downwards in a similar manner. Repeat the above procedure after every subsequent row, always sliding out the highest and lowest sticks, reinserting them in the new shed and pushing all sticks close up against the fell of the two fabrics.

As described, there will always be eight sticks in use, four above and four below, but there can be any even number.

The sword is not used at all as the successive rows are packed together entirely by the sticks.

It is this use of sticks in flat warp sprang and their universal use in circular warp sprang that has given rise to the German word, *Stäbchenflechterei,* and the Swedish word, *Pinnbandsflätning,* both of which cover the two types of sprang.

B. Using one set of temporary shed sticks

Sticks can be used as described above but only pushed to one end of the warp. If for instance it is the upper fabric which is looser and needs attention, then a single stick is introduced after each row and pushed upwards. The sword is used as usual to beat the lower fabric. When say four sticks have been introduced, they are pulled out, one by one, in the manner already described.

Hald describes the use of long temporary shed sticks in the lower half of the warp. Both uprights of the frame have cord wrapped spirally round them and each end of a stick is passed under a lap of this cord. Thus the sticks are held firmly in position and cannot ride up.

8. WORKING THE FINAL ROWS

A. Conventional method

As the work proceeds and the two sprang fabrics reach towards the centre of the warp, there is less and less room for the hands to work. Eventually the sword cannot be left lying in the shed but is removed after beating up and down to provide more space. It is only the safety cord which now lies in each new shed.

When the shed becomes so small that the hands cannot enter it, the work has to be done with the help of first one, then two, fine rods or knitting needles. Slide the left index finger into the shed and with the right hand, manipulate a knitting needle, picking up back layer threads on it and letting front layer threads drop behind it. Use the needle instead of the sword to push the twists up and down.

When even the left index finger will not fit into the shed, let the second knitting needle take its place. Working thus with two needles is difficult and slow, but it is the only way of making the two fabrics meet without any loosening of the mesh. It may be found easier to use a crochet hook instead of a knitting needle in the right hand. When the final row has been worked, leave the needle in place. See Fig. 129. The various ways of fastening this row are described in Chapter 10.

B. Working on a diagonal

If, as often happens, the final section of the work is in simple 1/1 interlinking, then the

usual difficulties can be side-stepped by working on a diagonal, a principle already met with twice in this chapter.

Stop the normal row-by-row interlinking some 2 or 3 inches short of the centre of the warp after an overplait row. Take out the sword and push the safety cord down so that it lies out of the way, against the fell of the lower fabric. Now two triangles of interlinking have to be built up as seen in Fig. 36. The work is begun at the left but each row of diagonal interlinking is done in the normal direction from right to left.

Pull over to the left the extreme left-hand front layer thread, labelled 1 in Fig. 35(a). Now with the right hand take the next front layer thread 3, across the back layer thread 2,

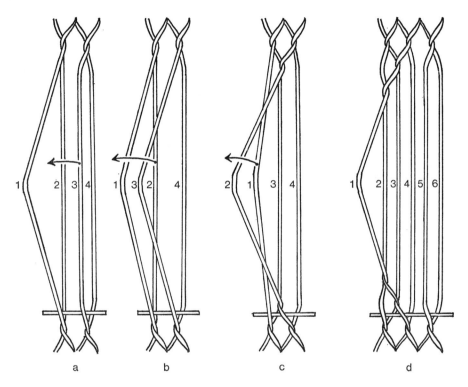

Fig. 35. Working the final rows by diagonal interlinking. (a) to (d) The first diagonal row

as in Fig. 35(b). Pick up thread 2 and drop thread 3, as in a normal interlinking movement. Now take thread 2 to the left across thread 1, as in Fig. 35(c). Pick up thread 1 and drop thread 2, see Fig. 35(d).

These can either be regarded as interlinking movements in which the back layer thread picked up in one interlinking immediately becomes the front layer thread for the next

interlinking, or as chaining or crocheting movements in which a loop is pulled through a loop. However regarded, they result in a row of diagonal interlinking.

Note—That the back layer thread 4, the partner of thread 3, is not involved in this row.

The second row of diagonal interlinking begins with the next front layer thread, which is thread 5. Thread 5 is interlinked with thread 4, 4 with 3, 3 with 2, and 2 with 1. There are four interlinkings as this time there are four threads (numbers 1 to 4 in Fig. 35(d)) between thread 5 and the selvage. Again thread 6, the partner of thread 5, is ignored.

In the third row, which starts with thread 7 the next front layer thread, there will be six interlinkings, and so on.

Continued thus and always starting a diagonal row of interlinking with the next front layer thread, the two triangles will eventually meet. In Fig. 36 this has happened after three such rows. At this point, slide a rod into the final loop of thread 1, securing the work done.

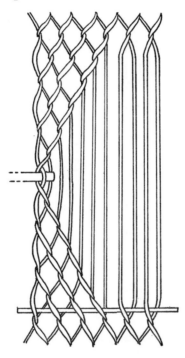

Fig. 36
Working the final rows by diagonal interlinking. Rod slid in to secure the two triangles of interlinking

From now on, there will always be the same number of interlinkings in each diagonal row (six, in the case of Fig. 36), at the end of which the rod is slid in further to hold the new final loop. If a crochet or latchet hook is used, instead of a rod, then these loops can be chained into one another as each row is completed.

Working from left to right, the gap between the upper and lower fabric is gradually closed. When the right selvage is reached, the process is continued but with a diminishing

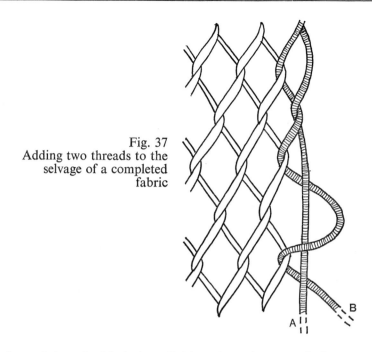

Fig. 37
Adding two threads to the
selvage of a completed
fabric

number of threads. If six interlinkings have been made in each diagonal row, then the last rows will consist of five, three and finally just one interlinking. The cord is then pulled out and, unless the final loops have been chained as suggested, the meeting line has to be permanently secured in one of the ways described in Chapter 10.

Note—that throughout this process there is plenty of room for the fingers to work, as neither hand has to lie in the shed.

It is possible though more difficult to interlink diagonally with S-twist, so the two types of twist can be combined. See the diagonal lines on either side of the meeting line in Plate 57, and the triangles in Plate 61.

9. ADDING THREADS WHEN THE FABRIC IS OFF THE FRAME

If for any reason the fabric needs to be widened when off the frame, threads can be added two at a time at either selvage. As Fig. 37 shows, one thread, A, is passive and the other, B, threaded on a needle, is active. The latter alternately loops around A and passes through the outer loops of the fabric.

6 · Interlinked Sprang

This chapter deals with the many technical possibilities of interlinked sprang. The basic working method is described at the beginning of Chapter 5.

1. TECHNIQUES BASED ON INTERLINKING ONE THREAD WITH ONE THREAD, OR 1/1 INTERLINKING

All the techniques in this section use the simplest form of interlinking, in which each thread interlinks alternately to left and to right with the adjacent warp threads.

A. Using a warp of several colours

Warps of more than one colour have been used from the fifth century A.D., e.g. striped woollen warps for Coptic bags, down to the present day, e.g. striped cotton warps for the belts made in Pakistan. For the sake of simplicity only two colours, called A and B, will be described here but there is obviously no limit to the number which can be used.

(i) WARP WITH WIDE STRIPES OF TWO COLOURS

If the warp has wide stripes of colours A and B, they will naturally appear as vertical warpway stripes in the finished fabric. However, the boundary between two stripes will not be a straight line but a toothed, or zigzag, line, a peculiarity arising from the nature of interlinking. Fig. 38(a) shows such a boundary when the fabric is stretched. The junction between the central white and grey stripe in Plate 4 shows this zigzag on a piece of unstretched sprang.

(ii) WARP WITH AN (A,B,A,B) COLOUR SEQUENCE

If the warp is made of two colours alternately, they will appear as narrow cross stripes. Fig. 38(b) shows the stretched fabric. When the fabric is relaxed, it is only the threads slanting down to the left which form the front surface, the other threads disappearing to form the back surface; hence the horizontal stripes which appear as the background in Plates 9 and 10 and as the motif in Plate 8.

When working a warp like this it will be found that after one row all colour A threads are in the front layer, and after the next row all colour B threads are in the front layer.

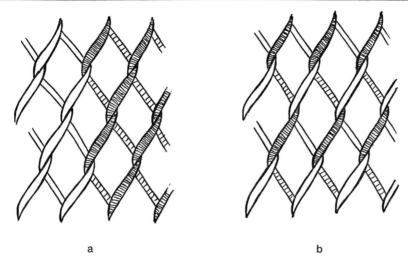

Fig. 38. Interlinking a warp, (a) with wide stripes of two colours; (b) with an (A, B, A, B) colour sequence

Such cross stripes are often combined with warpway stripes in belts, a section of cross stripes of colour A and B acting as a transition between a warpway stripe of A and of B. In this case the warp could have, say, twelve threads of colour A, then eight threads alternately of colour B and of colour A, then twelve threads of colour B. Or a warp could be made of, say, eight threads alternately B and A, then eight threads alternately A and B, and this sequence be repeated. There would then be two threads of the same colour at the junction of each eight thread section, and this would make the cross stripes 'jump'. If the sections are narrow enough, they will appear as checks.

A warp showing two colours alternately cannot be made very satisfactorily on a frame in the way described in Chapter 3, so another method is now given.

Wind the two colours A and B on separate bobbins and thread these on a stick so that they can revolve easily. Fasten the two threads to the bottom warping cord or rod at the left side. Carry the stick with its two bobbins around the two warping cords in a circular

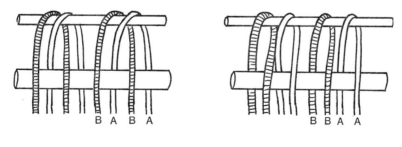

Fig. 39. Picking up the first shed to give (a) an (A, B, A, B) and (b) an (A, A, B, B) colour sequence

motion, gradually moving across to the right. There is no safety cord so no cross is made. Be careful to prevent the threads overlapping as they turn round the cords. When enough threads have been warped, tie the two ends to the bottom warping cord. Now with a stick pick up a shed just below the top of the warp where the threads will be as in Fig. 39(a) (top). Push the first thread at right, say, colour A, behind the stick, pick up the next thread which will be colour B and put it on to the stick, push next thread (A) behind the stick, pick up next thread (B) on to stick. Continue thus all the way across, and the stick will lie as in Fig. 39(a) with all colour B threads in front of it and all colour A threads behind it.

Introduce the sword and safety cord into this shed and the work can begin. Take care in the first row of interlinking that the threads are picked up in the correct sequence.

The yarn may be so fine that it would be difficult to pick up a shed as described. In this case, before the warping begins, clamp a stick to the middle of the left upright of the frame so that it projects across horizontally. It must be of a length so that it does not reach across to the right upright. Then during warping, every time the two bobbins of warp pass this stick, both on their upward and downward journey, put one of the colours, and always the same one, *behind* the stick. When warping is completed, this stick lies in the same shed as was picked up in the above description, so the sword and safety cord are put into it and the stick unclamped and removed.

(iii) WARP WITH AN (A,A,B,B) COLOUR SEQUENCE

The weaver will have recognised that a warp with wide stripes of two colours and one with two colours used alternately look almost the same whether *woven* as a warpface plain weave fabric or *interlinked* as a sprang fabric. But the similarity stops when using a warp with two threads of colour A alternating with two threads of colour B. Here the interlinked

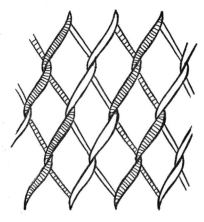

Fig. 40. Interlinking a warp with an (A, A, B, B) colour sequence

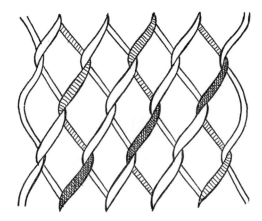

Fig. 41. Interlinking a warp with an (A, A, B) colour sequence

structure makes itself felt and the result is a diagonal striping. It does not appear in the stretched fabric, see Fig. 40. But when the fabric is relaxed the slanting threads of each colour join up to give waved diagonal lines, see the diamond in the centre of Plate 9. In the lower fabric, at the bottom of the frame, the diagonals will run in the opposite direction, i.e. downwards to the right, instead of downwards to the left. In other words the direction of the diagonal stripe is directly related to the direction of twist in the interlinking. See section C(iv) of this chapter. Notice that as the first and last pairs of threads only interlink to one side and not to the other, they appear as solid vertical lines. This is seen in Plate 8 and can be used as a way of making narrow edging stripes, if the warp begins and ends with two threads of a different colour.

Making a warp with an (A,A,B,B) colour sequence

(a) Such a warp can be made in the normal way on a frame, using two balls of yarn, as illustrated in Fig. 14 in Chapter 4.

(b) Alternatively, and more simply, a warp can be made as described in section (ii) above. When the first shed is picked up, bring the first thread at the right (colour A) over the stick, push the next colour A thread behind the stick, bring the first colour B thread over the stick, push the next colour B thread behind the stick. As Fig. 39(b) shows, the stick lies in a shed with the colours alternating in both its upper and lower layers, and with the warp now in an (A,A,B,B) colour sequence.

(iv) WARP WITH AN (A,A,B) OR (A,B,B) COLOUR SEQUENCE

Another sort of diagonal line can be made, using either an (A,A,B) or (A,B,B) colour sequence. In the former case there will be thin lines of colour B and thick lines of colour A, in the latter, thin lines of colour A and thick lines of colour B. In both cases the lines will be very straight and will lie on a diagonal not as steep as the natural diagonal of the interlinked structure. This may be understood from Fig. 41, which shows a warp with a two white, one shaded colour sequence. When the fabric is relaxed, the heavily shaded threads will join up to make one diagonal line, as also will all other similarly placed threads. Plate 5 shows an (A,A,B) and (A,B,B) colour sequence used in the same warp.

(v) WARP WITH AN (A,A,A,B,B,B) COLOUR SEQUENCE

Interlinking a warp, made with three threads of A alternating with three threads of B gives a neat small-scale pattern of interlocking triangles. See the diagonal stripe in Plate 10. It is similar to a type of pattern produced by simple tablet weaving.

Again it is probably simpler to make an (A,B,A,B) sequence warp as described in section (ii) and then rearrange the colours as the first shed is picked up. Fig 42(a) shows how this is done, the same pattern of rearrangement being repeated for every twelve threads.

(vi) WARP WITH AN (A,A,A,A,B,B,B,B) COLOUR SEQUENCE

When four or more threads of colour A alternate with the same number of colour B, the result is merely a stripe, but with the toothed edge described in section (i) above. Such a warp can be made as described in Chapter 4, see Fig. 14, or as described in section (ii) above, the colours being rearranged as in Fig. 42(b), when the first shed is picked up.

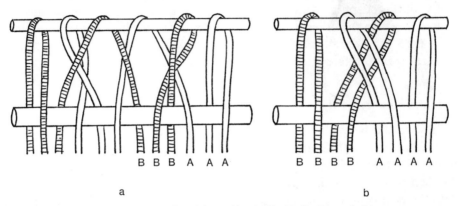

B B B A A A

a

B B B B A A A A

b

Fig. 42. Picking up the first shed to give (a) an (A, A, A, B, B, B) and (b) an (A, A, A, A, B, B, B, B) colour sequence

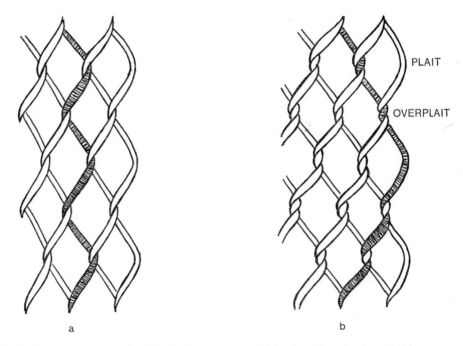

PLAIT

OVERPLAIT

a

b

Fig. 43. Path taken by thread (a) in single twist and (b) in double twist interlinking

(vii) WARP WITH VARYING COLOUR SEQUENCES

Obviously the above colour sequences can be combined in the same warp and this leads to many possibilities. Plate 4 shows a small sample piece whose warp has eight threads with an (A,B,A,B) sequence, then eight with an (A,A,B,B) sequence, then eight with an (A,A,A,A,B,B,B,B) sequence, then eight with (A,A,B,B) and eight with (A,B,A,B). It will be understood that such a complex colour sequence could be obtained from the simple warp described in section (ii) by the manner in which the first shed is picked up.

B. Multiple twist interlinking

In the descriptions of interlinked sprang so far, two threads have interlinked with each other in the simplest possible way, see Fig. 43(a). The twist at the point of interlinking has been single and the minimum needed to lock the two threads together. A whole new range of possibilities opens up if the twist is doubled, as in Fig. 43(b). So Fig. 43(a) shows *single twist interlinking* or *1/1 interlinking* and Fig. 43(b) shows *double twist interlinking*, which can be abbreviated to *1//1 interlinking*. Some writers call the former half twist and the latter complete twist (Johnson, 1958).

(i) DOUBLE TWIST OR 1//1 INTERLINKING

The double twist can be used throughout a sprang fabric, or in selected places, but in either case its purpose is to influence the patterning produced by a warp of two colours or of two materials.

(a) Double twist used all across the warp

The shaded threads in Fig. 43(a) and (b) show the chief difference between single and double twist interlinking. With a single twist, each warp thread interlinks throughout the length of the fabric with the same two threads, one being to its right and one to its left. Apart from this deflection from side to side, each thread takes a course parallel with the selvage, i.e. it runs down the length of the fabric almost as does a warp thread in a woven fabric. But with a double twist, each thread moves diagonally across the fabric, passing from one selvage to the other and then back again; see Fig. 43(b). So the general thread movement is similar to that found in plaiting or diagonal interlacing. Apart from this difference in the course taken by the threads, there will be a more open mesh because the double twist will hold the rows further apart. This is not shown in Fig. 43(b). The double twist also increases the amount of warp take-up in relation to the number of rows worked. So the warp tension increases more quickly and has to be readjusted more often.

(1) METHOD

There is the normal succession of plait and overplait rows, but the actual finger movements used differ from those already described, due to the need of putting in extra twist at each

point of interlinking. There is also a special difference at the beginning of a plait row as only one of the back layer threads that are picked up has to double twist with the front layer thread.

Plait Row

With the left hand in the shed in its normal position, pick up the first two back layer threads with the right thumb and index, and take them into the right hand. Do NOT drop off the first front\layer thread. Now slip the thumb between the two picked up threads lying across the right fingers, passing it over the right-hand and under the left-hand thread, making sure these two threads have not become crossed. Then, with the help of the index, pick up the first front layer thread. Allow the left-hand of the two threads first picked up to slip over it and drop to the back.

The result of this manœuvre is that the left-hand of the two picked up back layer threads is now double twisted with the first front layer thread. The right-hand of the two back layer threads is not involved in the twist at all and this is what is required at the right selvage. See the labelled plait row in Fig. 43(b).

Until the left selvage is reached, pick up one back layer thread and double twist it with one front layer thread, using the following finger movements. Pick up the next back layer thread between the right thumb and index plus middle finger. Do NOT drop off the next front layer thread. Draw this picked up thread to the right with the middle finger, so that the right thumb can easily move under it and, with the help of the index, can pick up the next front layer thread. Release the back layer thread from the right middle finger, so that it slides over the front layer thread and drops to the back of the fingers. Insert all right-hand fingers under this new front layer thread, so that it joins the others lying across the right fingers.

When the left selvage is reached, one thread will be left in the back layer and two threads in the front layer. Double twist the back layer thread and the right-hand of the two front layer threads, then let the left-hand of the front layer threads drop to the back behind the fingers.

Overplait Row

This consists of double twist interlinkings, always of the next back layer thread with the next front layer thread, all across the warp.

Note—After engaging in a double twist, each back layer thread returns to the back layer, and each front layer thread returns to the front layer. It is only when a thread has worked its way diagonally across to the selvage that it moves into the opposite thread layer for the returning diagonal passage. See Fig. 43(b).

—When the diminishing space between the upper and lower fabrics eventually cramps the hands, double twist interlinking can be worked *diagonally*, as described in section 8B of Chapter 5, right up to the meeting line.

(2) USE OF DOUBLE TWIST INTERLINKING WITH A WARP OF TWO CONTRASTING MATERIALS

Plate 6 shows a piece of double twist interlinked sprang made of horsehair and nylon. At the top, the horsehair is in the centre of the warp with the nylon on either side. As the work proceeds, the horsehair moves outwards towards both selvages and when the centre is reached the nylon and horsehair have changed places.

Note—That triangles appear where horsehair crosses horsehair, but where horsehair crosses nylon, the former shows as separate lines.

Such a simple effect can be mapped out on paper as the threads can be considered as travelling in straight lines, and only the dominant yarn (the horsehair in this case) need be drawn in. See Fig. 44(a). This pattern would not show unless the sprang fabric were stretched sideways in a frame.

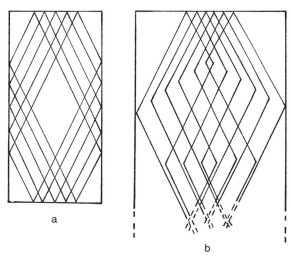

a

b

Fig. 44. Designs using double twist inter-
linking (a) throughout the fabric and
(b) combined with single twist interlinking

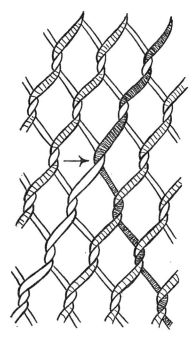

Fig. 45
Double twist interlinking. Altering
the diagonal path of a thread by
using a single twist

If double twist is used throughout, then the diagonal movement of the threads only changes direction at the selvage. But if at any point in one row a single twist is worked instead, then the two threads involved will immediately change on to the opposite diagonal. In the upper part of Fig. 45, all shaded threads are moving downwards to the left. At the centre, the arrowed interlinking has only a single twist and the heavily shaded thread

involved then changes course and angles down to the right; an unshaded thread takes its place on its previous course. Such single twists can be inserted anywhere and, within the limitations of diagonal lines, give considerable freedom in designing. See Fig. 44(b) for one idea.

(3) Use of double twist interlinking with a warp of two colours
The more traditional use of double twist interlinking is with a striped warp of two colours, both threads being of the same thickness. The fabric in this case is used in its relaxed state, the typical pattern not showing when the fabric is stretched.

Plate 7 shows a fabric with two grey stripes and three white stripes. As the work proceeds downwards from the top, the areas of solid grey and solid white steadily diminish so that they appear as inverted triangles. So far this is the same as in section (2) above. But instead of the grey or white beyond the triangles appearing as diagonal lines, they appear as cross stripes. The reason for this is found in Fig. 46, which shows the junction between three warp stripes.

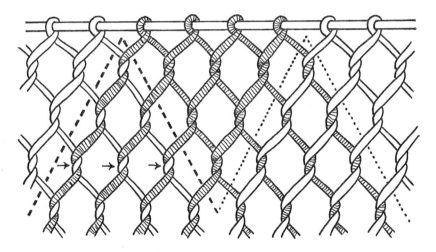

Fig. 46. Double twist interlinking on a striped warp

In the centre, shaded threads cross shaded threads giving an inverted triangle of these threads. At either side there is part of an inverted triangle of white threads. In between, there are two gradually widening areas. Consider first the area on the left, bounded by dashes. It might be thought that this would appear predominantly shaded when the fabric is relaxed. But in actuality the parts of the white threads involved in each double twist (the parts arrowed in one row) show just as plainly as do the shaded threads. Hence this becomes an area of cross stripes of shaded and white. Similarly the area to the right, bounded by dots, also appears as cross stripes of the two colours, although it looks quite different on the diagram.

It will be seen from Fig. 46 that a shaded cross stripe in the left area is on the same horizontal level as a white stripe in the right area and vice versa. This is inevitable and is seen clearly in Plate 7.

As the work continues these striped areas contract again and so show as diamonds. In between these diamonds of cross stripes, diamonds of solid shaded and white appear. See Plate 7. Thus as long as the double twist is continued, the stripes of two colours continue to move diagonally, forming diamonds of solid colour where two like colours cross and diamonds of cross stripes where two unlike colours cross.

Many variations are possible. The warp stripes can be of any size, they can be asymmetrical, more than two colours can be used, the diagonal movement of the colours can be temporarily changed into a vertical movement by working several rows with single twist, and so on.

(b) Double twist interlinking used in selected places

The double twist is here used as a simple way of changing the colour sequence of the warp, and hence the patterning, while the surrounding interlinking is being worked with single twist.

Consider a warp with an (A,B,A,B) colour sequence, which is being worked with single twist interlinking to give cross stripes, as in the top half of Fig. 47. In one row, every other interlinking (arrowed in Fig. 47) is made with a double twist. The colour sequence immediately changes into (A,A,B,B) and the following rows of single twist interlinking will show the characteristic diagonal stripes, as in the lower half of Fig. 47.

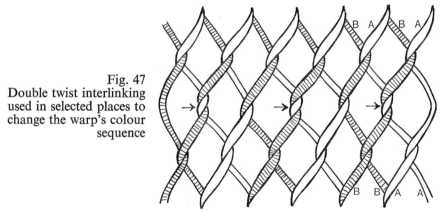

Fig. 47
Double twist interlinking
used in selected places to
change the warp's colour
sequence

The colour sequence can be changed back in exactly the same way, but it can only be done in the row in which at every interlinking one colour, say A, is picked up and the other colour, B, is dropped, or vice versa. The sequence obviously will not be effected if the double twists are inserted in the row in which colour A is picked up and colour A dropped, then B picked up and B dropped.

Now this change of colour sequence need not be made all across the warp. It can be made in one or several parts of the warp, so areas or blocks of cross stripes can be produced on a background of diagonal lines, as in Plate 8. The shape of these areas is completely controllable, though intricate shapes are not possible. Plate 9 shows a diamond of diagonal lines on a ground of cross stripes. The diamond started with one double twist interlinking at the centre of the warp, then on every other succeeding row, two more were added, further and further apart, until the middle of the diamond was reached. Then the process was reversed.

It is also possible to change an (A,B,A,B) into an (A,A,A,B,B,B) colour sequence, so their two patternings, cross stripes and interlocking triangles, can be combined in blocks. The conversion is done in any row by making every *third* interlinking with a double twist, i.e. the 1st, 4th, 7th and so on. If this is done in a plait row then the subsequent rows will show triangles of one colour, say A, pointing upwards. If it is done in an overplait row, the colour A triangles will point downwards. See Plate 10 which shows a diagonal band of triangles on a background of cross stripes.

The change from an (A,A,B,B) to an (A,A,A,A,B,B,B,B) colour sequence needs two stages. The first change has to be done in the row in which the interlinkings are of colour A with colour B, i.e. the row in which A is picked up and B dropped, or vice versa, at each interlinking. Assuming it is the plait row, then in this row make the 1st and 2nd, 5th and 6th, 9th and 10th interlinking with a double twist. This means two double twist interlinkings and then two single twist interlinkings all the way across. If some rows are now worked in single twist interlinking, a diagonal check pattern will be seen.

The second change is done in the opposite row to the first change, so it would be in the overplait row in this example. In this row every other interlinking will be of colour A with colour B, the alternate ones being of A with A or B with B. Put a double twist into each of these interlinkings of A with B. Subsequent rows of single twist interlinking will show the characteristic toothed stripes of a warp with an (A,A,A,A,B,B,B,B) colour sequence. These two changes can obviously be done in successive sheds.

So the insertion of double twists gives the ability to move from one known colour sequence to another and hence the possibility of combining two or more colour sequences in block designs. But there are many other possible colour sequences and therefore patterns, for as long as the double twists are used in some ordered way a small-scale pattern is bound to result. There is a large field for experiment here. This is perhaps indicated in Plate 11 where the initial colour sequence was (A,A,B,B,A,A). After two changes in the central section, this became (A,A,B,A,A,B) and so gave diagonal lines.

(ii) INTERLINKING WHOSE TWIST IS TREBLE, QUADRUPLE AND SO ON

The foregoing section showed that double twist interlinking is used to give some lateral movement to the threads of a warp made from contrasted materials or colours. Twisting the two threads at an interlinking point more than twice, i.e. producing a twist that is

treble, quadruple, and so on, could also serve the same purpose. Obviously any even number, no matter how large, of twists would have the same effect on the movement of threads as a double twist, and any odd number of twists would have the same effect as a single twist.

But twists greater than double are generally used for quite a different purpose, namely to make the structure of a one-colour fabric more open. Obviously the more twists that exist at each interlinking, the further each row is separated from the previous one. The diamond-shaped openings of the normal mesh become enlarged into hexagons, and these become elongated as more twist is used, see Fig. 48. Theoretically, this can continue until the fabric is little more than a set of parallel 2-ply threads, joined by occasional cross links.

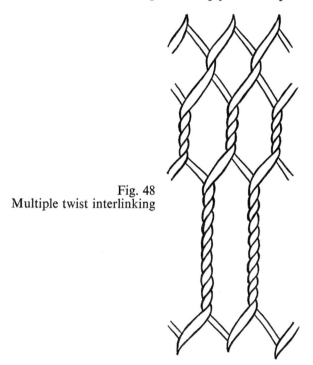

Fig. 48
Multiple twist interlinking

So the number of twists used gives an exact way of controlling the length of the openings in the interlinked mesh. The best known example of this technique is the Borum Eshöj hair-net (about 1400 B.C.) whose very sophisticated design shows several rows of double twists alternating with one row which has six twists (see Plate 31). The design also includes ridges, described in Section 4 of this chapter, which help to hold the fabric in a stretched out state. Another example is a first-century piece, possibly also a hair-net, found at Vindonissa, Switzerland, which shows treble twist interlinking on a fine woollen warp.

The number of twists can be varied in a regular way across each row to produce the effect shown very diagrammatically in Fig. 49.

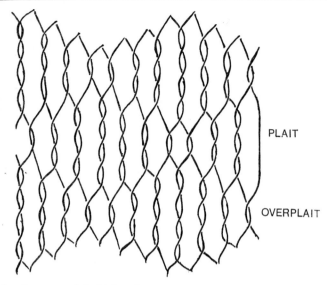

PLAIT

OVERPLAIT

Fig. 49
Multiple twist interlinking.
Effect produced by varying
the twist in a regular way

In the first row (plait) let the
 1st interlinking have 3 twists
 2nd interlinking have 2 twists
 3rd interlinking have 1 twist
 4th interlinking have 1 twist
 5th interlinking have 2 twists
 6th interlinking have 3 twists
 7th interlinking have 4 twists
and then repeat this sequence of seven interlinkings all across the warp.
In the second row (overplait) let the
 1st interlinking have 1 twist
 2nd interlinking have 2 twists
 3rd interlinking have 3 twists
 4th interlinking have 4 twists
 5th interlinking have 3 twists
 6th interlinking have 2 twists
 7th interlinking have 1 twist
and then repeat this sequence across the warp. The fabric has to be stretched sideways
to show this pattern.

As mentioned before, the warp threads involved in multiple twists lie like 2-ply threads
in the fabric, as shown in Fig. 48. These 2-ply threads have a Z-twist in the upper sprang
fabric and therefore an S-twist in the lower fabric. If the twist of the warp yarn itself is S,
it will ply well in the Z direction, but not in the S direction. So the 2-ply threads in the
lower fabric will tend to kink and not lie as straight as those in the upper fabric. The more
tightly the original yarn is spun, the more obvious this effect will be.

C. Combining S- and Z-twist interlinking

In all the techniques described so far, the interlinking of threads has shown Z-twist throughout the upper fabric, and therefore S-twist throughout the lower fabric. The present section deals with techniques in which S- and Z-twist interlinkings are combined in both upper and lower fabrics.

(i) HORIZONTAL STRIPES OF S- AND Z-TWIST INTERLINKING (Plate 12)

(a) Normal method

Working cross stripes in S- and Z-twist interlinking is a good way of making the hands familiar with both types. In Z-twist interlinking it is mainly the fingers of the right hand that do the work, in S-twist it is those of the left hand.

Work an even number of rows, say 4, of normal Z-twist interlinking, ending on an over-plait row. Place the left hand in its normal position separating the threads into a front and back layer.

PLAIT ROW IN S-TWIST INTERLINKING
The plait row in S-twist interlinking begins by picking up the first back layer thread and dropping off the first two front layer threads and it is worked in the following way.

Slide the left thumb under the first two front layer threads to join the index and then move them both to the right and pick up the first back layer thread. Carry this to the left under the two front layer threads which are then released from the left fingers. Then carry it to the right in front of the two front layer threads and give it to the right hand where it lies in front of the fingers. The two front layer threads lie behind the right-hand fingers.

The row continues by interlinking the next back layer thread with the next front layer thread, in the following manner.

Slide the left thumb under the next front layer thread, and pick up the next back layer thread. Carry it to the left under the front layer thread, which is then released from the left-hand fingers. Then carry it to the right in front of the dropped off front layer thread and give it to the right hand. There it joins the threads lying in front of the fingers, while the front layer thread slips behind these fingers. Repeat this all across the warp, until only three threads remain to be interlinked, one being a front layer thread *in* the left hand and two being back layer threads lying *behind* the hand. Pick up the two back layer threads with the left hand, carry them to the left under the front layer thread and then to the right over the front layer thread and give them to the right hand where they lie in front of the fingers.

The plait row can be abbreviated thus:

F\2B ——◄—— (F\B) ——◄—— 2F\B

OVERPLAIT ROW IN S-TWIST INTERLINKING

In the overplait row, a back layer thread is picked up and a front layer thread dropped off all across the warp, the two being interlinked with S-twist. The very first back layer thread will be found hidden behind the right selvage and is easy to miss. Similarly the last front layer thread will be found out of place on the front of the left selvage of the fabric. These positions are due to the change from Z-twist to S-twist interlinking and the threads will be correctly placed in subsequent rows. The overplait row is worked thus.

Slip the left thumb under the first front layer thread and pick up the badly-placed back layer thread, carry it round the front layer thread in the usual manœuvre and give it to the right hand. Repeat this all across the warp.

Note—The back layer thread to be picked up is always well over to the right, so care must be taken not to miss it where it lies behind the right-hand fingers. Pulling the hands apart will resolve any doubt, as it will then stand out by itself.

The overplait row can be abbreviated thus:

——◄—— (F\B) ——◄——

Work another plait and overplait row to complete the four rows of S-twist.

When the next stripe of Z-twist interlinking begins, the threads are not lying in their accustomed position. The extreme right thread is in the back layer of threads instead of the front layer. However this makes no difference to the normal Z-twist plait row procedure, which begins by picking up the first two back layer threads and dropping off the first front layer thread and so on.

When, after working a few stripes of S- and Z-twist interlinking, the fabric is stretched out, a difference in thread structure will be seen at each junction between stripes. Here, the opposite twist used in the first row of a stripe makes the previous row (the last row of the stripe before) appear not as a row of interlinked threads, but of crossed threads. See the arrows in Fig. 50. So although four rows are worked, only three rows of interlinkings are seen in the fabric.

A different method, described in section (c) below, does allow the transition to be made from one twist to the other without this change in thread structure. But in this case the suddenness of the reversal of twist direction prevents the fabric from lying smooth and flat. So the method described is preferable as it lessens the effects of twist reversal, each stripe joining easily on to the next. Even so, there will be a slight bulging of the selvage threads at these points, especially if an elastic yarn is used.

Obviously the stripes can consist of any even number of rows. The narrowest stripe

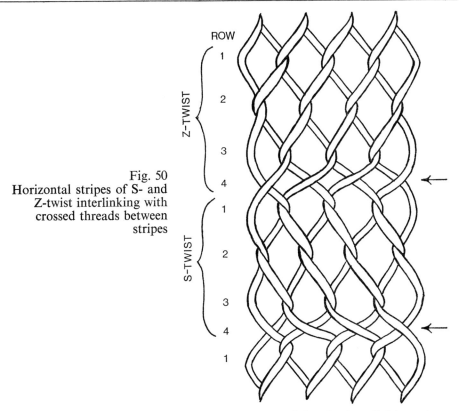

ROW

Z-TWIST

S-TWIST

Fig. 50
Horizontal stripes of S- and
Z-twist interlinking with
crossed threads between
stripes

will have two rows of Z-twist alternating with two rows of S-twist interlinking. As explained above, the resulting fabric will show one row of interlinking then one row of crossing threads throughout.

With a warp of one colour this technique gives subtle stripes, due to the way the light is reflected from the surface threads which slant downward to the left in one stripe and downward to the right in the next, see Plate 12. As with all designs arising from a combination of S- and Z-twist interlinkings, this will only show when the fabric is relaxed. When the fabric is stretched it is quite difficult to distinguish between an area of S-twist and one of Z-twist interlinking.

The earliest known example of this technique is a hood from a peat bog at Arden, Denmark, dated between 800 and 500 B.C. It has four rows of Z-twist alternating with four rows of S-twist interlinking, exactly as described and as shown in Fig. 50. A development of this type of structure is described in Chapter 7, section 4.

(b) Frame reversal method

The cross stripes described above can be made in a very simple way if a small frame is being used for the work.

Work an even number of rows, say four, of normal Z-twist interlinking, ending on an overplait row. Now turn the frame upside down. So what was the lower piece of sprang is now the upper and is of course in S-twist interlinking. With the frame in this reversed position work another four rows, again of normal Z-twist interlinkings, below the stripe of S-twist interlinking.

Then return the frame to its normal position and repeat the whole process.

It will be obvious that by this manœuvre, although the hands are continually working in Z-twist interlinking, the result will be horizontal stripes of S- and Z-twist interlinking in both upper and lower fabric. These stripes are exactly the same as those produced by the normal method, in fact from the finished fabric it is impossible to tell which method was used.

As mentioned above, at the start of each stripe the threads are not lying in their usual positions, but the first row is worked in the normal way.

(c) *Alternate rows of S- and Z-twist interlinking*

A fabric can be made with alternate rows of S- and Z-twist interlinking and without the intervening rows of crossed threads. It is described by Mary Atwater but with no mention of where the technique has been used, if indeed it is traditional. See Fig. 51.

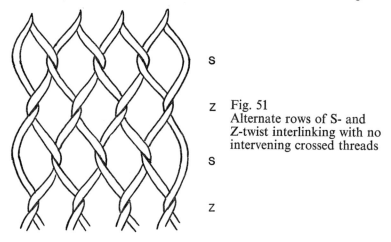

s

z Fig. 51
Alternate rows of S- and
Z-twist interlinking with no
intervening crossed threads

s

z

Row 1. Z-Twist 1//1 Interlinking
Work a plait row in Z-twist interlinking giving a double twist to each pair of threads. This is done as described in section B(i)(a)(1) earlier in this chapter.

Row 2. S-twist 1\\1 Interlinking
Work a row of S-twist interlinking, again giving a double twist to each pair of threads. Start by interlinking the two front layer threads that lie together at the right selvage. Then

interlink the next back and front layer threads with double twist. Carry on doing this all across the warp, finishing by interlinking the two back layer threads that lie together at the left selvage. This row can be abbreviated thus:

$$B\backslash\backslash B \longrightarrow \longleftarrow (F\backslash\backslash B) \longrightarrow \longleftarrow F\backslash\backslash F$$

Alternating the two rows will give the structure shown in Fig. 51. As suggested above, successive rows do not pack down on each other very well but against this is the absence of any tendency of the fabric to curl at its edges.

Obviously Row 1 or Row 2 can be used as a way of moving between areas of S- and Z-twist interlinking without intervening crossed threads.

It will be noticed that the double twists used in this method are merely temporary and do not appear in the fabric itself. In fact they only exist as double twists in the row that has just been worked. The direction from which the threads are picked up in the following row has the effect of reducing each interlinking to a single twist.

(ii) AREAS OF S- AND Z-TWIST INTERLINKING WITH ANGLED BOUNDARIES

Introduction

One of the oldest methods of patterning sprang fabrics is the working in S- and Z-twist interlinking of areas such as triangles and diamonds which have an angled outline or boundary. The interlinked structure gives natural diagonals along which the edges of these areas can lie. Moreover such designs show an interesting three-dimensional effect, for there is always a difference in surface level where an area of one twist abuts on an area of the opposite twist. See Plate 13.

The freedom of design found in this method is not coupled with any change in the one-with-one interlinking which might weaken the structure, as happens with hole designs. So the technique is ideal where a patterned but highly functional fabric is wanted.

The earliest find is the single woollen stocking from Tegle, Norway, belonging to the Migration Period, which for most of its length shows a series of interlocking triangles in S- and Z-twist interlinking (Hoffmann and Traetteberg, 1959). But the method reached its highest development in the woollen carrying bags from the Coptic graves in Egypt, dating from A.D. 500 onwards (Kendrick, 1921; Hald, 1950).

(a) A triangle of S-twist on a background of Z-twist interlinking

The best way to understand the principle is by making a triangular area of S-twist on a background of the normal Z-twist interlinking. This is now described in detail and is shown in Fig. 52.

Row 1

It does not matter whether a triangle, or any shape, is begun in a plait or in an overplait

Fig. 52
Triangle of S-twist on a
background of Z-twist
interlinking

row, so the rows will only be numbered and the beginnings and endings not indicated in the abbreviated directions.

Work normal Z-twist interlinking to the centre of the warp where the apex of the triangle is to appear. Give an S-twist interlinking to the next back layer and front layer thread, and then carry on with normal Z-twist to the end of the row. Make this S-twist interlinking in the following way. Drop the next front layer thread from the left fingers. Then slip the

Fig. 53
Triangle of S-twist on a
background of Z-twist
interlinking. Position of
threads after first row

left thumb and index behind the next back layer thread and pick up the dropped-off front layer thread. Draw it to the left behind the back layer thread, then to the right in front of the back layer thread, and give it to the right hand. Here it joins the other threads in the right hand while the back layer thread passes behind the right-hand fingers.

When the row is finished and the sword pressed upwards, the central point will look as in Fig. 53, where the single S-twist interlinking is arrowed. Normally the threads coming from the last row of interlinking pass alternately over and under the sword without exception, just as if the sword were in a plain weave shed pressed up against the fell of a woven fabric. But here two irregularities will be seen. To the right of the S-twist interlinking, there are two threads lying together behind the sword, labelled B,B, and to its left, there are two threads lying together in front of the sword, labelled F,F. These serve as important markers in the following rows.

The first row can be abbreviated thus:

$$\underrightarrow{\quad\longleftarrow\quad} (B/F) \underrightarrow{\quad\longleftarrow\quad} B\backslash F \underrightarrow{\quad\longleftarrow\quad} (B/F) \underrightarrow{\quad\longleftarrow\quad}$$

Row 2
Work normal Z-twist interlinking, until the right-hand of the two threads lying together (now behind the left-hand fingers, not the sword) has been included in the last interlinking, i.e. it has been picked up and a front layer thread dropped off.

This is the sign that the right-hand edge of the triangle has been reached and, as at this point the Z-twist interlinking worked so far is stopped, it will be called the Z-twist Stopping Point, see Fig. 54. Now, at the Z-twist Stopping Point, two unusual moves are made.

Interlink with S-twist the next two front layer threads, then interlink with S-twist the next two back layer threads. These interlinkings are done thus. Pass the left thumb under the left-hand of the two front layer threads and pick up the right-hand one with the left thumb and index. Carry it to the left behind the left-hand thread and then to the right in front of the same thread and give it to the right hand where it joins the other threads lying in front of the fingers. The left-hand thread joins the threads behind the right-hand fingers.
Repeat exactly the same manœuvre with the next two back layer threads.
After these two S-twist interlinkings, work the rest of the row normally in Z-twist.

Row 2 can be abbreviated thus:

$$\underrightarrow{\quad\longleftarrow\quad} (B/F) \underrightarrow{\quad\longleftarrow\quad} B\backslash B \cdot F\backslash F \underrightarrow{\quad\longleftarrow\quad} (B/F) \underrightarrow{\quad\longleftarrow\quad}$$

When the sword is pressed upwards two interlinkings in S-twist will be seen, flanked by the two pairs of threads lying close together.

Row 3

Work normal Z-twist interlinking up to the Z-twist Stopping Point which is recognised exactly as in Row 2.

Then make an S-twist interlinking of the next two front layer threads, an S-twist interlinking of the next back layer thread with the next front layer thread, and an S-twist interlinking of the next two back layer threads. The second S-twist interlinking is done in the normal method as described in section (i)(a) above.

Then work Z-twist interlinkings to the end of the row.

Row 3 can be abbreviated thus:

$$\text{———<— (B/F) ———<— B\backslash B \cdot F\backslash B \cdot F\backslash F ———<— (B/F) ———<—}$$

As the triangle grows, note that there is no departure from the normal diamond-shaped mesh. The only difference between the triangle and the background is in the direction of twist, the regular pattern of interlinking is unchanged. Occasionally open the fabric out to make sure this is so. Also notice that the two pairs of threads lying close together move outwards with each row and so they continue to act as markers for the right and left edge of the triangle.

Row 4

Work Z-twist interlinking up to the Z-twist Stopping Point. Then make an S-twist interlinking of the next two front layer threads, an S-twist interlinking of the next back layer thread with the next front layer thread, an S-twist interlinking of the next back layer thread with the next front layer thread and an S-twist interlinking of the next two back layer threads. Then work Z-twist interlinkings to the end of the row.

Row 4 can be abbreviated thus:

$$\text{———<— (B/F) ———<— B\backslash B \cdot (F\backslash B) \times 2 \cdot F\backslash F ———<— (B/F) ———<—}$$

The pattern of interlinkings now emerges. At the right edge of the triangle, two front layer threads are given an S-twist interlinking and at the left edge, two back layer threads are given an S-twist interlinking. Between these two points, there are a number of S-twist interlinkings between back layer and front layer threads, a number which increases by one in each row.

So Row 5 will be, in abbreviated form,

$$\text{———<— (B/F) ———<— B\backslash B \cdot (F\backslash B) \times 3 \cdot F\backslash F ———<— (B/F) ———<—}$$

Row 6 will have four back-with-front S-twist interlinkings, Row 7 will have five, and so on.

This means that having judged the right-hand boundary of the triangle correctly by recognising the Z-twist Stopping Point, the left boundary can be found simply by counting interlinkings from that point. But it is more satisfactory especially if working a large area,

or a large number of small areas, if the left boundary can also be recognised visually. So it is important to be able to recognise both the point at which normal *back-with-front thread Z-twist interlinking* has to stop, i.e. the Z-twist Stopping Point, and the point at which *back-with-front thread S-twist interlinking* has to stop, i.e. the S-twist Stopping Point.

Z-TWIST STOPPING POINT

This can be recognised in three ways, the first of which has already been described. The Z-twist Stopping Point is shown in Fig. 54. The junction between the Z-twist area on the right and the S-twist area on the left is shown by the diagonal dotted line.

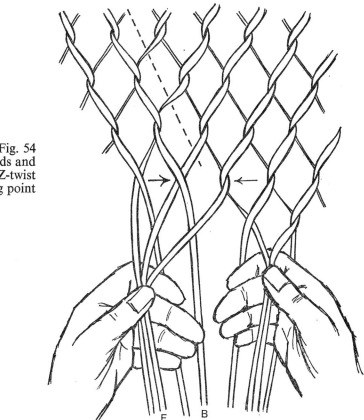

Fig. 54
Position of the threads and
hands at the Z-twist
stopping point

Note—That for clarity in this and other diagrams in this section, the parts of each thread which form the front surface of the fabric are shown much thicker.

(1) It is the point when the last back layer thread picked up was the right-hand of the two threads lying together behind the left fingers.

(2) This same back layer thread can also be recognised as it comes from the most left-hand of the Z-twist interlinkings in the row before, indicated by a small arrow in Fig. 54. So when this thread has been picked up and included in an interlinking, the Z-twist Stopping Point has been reached.

(3) The Z-twist Stopping Point is also the point at which, if the next back layer thread were picked up, a mistake would occur in the mesh. In Fig. 54 the large arrow shows where two threads would cross each other instead of interlinking, if the next back layer thread (labelled B) were picked up and the next front layer thread (labelled F) were dropped.

Whenever this point is reached, whatever angled shape is being made, the back-with-front Z-twist interlinking is stopped, and the next interlinking must be of the next two front layer threads.

S-TWIST STOPPING POINT

This again can be recognised in three ways and is shown in Fig. 55.

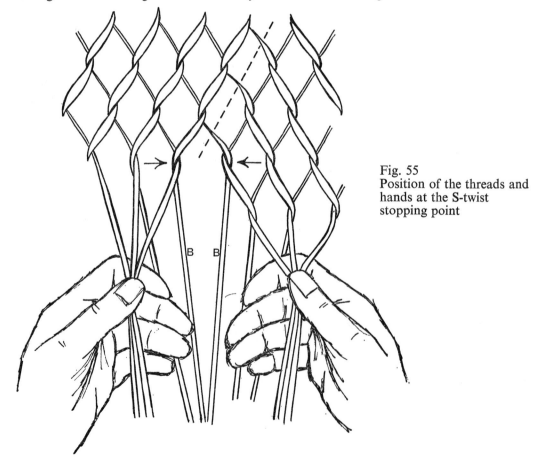

Fig. 55
Position of the threads and hands at the S-twist stopping point

(1) It is the point when the last front layer thread dropped off was the right-hand of the two threads lying close together in front of the left fingers.

(2) This same front layer thread can be recognised in another way, as it comes from the most left-hand of the S-twist interlinkings in the row before, shown by the right-hand arrow in Fig. 55.

(3) Perhaps the best way is this. It is the point at which, when the hands are drawn apart, it is seen that the next two back layer threads (labelled B in Fig. 55) run up to interlinkings of opposite twist. These are shown by two arrows in Fig. 55.

When this point is reached, the back-with-front S-twist interlinking is stopped and the next interlinking must be of the next two back layer threads. At this point, as the hands are drawn apart, there may also be noticed a line of slightly more open mesh running up to the right, in the position of the dotted line in Fig. 55.

The triangle was left at its fifth row. Further rows need not be described in detail as the principle should now be grasped.

When a row is finished and before the safety cord is changed into the new shed, notice that there is a thread passing straight from the upper sprang fabric to the lower, without being caught in by the cord. It comes from the right edge of the triangle just to the left of the two threads that lie close together behind the fingers. This is not a mistake but a direct result of the interlinking of two front layer threads. There is a corresponding thread on the back of the fabric coming from the left edge of the triangle, where two back layer threads were interlinked.

The triangle can be finished at any point by working a row of normal Z-twist interlinking from selvage to selvage. There will be the same crossed threads at the base of the triangle, as are always found at the junction of horizontal stripes of S- and Z-twist interlinkings. But normal interlinking will begin to show when the next row is worked. Fig. 52 shows diagrammatically a triangle made with five rows of S-twist interlinking.

THREE-DIMENSIONAL EFFECT

The three-dimensional effect should now be visible especially if the warp is of wool or some other elastic yarn. The effect follows a simple rule. The surface threads in a Z-twist interlinked area lie on a diagonal slanting down to the left and those of an S-twist interlinked area lie on a diagonal slanting down to the right. So Fig. 56(a) represents the triangle just made. Now at any boundary line, it is the area whose surface diagonals are parallel to the boundary which comes forward and stands at a higher level (see Plate 13). So the triangle should be standing at a higher level than the background along its right edge, but the background should be higher than the triangle along its left edge. In Fig. 56(a), the parts at a higher level are spotted. The surface diagonals of neither triangle nor background are parallel to the base of the triangle, so there is no change of level there.

This interesting effect is analogous to that produced by areas of S- and Z-twist twining in tablet weaving. The same lively and curved surfaces can be obtained by both methods,

Fig. 56
The three-dimensional effect
in S- and Z-twist interlink-
ing

a b

but they are more pronounced with sprang due to the absence of any weft. See also the
ends of sections (ii)(b) and (iii)(b) below

(b) *A diamond of S-twist on a background of Z-twist interlinking*

The top half of a diamond, being a triangle, is obviously worked exactly as described above.
When the centre of the diamond is reached, a way has to be found of gradually decreasing
the shape. This is very simple.

At the Z-twist Stopping Point, i.e. the right edge of the diamond, pick up the next two
front layer threads and give them a Z-twist, not an S-twist. Then work back-with-front
S-twist interlinking up to the S-twist Stopping Point and there give a Z-twist to the next
two back layer threads. Continue the row to the selvage with normal back-with-front
Z-twist interlinking.

So with a decreasing shape, the interlinkings of the two front layer and of the two back
layer threads are in Z-twist, whereas with an increasing shape they are in S-twist. The
Z-twist interlinking of the two front layer or two back layer threads is done thus:

Pass the right thumb and index under the right-hand of the two threads (either the two
front layer or the two back layer threads) and pick up the left-hand one. Draw it to the
right, under the right-hand thread and take it to join the other thread lying across the
right fingers. The right-hand thread drops behind these fingers.

Below is shown in abbreviated form the complete working of a diamond in S-twist on a background of Z-twist interlinking.

$$
\begin{array}{lllll}
\longrightarrow\!\!\leftarrow\ (B/F) \longrightarrow\!\!\longleftarrow & B\backslash F & \longrightarrow\!\!\longleftarrow & (B/F) \longrightarrow\!\!\leftarrow & \text{Row 1} \\
\longrightarrow\!\!\leftarrow\ (B/F) \longrightarrow\!\!\longleftarrow & B\backslash B \cdot F\backslash F & \longrightarrow\!\!\longleftarrow & (B/F) \longrightarrow\!\!\leftarrow & 2 \\
\longrightarrow\!\!\leftarrow\ (B/F) \longrightarrow\!\!\longleftarrow & B\backslash B \cdot F\backslash B \cdot F\backslash F \longrightarrow\!\!\longleftarrow & & (B/F) \longrightarrow\!\!\leftarrow & 3 \\
\longrightarrow\!\!\leftarrow\ (B/F) \longrightarrow\!\!\longleftarrow & B\backslash B \cdot (F\backslash B) \times 2 \cdot F\backslash F \longrightarrow\!\!\longleftarrow & & (B/F) \longrightarrow\!\!\leftarrow & 4 \\
\longrightarrow\!\!\leftarrow\ (B/F) \longrightarrow\!\!\longleftarrow & B\backslash B \cdot (F\backslash B) \times 3 \cdot F\backslash F \longrightarrow\!\!\longleftarrow & & (B/F) \longrightarrow\!\!\leftarrow & 5 \\
\longrightarrow\!\!\leftarrow\ (B/F) \longrightarrow\!\!\longleftarrow & B/B \cdot (F\backslash B) \times 4 \cdot F/F \longrightarrow\!\!\longleftarrow & & (B/F) \longrightarrow\!\!\leftarrow & 6 \\
\longrightarrow\!\!\leftarrow\ (B/F) \longrightarrow\!\!\longleftarrow & B/B \cdot (F\backslash B) \times 3 \cdot F/F \longrightarrow\!\!\longleftarrow & & (B/F) \longrightarrow\!\!\leftarrow & 7 \\
\longrightarrow\!\!\leftarrow\ (B/F) \longrightarrow\!\!\longleftarrow & B/B \cdot (F\backslash B) \times 2 \cdot F/F \longrightarrow\!\!\longleftarrow & & (B/F) \longrightarrow\!\!\leftarrow & 8 \\
\longrightarrow\!\!\leftarrow\ (B/F) \longrightarrow\!\!\longleftarrow & B/B . F\backslash B \cdot F/F \longrightarrow\!\!\longleftarrow & & (B/F) \longrightarrow\!\!\leftarrow & 9 \\
\longrightarrow\!\!\leftarrow\ (B/F) \longrightarrow\!\!\longleftarrow & B/B \cdot F/F \longrightarrow\!\!\longleftarrow & & (B/F) \longrightarrow\!\!\leftarrow & 10 \\
\end{array}
$$

Note—That just as the shape begins to decrease the number of back-with-front S-twist interlinkings actually increases. This is not a mistake, for it will be seen that the *total* number of S-twist interlinkings decreases from five to four in this row.

Provided the S-twist and Z-twist Stopping Points are recognised, the diamond can be easily worked without having to count any threads. Fig. 56(b) shows by means of the spotted areas which parts will lie at a higher level.

All four edges of a diamond can be made to lie at a higher level if the direction of interlinking twist in both the background and the diamond, is reversed along the latters' vertical and horizontal axes. See Plate 14.

(c) Diagonal stripes in S- and Z-twist interlinking

By drawing on the rules for increasing and decreasing shapes, it is possible to work diagonal stripes of S- and Z-twist interlinking (see Plate 13).

FOR STRIPES SLANTING DOWN TO THE LEFT
At the Z-twist Stopping Point make a Z-twist interlinking of the next two front layer threads.
At the S-twist Stopping Point, make an S-twist interlinking of the next two back layer threads.

FOR STRIPES SLANTING DOWN TO THE RIGHT

At the Z-twist Stopping Point, make an S-twist interlinking of the next two front layer threads.

At the S-twist Stopping Point, make a Z-twist interlinking of the next two back layer threads.

In each case, depending on the width of the stripes, there will be a variable number of back-with-front interlinkings of the correct twist in between the above two interlinkings. The narrowest possible diagonal stripe is one interlinking wide, the S-twist Stopping Point following immediately on the Z-twist Stopping Point. It can be abbreviated thus:

$$\longrightarrow\!\!\leftarrow\!\!-\ (B/F)\ \longrightarrow\!\!\leftarrow\!\!-B\backslash B\cdot F/F\ \longrightarrow\!\!\leftarrow\!\!-\ (B/F)\ \longrightarrow\!\!\leftarrow\!\!-$$

for a line slanting down to the left, and thus:

$$\longrightarrow\!\!\leftarrow\!\!-\ (B/F)\ \longrightarrow\!\!\leftarrow\!\!-\ B/B\cdot F\backslash F\ \longrightarrow\!\!\leftarrow\!\!-\ (B/F)\ \longrightarrow\!\!\leftarrow\!\!-$$

for a line slanting down to the right. The former will only appear on the back of the fabric, showing as a thin raised diagonal rib; the latter will only appear on the front.

With the information given above it is possible to work any design in S- and Z-twist interlinking as long as the boundaries between the areas are either at an angle or horizontal. Such designs can quite easily be carried right up to the meeting line if diagonal interlinking is used for the final stages. The designs can be planned on paper using a diamond grid which represents the basic interlinked mesh-work, see Fig. 57. At each intersection of two lines, make a dash showing the twist direction of the interlinking required at that point.

Fig. 58. S-twist interlinked areas starting at the selvages of a Z-twist interlinked fabric

Fig. 57. Planning or recording a design of S-and Z-twist interlinking

However, areas beginning at the selvages are complicated by the alternation of plait and overplait rows and their working is described below.

(d) Areas beginning at the selvage

Triangles of S-twist interlinking can start at the selvages of a Z-twist interlinked fabric, as in Fig. 58. The selvage-to-selvage Z-twist interlinking is stopped after a plait row, so the pattern begins in an overplait row thus.

Row 1. Overplait Row

$$B\backslash F \text{———}\twoheadleftarrow\text{——} (B/F) \text{———}\twoheadleftarrow\text{——} B\backslash F$$

Note that the first and last interlinking are both in S-twist and they are both of the type described in section (ii)(a), i.e., it is a front layer thread that is picked up and a back layer thread that is dropped.

Row 2. Plait Row
The plait row begins and ends with a new sort of interlinking and can be abbreviated thus:

$$F\backslash B + F \text{———}\twoheadleftarrow\text{——} (B/F) \text{———}\twoheadleftarrow\text{——} B + F\backslash B$$

First interlinking Slip the left thumb under the first front layer thread and under the second back layer thread, pick up the first back layer thread with the left thumb and index, draw it to the left under the two above-named threads then to the right in front of them. Give it to the right hand, the other two threads dropping behind the right fingers.

Then work normal Z-twist interlinking until only three threads remain in the left hand.

Last interlinking Slip the left thumb under the last front layer thread and pick up the last back layer thread and the penultimate front layer thread, draw them to the left under the last front layer thread then carry them to the right over this thread and give them to the right hand.

At the end of this row, there will be two threads lying together behind the hand at the right selvage and two threads lying together in front of the hand at the left selvage, which is the normal state at the end of an S-twist plait row.

Row 3. Overplait Row
This row can be abbreviated thus:

$$F\backslash B \cdot F\backslash F \text{———}\twoheadleftarrow\text{——} (B/F) \text{———}\twoheadleftarrow\text{——} B\backslash B \cdot F\backslash B$$

Start with a back-with-front S-twist interlinking being careful to pick up the extreme right-hand back layer thread. Immediately, the S-twist Stopping Point is recognised and the next interlinking is of the next two back layer threads with S-twist. Then work Z-twist interlinking up to the Z-twist Stopping Point, then make an S-twist interlinking of the next two front layer threads and another of the last back and front layer threads.

The subsequent rows need only be shown in abbreviated form, as follows:

Row 4. Plait Row

$$F\backslash 2B \cdot F\backslash F \longrightarrow \longleftarrow (B/F) \longrightarrow \longleftarrow B\backslash B \cdot 2F\backslash B$$

Row 5. Overplait Row

$$(F\backslash B) \times 2 \cdot F\backslash F \longrightarrow \longleftarrow (B/F) \longrightarrow \longleftarrow B\backslash B \cdot (F\backslash B) \times 2$$

Row 6. Plait Row

$$F\backslash 2B \cdot F\backslash B \cdot F\backslash F \longrightarrow \longleftarrow (B/F) \longrightarrow \longleftarrow B\backslash B \cdot F\backslash B \cdot 2F\backslash B$$

The process continues with the two areas of S-twist interlinking gradually encroaching on the central Z-twist interlinked area.

The reverse effect, i.e. a Z-twist interlinked triangle starting at the selvages of an S-twist interlinked fabric, will be shown in abbreviated form only. It begins after a plait row of S-twist interlinking.

Row 1. Overplait Row

$$F/B \longrightarrow \longleftarrow (F\backslash B) \longrightarrow \longleftarrow F/B$$

Row 2. Plait Row

$$B/B + F \longrightarrow \longleftarrow (F\backslash B) \longrightarrow \longleftarrow B + F/F$$

Row 3. Overplait Row

$$B/F \cdot B/B \longrightarrow \longleftarrow (F\backslash B) \longrightarrow \longleftarrow F/F \cdot B/F$$

Row 4. Plait Row

$$B/2F \cdot B/B \longrightarrow \longleftarrow (F\backslash B) \longrightarrow \longleftarrow F/F \cdot 2B/F$$

Row 5. Overplait Row

$$(B/F) \times 2 \cdot B/B \longrightarrow \longleftarrow (F\backslash B) \longrightarrow \longleftarrow F/F \cdot (B/F) \times 2$$

In both the last two methods, some confusion may arise from the abbreviated forms used for the first and last interlinking in the first two rows, but reference to the notes on abbreviations, in Chapter 5 section 1B, should make it clear.

(iii) VERTICAL STRIPES OF S- AND Z-TWIST INTERLINKING

(a) Reversing the direction of the twist in the centre of the warp

If a narrow sprang fabric, e.g. a belt or a tie, is made entirely of Z-twist interlinking, it will, when removed from the frame, twist on its long axis and refuse to lie flat. It may even take on a spiral form if hung up. The effect will be greater if an elastic yarn like wool is used. The cure is to reverse the twist of the interlinking at the centre of the fabric so that the right half is in Z-twist and the left half is in S-twist interlinking. The two halves then have a tendency to twist in opposite directions and the result should be a flat fabric.

This implies the working of a vertical junction between the areas of different twist, as shown in Fig. 59. The central, shaded, thread has alternately Z- and S-twist interlinkings as it zigzags between the Z-twist area on the right and the S-twist area on the left.

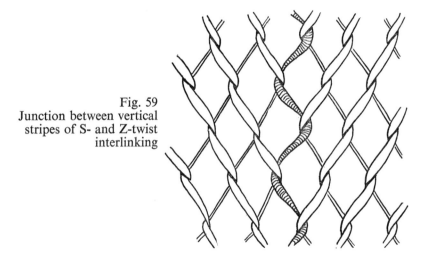

Fig. 59
Junction between vertical
stripes of S- and Z-twist
interlinking

It will be plain that to make a vertical junction, the rules for an increasing shape and those for a decreasing shape are used alternately row by row. To keep track of which row is being worked, it is simplest to link them to the plait and overplait row although there is no necessary connection between the central junction and the selvage. So the two rows can be abbreviated thus:

Plait Row

$$F\backslash 2B \longrightarrow \longleftarrow (F\backslash B) \longrightarrow \longleftarrow F/F \longrightarrow \longleftarrow (B/F) \longrightarrow \longleftarrow 2B/F$$

Overplait Row

$$\text{——} \twoheadleftarrow \text{(F\B) ——} \twoheadleftarrow \text{F\F ——} \twoheadleftarrow \text{(B/F) ——} \twoheadleftarrow$$

The normal Z-twist interlinking on the right half of the fabric is worked until the Z-twist Stopping Point is reached, then the next two front layer threads are interlinked either in Z- or S-twist, depending on the row. From there on, the fabric is in S-twist interlinking.

 Once the first two rows have been worked, an even simpler rule can be applied. As the centre of the row is approached, look at the interlinking that lies vertically above (made in the row before the last) and copy its twist.

Note—That as this junction between areas of different twists is vertical, and not angled, there will be no three-dimensional effect.

(b) *Several vertical stripes*

A wide fabric may be worked with many vertical stripes of S- and Z-twist interlinking, either for the visual effect or to achieve flatness, see Plate 15. Such stripes can be put in abbreviated form thus:

Plait Row

$$\text{B/2F ——} \twoheadleftarrow \text{(B/F) ——} \twoheadleftarrow \text{B\B ——} \twoheadleftarrow \text{(F\B) ——} \twoheadleftarrow \text{F/F ——} \twoheadleftarrow \text{(B/F) ——} \twoheadleftarrow \text{2B/F}$$

Overplait Row

$$\text{——} \twoheadleftarrow \text{(B/F) ——} \twoheadleftarrow \text{B/B ——} \twoheadleftarrow \text{(F\B) ——} \twoheadleftarrow \text{F\F ——} \twoheadleftarrow \text{(B/F) ——} \twoheadleftarrow$$

As always, the moment to stop normal back-with-front interlinking is either the S-twist or the Z-twist Stopping Point.

Note—In a plait row, the interlinking of two front layer or of two back layer threads is in the same direction as in the preceding stripe, but in the overplait row it is in the same direction as in the following stripe.

If such stripes are made to stop and start at different levels then a block design begins to emerge, in other words rectangles of one twist on a background of the opposite twist. This is a definite design possibility. If small blocks of alternate twist are worked and the changes of twist are made according to Section C(i)(c) above, the undulating surface shown in Plate 16 is produced.

(c) *Use of vertical stripes at the selvage*

Even if a piece of sprang fabric made in one twist does lie flat when off the frame, it will still tend to curl up at both edges. To prevent this, narrow stripes of S- and Z-twist inter-

linking can be worked at both selvages. The narrowest satisfactory stripes are just two interlinkings wide and can be abbreviated thus:

Plait Row

$$B/2F \cdot B/B \cdot F\backslash B \cdot F\backslash F \longrightarrow\!\!\!\!\!\!\leftarrow (B/F) \longrightarrow\!\!\!\!\!\!\leftarrow B\backslash B \cdot F\backslash B \cdot F/F \cdot 2B/F$$

Overplait Row

$$(B/F) \times 2 \cdot B\backslash B \cdot F\backslash B \cdot F/F \longrightarrow\!\!\!\!\!\leftarrow (B/F) \longrightarrow\!\!\!\!\!\leftarrow B\backslash B \cdot F\backslash B \cdot F/F \cdot (B/F) \times 2$$

It will be noticed that except in the overplait row, each form of interlinking is only done once at the selvage, so the only point that has to be recognised is the start of the left selvage, i.e. the Z-twist Stopping Point.

(iv) DESIGNS IN S- AND Z-TWIST INTERLINKING ON WARPS OF TWO COLOURS

Traditionally, S- and Z-twist interlinked designs were worked on one-colour warps, though occasionally broad stripes of different colours were introduced. But if warps with the sort of colour sequences described in section A of this chapter, i.e. (A,B,A,B), (A,A,B,B) and so on, are used, the results are quite striking. Plate 17 shows vertical stripes of S- and Z-twist interlinking using a warp with an (A,A,B,B) colour sequence and Plate

Fig. 60. S- and Z-twist interlinking combined to give a textured fabric

18 shows a triangle of S-twist on a background of Z-twist interlinking, using a warp with an (A,A,B) colour sequence. Other possibilities may be explored by the reader.

An interesting thread structure using a combination of S- and Z-twist interlinking gives a textured surface and a diamond pattern, see Fig. 60. It was worked out by Abraham de Miranda (1888–1946), a painter who has left some very fine examples of his sprang experiments in the Costume Museum, The Hague, Holland. Due to the forces acting on them, the arrowed interlinkings of two white threads are pushed forward. In the relaxed fabric, see Plate 19, they join up to make a white grid enclosing diamond-shaped areas of the grey weft. In the centre of the diamonds the intermediate white interlinkings, which are pushed backwards by a similar process, appear as small dots.

Using a warp with an (A,A,B,B) colour sequence the method is as follows.

Row 1

Start as a normal plait row with a 2B/F interlinking. Make the interlinkings in this row with twists in this sequence, (Z,Z,S,S) repeat.

Row 2

Interlink with twists in the sequence (Z,S,Z,Z).

Row 3

Interlink with an (S,S,Z,Z) sequence.

Row 4

Interlink with a (Z,Z,Z,S) twist sequence.

This is not very easy to do and the diagram (Fig. 60) should be used as a guide. It will be found that only in Row 1 and Row 3 are the interlinkings always between a back layer and a front layer thread and always between threads of opposite colours. In Row 2 and Row 4, the interlinkings are always between threads of like colour, but these may both lie in the front layer, both in the back layer, or one in each layer. It is even more difficult to do this pattern without the help given by two colours, but as Plate 20 shows, the texture is more apparent with a warp of one colour. Due to the frequent changes of twist direction the fabric has very little tendency to curl up when off the frame.

D. Increasing the lateral movements of the threads (Lattice Sprang)

In all the techniques described so far, a plait row in Z-twist interlinking starts by picking up the first *two* back layer threads. This not only establishes the diagonal movement of the threads, the back layer threads moving diagonally to the right, the front layer threads diagonally to the left, but also the extent of that movement. If a plait row starts by picking

up more than two back layer threads, this diagonal movement will be increased and the more back layer threads are picked up, the greater the movement will be.

One of the few pieces of lattice sprang mentioned in the literature is a narrow band from Denmark, of the type used for tying up jars, which shows the technique described below (Broholm and Hald, 1935).

(i) METHOD

In the simplest form of lattice sprang, three threads are picked up and it is worked thus (see Fig. 61):

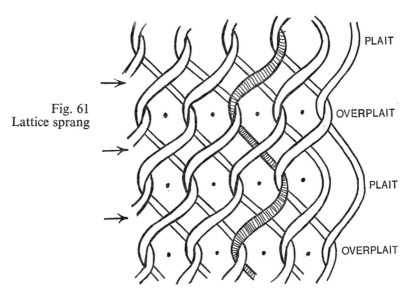

Fig. 61
Lattice sprang

PLAIT

OVERPLAIT

PLAIT

OVERPLAIT

Plait Row

$$\text{B/3F} \longleftarrow \text{(B/F)} \longleftarrow \text{3B/F}$$

Start the row by picking up the first three back layer threads and dropping the first front layer thread, and end the row by picking up the last back layer thread and dropping the last three front layer threads. In between, always pick up the next back layer thread and drop off the next front layer thread in the normal way. So at the end of the row, three threads lie together in front of the hand at the right selvage and three lie together behind the hand at the left selvage.

Overplait Row

$$\longleftarrow \text{(B/F)} \longleftarrow$$

When starting this row, take care that the front layer threads are selected in their correct

sequence, i.e. drop off the most right-hand for the first interlinking, then the next for the second interlinking, and so on. The same applies to the back layer threads which are picked up at the end of the row.

Note—Because of the greater diagonal movement, the thumb and index finger of the right hand have to reach further over to the left to find the next back layer thread.

 —That each of these back layer threads passes under three front layer threads, instead of the normal two.

From the resulting structure, shown in Fig. 61, it will be seen that between the rows of interlinking, there is a region, arrowed in the figure, where threads just cross each other without interlinking. It is the lattice-like appearance of these crossed threads that suggested the name of this technique. The openings which show most when the fabric is stretched are those with spots in them and these are vertically above each other.

The plait row can start by picking up four, or five, or more back layer threads. This will increase the sideways movement of the threads and the region of cross threads will become a thicker, and altogether more predominant, cross stripe. But however far each thread moves in the plait row, it always moves the same distance, but in the opposite direction, in the overplait row. So it ends up vertically beneath its starting point, the movement being merely an exaggeration of the normal zigzag. See the shaded thread in Fig. 61.

Lattice sprang is less elastic than normal interlinked sprang. When it is stretched sideways, the holes become more open, but the cross threads become closer as they more nearly approach the horizontal. It therefore shows as a pattern with rows of holes separated by almost solid stripes. The holes can be lengthened by giving each interlinking two, three or four twists instead of the normal single twist. Using a warp with an (A,A,B,B) colour sequence, lattice sprang shows strong diagonal lines. Other colour sequences should be explored.

(ii) COMBINING LATTICE SPRANG WITH NORMAL INTERLINKING

If a row of lattice sprang is alternated with a row of normal interlinking, the threads will move diagonally but on a zigzag course. So this is a way of achieving a diagonal movement without using the double twist, described in section B of this chapter. In order that the normal row can follow on the lattice sprang row, the latter has to be started and ended in a slightly different way. The lattice sprang row can be abbreviated thus:

$$F/2F \longleftarrow (B/F) \longleftarrow 2B/B$$

Begin by picking up the second and third back layer threads and drawing them under the first back layer thread, which then drops behind the fingers. So the next interlinking is of the fourth back layer thread with the first front layer thread, and this row is therefore, except at the beginning and end, the same as a row of lattice sprang beginning with 4B/F.

At the end of the row, three front layer threads will remain. Pick up the outside one, draw it under the other two, which drop behind the fingers.

The row which follows is exactly like a normal overplait row.

Repeat these two rows.

The resulting fabric is seen in Fig. 62 in which the shaded thread shows the typical diagonal but zigzag course. Using a two-colour warp, the sort of pattern made with double twist interlinking is possible, but here the fabric is much denser and the horizontal lines will be alternately thick and thin.

Fig. 62
Combining lattice sprang
with normal interlinking

E. Producing a tubular structure

A tube of interlinked sprang can be made in several ways:
 (i) Making a rectangle, folding it over and sewing the left selvage to the right selvage;
 (ii) Using double interlinked sprang, see section 5 of this chapter;
 (iii) Setting up a tubular warp, between two disks or rings, and working rows around the circumference;
 (iv) Making a tube in flattened form on a normal flat warp.
The actual method of work is the same for (iii) and (iv), but the latter is the easier and will now be described.

At the top warping cord, separate the warp into two halves. The first, third, fifth, and so on, pairs of threads form the front half. Pick up a normal over one, under one shed on these threads and put in the safety cord, A in Fig. 63. The second, fourth, sixth, and so on, pairs form the back half of warp. Pick up a similar shed on these threads and put in another safety cord, B in Fig. 63. The total number of warp threads must be divisible by four.

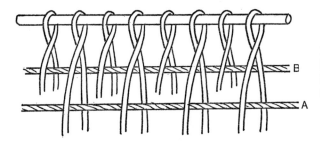

Fig. 63
Separating the warp into a
front and back half so that
a tube can be interlinked

Begin a plait row, being very careful only to use the threads of the front half of the warp. The row ends normally by picking up one thread and dropping off two threads, which go to lie at the back of the shed. Put the safety cord in this new shed. Then turn the frame over, so that the unworked half of the warp is now to the front. Insert the left hand into the shed occupied by the safety cord. Bring the last back layer thread, from the row just completed, around the right edge of the fabric and put in on to the left hand where it becomes the first front layer thread. This thread is one of the pair dropped off in the last interlinking.

Now work the row in the back half of the warp. It begins with a B/F interlinking and carries on with the same, because it is the continuation of the row already worked, not the start of a new row. This row will end with a B/2F interlinking as in a normal plait row. Put the safety cord into this new shed and turn the frame round once more so that the original side is now to the front. Now take the last back layer thread from the row just completed around the right edge of the fabric, and, treating it as a front layer thread, interlink it with the right-hand of the pair of front layer threads lying together, this latter thread being here treated as a back layer thread. Adjust the safety cord to include this interlinking.

As a result of the last manœuvre there is now a completely circular row of interlinkings which gives no indication of where it was started or ended. All subsequent rows are worked in exactly the same way, so this is a strange case where every row begins and ends like a plait row. A row can begin at any point (this applies especially when using a tubular warp), but obviously it is less confusing to begin at the same point each time.

Because the last thread of each row is carried around to become the first thread of the next row, there is a gradual shift of threads to the left, and every now and again this has to be corrected by repositioning the two safety cords. The structure obtained is identical with that described in section 5D of this chapter.

The tubular shape can naturally be combined with one of the pattern-making techniques such as holes, S- and Z-twist patterns, multiple twists, striped warps and so on. The tube can be made to branch into two or more smaller tubes. In this case each tube is treated exactly as described above. The front halves of all the tubes are worked, the frame turned over and the back halves worked and then the selvages of each tube joined.

Note—That the tube produced by methods (i) and (iii) will be open at both ends but, due to the way a flat warp is made, that produced by methods (ii) and (iv) will only be open at the top.

F. Introducing rows that do not go from selvage to selvage

In most of the other techniques described in this book, it is assumed that each row is produced by thread manipulations which start at one selvage and are then carried on continuously until the other selvage is reached. This is the normal method of work and ensures that the fell of the fabric is at right angles to the general warp direction. But it is quite possible to introduce two, four, or six rows of 1/1 interlinking so that they only span a small section of the total width of the warp. This is shown in Fig. 64 where the six shaded threads have been interlinked for two more rows than the surrounding threads.

Note—There must always be an even number of extra rows (here there are two), otherwise the threads will not join up correctly with the surrounding fabric in subsequent rows.

Such extra rows are seen in both selvages of a Coptic textile and may have been used to strengthen the fabric, which is in a hole design (Hald 1950). But used in the body of the fabric, as in Fig. 64, they can be used to create areas of dense interlinking surrounded by

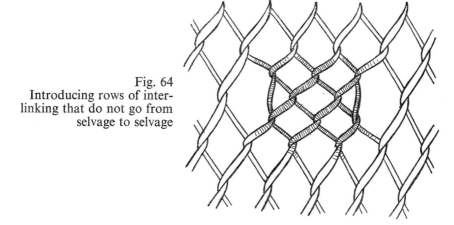

Fig. 64
Introducing rows of inter-
linking that do not go from
selvage to selvage

more open interlinking. Plate 21 shows a sample in which the extra rows have been alternated in position to give a block pattern of close and open interlinking. This is both less stable structurally and not so rigid visually as the hole designs described in section 2B(iii) of this chapter. However, the differences in warp tension arising from the technique set a limit to the design possibilities.

METHOD

The extra rows are worked in the course of a plait row. At the appropriate place, the normal interlinking stops with a B/2F interlinking. Then two rows are interlinked across the required number of threads (six in Fig. 64), first a plait, then an overplait row. The normal row then continues from where it stopped, the left-hand of the two dropped off threads being put into the left hand to act as the front layer thread in the next interlinking. When the selvage is reached, it will be seen that the fabric has in some places grown by one row, and in some places, where extra rows were inserted, by three rows. The following overplait row goes from selvage to selvage quite normally, but more extra rows can be added in any subsequent plait row.

A corollary of this method is to miss out interlinkings instead of adding them. If, in selected places across the width of a warp, interlinkings are omitted for some rows, the structure of subsequent rows will slip and cause the interesting effect seen in Plate 22.

2. TECHNIQUES BASED ON INTERLINKING SEVERAL THREADS TOGETHER (MULTIPLE THREAD INTERLINKING)

In all the techniques in the previous section, 1/1 interlinking was the rule except at the beginning and ending of rows. This section explores the various techniques based on a systematic use of interlinkings which involve more than two threads.

A. Mutliple thread interlinking all across the warp

The change from 1/1 interlinking to 2/2 interlinking, then to 4/4 interlinking and even to 8/8 interlinking is a common way of decreasing the width of a sprang fabric. It was used in the Coptic caps which tapered, and of course also thickened, towards the top. A nineteenth-century bride's cap from Lavocne shows an almost identical shaping (Hald, 1950). It was also used in the Coptic carrying bags both as a way of changing from double interlinked sprang to one layer constructions without increasing the width, and as a way of strengthening the bottom of the bag. In these instances, the multiple thread interlinking was always done near the finish of the fabric. The final rows therefore involved fewer interlinkings and were much easier to work. If the meeting line was fixed by chaining, then this used the same unit of threads as in the last rows of interlinking.

The method needs little description. Assuming that the 1/1 interlinking finished on an overplait row, then 2/2 interlinking can be abbreviated thus:

Plait Row

$$2B/4F \text{———}\leftarrow \text{— } (2B/2F) \text{———}\leftarrow \text{— } 4B/2F$$

Overplait Row

$$\text{——}\leftarrow \text{— } (2B/2F) \text{———}\leftarrow \text{—}$$

In other words, it is normal interlinking but using two threads as the unit instead of one. After an even number of rows of 2/2 interlinking, the structure can return to 1/1 interlinking.

Similarly 4/4 interlinking can be abbreviated thus:

Plait Row

$$4B/8F \xrightarrow{\quad\leftarrow\quad} (4B/4F) \xrightarrow{\quad\leftarrow\quad} 8B/4F$$

Overplait Row

$$\xrightarrow{\quad\leftarrow\quad} (4B/4F) \xrightarrow{\quad\leftarrow\quad}$$

B. Combining 1/1 interlinking with multiple thread interlinking

(i) AT ISOLATED POINTS IN THE WARP

A single 2/2, 3/3 or 4/4 interlinking can be put anywhere in a 1/1 interlinked fabric. Such an interlinking makes a tight concentration of threads in one row. In the next row, which is 1/1 interlinking all across, these threads have to be carefully selected to maintain their original sequence. This point is made clearly in Fig. 65 where a 3/3 interlinking is shown. Such interlinkings can be placed haphazardly or in some ordered sequence. If the fabric is stretched they are seen to distort the meshwork around them in an interesting way.

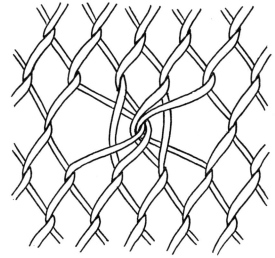

Fig. 65
A single 3/3 interlinking in
a 1/1 interlinked fabric

(ii) COMBINING AREAS OF 1/1 AND 2/2 INTERLINKING

Sometimes, to shape or strengthen an article, or just for the visual effect, an area of 2/2 interlinking is wanted on a background of 1/1 interlinking. As always it is simplest to let the boundaries of this area be dictated by the natural diagonals of the interlinked structure.

(a) A triangle of 2/2 interlinking on a background of 1/1 interlinking

This will first be shown in abbreviated form:

Plait Row

$$\text{B/2F} \relbar\!\!\leftarrow\!\!\relbar \text{(B/F)} \relbar\!\!\leftarrow\!\!\relbar \text{B/2F} \cdot \text{2B/F} \relbar\!\!\leftarrow\!\!\relbar \text{(B/F)} \relbar\!\!\leftarrow\!\!\relbar \text{2B/F}$$

Overplait Row

$$\relbar\!\!\leftarrow\!\!\relbar \text{(B/F)} \relbar\!\!\leftarrow\!\!\relbar \text{2B/2F} \relbar\!\!\leftarrow\!\!\relbar \text{(B/F)} \relbar\!\!\leftarrow\!\!\relbar$$

Plait Row

$$\text{B/2F} \relbar\!\!\leftarrow\!\!\relbar \text{(B/F)} \relbar\!\!\leftarrow\!\!\relbar \text{B/2F} \cdot \text{(2B/2F)} \times 2 \cdot \text{2B/F} \relbar\!\!\leftarrow\!\!\relbar \text{(B/F)} \relbar\!\!\leftarrow\!\!\relbar \text{2B/F}$$

Overplait Row

$$\relbar\!\!\leftarrow\!\!\relbar \text{(B/F)} \relbar\!\!\leftarrow\!\!\relbar \text{(2B/2F)} \times 3 \relbar\!\!\leftarrow\!\!\relbar \text{(B/F)} \relbar\!\!\leftarrow\!\!\relbar$$

Plait Row

$$\text{B/2F} \relbar\!\!\leftarrow\!\!\relbar \text{(B/F)} \relbar\!\!\leftarrow\!\!\relbar \text{B/2F} \cdot \text{(2B/2F)} \times 4 \cdot \text{2B/F} \relbar\!\!\leftarrow\!\!\relbar \text{(B/F)} \relbar\!\!\leftarrow\!\!\relbar \text{2B/F}$$

Overplait Row

$$\relbar\!\!\leftarrow\!\!\relbar \text{(B/F)} \relbar\!\!\leftarrow\!\!\relbar \text{(2B/2F)} \times 5 \relbar\!\!\leftarrow\!\!\relbar \text{(B/F)} \relbar\!\!\leftarrow\!\!\relbar$$

The first and second rows present no difficulties. In the second and subsequent plait rows, it is necessary to know when to stop the normal 1/1 interlinking and start the interlinkings for the triangle. It is when the 1/1 interlinking has reached a point five threads away from the first 2/2 interlinking of the triangle. Three of these threads lie *in* the left hand, two *behind* it. At this point, pick up two back layer threads and drop one front layer thread, then pick up two back layer and drop two front layer threads, and so on, according to the plan. As the stopping point at the right edge of the triangle is approached, pull the hands apart so that the threads can easily be seen and the moment judged correctly.

In the overplait row, the 1/1 interlinking continues until the threads are in pairs and then these are picked up and dropped in pairs.

Note—There is one more 2/2 interlinking in each row, and always an even number of them in a plait row, an odd number in an overplait row.

To make a decreasing shape, i.e. an inverted triangle, the normal interlinking is stopped when only one thread remains in the left hand to the right of the triangle's first 2/2 interlinking, and one less 2B/2F interlinking is made in each row.

A triangle of 3/3 interlinking can be worked in a similar way, the first row being abbreviated thus:

$$B/2F \longrightarrow (B/F) \longrightarrow B/3F \cdot 3B/F \longrightarrow (B/F) \longrightarrow 2B/F$$

The moment to start the triangle's interlinking is when the 1/1 interlinking has come to a point seven threads $(3 + 3 + 1)$ away from the nearest 3/3 interlinking in the previous row.
The first row of a triangle of 4/4 interlinking can be abbreviated thus:

$$B/2F \longrightarrow (B/F) \longrightarrow B/4F \cdot 4B/F \longrightarrow (B/F) \longrightarrow 2B/F$$

The moment to start the triangle's interlinking is when the 1/1 interlinking has come to a point nine threads $(4 + 4 + 1)$ away from the nearest 4/4 interlinking in the previous row.

(b) Triangles of 2/2 interlinking beginning at both selvages of a 1/1 interlinked fabric

This can be shown in abbreviated form thus:

Plait Row

$$B/2F \longrightarrow (B/F) \longrightarrow 2B/F$$

Overplait Row

$$2B/2F \longrightarrow (B/F) \longrightarrow 2B/2F$$

Plait Row

$$2B/4F \cdot 2B/F \longrightarrow (B/F) \longrightarrow B/2F \cdot 4B/2F$$

Overplait Row

$$(2B/2F) \times 2 \longrightarrow (B/F) \longrightarrow (2B/2F) \times 2$$

Plait Row

$$2B/4F \cdot 2B/2F \cdot 2B/F \longrightarrow (B/F) \longrightarrow B/2F \cdot 2B/2F \cdot 4B/2F$$

Overplait Row

$$(2B/2F) \times 3 \longrightarrow (B/F) \longrightarrow (2B/2F) \times 3$$

In a plait row, the start of the 2/2 interlinking area for the left-hand triangle is recognised as described above in section (a).

(iii) USING ALTERNATE ROWS OF 1/1 AND 2/2 INTERLINKING (HOLE DESIGNS)

Probably the most used method of patterning sprang fabrics is the controlled production of holes in the normal interlinked mesh. Wherever sprang has been practised, this technique has been explored. In fact some of the early twentieth-century Scandinavian instruction books present it as the only form of pattern possible with sprang.

As with other traditional fabrics, such patterns acquired local names, generally where the design suggested some natural object, e.g. plum stones, crabs' eyes, roses (Treiber-Netoliczka, 1970; Smolkova, 1904).

The earliest European example is a hair-net from Denmark (800–500 B.C.), sometimes called Queen Gunhild's hair-net, as it was found near where she was known to have been drowned in Haraldskar bog (Broholm and Hald, 1935). The Coptic finds have produced many examples in linen and wool, generally described as caps. A few pieces have come from Caracas, Peru (500–300 B.C.) and from pre-Columbian sites in New Mexico (about A.D. 1200) (O'Neale, 1932; Cosgrove, 1947). The technique is still found in Mexico in the making of servilletas (Johnson, 1958). Its use in circular warp sprang is seen in Plates 67, 68 and 69 and is described in Chapter 11.

(a) Used all across the warp

The structure of the holes can best be understood by producing them all across the warp. Fig. 66(a) shows a warp of eight threads, alternate ones being shaded for clarity.

Start after an overplait row so the warp looks as in Fig. 66(a). The stick represents the sword beating upwards.

Row 1

———————←—— (2B/2F) ——←———

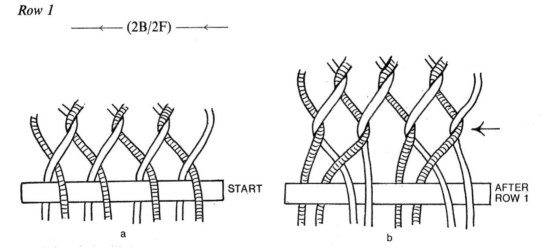

Fig. 66. Making holes all across warp. Position at (b) start, (b) after Row 1

Two back layer threads are picked up and two front layer threads dropped off all the way across the warp. If the number of warp threads divides by four, this works correctly up to the left selvage. The work now looks as in Fig. 66(b).

Row 2

—————←—— (B/F) ——————←——

This is a normal overplait row, but it is made a little difficult by the 2/2 interlinking of the row before. It will be seen from Fig. 66(b) that of the four threads involved in each of these interlinkings, there is nothing to stop the two front layer, or the two back layer, threads from crossing each other and so getting out of position. But the two correct threads to choose first for the 1/1 interlinking are those coming from the right-hand interlinking above. This is arrowed in Fig. 66(b). Then the remaining two of the four thread group are interlinked. If done correctly, this row does not close the holes which are beginning to appear between each group of four threads. The work now looks as in Fig. 67. It will be understood that the hole, indicated by a wavy line, is the result of not interlinking the two arrowed threads.

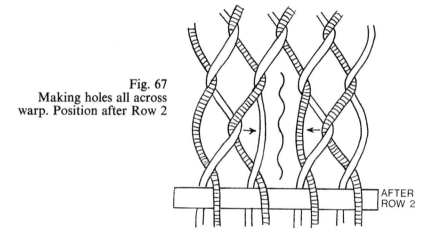

Fig. 67
Making holes all across
warp. Position after Row 2

AFTER
ROW 2

Row 3
Row 3 is like Row 1 and has 2/2 interlinking all across. But it is the essence of the technique that the 2/2 interlinkings in this row are not vertically under those in Row 1. They are shifted to one side. So each interlinking in Row 3 involves two threads from a Row 1 interlinking to its right and two threads from one to its left. The effect of this shift is twofold; it closes the holes started in Row 1 and it starts another set of holes halfway between those just closed. The shift is arranged by working Row 3 thus:

B/F —————←—— (2B/2F) ——————←—— B/F

The initial 1/1 interlinking, bracketed in Fig. 68, shifts all the 2/2 interlinkings two threads

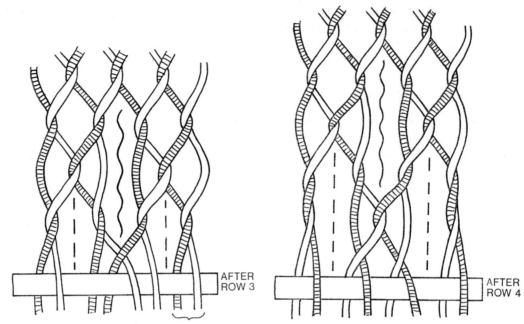

Fig. 68. Making holes all across warp. Position after Row 3

Fig. 69. Making holes all across warp. Position after Row 4

to the left. There is only one 2/2 interlinking in Fig. 68, on either side of which the two new holes are indicated by dotted lines.

Row 4

——→— (B/F) ——←——

This is a normal overplait row and identical with Row 2. The holes made in Row 3 stay open as shown in Fig. 69.

Note—That the first and last pair of threads only receive extra twist from the working of this row. They do not interlink in either Row 3 or Row 4. In Fig. 70 this twisted pair of selvage threads is arrowed.

The sequence of four rows is now complete. If it is repeated, the first row of the new sequence will close the last set of holes. Each repeat will add another two sets of holes. The sequence can always be stopped either after Row 2 or after Row 4, by working a normal plait row of 1/1 interlinking followed by an overplait row and so on. The plait row will close the last set of holes.

Fig. 70 shows in detail the thread structure around the holes. But from Plate 23 it will

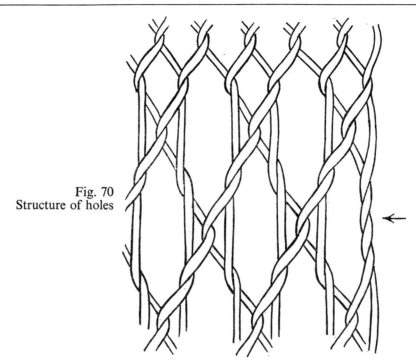

Fig. 70
Structure of holes

be seen that the threads run together more than shown on the diagram and form very fine lines between the holes.

It might be thought that this more open structure would be less stable than normal 1/1 interlinking, but in fact the reverse is true. If the rows are well beaten with the sword, the holes are quite difficult to distort although the fabric retains the elasticity typical of sprang.

An even more stable structure with slightly longer holes can be made by giving a double twist to all the 2/2 interlinkings, that is, in Row 1 and Row 3.

(b) Combining areas of 1/1 interlinking with areas of holes

(1) AREAS WITH ANGLED BOUNDARIES
To help understand this much used technique, the making of a triangle of holes on a background of 1/1 interlinking will be described in detail. As with most sprang techniques, it is natural for the boundary of an area to follow the diagonals of the mesh.

A Triangle of Holes on a Background of 1/1 Interlinking
Plait and overplait rows follow each other in the normal way. The interlinkings which cause the holes to appear are always worked in the plait row. The overplait row is a perfectly normal one going from selvage to selvage. So the pattern making results from manipulations in every other row, which helps to make this a fairly quick technique.

Row 1. Plait Row

$$\text{B/2F} \longleftarrow \text{(B/F)} \longleftarrow \text{2B/F} \cdot \text{B/2F} \longleftarrow \text{(B/F)} \longleftarrow \text{2B/F}$$

The row starts normally. Where the apex of the triangle is wanted, pick up one back layer and drop off two front layer threads, then pick up two back layer and drop off one front layer thread. This starts the first hole, because two threads which were interlinked in the previous plait row are not interlinked in this row. The row carries on normally to the left selvage.

Row 2. Overplait Row

$$\longleftarrow \text{(B/F)} \longleftarrow$$

A perfectly normal overplait row. As explained in the above section, care must be taken to choose the correct thread where two are lying together. The hole stays open.

Row 3. Plait Row

$$\text{B/2F} \longleftarrow \text{(B/F)} \longleftarrow \text{2B/F} \cdot \text{2B/2F} \cdot \text{B/2F} \longleftarrow \text{(B/F)} \longleftarrow \text{2B/F}$$

It is important in this and subsequent plait rows to know when to stop the 1/1 interlinking and begin the interlinking for the triangle. The correct moment is when the 1/1 interlinking has reached a point five threads away from the hole made in Row 1. This position is shown in Fig. 71, where the five threads are bracketed. Notice that three of these threads lie *in* the left hand and two *behind* it.

So when this position is reached, pick up one back layer and drop two front layer threads, then pick up two back layer and drop two front layer threads, then pick up two back layer and drop one front layer thread, as shown in the abbreviated form above. From there to the left selvage it is normal 1/1 interlinking. This row closes the first hole and starts two holes beneath it.

Row 4. Overplait Row
A normal row not affecting the holes.

Row 5. Plait Row

$$\text{B/2F} \longleftarrow \text{(B/F)} \longleftarrow \text{2B/F} \cdot \text{(2B/2F)} \times 2 \cdot \text{B/2F} \longleftarrow \text{(B/F)} \longleftarrow \text{2B/F}$$

The moment to stop 1/1 interlinking is recognised as before, i.e. when there are five threads (three *in* the left hand, two *behind* it) between the last interlinking and the most right-hand hole.

This row closes the two holes begun in Row 3 and starts another three holes.

Row 6. Overplait Row
A normal row.

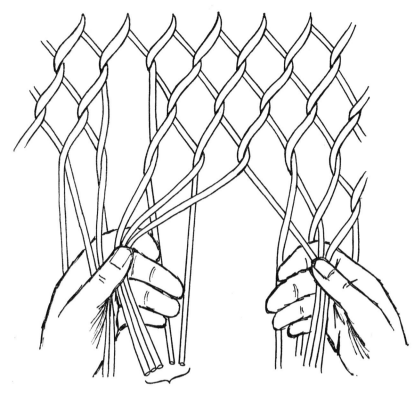

Fig. 71. Triangle of holes on a 1/1 interlinked background. Position of threads when a new hole should be started

Row 7. Plait Row

$$B/2F \longleftarrow (B/F) \longleftarrow 2B/F \cdot (2B/2F) \times 3 \cdot B/2F \longleftarrow (B/F) \longleftarrow 2B/F$$

By now the pattern of movements will have become obvious. At the right edge of the triangle, one back layer thread is picked up and two front layer threads are dropped, and at the left edge, two back layer threads are picked up and one front layer thread is dropped. Between these two points, there are a number of 2B/2F interlinkings, a number which increases by one in each plait row.

When the triangle becomes large it is useful to know when to stop the 2B/2F interlinking by some way other than counting. The moment can be found visually by continuing with these 2/2 interlinkings until the left-hand hole of the preceding row has just been closed, then pick up two back layer and drop off one front layer thread, and carry on with normal 1/1 interlinking to the left selvage.

So, as with areas of S- and Z-twist interlinking, there is a sign when to stop the background interlinking and another when to stop the triangle's interlinking.

An Inverted Triangle of Holes on a Background of 1/1 Interlinking
These signs will be different when making an area of holes, such as an inverted triangle,
that is decreasing row by row instead of increasing.

Row 1. Plait Row

$$\text{B/2F} \longleftarrow \text{(B/F)} \longleftarrow \text{2B/F} \cdot \text{(2B/2F)} \times 6 \cdot \text{B/2F} \longleftarrow \text{(B/F)} \longleftarrow \text{2B/F}$$

A plait row worked thus will give seven holes for the base of the triangle.

Row 2. Overplait Row
A normal row.

Row 3. Plait Row

$$\text{B/2F} \longleftarrow \text{(B/F)} \longleftarrow \text{2B/F} \cdot \text{(2B/2F)} \times 5 \cdot \text{B/2F} \longleftarrow \text{(B/F)} \longleftarrow \text{2B/F}$$

The 1/1 interlinking continues in this row, until there is only one thread in the left hand
between the last interlinking and the most right-hand hole. Then pick up one back layer
and drop two front layer threads, and so on. The 2/2 interlinkings of the triangle continue

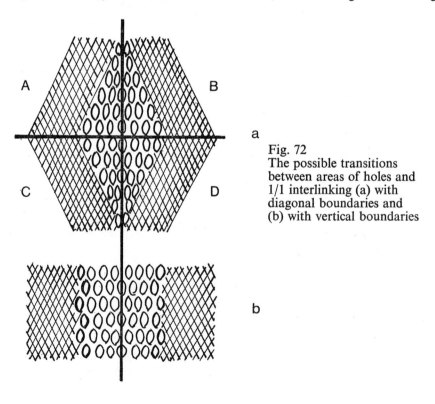

Fig. 72
The possible transitions
between areas of holes and
1/1 interlinking (a) with
diagonal boundaries and
(b) with vertical boundaries

until one of them closes the penultimate hole, i.e. not the extreme left-hand hole but the next one to it. This is also the moment when there are only two threads (one *in* the left hand, one *behind* it) between the last interlinking and the most left-hand hole. Recognising the place by either sign, pick up two back layer threads and drop one front layer thread, then carry on with normal 1/1 interlinking to the left selvage. So again there are two signs to be learnt.

This row will close the seven holes begun in Row 1 and start six more below them.

Row 4. Overplait Row
A normal row.

Row 5. Plait Row

$$\text{B/2F} \longrightarrow \text{(B/F)} \longrightarrow \text{2B/F} \cdot \text{(2B/2F)} \times 4 \cdot \text{B/2F} \longrightarrow \text{(B/F)} \longrightarrow \text{2B/F}$$

The points where to start and finish the triangle's interlinkings are recognised as for Row 3.

The system will now be obvious and needs no further description. It will be realised that if the abbreviated instructions for a triangle of holes are followed row by row but in a reverse order, then an inverted triangle will be produced. So the final row of the inverted triangle, giving a single hole, is the same as Row 1 for a normal triangle. This hole will stay open in the following overplait row and be closed in the following plait row.

The rules given above for moving from 1/1 interlinking to holes and back again on either diagonal are now summarised. Fig. 72(a) shows the four possible transitions, labelled A, B, C and D.

A. Stop when the last 2/2 interlinking closed the last hole, then 2B/F.
B. Stop when the last 1/1 interlinking is five threads away from the right-hand hole, then B/2F.
C. Stop when the last 2/2 interlinking closed the penultimate hole, then 2B/F.
D. Stop when the last 1/1 interlinking is one thread away from the right-hand hole, then B/2F.

With these four rules any design is possible so long as the areas have boundaries running on one of the diagonals. See Plates 67 and 69.

Note—That the reverse effect is also possible, i.e. areas of 1/1 interlinking on a background of holes. In many countries this has been the traditional interpretation of the technique (see Plate 68). So animals, trees, ornaments, even initials and dates, appeared as dense areas on an openwork ground, being built up in square units as used in cross-stitch patterns.

—That though a hole is begun in one plait row and closed in the next, it actually extends in height over three rows, not the expected two. This is because a hole is the continuation, or downward extension, of a normal 1/1 interlinked sprang

opening, which was made in the preceding (overplait) row. The manœuvre in the plait row, therefore, does not so much start a hole as prevent the normal closure of a 1/1 interlinked sprang opening, already in existence. So two such openings, lying one above the other, run together and make a hole that is three rows high.

(2) AREAS WITH VERTICAL BOUNDARIES

A vertical boundary is obtained by combining two of the above rules. So to move from 1/1 interlinking to holes, as in Fig. 72(b) right-hand side, work the rows thus:

> Plait Row, follow Rule B
> Overplait Row
> Plait Row, follow Rule D
> Overplait Row

Repeat these four rows.

To move from holes to 1/1 interlinking, as in Fig. 72(b) left-hand side, work the rows thus:

> Plait Row, follow Rule A
> Overplait Row
> Plait Row, follow Rule C
> Overplait Row

Repeat these four rows.

In other words the vertical boundary is obtained by increasing and decreasing the areas on alternate plait rows, so it is really a fine zigzag.

A narrow vertical stripe of 1/1 interlinking on a background of holes was used as decoration on the Ruthenian cap shown being made on the sprang frame in Schinnerer's *Antike Handarbeiten*. It is worked thus:

Row 1.

$$\longleftarrow (2B/2F) \longleftarrow B/2F \cdot 2B/F \longleftarrow (2B/2F) \longleftarrow$$

Row 2. A normal Overplait Row

Row 3.

$$B/F \longleftarrow (2B/2F) \longleftarrow B/2F \cdot (B/F) \times 2 \cdot 2B/F \longleftarrow (2B/2F) \longleftarrow B/F$$

The stripe is started according to rule C.

Row 4. A normal Overplait Row

Row 5.

$$\longleftarrow (2B/2F) \longleftarrow B/2F \cdot 2B/F \longleftarrow (2B/2F) \longleftarrow$$

The stripe is here started according to rule A. Rows 2 to 5 are repeated again and again, and the resulting structure is shown in Fig. 73.

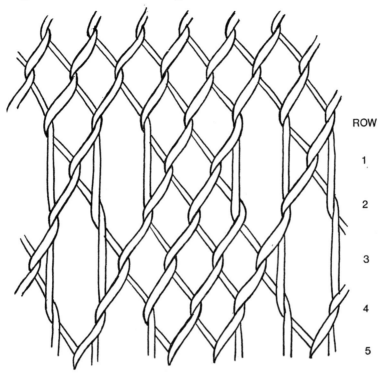

ROW

1

2

3

4

5

Fig. 73. Vertical stripe of 1/1 interlinking on a background of holes

(c) Alternative ways of making holes

In the above description a hole was always begun on a plait row, stayed open in the following overplait row and was closed in the next plait row. An alternative method, which is apparently the one seen by Schinnerer in Ruthenia, is also worked in the plait row (Reesema, n.d.; Schwetter, 1930; Hald, 1950). But a hole is made by undoing an interlinking made in the previous, overplait row. The following row, which is an overplait row, closes the hole. The manœuvre is done thus:

At the spot where a hole is wanted, pick up the next front layer thread on the back of the right thumb. Release the following front layer thread from the left hand, thus undoing an interlinking made in the previous row and leaving two loosely hanging threads. Pick up the right-hand one (this was the released back layer thread) and take it into the right hand and drop the thread lying over the right thumb behind the right hand. Now pick up the left-hand hanging thread with the left middle finger and take it to join the other front layer

threads in the left hand, where it becomes the next front layer thread. Work a normal 1/1 interlinking, i.e. pick up the next back layer thread and drop the next front layer thread.

If this manœuvre, which is simple to do though lengthy to describe, is then immediately repeated, holes are made at the normal spacing. In the following row, which is a normal overplait row, all the holes are closed.

In the next plait row, the same manœuvre can be repeated, but starting at the correct moment in relation to the previous holes. The rules are almost the same as those given in Fig. 72 except that as the preceding set of holes are already closed the threads have to be counted a little differently.

Note—In this method the holes are made in one row and closed in the next. In the normal method, holes are made in one row, stay open in the next row and are closed in the following row.

This method will be met again in circular warp sprang.

(d) Variations

(1) LONG HOLES

Made in the normal way, holes start in a plait row and close in the next plait row due to the sideways shift in the 2/2 interlinking. If the 2/2 interlinking is not shifted then the hole stays open. When making holes all across, this means repeating the first two rows (see section (iii)(a) above) as many times as wanted, thus:

Row 1

 ———←— (2B/2F) ———←—⎫

 ⎬ Repeat

Row 2 ⎭

 ———←— (B/F) ———←—

Take care that the narrow four-strand braids which appear between the holes do not twist.

Only when the holes are to close, are Rows 3 and 4 worked. These can also be repeated, thus:

Row 3

 B/F ———←— (2B/2F) ———←— B/F⎫

 ⎬ Repeat

Row 4 ⎭

 ———←— (B/F) ———←—

Very often long holes and normal holes are combined in the same design. If a plait row is worked thus:

$$B/2F \longleftarrow (B/F) \longleftarrow 2B/F \cdot B/2F \longleftarrow (B/F) \longleftarrow 2B/F \cdot B/2F \longleftarrow (B/F) \longleftarrow 2B/F$$

then two holes will start, and both will stay open in the following overplait row. Assuming that the right-hand hole is to be a normal one and the left-hand a long one, then they must be treated differently in the next plait row. So the 1/1 interlinking will go right across the right-hand hole, closing it, but it will stop short of the left-hand hole, when three threads remain (two being *in* the left hand, one *behind* it) between the hole and the last interlinking. Then the hole-opening manœuvre is repeated, i.e. B/2F, then 2B/F, and 1/1 interlinking continues to the left selvage. By stopping at the position described, the B/2F and 2B/F interlinkings are worked in exactly the same place as in the first row so the hole stays open. This plait row and its following overplait row is repeated as long as the hole is to stay open.

It may be helpful to realise that the sides of such a long hole are structurally the same as the selvages of a 1/1 interlinked fabric, the right side corresponding to the left selvage and the left side to the right selvage.

It will be understood now that a hole is always the result of *not* interlinking two threads that would normally be interlinked in a plait row. The smallest hole is closed on the following plait row, when those two threads *are* interlinked. For a longer hole, the two threads stay unlinked for an even number of rows until closed in a plait row.

A long hole hardly ever appears as the slit shown in a diagram. The surrounding elastic fabric acts on its edges and causes it to gape into an oval or even a circle. So although the length of a hole is controlled by the worker, its width is the product of tension forces within the fabric. Notice that however wide a hole may appear, it still results from the non-interlinking of only two threads.

Large holes are simply produced and have a strong visual effect, so are often used in sprang fabrics intended for wall hangings. When making such a fabric it will be found that there is an interaction between all its parts and no hole or other feature assumes its final shape or position until the last row is worked. It is because of this interaction that the mechanical and number-dominated sprang manipulations give a fabric with an altogether organic look.

Variations in the Spacing of Holes

There are many possible ways of spacing holes especially if they are long holes. Generally one type of spacing is used throughout the design but different types can be combined. Several types are now given, being classified by the number of threads between adjacent holes in a row. Many of these do not involve alternate rows of 1/1 and 2/2 interlinking but are included here for convenience.

(2) TWO THREADS BETWEEN LONG HOLES

If a triangle of holes is worked in the normal way, but the holes are kept open longer than

usual, they will be separated by only two threads. These two threads separating the holes acquire one more twist in each row, so that they lie like 2-ply threads.

A pattern which uses this principle and which is twice as wide as that shown in Fig. 74 is now described in abbreviated form. The position of the holes is indicated by vertical lines.

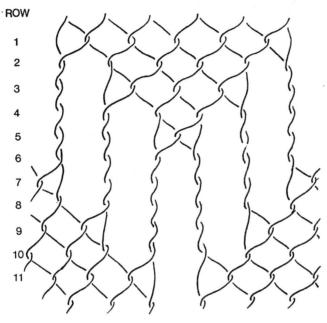

ROW
1
2
3
4
5
6
7
8
9
10
11

Fig. 74
Holes separated by two
threads

Row 1

B/2F · (B/F) × 3 · 2B/F | B/2F · (B/F) × 3 · 2B/F

Row 2
Normal overplait.

Row 3

B/F | B/2F · B/F · 2B/F | B/F | B/F | B/2F · B/F · 2B/F | B/F

Row 4
Normal overplait. Note that this just adds twist to the interlinkings flanking the central hole.

Row 5

B/F | B/F | 2B/2F | B/F | B/F | B/F | B/F | 2B/2F | B/F | B/F

Row 6
Normal overplait.

Row 7

 B/F | B/F | B/F | B/F | B/F | 2B/2F | B/F | B/F | B/F | B/F | B/F

Row 8

Normal overplait.

Row 9

 2B/2F | B/F | B/F | B/2F · B/F · 2B/F | B/F | B/F | 2B/2F

Row 10

Normal overplait.

Row 11

 B/2F · 2B/F | B/2F · (B/F) × 3 · 2B/F | B/2F · 2B/F

The sequence can now be reversed, i.e. work Rows 10, 9, 8, and so on back to Row 1, where it can again be reversed.

This obviously gives bad selvages and should have a stripe of 1/1 interlinking at both sides. See Plate 24 for a detail of a bag using this pattern.

Fig. 75 shows another use of very close holes separated by two threads, which was found on a red woollen Coptic cap (Bültzingslöwen). The openwork diagonal stripe occurs regularly across the width of the fabric and contrasts strongly with the intermediate stripes of 1/1 interlinking.

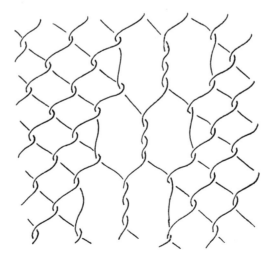

Fig. 75
Use of holes separated by
two threads taken from a
Coptic cap

The following abbreviated instructions are for one stripe:

Row 1. Plait Row

B/2F ——←—— (B/F) ——←—— 2B/F | B/F | B/2F ——←—— (B/F) ——←—— 2B/F

Two holes start in this row, shown by vertical lines.

Row 2. Overplait Row
Normal. One more twist is added to the two threads separating the holes.

Row 3. Plait Row
Normal. The two holes close.

Row 4. Overplait Row

——←—— (B/F) ——←—— 2B/F | B/F | B/2F ——←—— (B/F) ——←——

The moment to stop the 1/1 interlinking is when there are three threads (two being *in* the left hand, one *behind* it) between the last interlinking and the place where the hole should be. This is much easier than it sounds, knowing that the holes are on a diagonal running down to the left. At this point, work the three interlinkings that make the two new holes.

Row 5. Plait Row
Normal.

Row 6. Overplait Row
Normal. The two holes close.

These six rows are repeated. The moment to start making holes can always be judged as described for Row 4, but once the diagonal of holes is established there should be no difficulty.

Note—That this and the two following techniques disobey the general rule that holes are only started and closed in a plait row. Another more complex example is described by Hald (1950).

(3) THREE THREADS BETWEEN HOLES
This variation, found on a bride's head-dress from the Lavocne and dated to the beginning of the last century, is shown in Fig. 76 (Hald, 1950). Starting after a normal overplait row, the work is begun thus:

Row 1

——←—— (B//2F · 2B//F) ——←——

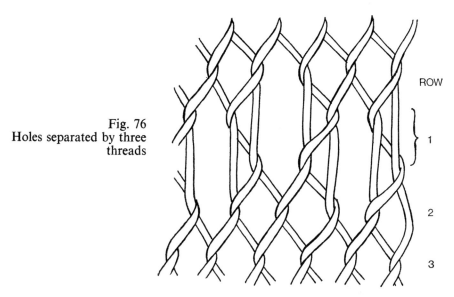

Fig. 76
Holes separated by three
threads

ROW

1

2

3

These two double twist interlinkings are repeated all across the warp, so the number of threads should be divisible by three. This row makes a set of holes, alternate ones being higher.

Row 2
Normal plait row. This closes the higher holes. Take care that the threads are picked up in the right sequence.

Row 3
Normal overplait row. This closes the lower holes.

The three rows can then be repeated.

(4) SIX THREADS BETWEEN HOLES
A Coptic cap has the patterning shown in Fig. 77 and it is worked thus (Bültzingslöwen).

Row 1
2B/F ———◄——— (B/2F · 2B/F) ———◄———

The 2B/F and B/2F interlinkings are repeated all across the warp, starting a row of holes.

Row 2
Normal overplait row. The holes stay open.

Row 3
Normal plait row. The holes close.

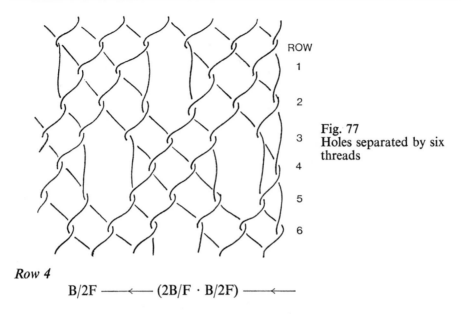

ROW
1
2
3
4
5
6

Fig. 77
Holes separated by six
threads

Row 4

$$\text{B/2F} \longlongrightarrow\longleftarrow \text{(2B/F} \cdot \text{B/2F)} \longrightarrow\longleftarrow$$

The B/2F and 2B/F interlinkings are repeated all across, and a new set of holes begins to appear in an intermediate position.

Row 5
Normal plait row.

Row 6
Normal overplait row. The second set of holes close.

 These six rows are repeated.

In the Coptic piece there is a stripe of simple 1/1 interlinking running down each selvage, presumably because this openwork pattern would be very untidy if carried right to the edge of the fabric. When stretched sideways this fabric shows nicely rounded holes.

(5) EIGHT THREADS BETWEEN HOLES

Holes separated by eight threads and of twice the length of normal holes are often combined with normal holes in the same design, as they can be aligned on the same diagonal. Fig. 78 shows the start of a triangle of such holes and the abbreviated instructions follow.

Row 1. Plait Row

$$\text{B/2F} \longrightarrow\longleftarrow \text{(B/F)} \longrightarrow\longleftarrow \text{2B/F} \mid \text{B/2F} \longrightarrow\longleftarrow \text{(B/F)} \longrightarrow\longleftarrow \text{2B/F}$$

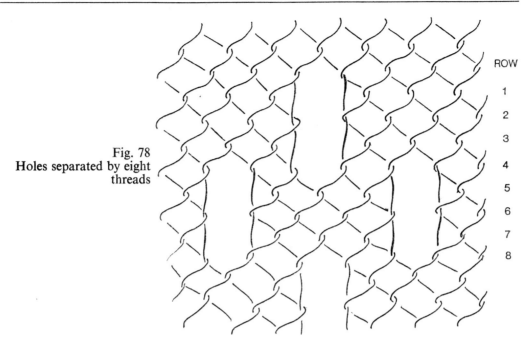

Fig. 78
Holes separated by eight
threads

ROW
1
2
3
4
5
6
7
8

Row 2. Overplait Row

$$——\!\!\leftarrow— (B/F) ——\!\!\leftarrow—$$

Rows 3 and 4 are repeats of Rows 1 and 2, siting the two central interlinkings in exactly the same place, so that the hole stays open. This is done by stopping the 1/1 interlinking when it is three threads (two being *in* the left hand, one *behind* it) away from the hole.

Row 5. Plait Row

$$B/2F ——\!\!\leftarrow— (B/F) ——\!\!\leftarrow— 2B/F \mid B/2F \cdot B/F \cdot 2B/F \mid B/2F ——\!\!\leftarrow— (B/F) ——\!\!\leftarrow— 2B/F$$

Row 6. Overplait Row

$$——\!\!\leftarrow— (B/F) ——\!\!\leftarrow—$$

In the plait row, the point at which to stop 1/1 interlinking is when there are seven threads (four being *in* the left hand, three *behind* it) between the last interlinking and the central hole. The central B/F interlinking closes the latter hole. For Rows 7 and 8, repeat Rows 5 and 6, siting the central interlinking correctly, as explained for Rows 3 and 4.

Row 9. Plait Row

$$B/2F——\!\!\leftarrow(B/F)——\!\!\leftarrow 2B/F \mid B/2F \cdot B/F \cdot 2B/F \mid B/2F \cdot B/F \cdot 2B/F \mid B/2F ——\!\!\leftarrow (B/F) ——\!\!\leftarrow 2B/F$$

Row 10. Overplait Row

$$\longrightarrow \longleftarrow (B/F) \longrightarrow \longleftarrow$$

For Rows 11 and 12, repeat Rows 9 and 10.

Because they are surrounded by so much 1/1 interlinked fabric, these holes are stretched into a good circular shape.

(e) Drafting hole designs on paper

As hole designs are much used and as they have infinite design possibilities, ways have been devised of writing them down on squared paper. It seems impossible to find a system by which every size and spacing of holes can be drafted easily, but the following is a fairly flexible method.

Each horizontal row of squares represents a plait row, each square representing two warp threads. The overplait rows are omitted as they contribute nothing to the design, hence the numbering of the rows goes up in twos, i.e. 1, 3, 5, and so on. A row of empty squares (Row 1 in Fig. 79(a)) therefore means a normal plait row, each square being a 1/1 interlinking, except of course the first and last.

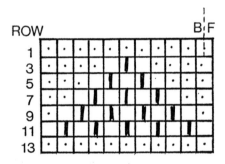

a

Fig. 79 (a) to (c)
Drafting hole designs on paper

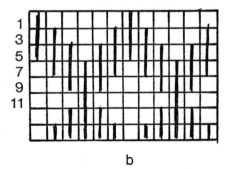

b

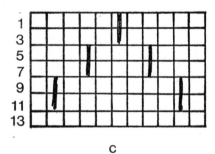

c

A line drawn down the middle of a square means that those two threads are not to be crossed in that plait row, in other words, a hole is to start. See Row 3 in Fig. 79(a). So the interlinking before the line must be B/2F and that after it must be 2B/F. These interlinkings are each represented by one and a half squares, which indeed suggests that they involve three threads. In Row 5, two holes begin and so on. The triangle represented is exactly similar to the one described in detail in section (b) above.

Note—A square before or after a square representing a hole is always a special type of interlinking. The only normal 1/1 interlinkings in Fig. 79(a) have a spot in them, all the others are either B/2F, 2B/F or 2B/2F. To start with it is a help to put these spots in.

Fig. 79(b) represents the first design described in section (d)(2) above and shown in Fig. 74. Here the holes are as close together as possible. They are only separated by two half squares, in other words, by two threads. Fig. 79(c) represents the triangle of large holes described in section (d)(5) above and partly shown in Fig. 78. The other spacings of holes, with three and six threads in between, cannot be shown very easily.

Note—If the right half of each square is thought of as representing the front layer thread and the left half the back layer thread, then the actual interlinking can be read off the draft. See Fig. 79(a) top right. For example the one and a half squares before the hole in Row 2 in Fig. 79(a) represents one back layer and two front layer threads (that is one left-hand half square and two right-hand half squares), so that the interlinking is B/2F. The one and a half squares after the hole represent two back layer and one front layer thread, so the interlinking is 2B/F. The one square and two halves between the holes in Row 5 represent two back layer and two front layer threads. These cannot be interlinked as (B/F) × 2, because that would perpetuate the first hole, so it has to be a 2B/2F interlinking.

To work out the number of threads in a warp from the draft, multiply the number of squares in the width by two, because each square represents two threads, then add two, because of the 2B/F and B/2F interlinkings at the start and end of the plait row. So Fig. 79(a) having eleven squares in its width would need 11 × 2 + 2 = 24 threads.

A draft is, of course, quite unnecessary if all the principles of hole making are understood. But it may be of use to even the advanced worker either in the planning stage of a fabric or to record a particular design.

(f) *Variations not giving holes*

In the simplest hole design described above, there was always a B/2F or 2B/F interlinking between the 2/2 interlinked area of holes and the 1/1 interlinked background. If these are

omitted, no holes are produced but there is in their place an area of denser structure. The technique is worked thus:

Plait Row

B/2F ——←— (B/F) ——←— (2B/2F) ——←— (B/F) ——←— 2B/F

The 2B/2F interlinking is repeated as often as required for the central area.

Overplait Row

——←— (B/F) ——←—

As each 2/2 interlinking is reached, the back layer thread has to be picked up under three front layer threads, instead of two. This may seem wrong but is correct. Spread the 2/2 interlinkings so that the right-hand and left-hand threads can be distinguished and selected in the right order.

Repeat these two rows, placing the same number of 2B/2F interlinkings exactly under those in the first row if a vertical stripe is wanted. But the area can be shaped in exactly the same way as a hole design.

From Fig. 80, which shows the structure when only two 2B/2F interlinkings are made, it will be seen that two pairs of threads move vertically, without the normal side-to-side interlinking. These twining pairs fill in the holes of the mesh which they cross and so make the fabric look denser.

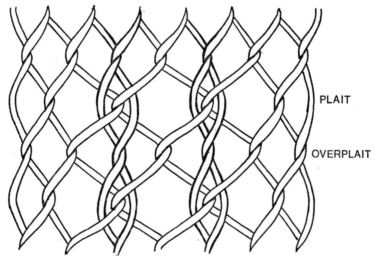

Fig. 80. Combining 2/2 and 1/1 interlinking without making holes

With a warp which has an (A,A,B,B) colour sequence, the twining pairs and the inter-linking pairs can be of different colours and the two colours can be counterchanged. It works best if the structure is used all across the warp thus:

Row 1

————←—— (2B/2F) ———←——

Row 2

B/2F ————←—— (B/F) ———←—— 2B/F

Then repeat these two rows. The counterchanging of colours is arranged by either starting Row 1 with a single B/F interlinking or by inserting a single B/F interlinking somewhere in this row.

(g) *Combining holes with warp transposition*

It is possible by combining holes with the transposition of sections of the warp to make a type of three-dimensional fabric. See Plate 25 for one possibility.

3. TECHNIQUES BASED ON THE USE OF EXTRA THREADS, ADDITIONAL TO THE NORMAL INTERLINKED STRUCTURE

A. Extra threads twining through the interlinked structure

Coptic woollen bags were very often decorated with pairs of twining warp threads, which move through the meshwork enclosing a thread of the ground structure between each twist (see Plate 26). As the left half of Fig. 81 shows, such a pair of threads lie like a 2-ply thread pierced by the interlinking threads. The twining threads move along one or other of the diagonals that exist naturally in the interlinked structure. With Z-twist interlinked sprang, as the twining threads move downwards to the left, as in the top half of

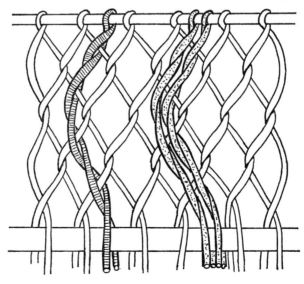

Fig. 81
Pairs of extra threads
twining through an inter-
linked fabric

Fig. 81, they are enclosing threads which form the back surface of the fabric. So here the twining threads show boldly on the back of the fabric and less so on the front. As they move on the opposite diagonal, as in the bottom half of Fig. 81, they are enclosing threads which form the front surface, so here they show boldly on the front and faintly on the back. The difference in the strength of the diagonal lines gives a special character to the designs using this technique (see Plate 27). In the Coptic textiles the twining threads were of different colours from the interlinked background and often many colours were combined in one piece. A common idea was for the two threads of a twining pair to be of different colours, so that it formed a series of spots of these two colours.

Sometimes threads to be twined were planted at widely spaced intervals when the warp was made. Then they showed as thin lines, perhaps making a diamond grid all over the background structure. But more commonly a warp was made with an (A,A,B,B) colour sequence, so there was an equal number of twining and interlinking warp threads. Then in order that the interlinking threads could show through and not be swamped by the twining threads, the latter were moved in units of two pairs, as shown in the right half of Fig. 81.

Patterns made thus generally alternated with horizontal stripes of double interlinked sprang, where only the interlinking threads were seen. The twining threads sank to the back where they were interlinked to form another fabric which lay behind the visible one. So there were at this point two separate layers of interlinking, one behind the other, i.e. true double interlinked sprang as described in section 5 of this chapter. At the lower end of this stripe the back threads reappeared and started twining again. See Plate 26.

(i) METHOD

There are three manœuvres to be learnt which make almost any design possible.

(a) *Threads twining on a diagonal running down to the right*

At the start of a row, the threads are held in the left hand in the normal way. According to the design there will be twining threads (in twos or fours) among the interlinking threads, but like the latter they too are divided into front layer and back layer threads.

Fig. 82 shows a small warp with only one pair of twining threads, which are shaded. A normal plait row has reached the point where the next back layer thread due to be picked up is one of the twining threads, marked B in Fig. 82.

Pick it up in the normal way with the right thumb and index so that it joins the threads in the right hand. With the left thumb push the other of the twining threads, marked F, which is lying in front of the left fingers, over the front layer thread to its right, labelled f, and drop it off. Make it go behind the right-hand fingers. Continue the interlinking normally picking up the next back layer thread, b, and dropping off the next front layer thread, f.

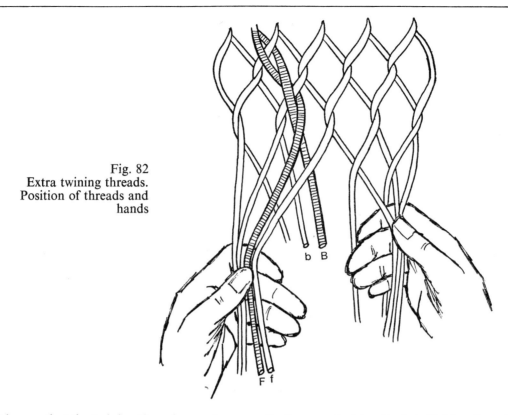

Fig. 82
Extra twining threads.
Position of threads and
hands

It is seen that the twining threads are given exactly the same twist as the interlinking threads, so the two threads in this case are always twined in a Z direction.

(b) Threads twining on a diagonal running down to the left

It can be imagined that the twining threads in Fig. 82 are about to change course and are now to lie on the opposite diagonal, running down to the left. To make this happen, the two interlinking threads, b and f, have to be dealt with *before* the two twining threads, B and F.

Move the right thumb and index to the left under F and f, and over B to pick up b, which is taken into the right hand in the normal way, and then let f drop off. Then pick up B and drop F and carry on with normal interlinking.

So it is seen that the diagonal on which the twining threads will lie depends on whether they or two interlinking threads are dealt with first at the point shown in Fig. 82.

If in one row the twining threads are made to move on one diagonal and in the next row on the other diagonal and so on throughout the fabric, they will make a wavy vertical

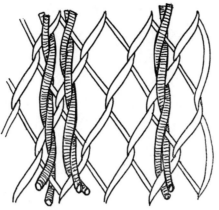

Fig. 83
Extra twining threads
making wavy vertical lines

line, as shown in the right half of Fig. 83. Two such lines made by four twining threads, as shown in the left half of Fig. 83, make a vertical stripe with spots where the interlinking threads show through (see right-hand side of Plate 30).

(c) *The crossing of two sets of twining threads*

Often two pairs of twining threads moving on opposite diagonals approach each other and then finally have to cross. As the row in which they cross is begun, all four threads lie

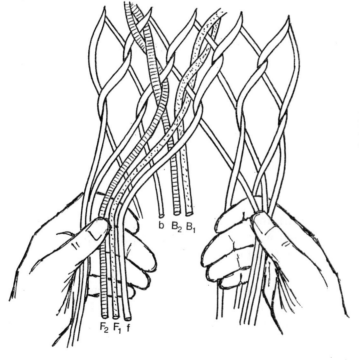

Fig. 84
Position of threads and
hands when two pairs of
extra twining threads are
about to cross

together, two in front of the left hand, labelled F1 and F2 in Fig. 84, and two behind it, labelled B1 and B2. The row has reached the same point as in Fig. 82, i.e. the moment when the next back layer thread due to be picked up is one of the twining threads.

Now move the right thumb and index to the left, passing under the front layer threads and over B1, to pick up B2, which is the left-hand of the two back layer twining threads. Bring it to the right where it joins the other threads in the right hand. With the left thumb push F2 (the left-hand of the two front layer twining threads) over the other two front layer threads to its right, let it drop off and push it behind the right fingers.

Now pass the right thumb and index finger between the two remaining twining threads, F1 and B1, and pick up b, the next back layer interlinking thread, and drop off f, the next front layer interlinking thread. Now pick up B1 and drop F1, thus twisting the two twining threads which have come down from the right. Then carry on with normal interlinking.

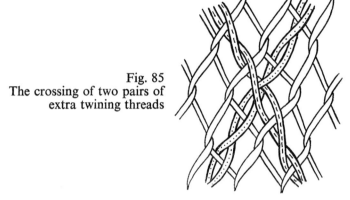

Fig. 85
The crossing of two pairs of
extra twining threads

The structure of this crossing is shown in Fig. 85 and will be met again in intertwined sprang. As described above, it will always be a thread from the pair which is moving down from the left which will lie on the surface. This will give the impression in the design that this twined line is crossing in front of the other. The reverse effect can be achieved by altering the first stage of the manœuvre thus:

Pick up B2 behind B1. Make F2 pass under F1 then over f, before it is dropped off. The next interlinkings of b and f and of B1 and F1 are as already described.

All the above descriptions have assumed that there was only one pair of twining threads making up a diagonal line, and it is advisable to first work out and understand the technique at this simple level. When there are two pairs making up each diagonal line, as in the right side of Fig. 81, the process is essentially the same (see Plate 27). The right-hand of the pair is dealt with as described above, then, immediately after, the left-hand of the pair is dealt with in exactly the same way. When two pairs cross two pairs, a little care has to be

taken to select the correct threads. To make a very thick line, three twining pairs can be used together.

(d) Twining on a less steep diagonal

Twining threads can be made to take a different and less steep diagonal course through the fabric. As Fig. 86 shows, the twining pair will enclose three interlinking threads instead of only one. The technique is worked thus:

When the pair is moving down to the right, stop the interlinking when three threads (two front layer, one back layer) away from the twining pair. Then pick up the back layer twining thread under the intervening back layer interlinking thread and take it into the right hand. Then push the front layer twining thread over the two intervening front layer threads and make it lie behind the right fingers. Then carry on normally.

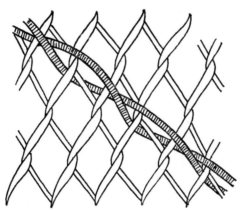

Fig. 86. Extra twining thread lying at a less steep angle

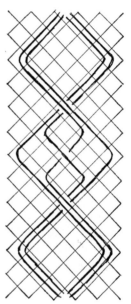

Fig. 87
Extra twining threads.
Drafting a design

When the pair is moving down to the left, stop the interlinking when one thread (a front layer thread) away from the twining pair. Then, passing the right thumb and index between the twining pair, pick up the next back layer interlinking thread and draw it into the right hand. Drop off the next front layer interlinking thread. Then pick up the next back layer interlinking thread in a similar way through the twining pair, and let the next front layer interlinking thread drop off, also passing between the twining pair. Then pick up the back layer twining thread and drop the front layer twining thread and carry on normally.

(ii) DRAFTING A DESIGN

Twining designs can easily be drafted or recorded on paper. A grid of lines is drawn, representing the background interlinked sprang, as in Fig. 87, and the twining threads entered on this, one line representing a pair of threads. Turning a piece of squared paper through forty-five degrees is a simple way of achieving the background grid. Fig. 87 shows a typical Coptic design using four pairs of twining threads. There is, of course, no need to make a repeating or symmetrical design.

(iii) TWINING THREADS BECOMING INTERLINKING THREADS

If twining threads are at some point suddenly treated as normal interlinking threads, they immediately become a vertical interlinked stripe. Referring back to Fig. 84, it can be seen that the row could easily continue with simple 1/1 interlinking, picking up the next back layer thread and dropping the next front layer thread all the way to the left selvage. So all the threads, whether they were twining or interlinking in the previous row, would be treated in the same way. The result would be a vertical stripe, four threads wide, as in Fig. 88. Naturally the process can be reversed and a thread can resume twining after any even number of rows of interlinking.

Fig. 88 illustrates that this manœuvre can be used for another purpose, namely to increase (or decrease) the width of a sprang fabric. But the increase is actually nothing like as great

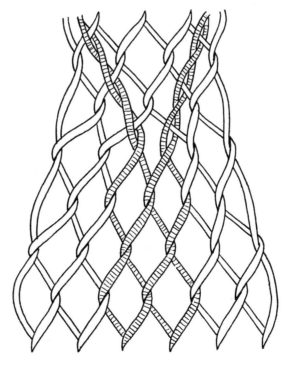

Fig. 88
Extra twining threads
becoming an interlinked
stripe

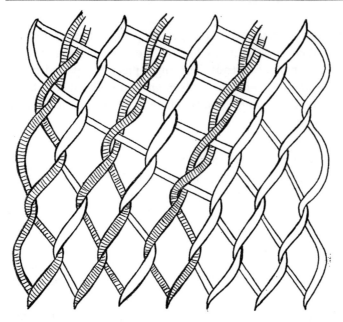

Fig. 89
Threads changing from
twining to interlinking
along a diagonal line

as illustrated, as the interlinked mesh bearing twined pairs is set far more openly than the normal mesh. It is more an increase in stretchability, than in width, that is achieved.

The transition from twining to interlinking can be worked gradually on a diagonal, as in Fig. 89. This is the method used in Plate 28. There will also be an increase in stretchability here. The transition can also be worked on a vertical line, as shown in Fig. 90, but this does leave a series of holes, marked X in the diagram. Naturally as more twining threads change into interlinking threads on the left, the transition line begins to lean away from the vertical. This method will give an area of solid colour to the left, whereas that in Fig. 89 and Plate 28 gives a striped area, as part of the background mesh also moves to the left.

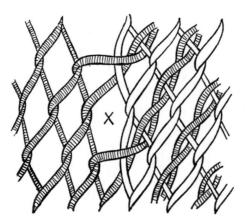

Fig. 90
Threads changing from
twining to interlinking
along a vertical line

A very convincing Coptic design of horizontal zigzags is shown in Fig. 91 and Plate 29. Each thread interlinks for four rows then twines for four rows, so the usual clear division between interlinking and extra twining threads does not exist. The warp has a colour sequence of 4A, 8B, [8A, 8B] 4A, the portion in square brackets being repeated *ad lib* to obtain the desired width.

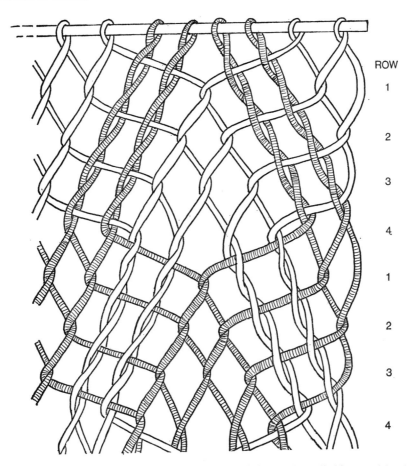

Fig. 91. Coptic design in which threads change from twining to interlinking and back again in a regular manner

The pattern is shown below in abbreviated form, using the symbols 2T↘ and ↙2T to represent two twining pairs moving to the right and to the left respectively. If the warp is widened by repeating the bracketed portion, then the part of the instructions also within square brackets must be repeated the same number of times.

Row 1

B/2F · ↙2T · B/F · 2T↘ [(B/F) × 3 · ↙2T · B/F · 2T↘] 2B/F

Row 2

$$B/F \cdot \swarrow 2T \cdot (B/F) \times 2 \cdot 2T\searrow [(B/F \times 2 \cdot \swarrow 2T \cdot (B/F) \times 2 \cdot 2T\searrow] B/F$$

Notice that in this row, apart from the first and last interlinking, the sequence is two interlinkings, two twinings all across.

Row 3

$$\swarrow 2T \cdot (B/F) \times 3 \cdot 2T\searrow [B/F \cdot \swarrow 2T \cdot (B/F) \times 3 \cdot 2T\searrow]$$

As this row begins, ignore the most right-hand thread of colour A, a back layer thread; and as the row finishes, ignore the last colour A thread, a front layer thread.

Row 4

$$\swarrow 2T \cdot (B/F) \times 4 \cdot 2T\searrow [\swarrow 2T \cdot (B/F) \times 4 \cdot 2T\searrow]$$

Note—That in this row, apart from its start and finish, the sequence is four interlinkings, four twinings all across.

—That the first and last twinings are about the extreme right and left-hand colour A threads, those that were ignored in the previous row.

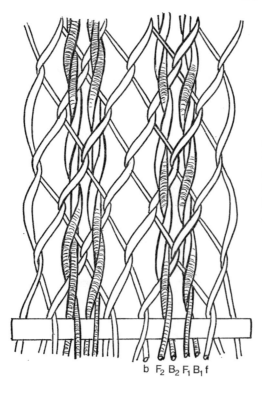

b F_2 B_2 F_1 B_1 f

Fig. 92
Vertically twining threads occasionally floating at the back of the fabric to give spots

After these four rows, it will be found that the colours have reversed their positions, see Fig. 91, so the sequence is now 4B, 8A, 8B, 8A, 4B. Keep on repeating these four rows exactly.

(iv) TWINING THREADS FLOATING AT THE BACK OF THE FABRIC

The Copts added variety to their twined designs by sometimes dropping one or two pairs of twining threads to the back of the fabric. They remained there for a few rows and then reappeared on the surface. This was generally used as a way of making a vertical line of spots. For instance if the two twining pairs making a vertical line at the left of Fig. 83 drop to the back on alternate rows, they will appear as a set of arrow-shaped spots, as on the right-hand side of Fig. 92 and centre of Plate 30. Or they can stay on the surface for two rows then drop to the back for the next two rows, as shown on the left side of Fig. 92 and Plate 30, to give bigger spots. Both of these are quite difficult to work because, although the twining threads do not enclose interlinking threads when they lie at the back, they still continue to twist around each other, as Fig. 92 shows. This is to ensure that their warp take-up stays the same as the interlinking threads around them.

The first type of spot, on the right half of Fig. 92, is worked as follows, starting from the point at the bottom of the diagram:

Row 1
Interlink normally until the next back layer thread due to be picked up is the twining thread, B1. Pick this up and drop off the front layer twining thread, F1, letting it slide under the first front layer interlinking thread, f, which has to stay on the left fingers. Now move the right thumb and index to the left under the first front layer thread, f, and over the next front layer thread, F2, and pick up the next back layer interlinking thread, b. This cannot be drawn far to the right as it crosses the second front layer twining thread, F2, and becomes caught. With the left thumb and index pick up this latter thread, F2, above the point of crossing and release the part of it on the left fingers. Now with the right thumb and index draw the back layer interlinking thread, b, freed by this manœuvre, into the right hand and let the front layer interlinking thread, f, drop behind the right fingers. Pick up the second back layer twining thread B2, and drop the second front layer twining thread, F2, and then continue normally to the left selvage.

Row 2
In this row the right-hand twining pair obeys the rules for diagonal lines running down to the left, and the left-hand pair those for a line running down to the right.

Repeat these two rows.

In the Coptic bags the twining threads were sometimes floated on the back of the fabric between more widely spaced motifs than the simple spot, described above. Fig. 93 shows

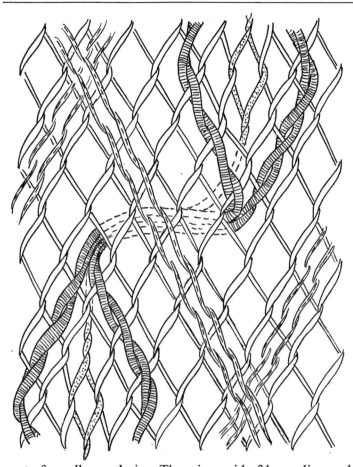

Fig. 93
Coptic design involving
several systems of extra
twining threads

part of an all-over design. There is a grid of large diamonds, each line made by two pairs of twining threads. In the middle of each diamond there is a smaller diamond, made from single pairs of threads, which are shaded. In the centre of that diamond there is one opening outlined by yet another coloured thread, shown as spotted. As suggested by the dotted lines the two latter sets of threads, six threads in all, move almost horizontally to the left from the lower point of one diamond to the upper point of the next diamond. At the next diamond down in the design, the same six threads will move back to the right. They twist on themselves in an orderly manner while they float on the back. The spotted thread outlining the centre of each diamond is of course not twining.

See section 6D in Chapter 8 for the use of extra twining threads in intertwined sprang.

B. Laid-in wefts

A sprang fabric is essentially weftless and needs no cross threads for structural stability. But at the end of each row a new shed is obtained, an opening between the front layer and

back layer threads, and there is no reason why wefts should not be laid here experimentally. Such a weft would limit the side-to-side stretch of the fabric, but not the stretch in the warp direction. So it could be used in shaping a garment, as it would decrease the effective width of the fabric. Also rods could be laid in and used for shaping a fabric when off the frame.

An example does exist from Egypt, in which a laid-in weft is pulled up into loops. But the loops are extremely unstable and must only have served a decorative purpose.

The use of laid-in wefts in the finishing of a sprang fabric is described in Chapter 10.

4. RIDGES

Interlinked sprang is generally a fairly flat-surfaced fabric with little variations of texture. But there are two ways of making ridges which stand well above this surface. They could also be used in association with interlaced or intertwined sprang.

A. Chained ridge

The chained ridge is very similar to that described in section 2B(i) of Chapter 10. Here it is used as a decorative ridge; there it is used as a method of securing the threads before cutting. Its only known historical occurrence is in the Borum Eshöj hair-net, where six such ridges lie across a background of multiple twist interlinked sprang. See Plate 31.

Method
Untie the safety cord and take out the sword. Then with the left hand in the shed made by the last row of interlinking, pass the right thumb and index under the first front layer thread and pick up the second front layer thread. Pull it to the right under the first front layer thread, dropping the latter from the left hand. Slip the left index finger under the second front layer thread and push the crossing upwards, while at the same time pushing the crossing downwards against the lower fabric with the right index finger. This is exactly the same as the movement shown in Fig. 143, except that here only front layer threads are involved. Now pick up the third front layer thread under the second and pull it to the right. Again force the crossing up and down. Now pick up the fourth front layer thread under the third, and so on.

As the bottom of Plate 32 shows, such a single ridge does not stand out very prominently.

It is easier to make the ridge horizontal if the warp tension is slackened and if a non-slippery yarn is used.

At the end of the row there is no shed. So the back layer threads, the ones which were not chained, are now drawn individually to the front each one passing between two front layer threads. These form the new front layer threads, and the above procedure can be repeated with them to make a double thickness ridge as in the centre of Plate 32. The

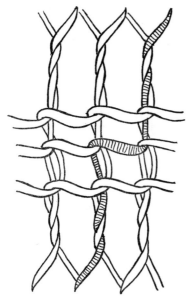

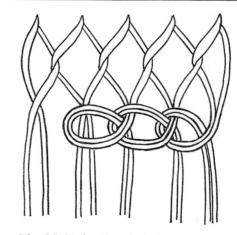

Fig. 95. Twisted and chained ridge

Fig. 94
Triple chained ridge

process can then be repeated again to make a triple thickness ridge. The ridges on the Borum Eshöj hair-net are of double and triple thickness. Fig. 94 shows the form the triple ridge takes, with one thread shaded to help explain the structure. See the top of Plate 32. If the warp has an (A,B,A,B) colour sequence then the ridges will be alternately of these two colours.

The back layer threads can be brought to the front while the ridge is being made. After the crossing has been forced up and down, select the next back layer thread, draw it to the front either between the two crossed threads or immediately to their right and slip it on to the right-hand fingers. By the end of the row all the back layer threads will be on the right hand.

It will be obvious that the more ridges are made, the more all the threads will be shifted to the left. This might be used as a way of shaping a fabric. But it can be counteracted by occasionally working the ridge in the opposite direction, i.e. left to right, by starting with the right hand in the shed and by picking up the threads with the left hand.

Bolder ridges can be made by using two threads as the unit.

Chained ridges can lie at an angle, so they can form diagonal lines, zigzag lines, curved lines and so on. This makes use of the natural tendency of such ridges to lie at an angle to the horizontal.

B. Twisted and chained ridge

This is a type of ridge found in Coptic bags near the drawstring, but it could be used any-where in a sprang fabric. See Fig. 95. It is unusual in that it is a manipulation of stretched

threads which does not produce a duplication of itself at the other end of the warp, see Plate 33.

Method

Slacken the warp so that it hangs loosely. Pick up the first two threads at the right (a back layer and a front layer thread), and twist them to make a loop. The twist can be either clockwise or anti-clockwise. Then through this loop, pick up the second pair of warp threads and give them a similar twist to make the second loop. Through this second loop, pick up the third pair of warp threads and twist them. This is the stage reached in Fig. 95. The fourth pair of warp threads, showing through the last loop, are the next to be picked up.

Carry on to the left selvage where the final loop has to be tied to prevent the whole ridge becoming undone.

Re-applying tension to the warp makes this into a very neat compact ridge, which looks like the weft chaining used in rug weaving. It will be understood that the ridge takes up a lot of warp, so to avoid inequalities in tension it must run from selvage to selvage.

5. DOUBLE INTERLINKED SPRANG

Introduction

In double interlinked sprang, two pieces of interlinked sprang of different colours are worked one behind the other. Designs come from interchanging threads between the two fabrics so that, for example, black threads from the back fabric come to the front in certain areas and the corresponding white threads from the front fabric move to the back. Thus black shapes on a white background are seen on the front of the fabric; when it is turned over the same shapes are seen but with the colours reversed. The two pieces of fabric are quite unconnected except where there is an interchange of threads. Weavers will realise the close parallel existing between this technique and plain weave double cloth.

The only historical examples of this technique are the Coptic bags, where it was used more as a convenient way of dealing with unwanted threads on the back of a fabric than as a creative technique (see Plate 26). The double and quadruple sprang fabrics from Peru are in the intertwined, not interlinked, structure (see Chapter 8 and Plate 43).

The modern exploration of double interlinked sprang started when Reesema, a Dutch textile expert, tried to copy a head-dress pictured on an Italian plate of 300 B.C. Although she was convinced that the technique was sprang, there were elements in the design which she could not reproduce using conventional methods. Finally she worked out double sprang for herself and made an exact copy. She realised that the technique gave almost complete freedom of design and she wondered whether it had been used in other historical textiles. The culmination of her studies was an article published after her death. It was

largely concerned with refuting the theory advanced by van Gennep and Jequier, that the ancient Egyptians derived certain patterns depicted on their statues and tombs from tablet weaving. She was able to show that these patterns could be reproduced far more accurately by using double, and sometimes even quadruple and quintuple, sprang than was possible with tablet weaving. The illustrations to this article prove she had attained an astonishing mastery over the technique, but they do not prove its existence in ancient Egypt.

In the method described by Reesema in her instruction book on sprang, the back and front fabrics are worked independently, i.e. they each have their own safety cord and their own sword (Reesema, n.d.). A few rows were worked on the front piece, then the frame turned over and the same number of rows worked on the back piece. According to the demands of the design, threads were carefully changed from the front to the back fabric and vice versa. This manoeuvre was very difficult and involved much counting of threads.

A quite different method in which both front and back fabrics are worked simultaneously and in which the reproduction of any design is extremely simple will now be described. It was discovered by the author while working lattice sprang in two colours.

The principle of this method is that the threads of both front and back fabrics are combined, and lie in an (A,A,B,B) sequence, in each successive shed. See Fig. 96. As a row is worked, an interlinking of two white threads for the front fabric is followed by an interlinking of two black threads for the back fabric. Obviously these interlinkings have to be worked in a special way so that two layers of fabric are made, not one. At the end of the row it will be found that both the front and back fabrics have simultaneously grown by one row.

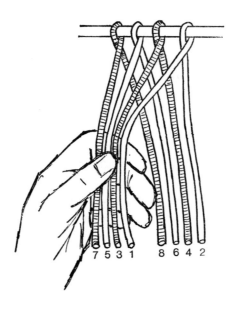

Fig. 96
Double interlinked sprang.
Position at beginning

A. Unpatterned double interlinked sprang

Make a warp with an (A,A,B,B) colour sequence and insert the left hand in the first shed, as in Fig. 96, where the threads have been numbered. The shaded threads will be referred to as black and the unshaded as white. The following description is to make the front fabric white and the back fabric black.

Plait Row
First a 2B/F interlinking has to be made using only white threads.

Put the right fingers under the first back layer white thread, 2. Move the right thumb and index to the left going under thread 1, over thread 3 (that is, in between the first two front layer threads), and pick up thread 6, the second back layer white thread. As it is drawn back to the right, its movement will be stopped by thread 3, the first front layer black thread, which it crosses above the left fingers. This crossing is arrowed in Fig. 97.

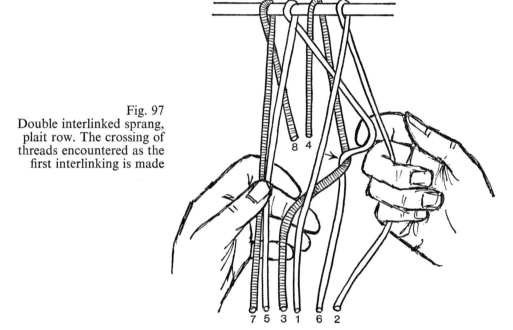

Fig. 97
Double interlinked sprang,
plait row. The crossing of
threads encountered as the
first interlinking is made

Now with the left thumb and index, pick up thread 3 above this crossing and let it slip from the left fingers below the crossing. This now allows thread 6 to complete its movement and join thread 2 in the right hand. At the same time thread 1 will drop off the left fingers and go behind the right fingers. Fig. 98 shows the stage now reached. It will be seen that a normal 2B/F interlinking has been worked with the first three white threads, but in front of any intervening black threads, and so the front, white, fabric has been started.

Now the black fabric has to be started with a 2B/F interlinking, and this presents no problem as the next two back layer threads, 4 and 8, and the next front layer thread, 3,

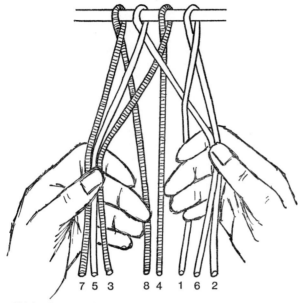

Fig. 98
Double interlinked sprang, plait row. Position on completion of first interlinking of the front fabric (white)

7 5 3 8 4 1 6 2

are all black, see Fig. 98. So simply pick up 4 and 8 and drop off 3. The plait row has now started for both front and back fabrics with a normal 2B/F interlinking, and the stage reached is shown in Fig. 99.

From here to the end of the row, interlinkings of two white threads must alternate with interlinkings of two black threads, but the former threads must always pass in front of

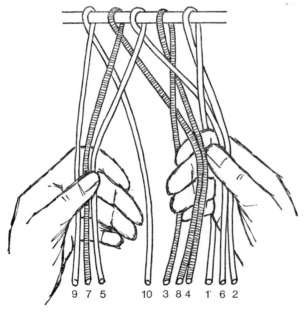

Fig. 99
Double interlinked sprang, plait row. Position on completion of the first interlinking of the back fabric (black)

9 7 5 10 3 8 4 1 6 2

the latter. If the hands are separated, as in Fig. 99, it will be seen that the next front layer and back layer threads are white, 5 and 10, and these are the next to be interlinked. But because the front fabric is to be white, the back layer white thread, 10, has to be picked up in front of the intervening black thread, 7.

So pass the right thumb and index to the left under the next front layer white thread, 5, and over the next front layer black thread, 7, pick up the next back layer white thread, 10, and draw it to the right. As before it will get caught as it crosses the front layer black thread, 7, and a situation very similar to that in Fig. 97 will be seen. Pick up thread 7 with the left thumb and index above this crossing, and at the same time let it slip from the left fingers below the crossing. The back layer white thread is now free to move into the right hand. This manœuvre also releases the next front layer white thread from the left fingers and it goes behind the right hand.

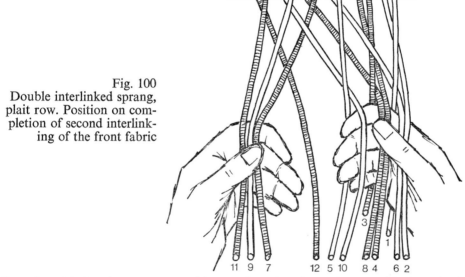

Fig. 100
Double interlinked sprang, plait row. Position on completion of second interlinking of the front fabric

See Fig. 100 for the present position and notice that wherever black and white threads cross, the white is always in front.

The above manœuvre is very important and must be thoroughly understood as it is the whole basis of the technique. It will be represented by an asterisk, *, in abbreviated instructions (see the note on abbreviations below), and will always be referred to as a *special* interlinking in the following descriptions.

The next interlinking is of the next front layer and back layer threads, which are black and numbered 7 and 12, and it is done in the normal way.

These two interlinkings, one of the special type and one of the normal type, are repeated to the end of the row, where in the final interlinking of each colour, two front layer threads are dropped off in the normal manner of ending a plait row.

Overplait Row

Interlink the first back layer white thread with the first front layer white thread in the normal manner. Now interlink the first back layer black thread with the first front layer black thread, allowing the latter to slide off the left fingers under the second front layer white thread.

Now interlink two white and two black threads to the left selvage, exactly as described for the plait row. In other words always pick up a back layer white thread in front of any intervening black threads. Due to the irregularity at the end of a plait row, it will be found that in the penultimate black interlinking, the back layer thread has to be picked up behind a white thread. But if the principle behind this method is understood, there will be no difficulty.

Note—There is no exception to the rule that an interlinking of two white threads alternates with an interlinking of two black threads across every row.

—If the first row began by interlinking two white threads, this sets the pattern; all subsequent rows must begin with a white interlinking and so must end with a black interlinking.

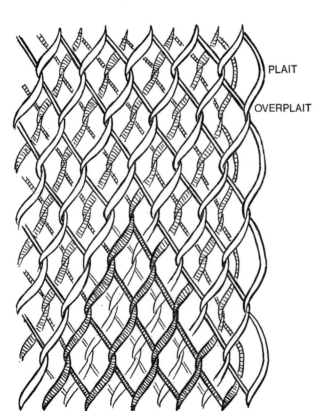

PLAIT

OVERPLAIT

Fig. 101
Double interlinked sprang.
Black triangle on a white
background shown at the
bottom

After several plait and overplait rows have been worked, the separation between the front, white, and back, black, fabric will be obvious, and can be demonstrated by sliding a rod between the two.

The top half of Fig. 101 shows how this structure can be represented diagrammatically on paper. Naturally the back layer of the fabric does not show through the front layer as it does in the diagram, unless the fabric is stretched sideways. If it is imagined that all threads are the same colour, the relation to lattice sprang will be seen.

B. Abbreviations for double interlinked sprang

It is obvious that the symbols used so far will not enable the above instructions for double interlinked sprang to be written in abbreviated form. So a few new symbols have to be introduced.

b and f (in light type) represent the next back layer and front layer thread of the front fabric. They are white in the above description.

b and **f** (in heavy type) represent the next back layer and front layer thread of the back fabric. They are black in the above description.

* represents the special manœuvre whereby an interlinking is made of one colour in front of the intervening threads of the other colour, i.e. it is the interlinking that establishes which colour shows on the front, which on the back.

The plait and overplait rows described above can be abbreviated thus:

Plait Row

$$\mathbf{b}/2\mathbf{f} \cdot \mathbf{b}*2\mathbf{f} \longrightarrow\!\!\!\longleftarrow (\mathbf{b}/\mathbf{f} \cdot \mathbf{b}*\mathbf{f}) \longrightarrow\!\!\!\longleftarrow \mathbf{2b}/\mathbf{f} \cdot \mathbf{2b}*\mathbf{f}$$

Overplait Row

$$\longrightarrow\!\!\!\longleftarrow (\mathbf{b}/\mathbf{f} \cdot \mathbf{b}*\mathbf{f}) \longrightarrow\!\!\!\longleftarrow$$

It is seen that an interlinking of the special type between white threads is always followed by a normal interlinking between black threads.

C. Pattern-making by interchanging threads between front and back fabrics

(i) A BLACK TRIANGLE ON A WHITE BACKGROUND

As with other pattern-making techniques it is best to start by describing the making of a triangle, in this case a black triangle on a white background.

Threads can be interchanged, and therefore patterns started, in either a plait or an overplait row, so in the following description the rows will only be numbered.

Row 1

$$\longrightarrow\!\!\!\longleftarrow (\mathbf{b}/\mathbf{f} \ \mathbf{b}*\mathbf{f}) \longrightarrow\!\!\!\longleftarrow \mathbf{b}*\mathbf{f} \ \mathbf{b}/\mathbf{f} \longrightarrow\!\!\!\longleftarrow (\mathbf{b}/\mathbf{f} \cdot \mathbf{b}*\mathbf{f}) \longrightarrow\!\!\!\longleftarrow$$

Work the row, either a plait or an overplait row, normally towards the centre of the warp, i.e. white-with-white interlinkings lying in front of black-with-black interlinkings. At the centre, stop after a black interlinking and immediately make a normal white interlinking. That is, just pick up the next back layer white thread behind the front layer threads in the usual way, and drop off the next front layer white thread. Follow this with a black inter-linking of the special type, i.e. pick up the next back layer black thread *in front of* the intervening white threads. This is the exact way in which white threads have been inter-linked so far; the same manœuvre is merely done with the opposite colour.

These two interlinkings, in which white threads are worked in the way previously used for black, and black threads are worked in the way previously used for white, establish the apex of the triangle, and a black spot begins to appear in the centre of the warp.

Note—That in this pair of interlinkings the usual sequence of a special interlinking then a normal one is reversed.

The row is worked thereafter in the normal way.

Some confusion may arise here from the symbols used in the abbreviated instructions because, as the triangle is made, front fabric threads become back fabric threads and vice versa. But b and f always refer to the threads which form the front fabric *at the beginning of the row*, no matter in what fabric they may lie in patterned areas, i.e. they are always the *white* threads in descriptions in this chapter. Similarly **b** and **f** always refer to the threads forming the back fabric *at the beginning of the row*, i.e. they are always the *black* threads in descriptions in this chapter.

Row 2

$$\text{———<—— (b/f b∗f) ———<—— (b∗f · b/f) × 2 ———<—— (b/f b∗f) ———<——}$$

As the instructions show, this only differs from Row 1 in that there are four interlinkings contributing to the triangle, two to the black triangle on the front of the fabric and two to the white triangle on the back. The moment to start these interlinkings is when, after a **b/f** interlinking, there are four threads between that interlinking and the most right-hand of the triangle's interlinkings. Of these four threads, three (two whites and a black) lie *in* the left hand, and one (a white) lies *behind* it.

Row 3

$$\text{———<—— (b/f · b∗f) ———<—— (b∗f · b/f) × 3 ———<—— (b/f · b∗f) ———<——}$$

In the third row the two interlinkings of the triangle are worked three times, in the fourth row four times and so on. The lower half of Fig. 101 shows part of this triangle.

As the triangle increases in size, it is useful to have a way of fixing its left boundary other

than by counting the triangle's interlinkings. These interlinkings stop when the front layer thread included in the last **b∗f** comes from the most left-hand interlinking of the triangle.

Note—That the right edge of the triangle has a toothed outline whereas the left edge is a straight line. If the work is turned over, the same applies to the white-on-black triangle on the reverse.

—That at the right edge of the triangle, two interlinkings of the same type follow each other, i.e. **b/f** then b/f. On the left edge, the same happens, i.e. **b∗f**, then b∗f.

(ii) A BLACK INVERTED TRIANGLE ON A WHITE BACKGROUND

The only differences in making a decreasing shape are the moments to start and to stop the interlinkings that make the triangle. The moment to start them is after a **b/f** interlinking in which the back layer black thread picked up came from the most right-hand of the triangle's interlinkings. These interlinkings are stopped after a **b∗f** interlinking, when one black thread from the triangle's most left-hand interlinking still remains in the left hand.

Naturally by combining the rules for an increasing and a decreasing shape, a shape with vertical edges can be made. So in the first row, work as if the shape was a triangle, and in the second work as if the shape was an inverted triangle. With practice, double interlinked sprang will be found a very free and very simple way of achieving a two-colour design. See Plate 34.

D. Joining the two fabrics at both selvages

As described above, the selvages of the front and back fabric are quite distinct and un-attached to each other, so a finger can be slid in between the two fabrics at either selvage. But the two fabrics can be sealed together by a manœuvre that is carried out in every over-plait row. As in other techniques in this section, it is assumed that the warp used is exactly as in Fig. 96.

Overplait Row

At the right selvage there is a pair of white threads, then a pair of black threads, in front of the left fingers. Carry the right-hand thread of the black pair to the right behind the two white threads, dropping it off the left fingers to allow it freedom of movement. Now return it to its starting position, passing over the right-hand thread of the white pair, but under the left-hand thread of the pair.

This rather clumsy movement has the effect of interlinking the right-hand threads of the two selvage pairs. The row is now worked normally in double interlinked sprang until only two white and two black threads remain in the left hand. There is a thread of each colour over the fingers and another of each colour behind them.

Now move the back layer white thread to the left over the back layer black thread and then return it to its starting position, passing under the back layer black thread. So these two back layer threads are now interlinked. Work the two final interlinkings normally.

Note—This manœuvre is only carried out in the overplait row. The plait row is quite normal.
 —The structure is identical with that described in section 1E of this chapter, which was worked in quite a different manner. Another way of sealing the two fabrics together is described in section 5E(ii)(c) below.

E. Combining double interlinked sprang with other techniques

Various interesting structural and colour effects result from combining double interlinked sprang with the single layer sprang techniques described earlier in this book. Two examples are given.

(i) COMBINING DOUBLE INTERLINKED SPRANG WITH LATTICE SPRANG

Due to the relationship between the two techniques this is an obvious combination.

Work normal double interlinked sprang to the point where lattice sprang is to begin, ending on a **b/f** interlinking. Then interlink the next two white and then the next two black threads, and so on, just as in normal lattice sprang, i.e. the special manœuvre which creates double sprang is entirely omitted. It is always the next back layer thread which is picked up and the next front layer thread which is dropped, the former passing under three threads as in the simplest form of lattice sprang. After a black interlinking in lattice sprang, revert to double interlinked sprang.

So the row can be abbreviated thus, the central block representing the area of lattice sprang.

$$\text{———}\!\!\longleftarrow \textbf{(b/f} \cdot \text{b}*\text{f)} \text{———}\!\!\longleftarrow \textbf{(b/f} \cdot \textbf{b/f)} \text{———}\!\!\longleftarrow \textbf{(b/f} \cdot \text{b}*\text{f)} \text{———}\!\!\longleftarrow$$

Subsequent rows are similar. The area of lattice sprang can be made to increase or decrease in size. There will always be an even number of lattice sprang interlinkings, so in a triangle there will be two (one white, one black) in the first row, four in the second row and so on.
 The lattice sprang area will show as diagonal stripes if, as has been assumed, the warp is in an (A,A,B,B) colour sequence. It would show as an area of different texture on a warp of only one colour.

(ii) COMBINING DOUBLE INTERLINKED SPRANG WITH SINGLE INTERLINKED SPRANG

(a) An area of single on a background of double interlinked sprang

The transition from normal 1/1 interlinking to double interlinked sprang is slightly more complicated than the transition from lattice sprang described above. The following description assumes that the warp has an (A,A,B,B) colour sequence as in Fig. 96 and that the front fabric is white and the rear fabric is black.

Plait Row
Work double interlinked sprang from the right selvage to the point where the single 1/1 interlinking is to begin, ending on a **b/f** interlinking, i.e. two black threads.

Now pick up the next back layer thread, white, and drop off the next two front layer threads, a black and a white. This interlinking, A in Fig. 102, positions the following threads correctly for normal 1/1 interlinking. Work an odd number of the latter interlinkings, say five. These are numbered 1 to 5 in Fig. 102. Notice that each interlinking is made with one white and one black thread. After the fifth interlinking, pick up the next two back layer threads, a black and a white, and drop off the next front layer thread, black. This interlinking is labelled B in Fig. 102. The threads are now set for double interlinked sprang (starting with b∗f), so work this to the left selvage.

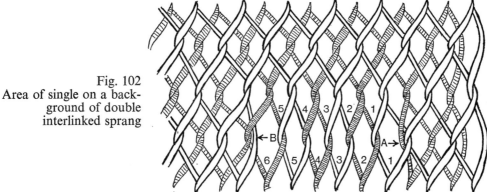

Fig. 102
Area of single on a background of double interlinked sprang

This row can be abbreviated thus:

—<— (b/f · b∗f) —<— bb/f · b/f · b/f · b/f · b/f · b/f · b/ff —<— (b/f · b∗f) —<—

Note—That the 1/1 interlinkings and the 1-with-2 interlinkings are written in terms of the back and front fabric threads.

Overplait Row
As the double interlinked sprang is worked in from the right selvage it gradually approaches the pair of threads, one black and one white, lying together behind the left fingers. Stop

the double interlinking when these have been included in the last two interlinkings. This will mean stopping after a **b/f** interlinking as usual.

Now work six single 1/1 interlinkings, i.e. one more than in the plait row. These interlinkings will be either of white with white threads or of black with black threads, and they are numbered 1 to 6 in Fig. 102. After the sixth interlinking it will be seen that the next front layer threads are the pair of threads lying together in front of the left fingers. Begin the double interlinking, using the white thread and then the black thread from this pair, and work it normally to the left selvage.

The overplait row can be abbreviated thus:

$$\text{——} \leftarrow \text{(b/f } \cdot \text{ b}*\text{f)} \text{——} \leftarrow \text{(b/f } \cdot \text{ b/f)} \times 3 \text{——} \leftarrow \text{(b/f } \cdot \text{ b}*\text{f)} \text{——} \leftarrow \text{——}$$

Repeating the two rows exactly will naturally make a rectangle of single interlinked sprang on a background of double interlinked, but the area can be shaped at will. To make a triangular shape, there have to be four more 1/1 interlinkings in each succeeding plait row; and every overplait row must have one more such interlinking than the preceding plait row. So the number of 1/1 interlinkings in successive rows, starting from the apex of the triangle in a plait row, will be 1, 2, 5, 6, 9, 10, and so on. The 1/1 interlinked area will show as diagonal lines due to the (A,A,B,B) colour sequence in the warp.

At any point, the area of 1/1 interlinking can be ended by working a plait row of double interlinked sprang all across.

(b) An area of double interlinked sprang on a single interlinked sprang background

(1) TYPE ONE DOUBLE SPRANG AREA ATTACHED AT ITS SIDES TO THE BACKGROUND

In this type, the area of double interlinked sprang is joined all round its edges to the background 1/1 interlinking; so the two fabrics enclose a pocket which is completely sealed off around its perimeter (see Plate 35).

Plait Row

Work normal 1/1 interlinking to the point where double interlinked sprang is to begin, then pick up the next two back layer threads and drop off the next front layer thread. Now begin the double interlinking in the usual way, with a special interlinking followed by a normal interlinking, and work it for the required distance. After an even number of double interlinkings, pick up the next back layer thread and drop off the next two front layer threads and then work normal 1/1 interlinking to the left selvage.

This row can be abbreviated thus:

$$\text{B/2F} \text{——} \leftarrow \text{(B/F)} \text{——} \leftarrow \text{B/2F} \cdot \text{(b/f } \cdot \text{ b}*\text{f)} \cdot \text{2B/F} \text{——} \leftarrow \text{(B/F)} \text{——} \leftarrow \text{2B/F}$$

It will be found that the colour of the front fabric in the double interlinked sprang area

is controlled by the moment at which the 1/1 interlinking is stopped. If it is stopped at a point when the front layer thread in the 2B/F interlinking is black, then the front fabric will be white. If, however, one more or one less 1/1 interlinking is made, then the front layer thread in the 2B/F interlinking will be white and the front fabric will be black. In the latter case, the central part of the abbreviated instructions would be (b/f · **b∗f**).

Overplait Row
Work the row normally until the next front layer threads are the pair lying together in front of the left fingers. Start the double interlinking at this point, i.e. these two threads are the front layer threads involved in the first two double interlinkings. Continue the double interlinkings until the pair of threads lying together behind the left fingers have been included in the last two interlinkings. Then work 1/1 interlinking to the left selvage. The overplait row can be abbreviated thus:

$$\longrightarrow\!\!-\!\!\longleftarrow (B/F) \longrightarrow\!\!-\!\!\longleftarrow (\mathbf{b/f} \cdot \mathbf{b∗f}) \longrightarrow\!\!-\!\!\longleftarrow (B/F) \longrightarrow\!\!-\!\!\longleftarrow$$

If these two rows are repeated the double sprang area will appear as a white or black block on a background of diagonal stripes. See Plate 35.

(2) Type Two, double sprang area unattached at its sides to the background
In this type, one or both vertical edges of the block are free, having no connection with the 1/1 interlinking. As usual the following description assumes the warp is as in Fig. 96.

Plait Row

$$B/2F \longrightarrow\!\!-\!\!\longleftarrow (B/F) \longrightarrow\!\!-\!\!\longleftarrow \mathbf{b/2f} \cdot b∗f \longrightarrow\!\!-\!\!\longleftarrow (\mathbf{b/f} \cdot b∗f) \longrightarrow\!\!-\!\!\longleftarrow \mathbf{2b/f} \cdot b∗f \longrightarrow\!\!-\!\!\longleftarrow (B/F) \longrightarrow\!\!-\!\!\longleftarrow 2B/F$$

Stop normal 1/1 interlinking at some point where the next front layer thread is white. Then after a special interlinking of the next two white threads, interlink the next two back layer black threads with the next front layer black thread. Carry on with normal double sprang interlinkings, finishing the area by interlinking the next back layer black thread with the next two front layer black threads. Then work normal 1/1 interlinking to the left selvage.

It will be understood that the back fabric, black, has begun and ended with the interlinkings normal to a plait row, so it will have its own two selvages. It will only be attached to the rest of the fabric at the horizontal line where it begins and where it ends, rather like a jug handle.

Overplait Row

$$\longrightarrow\!\!-\!\!\longleftarrow (B/F) \longrightarrow\!\!-\!\!\longleftarrow (b∗f \cdot \mathbf{b/f}) \longrightarrow\!\!-\!\!\longleftarrow (B/F) \longrightarrow\!\!-\!\!\longleftarrow$$

Stop the 1/1 interlinking when the next front layer threads are a white followed by a pair

of black threads. Then begin the double sprang interlinking, but starting with a back fabric interlinking. It will be obvious when the left selvage of the back fabric is reached and thereafter work 1/1 interlinking to the left selvage of the whole fabric.

(3) CONVERTING THE BACK FABRIC INTO A STRIPE

A fairly common decoration on Coptic bags involves the above method, Type Two, with an interesting variation. After several rows producing double interlinking a row is worked which brings the back fabric forward through a central slit in the front fabric, so that both fabrics lie in the same plane. This manœuvre can be understood from Fig. 103, where in the upper part, the shaded, black, threads form the back fabric of a double interlinked area and in the lower part they have come forward to form a simple warp stripe in a piece of single layer interlinking. The fabric naturally becomes wider at this point.

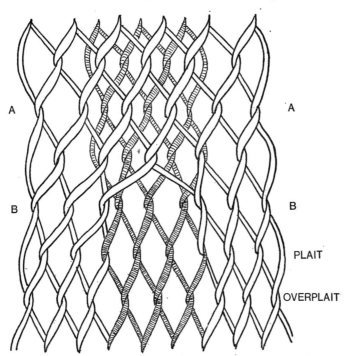

A
A

B
B

Fig. 103
Double interlinked sprang.
Back fabric coming to the
front as a stripe

PLAIT

OVERPLAIT

In the Coptic examples, the black stripe disappears again to the back after a few rows, so the effect is of an oval black spot on a white background. There are three such systems side by side which work in alternation; when the central one is showing a spot, the outer two are worked as double sprang and when the outer two are showing spots, the central one is worked as double sprang. Naturally the colours of the spots in each system can be different. Plate 36 shows a set of three systems of spots with alternated colours. Using an elastic yarn the spots form depressions and so would show well even if only one colour was being used in the warp.

The transition from double interlinking to a warp stripe is worked in a plait row. The simple way to do it is by rearranging the threads in the left hand before the row starts. If for instance the back fabric has three pairs of black threads, they lie between pairs of white threads as seen in Fig. 103 at the level marked AA.

Now move the two outer black pairs under the intervening white pairs to join the central black pair. So now the three pairs of black threads lie together; and they come forward to the front layer under an arch formed by a widely-split white pair. This is the stage shown at the level marked BB in Fig. 103. Now work the plait row normally with 1/1 interlinking all across, and notice how the black threads and white threads are all now in one plane.
Continue with rows of normal 1/1 interlinking as long as the stripe is wanted.

Return the stripe to its original position as the back fabric in a plait row. Before working this row, rearrange the black pairs so that they lie between white pairs, exactly as at the beginning of this manœuvre, and work the row appropriately to give double interlinking where required.

With practice it will be found that the rearrangement of threads, to start and to end a stripe, can be done as the plait row is being worked. In other words, threads are selected in the sequence required for the stripe, but from positions required for double sprang, and vice versa. It involves some rather awkward finger movements, especially if the stripe is wide.

(c) Joining the selvages of double interlinked sprang with a few 1/1 interlinkings

If in the above method, Type One, the side areas of 1/1 interlinking are reduced to very narrow stripes, this technique provides a simple way of joining the two interlinked fabrics at their selvages.

(1) ONE 1/1 INTERLINKING PAIR AT EACH SELVAGE

Plait Row

$$\mathbf{b/f\,f\,f} \longleftarrow (\mathrm{b}*\mathrm{f} \cdot \mathbf{b/f}) \longleftarrow \mathrm{bbb/f}$$

Start the plait row by picking up three back layer threads (two whites and one black) and dropping off one front layer thread (one white). Now start the double interlinking, but it has to begin on an interlinking of two black threads instead of the normal two white threads. After the final double interlinking of two white threads, when only four threads remain to be interlinked, pick up the remaining back layer thread (black) and drop off the three remaining front layer threads (two blacks and a white).

Overplait Row

$$\mathbf{b/f} \cdot \mathbf{b/f} \cdot \mathbf{b/f} \longleftarrow (\mathrm{b}*\mathrm{f} \cdot \mathbf{b/f}) \longleftarrow \mathrm{b/f}$$

Start with a single 1/1 interlinking, then begin the double interlinking, again making a black interlinking first. When only six threads remain to be interlinked, make three normal 1/1 interlinkings.

Repeat these two rows.

(2) Two 1/1 interlinking pairs at each selvage

Plait Row

$$\mathbf{b/f}\,f \cdot \mathbf{b/f}\,f \xrightarrow{\quad\longleftarrow\quad} (\mathbf{b/f} \cdot b*f) \xrightarrow{\quad\longleftarrow\quad} \mathbf{bb/f} \cdot \mathbf{bb/f}$$

Start with two interlinkings each of the normal 2B/F type, then begin the double interlinking with two white threads. Stop the double interlinkings when only six threads remain (four being *in* the left hand, two *behind* it) and then make two normal B/2F interlinkings.

Overplait Row

$$\mathbf{b/f} \cdot \mathbf{b/f} \xrightarrow{\quad\longleftarrow\quad} (\mathbf{b/f} \cdot b*f) \xrightarrow{\quad\longleftarrow\quad} \mathbf{b/f} \cdot \mathbf{b/f}$$

After the normal 1/1 interlinkings, start the double interlinking. When there are only four threads left, stop the double interlinking and make two normal 1/1 interlinkings.

Repeat these two rows.

In both these methods and using a warp with an (A,A,B,B) colour sequence, the colour of the back fabric will show slightly at the edges. Obviously if one selvage is worked as described above and one is worked normally, i.e. with the two fabrics left unattached, a pocket will be made with an opening towards one of the selvages.

(iii) Combining double interlinked sprang with twined patterns

It was mentioned earlier that in the Coptic bags, between the stripes of twined patterning with, say, black twining threads on a white interlinked background, there would be a stripe of plain white interlinking. At this point all the black twining threads drop through to the back and are interlinked to form the back layer of a section of double interlinked sprang. See Plates 26 and 27.

There is no great difficulty in doing this. At the end of the pattern section, the black twining threads probably lie in the final shed in irregular groups amongst the white threads, here eight, here four, here six, and so on. Before the double interlinking can begin, the threads have to be reordered in this shed, so that the sequence is two white, two black, all across the warp. The stripe of double interlinked sprang ends on an overplait row, and after that the threads are again rearranged to suit the following twined section. With practice these two rearrangings can be done while the appropriate row is being worked.

F. Design possibilities

Of the various methods of making two layered structures from thread, such as shaft weaving and tablet weaving, double interlinked sprang is the one under the most direct control of the hands. Pockets of any shape or size, closed or open along one or both edges, can be made at will; selvages can be joined or left separate; a stripe of warp can disappear on to the back of the fabric. This great flexibility, combined with the elasticity of an inter-linked structure, suggests many possibilities for three-dimensional forms, either stuffed or stretched on rods inserted when the work is finished.

G. Triple interlinked sprang

Using the principle described for double interlinked sprang, it is quite possible though slow to make triple interlinked sprang, that is, a fabric with three distinct layers which are worked simultaneously. The warp has an (A,A,B,B,C,C) colour sequence and there are two types of special interlinking, one for the front fabric in which the fingers reach over *two* intervening front layer threads to pick up the required back layer thread, and one for the middle fabric in which the fingers reach over *one* intervening front layer thread. The interlinking for the back fabric, as in double interlinking, is of the normal type. Plate 37 shows a small sample.

7 · Interlaced Sprang

INTRODUCTION

In the interlinked sprang techniques with a few exceptions, the general course of the warp threads was parallel to the selvages of the fabric. In both interlaced and intertwined sprang, the warp threads move on a diagonal course. That is, a thread moves diagonally downwards to the left until it meets the left selvage. It then changes course and moves on the opposite diagonal until it reaches the right selvage. See Plate 38.

As each thread moves diagonally, it encounters all the threads moving on the opposite diagonal and it has to interlace with them in some order, perhaps going over one, under one or over two, under two. This interlacing is exactly similar in structure to the interlacing in woven fabrics, the only difference being the angle at which the threads lie in relation to the selvage. So in the absence of selvages, it is very hard to distinguish between fragments of diagonal interlacing and of interlacing with threads parallel and at right angles to the selvage.

Diagonal interlacing is a very commonly used technique where a narrow strong fabric with some elasticity is wanted and its use for belts, straps and so on is practically universal. There is little evidence that such objects have been made by the flat warp sprang method, and indeed where sprang is the method involved it is the circular warp type that has been used. See section 5A in Chapter 11. The few definite examples of interlaced sprang made on a flat warp include the small carrying bags (mechita) from Columbia and a small Peruvian bag illustrated by d'Harcourt. Also the Mazahua Indians of Mexico made the carrying strap for a shoulder bag in this way, but inserted a weft in each shed at both ends of the warp, presumably for added strength (Johnson, 1950). It is a matter of opinion whether this wefted structure can still be classified as sprang. In addition there is a group of historical fabrics, combining rows of interlacing and interlinking, which were made on a flat warp. They are described in section A4 below.

Although a circular warp has generally been preferred for interlaced sprang, being more suitable for a long narrow fabric, all the interlacing techniques can be worked on a flat warp, as the following descriptions show.

The simplest form of diagonal interlacing is the three-strand braid; a description of this was given in Chapter 1, to explain the principle of the sprang technique; see Fig. 2.

In interlinked sprang it is found that where a stripe of Z-twist interlinking meets a stripe of S-twist interlinking, there is a row of crossed threads. All the interlaced sprang methods depend on this fact and by alternating the rows of S- and Z-twist interlinking

in various ways, the rows of crossing and interlacing threads are built up. So the actual finger movements are generally identical with those used for interlinked sprang; it is only their sequence which produces interlacing. This means that the same abbreviations can be used in this chapter as in the last.

But it will be realised that it is in fact inaccurate to write of the working, for example, of a row of S-twist interlinking, in the description of an interlacing technique, because no linking of threads whatsoever results from this row. What is meant by this (and similar descriptions in this chapter) is that the hands manipulate the threads as they would in a row of S-twist interlinking. These manœuvres would in interlinked sprang lead to the normal side-to-side movement of each thread, but here due to their context they lead to its continued diagonal movement.

The types of interlaced sprang are classified according to the manner in which the threads interlace.

1. OVER ONE, UNDER ONE INTERLACED SPRANG

In this type the threads interlace in an over one, under one sequence exactly as in a plain weave textile. See Fig. 104(a) and Plate 38.

Plait Row

$$B/2F \longleftarrow (B/F) \longleftarrow 2B/F$$

A perfectly normal Z-twist interlinked plait row.

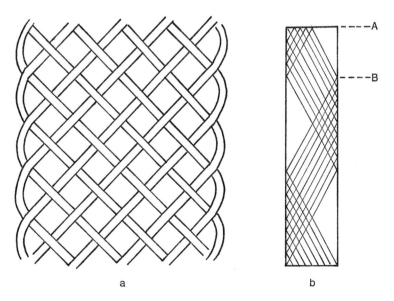

a b

Fig. 104. (a) Over one, under one interlaced sprang; (b) result when using a striped warp

Overplait Row

There are three distinct ways of working the overplait row, but they all achieve the same result.

(1) *Row of S-twist interlinking starting at the right selvage*

$$B\backslash B \longleftarrow (F\backslash B) \longleftarrow F\backslash F$$

Start with an S-twist interlinking of the first two front layer threads. Continue the row with S-twist interlinkings of the next back layer thread and next front layer thread and end with an S-twist interlinking of the last two back layer threads.

(2) *Row of S-twist interlinking starting at the left selvage*

$$B\backslash B \longrightarrow (F\backslash B) \longrightarrow F\backslash F$$

This is the first time it has been suggested that a row be worked from left to right. But if this is done, with the left and right hand exchanging their normal roles, a row of S-twist interlinking is produced.

Begin with the right hand in the shed. With the left hand, interlink the first two back layer threads in the S-direction; these are the first two at the left selvage of course. Then for the rest of the row, simply pick up the next back layer thread with the left hand and drop off the next front layer thread from the right hand. At the end of the row give an S-twist to the final two front layer threads.

(3) *Reversing the frame*

$$F/F \longleftarrow (B/F) \longleftarrow B/B$$

Reverse the frame, so that the bottom is now at the top but the front of the fabric is still to the front. Interlink the whole row normally with Z-twist, but start with the first two back layer threads and end with the last two front layer threads.

Return the frame to its original position.

However the overplait row is worked, it is followed by a plait row and another overplait row and so on. The resulting fabric is shown in Fig. 104(a).

Note—That despite the finger movements used there is no twisting or interlinking of threads.

—That this structure has little tendency to curl when off the frame unless very highly twisted yarns are used.

Any colour in the warp will appear as diagonal stripes, exactly as it does with double twist interlinking. If the left half of the warp is black and the right white, then the striping

shown in Fig. 104(b), beginning at level A, will result. If the warp is made of alternate black and white threads, then the same stripe will result but beginning at level B. As suggested by the diagram there will be triangles of solid colour at alternate selvages, where black interlaces with black and white with white, and between them there will be diamond-shaped areas where black interlaces with white.

2. OVER TWO, UNDER TWO INTERLACED SPRANG

The threads here interlace in an over two, under two sequence as in a woven 2/2 twill, but whereas in the latter the twill lines lie at 45°, in interlaced sprang, where the threads lie at 45°, they must lie either as horizontal or vertical ribs. This technique is used for the carrying bags made in Columbia on the frame shown in Fig. 9a (Cardale-Schrimpff, 1972).

A. Horizontal ribs (see Fig. 105 and Plate 39)

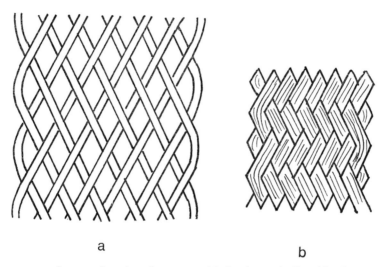

a

b

Fig. 105. Over two, under two interlaced sprang with horizontal ribs, (a) when stretched and (b) when relaxed

Row 1

F/F ———◂——— (B/F) ———◂——— B/B

On a warp with an even number of threads, work a row of Z-twist interlinking, which begins by interlinking the first two back layer threads and ends by interlinking the last two front layer threads.

If this follows a normal overplait row, it will be found that the back layer threads are being picked up under three front layer threads, but in subsequent rows it will be under two.

Row 2
Again this can be done in three ways, as follows:

(1) *Row of S-twist interlinking beginning at the right selvage*

 B\B ——⟵—— (F\B) ——⟵—— F\F

(2) *Row of S-twist interlinking beginning at the left selvage*

 B\B ——⟶—— (F\B) ——⟶—— F\F

The above two methods are both worked exactly as for over one, under one interlacing.

(3) *Reversing the frame* Reverse the frame and work exactly as for Row 1, as follows.

 F/F ——⟵—— (B/F) ——⟵—— B/B

Return the frame to its original position.

Continue thus, alternating Row 1 and Row 2.

It will be seen that this is a very simple technique. If Row 2 is worked by reversing the frame then every row is produced by exactly the same finger movements. Fig. 105 illustrates the resulting structure, (a) showing the course taken by the threads and (b) showing the appearance when closely beaten. As Fig. 105 suggests, there is some unavoidable looseness at the selvages where threads either pass over or under three threads as they change their course from one diagonal to the other.

Stripes in the warp will behave essentially as shown in Fig. 104(b), except that the diamond-shaped areas will consist of horizontal stripes of the two colours involved.

Half of the warp of the sample in Plate 39 had an (A,B,A,B) colour sequence and half a (B,A,B,A); in other words, there were two threads of the same colour lying together at the centre of the warp.

B. Vertical ribs (see Fig. 106)

The warp has to consist of a multiple of four threads, plus one extra thread, so some number like 32 + 1 = 33 would be suitable. Start by making a two up, two down shed in the warp, the first two threads at the right selvage being down, and the odd thread also being down at the left selvage, as in Fig. 106(a).

Row 1
Insert the left hand into this shed. Ignoring the first back layer thread, 1, which passes to the back of the right hand, pick up the next two back layer threads, 2 and 5, and drop off the first two front layer threads, 3 and 4. Continue thus, picking up the next two back

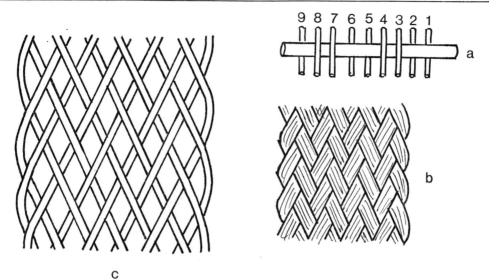

c

Fig. 106. Over two, under two interlaced sprang with vertical ribs, (a) arrangement of warp before starting, (b) fabric when relaxed, (c) fabric when stretched

layer threads (which will always consist of the left-hand thread of one pair and the right-hand thread of the next pair) and always dropping off the next two front layer threads (which will always consist of a complete pair).

At the end of this row there will be an odd back layer thread at the right selvage.

Row 2
Again this can be done in three ways, as follows:

(1) *Row of S-twist 2/2 interlinking starting at the right selvage*

———←—— (2F\2B) ——←——

These are not quite normal S-twist interlinkings and are done thus.

Put the left thumb down between the first and second pair of front layer threads. Move it and the index to the right and pick up the first two back layer threads. Carry them to the left under the first pair of front layer threads (which now fall from the left fingers), then to the right and give them to the right hand. The two front layer threads go behind the right fingers. The right fingers can assist in the first part of this manœuvre by drawing the first pair of front layer threads to the right.

Now put the thumb down between the next two pairs of front layer threads, and pick up the next two back layer threads and so on.

One back layer thread will be left over at the end of the row. Let this stay in the back layer of the newly formed shed.

(2) *Row of S-twist 2/2 interlinking starting at the left selvage* Ignoring the first back layer thread, work exactly as in Row 1, but with the hands reversing their roles.

(3) *Reversing the frame* Reverse the frame and repeat Row 1 exactly. This is the simplest way.

Repeat Rows 1 and 2.

Note—That there is a single thread lying at the right selvage after Row 1 and at the left selvage after Row 2. Thus there need never be any doubt as to the stage that has been reached.

As a sample of this technique is begun, the pairs of threads may twist and their exact order be doubtful, but once a few rows have been worked there is no difficulty. Fig. 106(c) shows the structure. It has a good strong selvage with no distortion of the over two, under two interlacing. Fig. 106(b) shows the appearance when the work is closely beaten. Again a warp stripe will appear as in Fig. 104(b), but in this case the diamond-shaped areas will have vertical stripes of the two colours involved.

3. OVER THREE, UNDER THREE INTERLACED SPRANG

A. Horizontal ribs

Row 1

$$F/F \underrightarrow{\hspace{1cm}} (B/F) \underrightarrow{\hspace{1cm}} B/B$$

On a warp with an even number of threads, work a row of normal Z-twist interlinking, starting with an interlinking of the first two back layer threads and ending with an interlinking of the last two front layer threads.

Row 2
This can be done in three different ways but only one will be described.

$$F/2F \underrightarrow{\hspace{1cm}} (B/F) \underrightarrow{\hspace{1cm}} 2B/B$$

Reverse the frame. Pick up the second and third back layer threads, the right-hand thumb and index passing behind the first back layer thread. Take them into the right hand, letting the first back layer thread drop behind the fingers. Continue the row with normal 1/1 interlinking, noticing that every back layer thread that is picked up is passing behind three front layer threads as in lattice sprang. At the end of the row, three front layer threads will remain. Pass the right thumb and index under the nearest two and pick up the last one, allowing the other two to fall behind the fingers. Before the frame is returned to its normal position, drop the extreme right-hand thread (one of a pair) to the back, and bring the

extreme left-hand thread (also one of a pair) to the front. So there is now a one up, one down shed all across the warp. With practice this can be done as the first and last inter-linkings are worked.

Repeat Row 1 and Row 2 alternately.

The structure obtained is similar to that shown in Fig. 105 except that the interlacing is over and under three threads, not two. Again the selvage is untidy, with threads passing over or under four threads. As would be expected, the fabric is heavier and thicker due to the longer floats.

B. Vertical ribs (Plate 40)

The warp must consist of a multiple of six threads, plus one extra thread, so $30 + 1 = 31$ would be suitable.

Start by making a three up, three down shed in the warp, the three threads at the right selvage being down and the odd thread at the left selvage also being down, as in the top of Fig. 107.

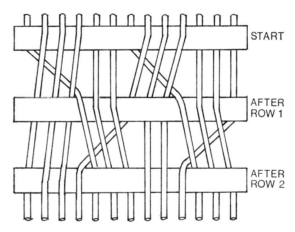

Fig. 107
Over three, under three
interlaced sprang with
vertical ribs. The starting
position and first two rows

Row 1

Insert the left hand into this shed. Ignore the extreme right-hand back layer thread, which passes behind the right fingers, and work the row by picking up the next three back layer threads and dropping off the next three front layer threads.

The three back layer threads that are picked up always consist of the two left-hand threads from one group of three and the right-hand thread from the next group to the left. The three threads dropped off are always a group of three lying together in front of the left fingers. See the centre of Fig. 107 where a rod has been left in this new shed for the sake of clarity.

Row 2
Again this can be done in three ways, as follows.

(1) *Row of S-twist 3/3 interlinking starting at the right selvage* There will be an odd back layer thread at the left selvage which is left in the back layer. This row is done exactly as the corresponding row in over two, under two interlacing, which is explained in section 2 B, Row 2, (1) above.

(2) *Row of S-twist 3/3 interlinking starting at the left selvage* Ignore the first back layer thread and then pick up three back layer threads and drop three front layer threads all across the warp, the hands reversing their normal roles.

(3) *Reversing the frame* Reverse the frame and repeat Row 1 exactly. Return frame to its original position.

Again it will be seen that in all the methods, the three threads dropped off are a group of three lying in front of the fingers, but the three back layer threads picked up always consist of two threads from one group and one thread from the next group. The bottom of Fig. 107 shows the stage now reached. The two rows are repeated.

The resulting structure is simliar to that in Fig. 106(b) and (c) except that all the floats are over or under three threads, instead of two, so the fabric is thicker and more flexible and very suitable for belts. See Plate 40.

4. COMBINING INTERLACED WITH INTERLINKED SPRANG

A. In horizontal stripes

The fabrics in this group are very practical as they have little tendency to curl when off the frame. This is because the interlacing predominates over the interlinking; in some cases there is the additional factor that the twist is reversed in successive stripes of interlinking. In addition they combine the denseness of interlacing with some of the elasticity of interlinking.

(i) INTERLINKED STRIPES ALTERNATELY IN S- AND Z-TWIST

(a) *Over two, under two interlacing with two rows of interlinking*

A woollen stocking found at York and thought to date from Viking times shows the structure seen in Fig. 108 (Henshall, 1951). Two rows of interlinking alternate with an area where threads interlace in an over two, under two sequence. This structure can be obtained in two ways, both of which start after a normal Z-twist overplait row.

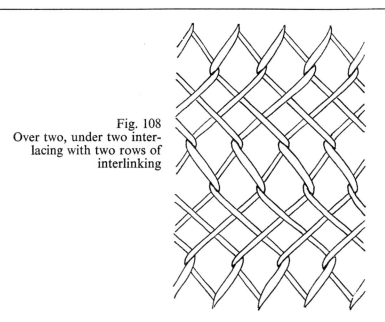

Fig. 108
Over two, under two inter-
lacing with two rows of
interlinking

FIRST METHOD

The abbreviated directions are as follows:

Row 1

B\B ——←—— (F\B) ——←—— F\F

Row 2

F\2B ——←—— (F\B) ——←—— 2F\B

Row 3

——←—— (F\B) —←——

Row 4

F/F ——←—— (B/F) ——←—— B/B

Row 5

B/2F ——←—— (B/F) ——←—— 2B/F

Row 6

——←—— (B/F) ——←——

Notice that Rows 2 and 3 are normal S-twist plait and overplait Rows, and that Rows 5 and 6 are normal Z-twist plait and overplait rows. Repeat these six rows.

SECOND METHOD
This method starts by reversing the frame, so that the first thread on the right is in the back layer, not in the front layer as is usual. Then work Rows 4, 5 and 6 as just described. Return the frame to its normal position and repeat the same three rows exactly. Continue thus, working the three rows with the frame in each position.

(b) Over two, under two interlacing with one row of interlinking

A cotton fragment from a pre-ceramic refuse mound in Asia, on the Peruvian coast, shows this construction (Engel, 1963). Again two methods can be used, both beginning after a normal overplait row.

FIRST METHOD
The abbreviated directions are as follows:

Row 1
$$B\backslash B \longleftarrow (F\backslash B) \longleftarrow F\backslash F$$

Row 2
$$F\backslash 2B \longleftarrow (F\backslash B) \longleftarrow 2F\backslash B$$

Row 3
$$F/2F \longleftarrow (B/F) \longleftarrow 2B/B$$

Row 4
$$\longleftarrow (B/F) \longleftarrow$$

Repeat these four rows.

SECOND METHOD
Reverse the frame.

Row 1
$$F/F \longleftarrow (B/F) \longleftarrow B/B$$

Row 2
$$B/2F \longleftarrow (B/F) \longleftarrow 2B/F$$

Reverse the frame again so it is now the right way up.

Row 3
$$F/2F \longleftarrow (B/F) \longleftarrow 2B/B$$

Row 4
$$\longleftarrow (B/F) \longleftarrow$$

Repeat these four rows.

(c) Over three, under two interlacing with three rows of interlinking

A woman's cap found at Skrydstrup, Denmark, and dated to the Bronze Age, shows this technique (Hald, 1950). It is unusual for a sprang fabric in that it is wider than it is long. Again the two methods start after a normal overplait row and the abbreviated instructions are as follows:

FIRST METHOD

Row 1

B\2B ———◄——— (F\B) ———◄——— 2F\F

Row 2

———◄——— (F\B) ———◄———

Row 3

F\2B ———◄——— (F\B) ———◄——— 2F\B

Row 4

———◄——— (F\B) ———◄———

Row 5

F/2F ———◄——— (B/F) ———◄——— 2B/B

Row 6

———◄——— (B/F) ———◄———

Row 7

B/2F ———◄——— (B/F) ———◄——— 2B/F

Row 8

———◄——— (B/F) ———◄———

Repeat these eight rows.

SECOND METHOD

Reverse the frame and work Rows 5, 6, 7 and 8 as above. Return the frame to its normal position and repeat the four rows exactly. Continue in this way, working the same four rows with the frame in each position.

(d) Over three, under two interlacing with one row of interlinking

A Berber woman's scarf from the last century shows this variation of the last technique (Hald, 1950). It is done by omitting Rows 3, 4, 7 and 8 in the first method or Rows 7 and 8 in the second method.

(ii) ALL INTERLINKED ROWS IN THE SAME TWIST

In this group there are always three interlacings between the interlinked rows whereas in the former group there were only two.

(a) Over two, under two, over one interlacing with one row of interlinking

This structure is found on the long head scarfs worn by bedouin women in Tripolitania (Ricard, 1925–26; Rackow, 1943). It is very simple to make and is shown in Plate 41. Beginning after an overplait row, the abbreviated instructions are as follows:

Row 1
> B/2F ——←—— (B/F) ——←—— 2B/F

Row 2
> ——←—— (B/F) ——←——

Row 3
> B\B ——←—— (F\B) ——←—— F\F

Repeat these three rows.

(b) Over two, under two, over two interlacing with one row of interlinking

A very similar structure to the last is found in woollen shawls from Tunis, which are sometimes tie-dyed when off the frame. The abbreviated instructions are as follows:

Row 1
> B/2F ——←—— (B/F) ——←—— 2B/F

Row 2
> ——←—— (B/F) ——←——

Row 3
> B\B ——←—— (F\B) ——←—— F\F

Row 4
> F/F ——←—— (B/F) ——←—— B/B

Row 5
> B/2F ——←—— (B/F) ——←—— 2B/F

Row 6
> B\2B ——←—— (F\B) ——←—— 2F\F

At the end of the last row, bring forward the extreme right-hand thread (one of a pair lying in the back layer), and drop the extreme left-hand thread (also one of a pair) to the back. This is similar to what was done in Row 2 in section 3A above.

Repeat these six rows.

(c) Over three, under three, over three interlacing with one row of interlinking

This is one of the many non-traditional structures that can be invented.

Row 1

> F/F ———←— (B/F) ———←— B/B

Row 2

> B\2B ———←— (F\B) ———←— 2F\F

Row 3

> F/F ———←— (B/F) ———←— B/B

Repeat these three rows.

This method is unusual in that the manipulations in two successive rows, 3 and 1, are identical.

In any fabric from the above group, the difference between the compactness of interlacing and the open nature of interlinking will be obvious. This is seen very clearly if the fabric is held against the light and stretched sideways. Such distortion brings the interlaced threads more nearly horizontal, but makes the interlinked areas more open.

B. In areas

(i) AREA OF OVER ONE, UNDER ONE INTERLACING ON A BACKGROUND OF 1/1 INTERLINKING

This is very simple and can be shown in abbreviated form.

Row 1
A normal plait row.

Row 2

> —←— (B/F) —←— B\B —←— (F\B) —←— F\F —←— (B/F) —←—

Begin the row as a normal overplait row. Where the interlaced area is to begin, give an

S-twist interlinking to the next two front layer threads. Continue with S-twist interlinking of a back layer and a front layer thread and end this area with an S-twist interlinking of two back layer threads. From there to the left selvage, work normal Z-twist interlinkings.

Repeat these two rows.
Plate 42 shows such an area on a warp with an (A,B,A,B) colour sequence.

(ii) AREA OF VERTICAL RIBS OF OVER TWO, UNDER TWO INTERLACING ON A BACKGROUND OF 1/1 INTERLINKING

This is a more difficult combination to work but if it is done correctly there is a perfect join between the two structures, as shown in Fig. 109.

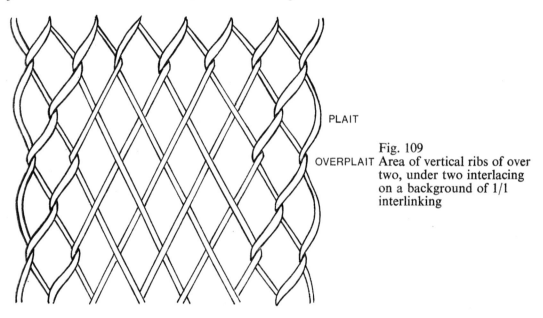

PLAIT

OVERPLAIT

Fig. 109
Area of vertical ribs of over two, under two interlacing on a background of 1/1 interlinking

Row 1. Plait Row

B/2F —◄— (B/F) —◄— 2B/F · (2B/2F) × 6 · B/2F —◄— (B/F) —◄— 2B/F

Start the row normally. Where the interlaced area is to begin, pick up one back layer thread and drop two front layer threads. Then pick up two back layer threads and drop two front layer threads, say, six times, then pick up two back layer threads and drop one front layer thread.

The remainder of the row is normal 1/1 interlinking. The result of this manœuvre is that there is a central section where the warp is two up, two down, exactly as is required for the start of over two, under two interlacing.

Row 2. Overplait Row

$$\longleftarrow (B/F) \longleftarrow B/B \cdot 2F\backslash B \cdot (2F\backslash 2B) \times 6 \cdot B/2F \longleftarrow (B/F) \longleftarrow$$

Work a normal overplait row until the next back layer thread is the right-hand of the first pair lying together behind the left fingers. Then interlink B/2F, but immediately bring the left-hand of the two new back threads to the front layer. Then make six S-twist interlinkings of the next two back layer threads with the next two front layer threads. These are of the type described in detail in section 2B, Row 2 (1) above. The interlacing will begin to appear. The final front layer pair is given a similar interlinking with the next back layer thread. Then a Z-twist interlinking of the next two back layer threads and then normal Z-twist interlinking to the left selvage.

Row 3

This is exactly similar to Row 1 but the moment to start the interlacing has to be recognised. Work the row normally until the next back layer thread to be picked up comes from the interlaced area, then interlink B/2F. It will be found that the two front layer threads dropped off come from the interlinked area, so this is the point where the two structures meet. Now work six 2B/2F interlinkings followed by a single 2B/F interlinking. In the last interlinking it will be found that the two back layer threads are coming from the inter-linked area and the front layer thread from the interlaced area, so this is the other meeting point of the two structures. Then work normal interlinking to the two selvages.

Row 4

Exactly as Row 2.

Fig. 109 shows the area of interlacing produced when the 2B/2F and 2F\2B interlinkings are each only done once, not six times as described above.

Note—That as the interlacing begins some threads have to pass over three instead of two threads.

If the warp is of one colour, there is a pleasant textural difference between the two areas. The interlaced area is looser than the surrounding interlinking, as the presence of the latter prevents the sword pushing the interlacing into its normal state of compactness.

5. DOUBLE OVER ONE, UNDER ONE INTERLACED SPRANG

Narrow belts made with two layers of diagonal interlacing and patterned by the movement of threads from one layer to the other, are found in the Far East and in Japan. But in both cases they are not produced by the sprang method, as the warp threads are only fixed at one end, and they hang free at the other end in balls or on bobbins. In fact,

double interlaced sprang does not seem to have been used in old fabrics, but as **Plate 44** and the following description show it is a feasible technique.

METHOD

Set up a warp with an (A,A,B,B) colour sequence and put the left hand in the first shed. The first two threads at the right are white and the last two at the left are black in the following description.

Row 1

$$\mathbf{b/2f} \cdot \mathrm{b}*\mathrm{2f} \longleftarrow (\mathbf{b/f} \cdot \mathrm{b}*\mathrm{f}) \longleftarrow \mathbf{2b/f} \cdot \mathrm{2b}*\mathrm{f}$$

The first row is exactly the same as Row 1 for double interlinked sprang, so no further explanation is necessary.

Row 2

Reverse the frame. The first threads at the right are now black, so in this row the sequence will be an interlinking of two black threads, then one of two white threads. The row can be abbreviated thus:

$$\mathbf{f/f} \cdot \mathbf{f/f} \longleftarrow (\mathrm{b}*\mathrm{f} \cdot \mathbf{b/f}) \longleftarrow \mathrm{b}*\mathrm{b} \cdot \mathbf{b/b}$$

Start by interlinking the first two back layer threads, which are the black pair lying together, i.e., pick up the left-hand thread under the right-hand thread. Then reaching over the first front layer thread, black, interlink in a similar way the next two back layer threads, which are the white pair. The movement to the right of the picked-up white thread will be stopped by its crossing with the black front layer thread above the left fingers. As in other special interlinkings (see section 5B in Chapter 6), pick up this black thread with the left thumb and index above the crossing, allowing it to slide off the left fingers below the crossing. The picked-up white thread is then free to move into the right hand, and the other white thread of the pair is free to lie behind the right fingers.

Then work a normal interlinking of the next two black threads, followed by a special interlinking of the next two white threads, i.e. the latter interlinking, shown by an asterisk, is in front of any intervening black threads. These two interlinkings are repeated across the warp, until only six threads remain. Then in the final b*f interlinking, the white back layer thread has to be picked up in front of a pair of black threads. Then work a simple interlinking of these last two black threads, which are in the front layer and of the last two white threads which are also in the front layer.

Row 3

Reverse the frame and work exactly as Row 1.

Row 4

Reverse the frame and work exactly as Row 2.

The second and fourth rows can be worked in either of the two other methods given in section 1 above, but the above method is simpler as it uses finger movements already learnt for double interlinked sprang.

Patterns are made exactly as in the latter technique, by interlinking black threads in front of white in some areas, instead of white in front of black. So omitting the first and last interlinkings which remain unchanged, the two rows can be abbreviated thus:

Row 1

$$\longleftarrow (\mathbf{b/f} \cdot \mathrm{b}*\mathrm{f}) \longleftarrow (\mathbf{b}*\mathbf{f} \cdot \mathrm{b/f}) \longleftarrow (\mathbf{b/f} \cdot \mathrm{b}*\mathrm{f}) \longleftarrow$$

Row 2

$$\longleftarrow (\mathrm{b}*\mathrm{f} \cdot \mathbf{b/f}) \longleftarrow (\mathrm{b/f} \cdot \mathbf{b}*\mathbf{f}) \longleftarrow (\mathrm{b}*\mathrm{f} \cdot \mathbf{b/f}) \longleftarrow$$

The pair of interlinkings in the centre of each row represents the area where the back colour will show on the front. If the back colour is brought to the front for only one row, then dropped to the back again, it will appear as a zigzag line. See bottom of Plate 44.

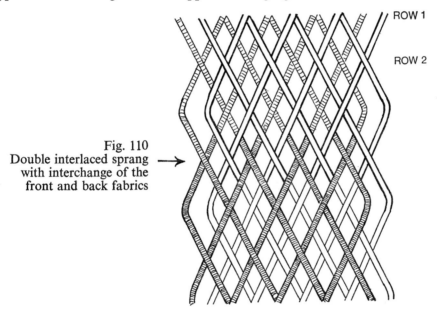

ROW 1

ROW 2

Fig. 110
Double interlaced sprang
with interchange of the
front and back fabrics →

Fig. 110 shows the structure diagrammatically. In the upper half, above the arrow, the white interlaced fabric is in front of the black fabric, but in the lower half the black is in front of the white. The similarity in structure to double cloth plain weave is obvious. Naturally in the actual fabric the back layer is completely hidden by the front layer, so the upper half would appear solid white and the lower half solid black.

8 · Intertwined Sprang

INTRODUCTION

Historically, intertwining is the least used of the thread structures produced by the sprang method; in fact it is only recorded from Peru (Harcourt, 1935). See Plate 43. But it has a great deal to offer in the field of purely decorative sprang fabrics, as Plates 53–56 show. The Guajiro Indians in Columbia use it today for hammock making (Cardale-Schrimpff, 1972).

Twining means the twisting about each other of two or more threads, so that another thread, or threads, is enclosed. In weft-twining, two threads move in the weft direction, turning around each other and enclosing a warp thread in each twisting movement. So the two twining wefts lie like a 2-ply thread pierced by the warp threads, see Fig. 111(a). In tablet or card weaving, it is the warp threads, often in groups of four, which twine and enclose the weft threads. So in both these cases one set of elements, the twining threads, is active and the other set is passive.

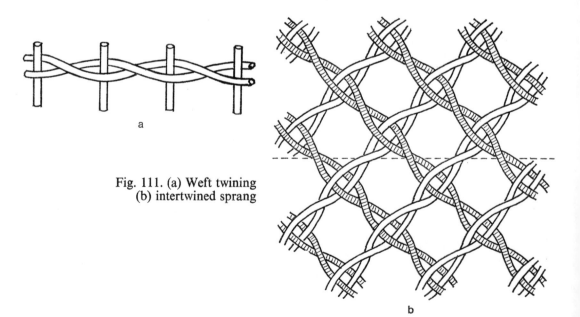

a

Fig. 111. (a) Weft twining
(b) intertwined sprang

b

But in the intertwined structure described in this section, there is no division into active and passive sets. The threads move in pairs diagonally and every pair is active, see Fig. 111(b) and top of Plate 45. Whenever a pair moving on one diagonal meets a pair moving on the other diagonal, the threads pass through each other as shown. So at this point there are four thicknesses of thread, one above the other. The two pairs of threads can pass through each other in two ways. Either the topmost thread can belong to the pair coming from the left, as in the top half of Fig. 111(b) above the dotted line, which is called a left-over-right crossing; or the topmost thread can belong to the pair coming from the right, as in the lower half of Fig. 111(b) which is called a right-over-left crossing.

The pairs of threads can pass through each other in other ways but the way illustrated gives great stability to the very open structure. As a result, an intertwined fabric has much less tendency to pull in at the edges when on the frame and to curl up when off the frame than does an interlinked fabric made from the same yarn. It will be remembered that this is also the way that the extra twining threads crossed each other, see Fig. 85 in Chapter 6.

As with interlinking and interlacing, intertwining is a structure that can be either made on threads fixed at both ends, i.e. by the sprang method, or on threads only fixed at one end. However, some of the more advanced variations would be very difficult to work by a non-sprang method. Some of the Peruvian examples are done in the sprang method, some not (Harcourt, 1935; O'Neale and Kroeber, 1930). A hair-net found in a woman's grave at Skrydstrup, Denmark, and dating from 1500 B.C. has an intertwined structure (Broholm and Hald, 1939, 1940). As it crumbled away soon after excavation, there is now no way of telling how it was made. However the material used, horse's tail or mane hair, would have been in limited lengths and this argues against sprang.

1. BASIC METHOD

A. Left-over-right crossing

This is the type of crossing seen in the top of Fig. 111(b). The number of warp threads should be divisible by four.

Row 1

Insert the left hand into the usual shed at the top of the warp. In Fig. 112 a stick is shown in this shed, not a hand. The second pair of threads, 3 and 4, have to pass through the first pair, 1 and 2, in the manner shown by the two arrows in Fig. 112 and then each pair has to be given a twist. The finger movements are as follows:

Put the right thumb and index between threads 1 and 2, pick up thread 4 and draw it to the right. Then with the tip of the left thumb, push thread 3 over thread 1 to the right. The threads have now passed through each other and it remains to give a twist to each pair. With the back of the right index push thread 3 to the back, so thread 4 is now in front of the right index and thread 3 behind it. As the right index returns to the front,

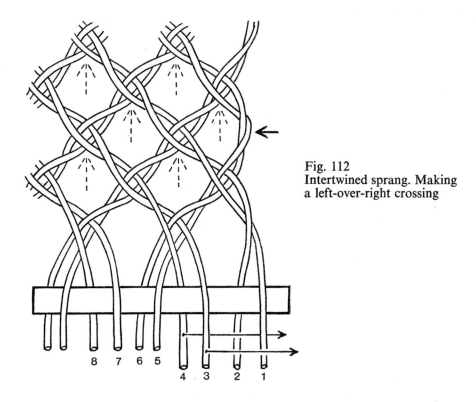

Fig. 112
Intertwined sprang. Making
a left-over-right crossing

pick up thread 2 on it. The left hand can assist in this movement by bringing thread 2 to the front. Finally drop thread 1 from the left hand and let it lie behind the right fingers. Threads 4 and 2 should now lie in front of the right fingers and threads 3 and 1 behind them.

Repeat the manœuvre, which with practice can be done quickly, with every two pairs of threads. So work it next on threads 5–8, see Fig. 112.

Row 2

The second row is similar to the first, except that to make the diamond-shaped mesh each crossing of two thread pairs is situated halfway between two crossings in the previous row and receives its threads from these two crossings. So the row has to start differently, to achieve this lateral shift.

Begin by twisting the first two threads, i.e. pick up the first back layer thread and drop off the first front layer thread, as at the start of an overplait row in interlinked sprang. These two threads are not involved with any other threads in this row and they make a loop at the right selvage, like the one shown by a heavy arrow in Fig. 112. With the next four threads 3–6, work the manœuvre described in Row 1 and repeat this with every succeeding

four threads. At the end of the row, there will be two threads left over. Twist these in the same way as the first two threads so that they form a similar loop at the left selvage.

Repeat these two rows.

Note—That the intertwined structure results from applying two distinct types of movement to each successive group of four threads:
(1) *the passing-through or crossing movement*
 whereby the left-hand pair of threads comes to lie on the right, and vice versa. This is worked first and is followed by
(2) *the twisting movement*
 whereby each pair is given a twist. It is similar to the basic interlinking movement because a back layer thread is brought to the front and a front layer thread dropped or pushed to the back.
—That beating is difficult as both these thread movements have to be pushed to the other end of the warp at the same time. It can be made easier either by beating only a section of the width at a time and gradually moving across the warp, or by putting a pointed stick in the diamond-shaped openings and forcing the crossing points in the right direction, see dotted line arrows in Fig. 112.

The surface of an intertwined fabric made with left-over-right crossings has marked surface ridges running diagonally down to the right, see Plate 45. This is true of both sides of the fabric, though of course it is the other twining pairs which form the ridges on the back. Naturally in the lower fabric, at the bottom of the frame, the ridges will run on the opposite diagonal and the pairs of threads will twist round each other in the opposite direction.

B. Right-over-left crossing

This type, seen in the lower half of Fig. 111(b), only differs in the way the pairs of threads pass through each other. It can be understood by referring to Fig. 113, which shows the same four threads as in Fig. 112.

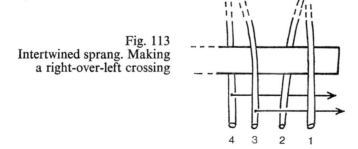

Fig. 113
Intertwined sprang. Making
a right-over-left crossing

Pick up thread 4 under both thread 1 and thread 2. Push thread 3 between thread 1 and thread 2. Then twist threads 3 and 4 and threads 1 and 2 as done for the left-over-right crossing.

The manœuvre is a little less easy than the one for a left-over-right crossing, so the latter is generally used as the normal basic type. Using right-over-left crossings, the ridges will run diagonally down to the left.

Note—That with either type of crossing, this is a far more stable fabric than an interlinked or an interlaced one. As each pair of threads moves through the fabric, it both grips and is gripped by each pair that crosses its diagonal course. So once an intertwined fabric is made and well beaten, there can be hardly any sliding of one thread relative to another, the sort of movement that easily happens when a finger is pushed through an interlinked or interlaced fabric. Distorting the fabric by stretching only alters the angle at which pairs of threads cross each other.

2. COMBINING BOTH TYPES OF CROSSING

As each successive group of four threads is worked along a row, the choice is open to use either a left-over-right or a right-over-left crossing.

A. On a warp of one colour

Subtle designs can be made with areas of the two types of crossing, which will only differ from each other in the direction taken by the surface ridges. See Plate 46.

B. On a warp of two colours

Imagine a warp of two colours, the right half being white, the left black. As the work proceeds the colours will begin to move on diagonals exactly as in interlaced sprang, see Fig. 114. But the visual results will be different. If left-over-right crossings are being used, then it is the threads moving diagonally down to the right which will show strongly as solid lines, and the threads moving on the opposite diagonal which will only appear as a background.

So the central diamond, C in Fig. 114, will show black diagonal lines on a white background. The next diamond, D, will show white diagonal lines on a black background. The triangles, A and B, will be solid black and white respectively, as here the threads moving on both diagonals are of the same colour. It will be understood, therefore, that threads moving diagonally down to the right show on the face of the fabric; the solid lines in Fig. 114 show this for the black threads. When each pair meets the right selvage, it changes course on to the opposite diagonal and shows on the back of the fabric until

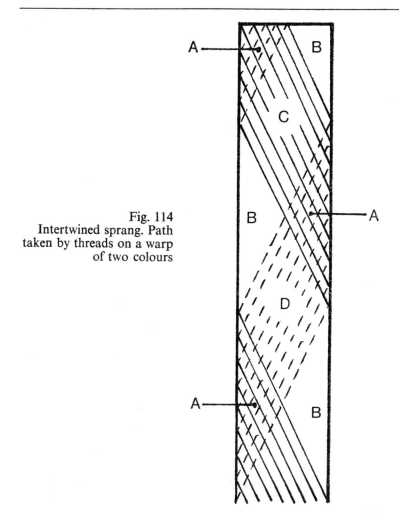

Fig. 114
Intertwined sprang. Path
taken by threads on a warp
of two colours

it reaches the left selvage; the dotted lines in Fig. 114 show this. At the left selvage it changes course again and the process repeats itself. The heavy arrow at the right of Fig. 112 shows a pair of threads changing course at the right selvage.

Now if at any point in diamond C, the crossings are changed to right-over-left, the white threads will immediately come on to the front surface and appear as an area of white diagonal lines running down to the left, see top of Plate 47. A similar manœuvre in diamond D will produce areas of black diagonal lines. In Plate 47, the crossings were changed to make the three small white triangles in the upper half of the diamond. At the midpoint of the diamond, one row was repeated twice as described in the next section, so that the lower half of the diamond shows white lines instead of black, and on this background three black triangles were made.

So this technique gives the opportunity for any sort of two-colour design, but of course it can only be within an area of the warp where black and white pairs of threads are crossing each other, as in diamond C or D in Fig. 114.

3. REPEATING ONE ROW TWICE OR SEVERAL TIMES

As described in the basic method, the two pairs of threads that are crossed change row by row. This causes the diagonal movement of the pairs and the diamond-shaped spaces they enclose. But if two successive rows are started in exactly the same way, then in the second row the same two pairs are crossed as in the first row. The effect of this is seen in Fig. 115, where the two rows are arrowed. The diagonal movement of the pairs ceases and a type of interlaced braid begins to appear. These vertical braids would grow longer, as would the slits between them, if the same row was repeated several times. So this is a way of making large and extremely stable holes in the intertwined structure.

Note—That these braids are structurally different from those dividing long holes in inter-linked sprang and also from both flat and square four-strand braids.

If the row is worked twice, or any even number of times, there is an interesting effect on a two colour warp. As Fig. 115 shows, the surface changes from black diagonals moving

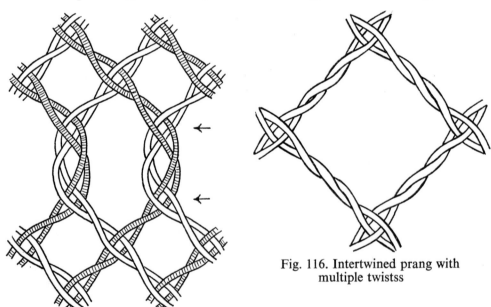

Fig. 116. Intertwined prang with
multiple twistss

Fig. 115
Intertwined sprang. Vertical braids pro-
duced by starting two rows in the same way

down to the right (top of the diagram) into white diagonals also moving down to the right (bottom of the diagram). So this is a way of changing the colour of the diagonals without changing their direction, but it has to be worked all across the warp. See the mid-point of the diamond in Plate 47. If long braids are made by repeating a row several times, the two colours will spiral round each other. See Plate 48. To avoid an odd pair of threads at each selvage, it is better if the row which is repeated is Row 1 as described above. This variation is found in the hammocks made by the Guajiro Indians in Columbia, combined with rows of weft-twining to hold the braids in position.

4. MULTIPLE TWISTS

A far more open fabric can be made if, after two pairs of threads have passed through each other, they are each given more than a single twist. Fig. 116 shows the result when the pairs are each given three twists. A type used in Peru is shown in more diagrammatic form in Fig. 117. It is not clear from descriptions whether this technique was worked in the sprang method or not. Starting from the top it is worked thus:

Fig. 117. Intertwined sprang with multiple twists. Diagrammatic representation of a Peruvian fabric

Row 1
A normal Row 1 as described in the basic method.

Row 2
Twist the first pair (three intertwinings, twist the next two pairs). Repeat the directions in brackets as often as necessary.

Row 3

Twist the first two pairs (two intertwinings, twist the next four pairs). Repeat the bracketed directions.

Row 4

Twist the first three pairs (one intertwining, twist the next two pairs). Repeat the bracketed directions. This row ends the two triangles and begins the central diamond.

Row 5

Twist the first six pairs (two intertwinings, twist the next four pairs). Repeat the bracketed directions.

Row 6

Twist the first pair, one intertwining (twist the next two pairs, three intertwinings). Repeat the bracketed directions.

Row 7

Normal intertwinings all across the warp.

Now reverse the sequence, working Rows 6, 5, 4 back to Row 1, then again reverse and so on.

Note—The special way the right selvage is worked to avoid overlong floats. The above description includes the working of this selvage but not of the similar structure at the left selvage.

5. CROSSING MORE THAN TWO PAIRS OF THREADS

A heavier structure in which the threads lie at a flatter angle and enclose smaller holes can be made by letting two pairs of threads pass through two pairs, as shown in the top of Fig. 118 and in the lower part of Plate 45. It is worked thus:

Draw thread 6 to the right over threads 4 and 2 and under threads 3 and 1, see top arrow. Push thread 5 to the right in front of threads 3 and 1, see bottom arrow. Twist threads 5 and 6. Repeat this manœuvre exactly with threads 7 and 8. Then twist threads 1 and 2, and threads 3 and 4.

The unit of threads that pass through each other could be increased to three pairs or four pairs, but the larger the number of pairs, the less stable the structure becomes and the more the selvages tend to pull in. Different types of crossing can naturally be combined in the same fabric.

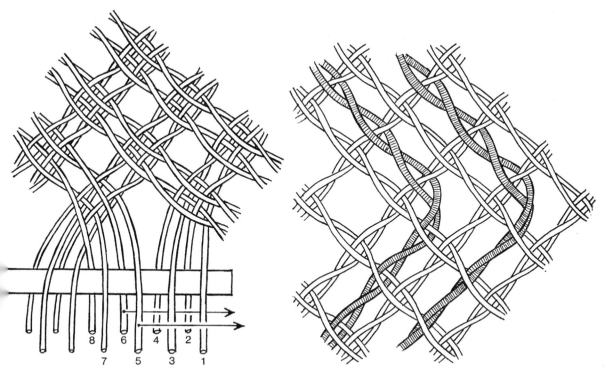

Fig. 118. Intertwined sprang. Using two pairs of threads as the unit when crossing

Fig. 119. Extra threads twining on an intertwined sprang background

A belt from the woman's grave (about 1500 B.C.) at Bredhoj, Denmark, which is too delicate to allow analysis looks as if it has the structure in Fig. 118, but it seems unlikely that it was made by the sprang method (Broholm and Hald, 1940).

6. EXTRA TWINING PAIRS OF THREADS

As with interlinked sprang, pairs of extra threads can twine through the basic structure, see the shaded threads in Fig. 119, but here there are more possibilities. The extra threads can either show on the front of the fabric only, as the left-hand pair in the upper half of Fig. 119, or show on the back only, as the left-hand pair in the lower half of Fig. 119. In addition, they can either show equally on both sides, as the right-hand pair in the upper half of Fig. 119, or show hardly at all on either side, as the right-hand pair in the lower half of Fig. 119. The four possibilities depend on the way the twining threads cross the basic threads.

Note—That Fig. 119 is inaccurate in that the left-hand twining pair will not lie centrally between the two background pairs flanking it as is shown. It will move towards

the left-hand pair when moving down to the right, and towards the right-hand pair when moving on the other diagonal.

A. Extra twining threads showing on the front only

Intertwine normally until the extra twining threads are the next pair coming down from the left. This point is shown in Fig. 120(a). Then draw thread 4 to the right between threads 2 and 1 and push thread 3 over thread 1, then twist threads 4 and 3 in the usual way. Repeat this exactly for threads 5 and 6. Then twist threads 1 and 2.

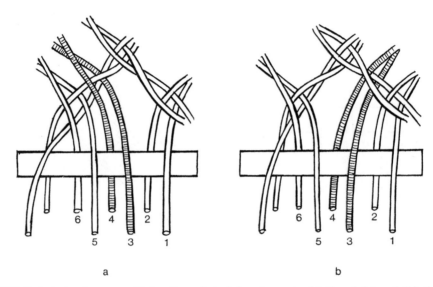

Fig. 120. Intertwined sprang. Extra threads twining down to (a) the right and (b) the left

So all that has really happened is that two pairs of threads coming from the left have passed through one pair coming from the right.

B. Extra twining threads showing equally on both sides

Referring to Fig. 120(a) draw thread 4 to the right behind thread 2 and push thread 3 over thread 1, then twist threads 3 and 4. Now deal with threads 1 and 3 and threads 5 and 6 as in a normal crossing.

C. Extra twining threads showing on the back only

Here one pair of threads coming from the left has to pass through two pairs coming from the right.

Intertwine normally until the point shown in Fig. 120(b) is reached. Draw thread 6 over threads 4 and 2 and under threads 3 and 1, push thread 5 over threads 3 and 1, then twist threads 5 and 6. Twist threads 1 and 2, and threads 3 and 4 normally.

D. Extra twining threads hidden from both sides

Referring to Fig. 120(b), draw thread 6 to the right under thread 4 and between threads 2 and 1; push thread 5 over thread 3 and thread 1, then twist threads 5 and 6. Twist threads 1 and 2 and threads 3 and 4 normally.

Obviously each of these types can be made to move on the opposite diagonal to that described.

Such twining pairs can be spaced across the warp at intervals or can occur in every available space. In the latter case the warp will have a sequence of four background threads, two twining threads all across its width.

The sample in Plate 49, showing three chevrons, used methods A and C above.

7. USING S- AND Z-TWIST

As threads are being twisted around each other throughout intertwined sprang, the fabric tends to curl when the warp tension is released and it is taken from the frame. The amount of curling will depend on the twist and springiness of the yarn used, but it is in any case much less than if the same yarn was interlinked. If an intertwined fabric is to hang freely, this effect must be countered by combining S-twist with Z-twist in the making. This can be done in two ways.

A. Reversing twist in the centre of the warp

The obvious way would seem to be the use of Z-twist to the right of the midline and S-twist to the left, as was described for interlinked sprang. This change of twist would apply to the threads running on both diagonals. But there is a point of weakness when the twist of a pair of twining threads is suddenly reversed. A solution is suggested in Fig. 121, which represents the midline of a fabric. To the right the twists of all threads are in the Z direction, to the left in the S direction. Where the twist changes, one of each pair moves on its normal diagonal (shaded threads) and one of each pair turns through 90° (spotted threads). This only occurs on alternate rows, as the midline runs between two crossings on the other rows. When the spot is reached, the four threads concerned will lie as shown at the bottom of Fig. 121, i.e. with the two central ones, numbers 2 and 3, behind the left fingers.

Twist these two back layer threads with Z-twist, then twist the two front layer threads, numbers 1 and 4, with S-twist and carry on to the left selvage with S-twist.

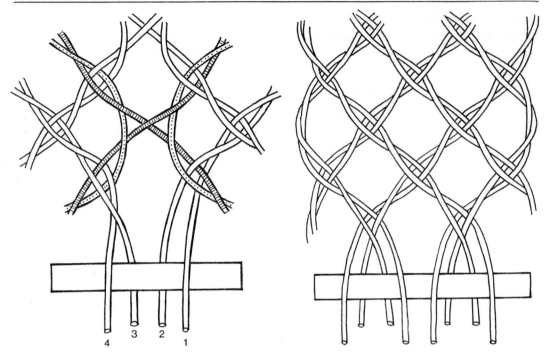

Fig. 121. Intertwined sprang. Reversing the direction of twist

Fig. 122. Intertwined sprang. Using S-twist on one diagonal and Z-twist on the other

In the next row, the Z-twisted pair will cross normally with the Z-twisted pair to its right, and the S-twisted pair will cross normally with the S-twisted pair to its left.

B. Using Z-twist on one diagonal, S-twist on the other

The principle of this idea is seen in Fig. 122, where the pairs moving diagonally down to the right are in Z-twist, and those on the opposite diagonal are in S-twist. The change of twist occurs at the selvages where each pair in turn changes its diagonal course, and this is the only place where some distortion of the surface may occur. One disadvantage is suggested at the bottom of the diagram. As every pair twists in the opposite direction to its neighbour, the threads lie over the left fingers in a two up, two down sequence, instead of the normal one up, one down sequence. The two in front, and more especially the two behind, can twist over each other so care has to be taken to select the correct threads.

8. COMBINING INTERTWINING WITH OTHER STRUCTURES

Intertwining combines well with the other structures used for sprang and below are given the directions for working a diamond of intertwining on a background of interlinking. See Fig. 124 and Plate 50.

Row 1. Plait Row

B/2F —◄— (B/F) —◄— 2B/F · x · B/2F —◄— (B/F) —◄— 2B/F

Start a normal plait row of interlinking. Near the centre of the warp, interlink B/2F as if the left selvage had been reached. Then with the next four threads (two front, and two back) work a normal left-over-right intertwined crossing. A cross has been used as the abbreviation for this manœuvre. Then interlink 2B/F and work normally to the left selvage.

Row 2. Overplait Row

—◄— (B/F) —◄— x · x —◄— (B/F) —◄—

Interlink normally until one of the pair of threads lying together in the back layer has just been included in the last interlinking. Then work two normal intertwinings. The second one includes one of the pair of threads lying together in the front layer. Then interlink normally to the left selvage. This is the stage shown in Fig. 123.

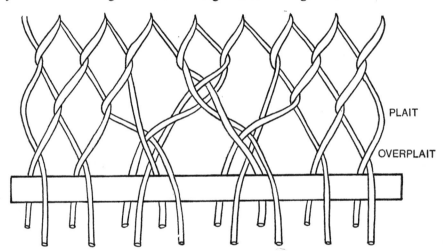

PLAIT

OVERPLAIT

Fig. 123. Triangle of intertwined on a background of interlinked sprang. Position after Row 2

Row 3. Plait Row

B/2F —◄— (B/F) —◄— 2B/F · x · x · x · B/2F —◄— (B/F) —◄— 2B/F

Interlink normally until there are five threads (three being *in* the left hand, two *behind* it) between the last interlinking and the most right-hand intertwining pair. This is the moment to interlink B/2F, work three intertwinings, and so on.

Row 4. Overplait Row
Exactly as Row 2, but here there are four intertwinings.

The principle will now be obvious and subsequent rows need not be described. As will be seen from Fig. 124 the natural diagonal on which the threads lie is slightly different for interlinking and for intertwining, the former being steeper. This is part of the reason why there are rather large holes, marked with crosses in Fig. 124, where the two structures meet.

To make the diamond decrease in size, new rules have to be learnt.

Stop the above manœuvres after an overplait row.

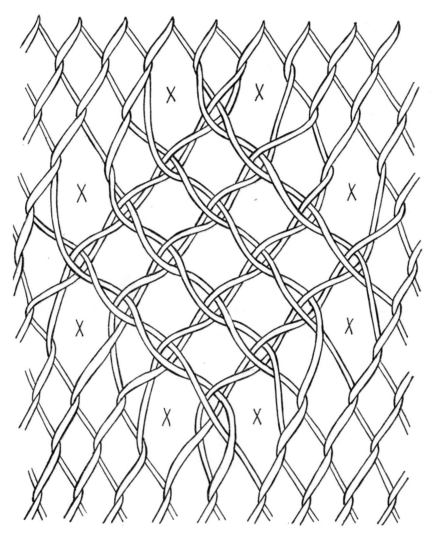

Fig. 124. Diamond of intertwined on a background of interlinked sprang

Plait Row

Interlink normally until only one thread remains in the left hand between the intertwined area and the last interlinking. Then work as in the plait rows described above, i.e. B/2F, followed by the correct number of intertwinings (i.e. one less than in the previous row), then 2B/F, and normal interlinking to the left selvage.

Overplait Row

Interlink normally until the next front layer and back layer thread both come from the intertwined area. DO NOTHING to these two threads. Make the correct number of intertwinings, then DO NOTHING to the following two threads, then interlink normally to left selvage.

Note—That the reason for this rather unusual procedure is found in the fact that intertwining consists of two movements, the crossing of the two pairs of threads and then the twisting of each pair. At each edge of the diamond of intertwining, two threads change from one structure to the other in every row. As the shape increases in size, these two threads receive a twist in one row as they are interlinked and then in the next row they are intertwined, that is, they cross another pair and then are twisted. So the sequence is twisting, crossing, twisting. But as the shape decreases, the two threads are intertwined in one row, that is crossed and then twisted, and in the next row receive another twist as they are interlinked. The sequence is therefore crossing, twisting, twisting. It is to avoid this double twisting, which would make the large holes still larger, that these two threads receive no twist in each overplait row.

The plait and overplait rows are repeated with a smaller number of intertwinings each time. The diamond will end as it began in a plait row. In the next overplait row there will be two adjacent pairs of threads below the point of the diamond, to which nothing is done. In the next row everything is normal.

A similar structure is seen in the cap shown in Plate 51, which was made on a striped warp. In Plate 52 diagonal stripes of intertwining, only eight threads wide, move through an otherwise interlinked fabric.

9. DOUBLE INTERTWINED SPRANG

Double intertwined sprang can be worked, but as the unit manipulated consists of four threads it is more difficult than double interlinked or double interlaced sprang where the unit is only two threads. But exactly the same principle is used.

The warp has an (A,A,A,A,B,B,B,B) colour sequence. A left-over-right crossing is made with colour A threads, in front of the intervening threads of colour B. Then a similar crossing is made with colour B threads, behind any intervening threads of colour A.

This sequence is repeated across the warp in every row. Patterns are made by bringing colour B crossings to the front, and dropping colour A crossings to the back, in the normal way. The back colour will always show through the open mesh of the front colour, and vice versa, so areas of solid colour are not possible. See Plate 56.

The Peruvian examples use a variant of intertwining which is difficult to analyse. They were very advanced technically and often included areas of interlacing at the beginning and end of the fabric and of interlinking between vertical colour boundaries. See Plate 43. Examples exist in which two double intertwined sprang fabrics were worked one in front of the other. At various levels, the threads of the two double fabrics changed places completely. So what was, say, a red and black fabric with, say, a green and blue fabric behind it, became a green and blue fabric with a red and black fabric behind it. These are probably the most complex sprang fabrics ever produced.

9 · Shaping a Sprang Fabric

The typical product of the flat warp sprang process, as of the weaving process, is a rectangle of fabric. But, unlike a woven textile, this fabric has a structure unsuitable for cutting into pieces which are meant to be stitched together into some desired shape. So where a non-rectangular sprang fabric is wanted, the shaping has either to be an integral part of its making or has to result from some process, other than cutting, carried out after the fabric has been made. Most of the methods to be described have been used in the past for garments, but the principles involved could equally well be applied to purely decorative sprang fabrics.

1. SHAPING A SPRANG FABRIC AS IT IS MADE

A. By adding extra warp threads to increase its width

(i) ADDING SIDE PANELS OF WARP

The method of adding extra sections of warp after the main section of warp has been worked for some distance has been described in section 1F(i) in Chapter 4. See Fig. 16 in Chapter 4 and Figs. 138 and 139 in Chapter 10. It is used wherever a *sudden* increase in width is wanted.

(ii) INTERSPERSING NEW THREADS AMONG THE ORIGINAL THREADS

This method was described in section 1F(ii) of Chapter 4 and is used where a more gradual increase in width is wanted. See Fig. 17. By adding progressively more threads in this way, it is possible to increase the fabric's width to such an extent that when off the frame both upper and lower fabrics can be made into a circular shape. See photographs of de Miranda's work in Reesema, n.d.

B. By altering the thread structure

The many structures used for sprang fabrics have different degrees of elasticity and so can be used to effect the width of the fabric.

(i) VARYING THE NUMBER OF HOLES USED IN THE DESIGN

Any fixed number of threads make a more stretchable fabric if worked in a hole design

(see section 2B(iii)(a) in Chapter 6) than if worked in simple 1/1 interlinking. So if more holes are gradually introduced into the design, e.g. by working triangular areas of holes on a background of 1/1 interlinking, the fabric will become increasingly stretchable. Reducing the number of holes naturally reduces the stretchability. This principle has been used for shaping dresses, gloves and so on. Note that this is more a variation of stretchability, i.e. potential width, than of actual width.

(ii) INTERLINKING WITH MORE OR LESS THREADS AS A UNIT

If the normal 1/1 interlinking is succeeded by rows of 2/2 interlinking, then by rows of 4/4, and even by rows of 8/8 interlinking, the fabric will obviously narrow. The classic example of this technique is the tapering of the Coptic caps, which were worked so that they practically came to a point. The technique can be used more gradually than described if, for instance, triangular areas of 2/2 interlinking slowly encroach on a 1/1 interlinked background. See section 2B(ii) in Chapter 6. Again the process can be used in reverse to increase width, but this is difficult.

In intertwined sprang, the width can be varied by altering the number of pairs of threads used in each crossing.

(iii) CHANGING FROM DOUBLE TO SINGLE SPRANG, AND VICE VERSA

If the threads forming the two layers of a double sprang fabric are combined to form one layer, the fabric will double in width. Naturally this increase in the fabric's width is accompanied by a decrease in its thickness. The process can be made less sudden by incorporating the back layer threads into the front layer in a more gradual manner. Again the process can be reversed to reduce the width of a fabric.

To change from double to single interlinked sprang *without* increasing the width, the threads in the latter must be worked in 2/2 interlinking. This method was used for the last few rows before the meeting line in those Coptic bags which involved double interlinked sprang.

(iv) CHANGING FROM INTERLINKING TO EXTRA TWINING, AND VICE VERSA

In Chapter 6, section 3A(iii), several methods were described whereby threads could change from the role of extra twining threads to that of normal interlinking threads, and back again. See Figs. 89 and 90. Extra twining threads occupy space in the interlinked structure holding the meshwork open wherever they are used, so their presence increases the width of the fabric. When they are changed into interlinking threads this effect is lost, but they then increase the total number of interlinking threads and thus the stretchability of the fabric.

(v) CHANGING FROM INTERLINKING OR INTERTWINING TO INTERLACING, AND VICE VERSA

Interlacing is the least elastic of the three structures used in sprang fabrics, so changing gradually or suddenly to this structure from either interlinking or intertwining will increase the width of a fabric.

C. By laying in wefts

(i) YARN

Yarn laid in a few successive sprang sheds while the fabric is being worked can later be tightened, exerting a drawstring effect. In this way the fabric can be narrowed where desired without any change in the thread structure. The method is often used at both ends of a belt or sash made on a circular warp.

The recorded use of a weft in *every* shed of an interlaced sprang carrying strap has been mentioned in the introduction to Chapter 7.

(ii) STIFF RODS

Rods can be introduced during or after working to push out the selvages, see Fig. 136(b) in Chapter 10. These can also be in the form of rings, holding open a tubular structure.

D. By stuffing a hollow fabric

A hollow fabric, either made as double sprang or as described in section 1E in Chapter 6, can be stuffed to make a three-dimensional object. If several separate compartments are being made, each has to be stuffed before it is sealed off by a change in the design.

E. By beating the upper and lower fabric unequally

This is hardly a shaping of the fabric but it is a departure from the normal in that the meeting line is deliberately placed off-centre, either for functional reasons as in the Coptic turbans (see section 1, Introduction, in Chapter 10) or for visual reasons in a purely decorative fabric.

2. SHAPING A SPRANG FABRIC AFTER IT IS MADE

The many traditional ways of converting a sprang fabric into a shaped object, usually a garment, are described in Chapter 10. They rely on sewing together two edges of a fabric, gathering the end loops of warp with a drawstring, and on other procedures.

10 · Methods of Finishing

The two sprang fabrics grow from the top and bottom end of the warp towards its centre. What is to be done at this point depends largely on the intended use of the fabric. Either the work can continue right to the centre, where some form of fastening is essential, in which case *one fabric* is made; or the work stops short of the centre and the unworked threads are cut, in which case *two fabrics*, identical but mirror-imaged, are made.

1. MAKING ONE FABRIC

INTRODUCTION

In all the earliest finds of sprang in Denmark, Peru and Egypt, the fabric was finished in this way. See Fig. 125(a), where the meeting line is shown by two dotted lines. When off the frame, it was usually shaped to make a head or neck covering or a carrying bag, according to one of the following methods.

The simplest method was to fold the fabric along the meeting line and sew the two selvages together, as in Fig. 125(b). In the case of a bag, a heavy drawstring was threaded

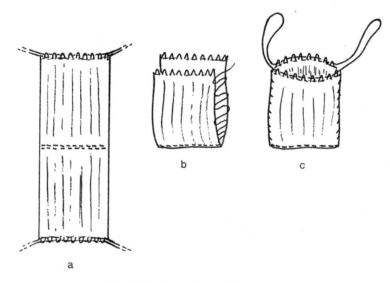

Fig. 125. Stages in making a bag

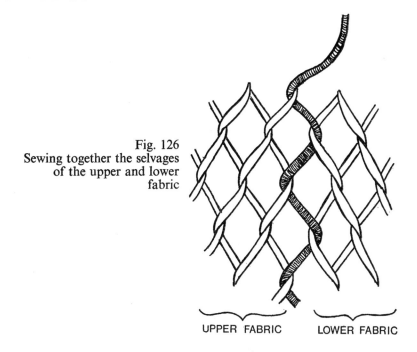

Fig. 126
Sewing together the selvages
of the upper and lower
fabric

UPPER FABRIC LOWER FABRIC

through the end loops of warp, as in Fig. 125(c); in the case of caps a finer yarn was used. A slightly different way was used in Peru, when after folding along the meeting line, only one selvage was sewn but the loops from both ends of the warp were joined to each other. A neck covering was produced but with the warp running across it, instead of down it.

Fig. 126 shows how two selvages are sewn together, the seaming thread, shaded, becoming an almost indistinguishable part of the interlinked structure.

The Danish Bronze Age finds show two further ways of converting the flat rectangle of fabric into a head covering. The Borum Eshöj hair-net had a cord passed through both sets of end loops of the warp, see Fig. 127(a). One cord, A, was pulled tight and knotted. The other, B, was left loose and, together with two cords, C, threaded through the selvages, provided a method of fastening. It is uncertain how this net was worn. In the other method, found in the Skrydstrup cap, both the cords through the warp end loops were tightened so that a semi-spherical head covering was formed, see Fig. 127(b).

Apart from bags and caps, the Coptic finds have brought to light a few women's turbans, which used the possibilities of sprang in an ingenious way (Collins, 1922; Scott, 1939; Reesema, n.d.). The twists were pushed to the two ends of the warp in such a way that the meeting line was very much off-centre, see Fig. 128(a). So there was a short upper part with a close mesh and a long lower part with a more open mesh. The latter was divided into two by cutting an end loop of warp at the centre (arrowed in Fig. 128(a)), and pulling out the two warp threads as far as the meeting line, where they were tied together. This was really the reverse of a sewing operation and, due to the nature of interlinking, there

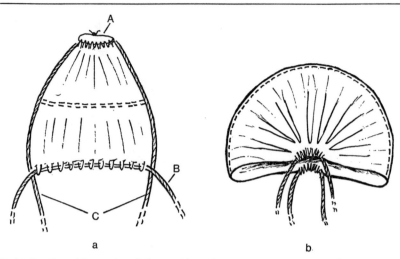

Fig. 127. Methods of making a head-dress, (a) as in the Borum Eshöj hair-net and (b) as in the Skrydstrup cap

was a perfect selvage left on either side of the resulting slit (marked by a wavy line in Fig. 128(a)). Three drawstrings were threaded into the three sets of end loops and pulled tight when the fabric was removed from the frame. The upper part formed the crown of the turban, and the divided lower part formed two tails which could be wound round the head and tucked in as desired, see Fig. 128(b).

The idea of folding the finished piece along the meeting line can be applied to larger garments, such as the basic upper garment shown in Fig. 128(c). A vertical slit is left in the fabric to become the neck opening and the meeting line is fastened on either side of it. The sewing together of the selvages only goes part of the way to leave armholes. Many variations, with or without added sleeves, can be developed from this simple idea.

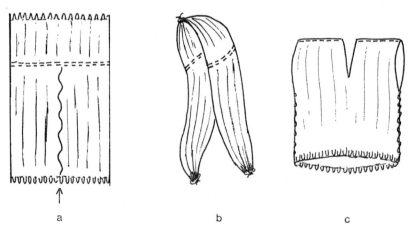

Fig. 128. (a) and (b) Making a turban, (c) basic upper garment

The single piece of sprang fabric can naturally be used unfolded as a flat rectangle, which is the form it generally takes in a wall hanging.

METHODS OF FASTENING THE MEETING LINE

At the meeting line the work can be fastened in a number of ways which are now described.

A. Chaining or Interlooping

The most frequently used method of fastening is chaining. Though not the simplest to do, it has the advantage of being stretchable so it does not interfere with the general elastic nature of the surrounding fabric.

The last few rows of interlinking are worked with the help of knitting needles or by diagonal interlinking (as described in section 8 of Chapter 5), a rod being left in the final shed, as shown in Fig. 129. The chaining is done with a crochet hook or with the type of

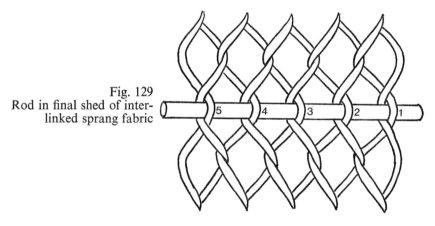

Fig. 129
Rod in final shed of inter-
linked sprang fabric

latchet hook used in the making of hooked rugs, and the work goes from right to left. There are two ways of chaining, either dealing with the two layers of the warp separately or dealing with them together.

(i) CHAINING THE TWO LAYERS OF WARP SEPARATELY

The front layer threads have been numbered in Fig. 129, where they pass in front of the rod, and these are the threads which are chained first.

Insert the hook under thread 1, slide it to the left where it picks up thread 2. Withdraw the hook, pulling a loop of thread 2 under thread 1. Then pick up thread 3 and pull a loop of it through the loop of thread 2, and so on in the manner of crocheting, until all

the front layer threads have been chained, see Fig. 130. Secure the final loop by tying it to the fabric as shown in the figure (See Plate 57).

Note—The rod is left in place during the chaining. In Fig. 130, it is shown greatly enlarged to help clarify the diagram.
 —The chaining is made easier if the warp tension is slackened.

Now turn the fabric over and do exactly the same to the back layer, again chaining from right to left and securing the final loop. Then slide out the rod which now lies in a tunnel between the two rows of chaining. (In the Coptic bags, a heavy braided cord was put in this tunnel and its two ends tied together.)

In order to shape a fabric, the interlinking can be worked with progressively more threads as the centre of the warp grows near. It can change from 1/1 to 2/2, to 4/4, to 8/8 interlinking. This means that the chaining has to be done with groups of threads, not single threads. So perhaps a group of four front layer threads might be picked up and drawn under another group of four threads. Apart from this, the method is exactly as described above.

 This method is a necessity where a closely set warp has been used. If single threads are used the line of chaining will prove to be much longer than the fabric is wide, so either the latter is stretched at this point or the former becomes buckled. The effect can only be overcome by using groups of threads for the chaining.

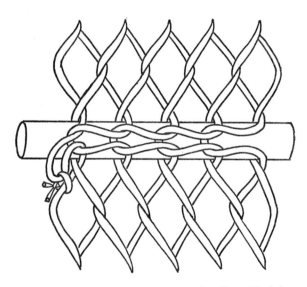

Fig. 130. Securing the meeting line. Chaining the front layer of the warp

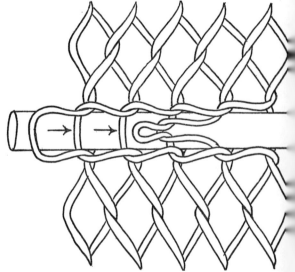

Fig. 131. Securing the meeting line. Two rows of chaining

VARIATIONS

(a) Continuous chaining

When the chaining of the front layer threads is finished, the last loop is left on the hook instead of being tied to the fabric. The fabric is then turned over and, using this final loop as the starting loop, the back layer threads are chained. The final loop of this chaining is tied as before. In this method, the chaining is a continuous circle, not two separate rows.

(b) More than one row of chaining

If the interlinking has not been worked right up to the meeting line, the chaining will be loose, with vertical threads (arrowed in Fig. 131) showing between the upper and lower ridge of the chaining. There is therefore room for a second row of chaining and the right half of Fig. 131 shows this beginning. For clarity in this diagram, the back layer threads have been hidden by a greatly enlarged rod, but these will also bear the same two rows of chaining. Both Danish and Coptic finds exhibit this double row of chaining (Hald, 1950). See Plate 58.

Naturally more than two rows can be worked. The chaining gives a thick raised ridge and there might be occasions when a wide ridge would be useful, for instance, to make a strengthened bottom for a bag. Variations (a) and (b) can be combined.

(c) Only chaining one of the two layers of threads

If only one layer, say the front layer, of threads is chained, the meeting line will still be securely fastened. The only drawback is that the unchained threads of the back layer will tend to hang loosely at this point. But the unwanted slack will be absorbed into the fabric if it is stretched and relaxed in use. Such a fastening is found on the Borum Eshöj hair-net (Hald, 1950).

(d) Two-through-one chaining

In normal chaining a single loop is pulled through a single loop, but in this variation it is always two loops which are pulled through one loop. See Plate 59.

Again numbering the threads as in Fig. 129, insert the hook under thread 1, pick up threads 2 and 3, and pull loops of them under thread 1 to the front. Threads 2 and 3 now lie on the hook. Now pick up thread 4 and draw threads 3 and 4 under thread 2, which drops off the hook. Threads 3 and 4 are now on the hook. Pick up thread 5 and draw threads 4 and 5 under thread 3, which drops off the hook. Continue thus, always picking up one new thread and drawing it, plus the left-hand of the pair already on the hook, under the right-hand of the pair, which then drops to the back.

Note—It may be necessary to use the fingers to help the one thread that is to slide off the hook pass over the two that are to stay on it.

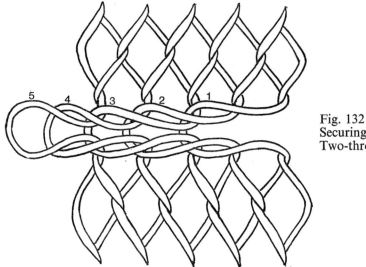

Fig. 132
Securing the meeting line.
Two-through-one chaining

Fig. 132, which again omits the back layer threads for clarity, shows the resulting chaining which is seen to be more complex and thick than the type first described. As the loops of thread travel further in a horizontal direction in this type, the warp tension must be lessened more than before to allow the work to go easily. Chaining of this type, and only done on the front layer threads, was used on the hair-net found at Haraldskar, Denmark (Hald, 1950).

The above principle can be extended to make a three-through-one or four-through-one chaining, which will be correspondingly thicker and take up more thread.

(e) Twisting the loops

A very neat tight edge is made if each loop is twisted, see Plate 60. The construction is identical with the twisted and chained ridge described in section 4B of Chapter 6 and shown in Fig. 95.

To put a half twist in a loop, pick a thread up with the hook from its *far* side and then pull it through the previous loop normally. To put a full twist in a loop, pick a thread up normally, but when it has been pulled through the previous loop, swing the hook through a full circle. The warp must be very slack to allow this method to be used.

(ii) CHAINING BOTH LAYERS OF WARP TOGETHER

If both layers are chained together, the rod lying in the final shed has to be gradually withdrawn, releasing pairs of threads for the hook to pick up.

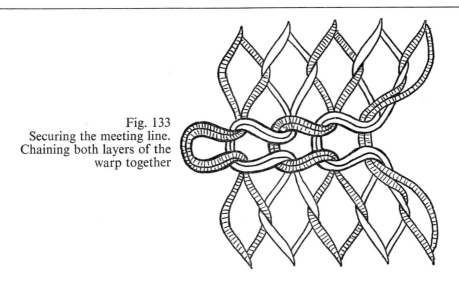

Fig. 133
Securing the meeting line.
Chaining both layers of the
warp together

Insert the hook under the first pair of threads at the right, one of which is a back layer, one a front layer thread. Slide the rod to the left to release the next pair of threads. Pick up this second pair on the hook and pull them under the loops of the first pair. Again slide the rod to the left and with the hook pick up the next pair of threads thus released, and pull it through the loops of the second pair. Continue thus, always drawing two new threads (a back and a front layer thread) through the two already on the hook. Fasten the final double loop at the left.

This type of chaining is seen in Fig. 133, where some indication is given on the right that it begins less tidily than the types where the two layers are chained separately. A thick ridge is produced but only on the front of the fabric. The head covering found at Arden, Denmark, shows this type of chaining (Hald, 1950). See Plate 8.

(iii) CHAINING WITH A STRIPED WARP

If the warp is made with an (A,B,A,B) colour sequence, in the final shed all colour A threads may lie in front of the rod and all colour B threads behind it. Then if the two layers of the warp are chained separately, the ridge on the front will be entirely of colour A and that on the back entirely of colour B.

If the warp is made with an (A,A,B,B) colour sequence, it can be arranged in the final shed that the first two threads (one over, one under the rod) are colour A and the next two are colour B and so on. Chaining both layers together will then show alternate loops of the two colours. See the shaded and unshaded loops in Fig. 133 and also Plate 8.

These are just two possible ways of relating the warp colours to the type of chaining.

B. Putting threads in the final sheds

(i) PUTTING A THREAD OR THREADS IN THE FINAL SPRANG SHED

The simplest way of fastening the meeting line is to introduce a thread into the last shed and then to take out the rod. The thread can be secured at both ends by tying it to the fabric. Alternatively, if some form of bag is to be made, the ends of the thread are left hanging out of the shed at both sides. They are then used for sewing up the selvages, as in Fig. 125(b), at the top of which they are secured by tying to the fabric. If several threads are laid in together, they can be split into two groups, one passed round each side of the selvage thread and then the two groups knotted to each other. See Plates 9 and 61.

(ii) PUTTING THREE THREADS IN THE FINAL SPRANG SHEDS

Two threads or cords are put into the penultimate shed. One is pushed up and one pushed down to allow space for the last row of interlinking to be worked between them. A third thread is put into this final shed and all three are either knotted together or whipped, as in Fig. 134 and Plate 10. See section 5A in Chapter 11 for the use of this method in ring slings.

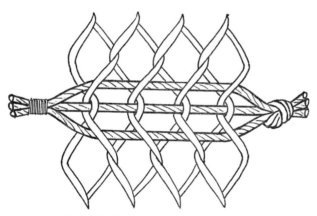

Fig. 134. Securing the meeting line. Putting three threads in the final sprang sheds

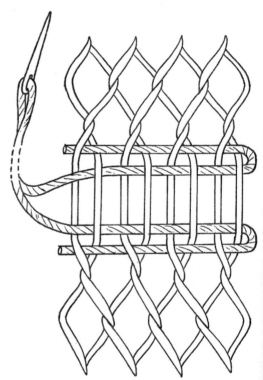

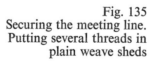

Fig. 135
Securing the meeting line.
Putting several threads in
plain weave sheds

(iii) PUTTING SEVERAL THREADS IN PLAIN WEAVE SHEDS

In this method as many plain weave picks as possible are inserted between the two sprang fabrics.

Thread a needle with a doubled length of thread. Pass it through the final shed, from left to right in Fig. 135, and remove the rod. Separate the two threads, pushing one up and one down. This leaves enough space between them for the needle to return to the left, moving through the warp in the opposite plain weave shed. Again separate the two threads, pushing one up and one down. Fig. 135 shows the stage now reached. Continue thus, leaving two plain weave picks, an upper and a lower, for every passage of the needle. Finally when there is practically no more space, cut the thread so that the needle carries a single strand into the last shed. There are now four ends to be secured.

Such a band of closely packed plain weave, interposed between the two elastic interlinked fabrics, will have no elasticity of its own, so the method can only be used where this does not matter or where it is in fact a desirable feature, as at the bottom of a carrying bag.

C. Putting a stiff element in the final shed

To put a wooden or metal rod or some other stiff element in the final sprang shed is a simple and efficient way of fastening the meeting line but it immediately limits the use of the fabric. In fact this method is only used for purely decorative sprang fabrics, such as wall hangings. As described in section 5 of this chapter, a sprang hanging is often mounted under slight tension within a rigid frame. The rod in the final shed can then stretch from one side of the frame to the other, and can actually be joined to the frame. (See Plates 6 and 53–56.)

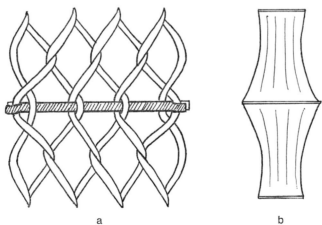

a b

Fig. 136. Securing the meeting line. (a) Putting a rod in the final shed, (b) using a long rod to stretch the fabric

A piece of sprang fabric hung freely with just a supporting stick at the top and maybe a tensioning stick at the bottom, can have the final shed secured by a rod. It will overcome the tendency of the fabric to curl at this point, where the two areas of opposite twist meet.

A neat and permanent way of fixing such a rod is by means of two threads added to either selvage of the finished fabric, as shown in Fig. 37 and described in section 9 of Chapter 5. As these threads reach the meeting line at each side, pass them through a hole drilled at the end of the rod and then carry on attaching them to the selvage. Alternatively a rod with similar holes can be just tied to the selvage threads with two extra lengths of thread. Another way is to notch each end of the rod so that the selvage thread can slot in, see Fig. 136(a).

These methods offer the opportunity of stretching the fabric at this point by using a long rod as shown in Fig. 136(b). Such a rod can either be made of a transparent material like polystyrene and so be practically invisible, or be made of a suitable opaque material which will become part of the finished design. Additional rods can be inserted into the actual fabric to stretch it at points other than the centre, thus making use of sprang's elasticity to achieve a non-rectangular form.

In a hanging mounted in a frame, there is no need for the work to continue until the two fabrics meet. A central area of vertical unworked threads can be left and so become

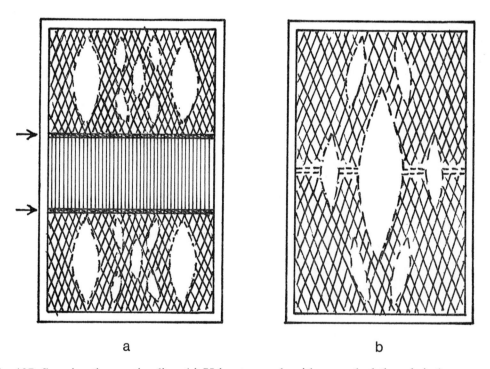

a b

Fig. 137. Securing the meeting line. (a) Using two rods with unworked threads in between, (b) discontinuous fastening to allow holes to cross the meeting line

part of the design. But some form of fastening is still necessary to stop the twisted threads encroaching on this area. Two rods, both in the final shed, will suffice; see arrows in Fig. 137(a).

D. Discontinuous fastening

The design may require one or more openings in the fabric to cross the meeting line, as in Fig. 137(b). In this case whatever type of fastening is used, it must be worked in sections, each of which is treated as a unit and secured at its end.

2. MAKING TWO FABRICS

The method of stopping the work short of the centre of the warp, cutting the unworked threads and thus ending up with two separate fabrics, would seem to be a later development. The earliest known piece is from Tegle, Norway, and is dated about 2000 years later than the Borum Eshöj and Skrydstrup finds in Denmark (Dedekam, 1925; Hoffmann and Traetteberg, 1959). The fact that the Tegle find is a woollen stocking suggests that the method may have been first adopted because it so neatly produced the two identical fabrics, essential for making stockings, sleeves, gloves, garters and so on.

Much nearer our own time, the method has been extensively used for making borders which were sewn on to the edges of table cloths, alter cloths, pillows, towels and the like. They were usually patterned with holes, and the work stopped a good way from the centre of the warp so that the cut threads gave a long fringe, which could be knotted decoratively. Some of the early twentieth-century textbooks only describe this one particular use of sprang.

Another traditional use of the method is in the making of women's caps, not because caps are wanted in pairs, but because this is the only way to arrive at a piece of interlinked fabric of the correct shape (Schinnerer, 1895; Hald, 1950; Treiber-Netoliczka, 1970). A

Fig. 138 (a) and (b). Two stages in making a shaped cap

warp was set up and worked as explained in section 1F(i) of Chapter 4, see Fig. 16(b) and
Plate 1. But in this case, the work stopped well short of the centre with a few rows of
some form of interlinking which would make the fabric pull in. Cutting the intervening
threads produced two pieces, shaped as in Fig. 138(a). The selvage, A, was sewn to the
end loops of warp, B, on both sides and the cut warp threads were secured. The cap was
worn with the two seams to the back, see Fig. 138(b).

The method is especially suited for gloves or mittens because, if the fabric has a definite
right and wrong side, the mirror-image relationship of the two fabrics automatically gives
a right- and a left-hand glove. To make a pair of mittens, a long section of warp had a
shorter section added on one side only, at the stage shown in Fig. 139(a). From there on,
the new width of warp was worked with two longitudinal slits at the positions marked by
dotted lines. When cut off, there was one fabric shaped as in Fig. 139(b), and another its
mirror-image. The fabric was folded over in half, as in Fig. 139(c), and sewn up as shown,
to give one opening for the thumb and another large opening for the fingers. The extra
flap of fabric lay behind the fingers and was shaped into a curve by a drawstring in the end
loops of the warp, see Fig. 139(d). The cut warp ends were knotted.

Similar mittens made of silk and with the finger holes edged with ribbon, to cover the
end loops of warp, were produced in large quantities. In Sweden, five finger gloves were
also made on the same principle. Examples in silk dating from about 1700 show intricate
hole designs (Collins, 1922; Grastøl, 1932).

The upper and lower fabrics need not be used for making two separate objects as just
described, but they can be joined together in some way to make a single object. In this

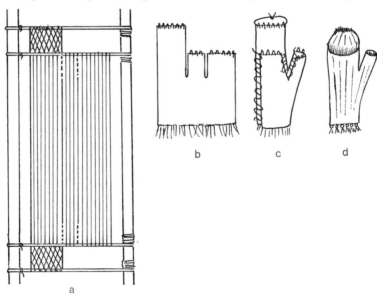

Fig. 139. Making mittens. (a) The warp, (b) the shaped fabric, (c) sewing and (d) the finished
mitten

way a two-piece version of the basic garment already described can be made, and with a better shaped neck opening. A central slit is worked when the sprang begins, so the finished fabrics look as in Fig. 140(a). When the unworked threads are cut, the two fabrics are superimposed and the selvages sewn up to the arm holes. The central slit on the back of the garment is also sewn up. The warp loops of both front and back fabrics are sewn together along the shoulder line, but leaving a central opening, see Fig. 140(b). This type of horizontal neck opening is found on the shirt from Tonto Monument (Kent, 1957). The cut threads at the lower edge of the garment are knotted or secured in some way.

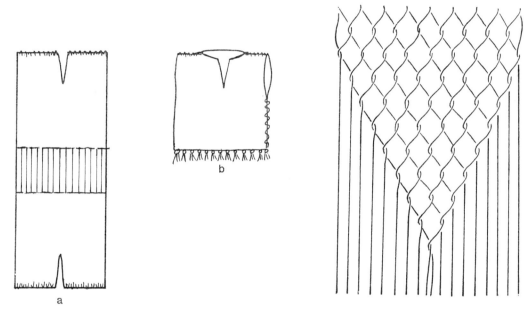

Fig. 140. Making an upper garment. (a) The two fabrics as made, (b) when sewn together

Fig. 141. Interlinked fabric ending in a point

There is of course no need for the boundary line between worked and unworked threads to be horizontal, i.e. the work need not stop after a complete selvage-to-selvage row. But, using the diagonals natural to the various structures, the fabric can end with a point or series of points, as suggested in Fig. 141.

From the foregoing, it can be seen that the two-piece method of finishing sprang has been deliberately chosen in preference to the one-piece method for one of the following reasons:

—where two separate but identical fabrics were wanted,
—where a fringe was wanted,
—where an asymmetrical shape, not obtainable by the one-piece method, was wanted.

However it is used, the method has one obvious practical advantage in that the sprang stops before lack of space makes the work difficult or diagonal interlinking has to be used.

So a fourth reason for its choice is ease of working as long as the resulting fringes are not an unwanted feature.

Some form of fastening is necessary at the line where the interlinking stops and the unworked threads begin, in order to prevent the former running down into the latter. These methods of fastening are now described.

A. Methods of securing the fabric immediately after the final sprang row

(i) KNOTTING

The simplest method is to knot the threads in groups.

Cut several unworked threads halfway between the two fabrics, while still on the frame. Make one overhand knot against the upper fabric and one against the lower fabric, see the right side of Fig. 142(a). Continue thus, until all the threads are cut and knotted.

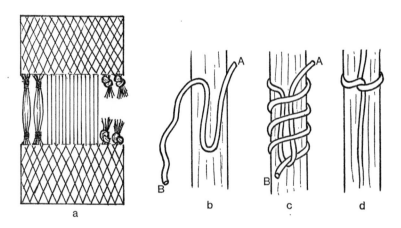

Fig. 142. (a) Finishing the two fabrics with knotting and whipping, (b) and (c) stages in whipping with an extra thread, (d) knotting with one of the warp threads

It is difficult to make the knots in a straight line, as there is nothing to act as a guide, like the last picks of weft in a woven fabric. If the fabric is made from a heavy yarn, the knots will tend to be too bulky.

To make a bag with a fringe at the bottom, the two knotted pieces are superimposed and sewn together. Alternatively, the work can be taken from the frame (uncut and unknotted), and the upper and lower fabrics superimposed. Threads from the *two* fabrics are then knotted together, thus sealing the bottom of the bag, which needs no sewing. The fringe will be in the form of loops unless these are subsequently cut.

(ii) WHIPPING

To avoid the bulkiness of knots, the threads can be whipped or bound in groups. This is done all the way across, close to both the fabrics, see the left side of Fig. 142(a).

A piece of thread, as used in the warp, is needed for each whipping. Make a loop in one end, A, and lay it on a bunch of warp threads, as in Fig. 142(b). Wrap the other end, B, tightly round the threads plus the loop, each successive turn going below the one before. When sufficient turns have been made, tuck the end B into the still protruding loop, as in Fig. 142(c), where for clarity the wrapping has been well spaced out. Then pull on the end A, drawing a loop of B under the wrapped threads. Cut the ends A and B.

Only when all the thread groups have been whipped, are the intervening threads cut at the centre.

A simpler way is to take one warp thread, wrap it round a bunch of neighbouring threads and make the knot shown in Fig. 142(d). The knot can be repeated several times as in Plate 36.

(iii) PLYING AND PLAITING

Obviously the warp threads can be cut at the centre and then treated as the fringe of a rug. So any of the warp-protectors, such as plying, plaiting, can be used. See *The Techniques of Rug Weaving*, Chapter 14.

(iv) WEFT TWINING AND WEFT CHAINING

If the warp is of a heavy yarn and is close set, one or two rows of weft twining (using a yarn similar to the warp) makes a satisfactory finish. This is comparable to the finishing of a warpface rug. A row of weft chaining, pushed tightly against the fell of both upper and lower half fabrics, was used on Moravian head-dresses (Markova, 1957).

B. Methods of modifying the edges of the fabrics before they are secured

(i) CHAINING

This frequently used method gives a raised horizontal ridge of controllable width between the sprang fabric and the unworked threads. The ridge only shows on the front of the fabric.

Put the left hand into the last shed as if the sprang was to continue normally. Take out the beater and the safety cord. On the back of the right thumb pick up the first two threads at the right, threads 1 and 2 in Fig. 143, a back layer and a front layer thread. Between the

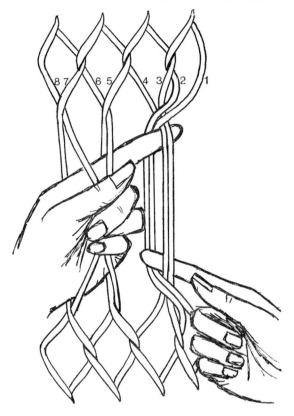

Fig. 143
Chaining the edges of the
two fabrics

right thumb and index pick up the next two threads, 3 and 4, again a back and a front layer thread. Pull them to the right, letting the first two threads slip off the back of the thumb. The crossing thus made is pushed up with the left index and down with the right index, as shown in Fig. 143. Move both hands at the same time and force the crossing close to the edges of the two fabrics.

As the right hand rises to carry on chaining, slip the right thumb in beside the index, so they both lie under the two front threads, 3 and 4. Now with the right thumb and index pick up the next two threads, 5 and 6, and pull them to the right, dropping threads 3 and 4 off the back of the thumb. Again push this crossing up and down. Continue thus all the way across and fasten the final crossing by tying it, top and bottom, to the fabrics.

Note—It is always difficult to keep the ridges horizontal and stop them converging as the work proceeds to the left, but slackening the warp tension helps.
　　—This differs from the chaining described in section 1A of this chapter, both in method (fingers are used, not a hook) and in the visible result (two distinct ridges), but it is structurally identical.

As many rows as wanted can be chained, each time using the same pairs of threads. Secure the final row by knotting, whipping or plying the warp threads as already described. See Plate 15 which shows three rows of chaining.

It will be discovered that the ridge produced by chaining takes up more space than the preceding fabric, if the latter is in a technique which gives very closely set threads. In other words the ridge will be longer than the fabric is wide. As a result the ridge buckles and cannot lie flat, unless the fabric is stretched out sideways. To overcome this, use more than two threads as the unit in chaining. The ridge will then be shorter but of course correspondingly thicker.

(ii) PUTTING THREADS IN THE FINAL SPRANG SHEDS

This is a way of making the edge of the sprang fabric more firm and heavy. It provides a more solid foundation against which to tie knots or plait or ply the warp.

When the fabric is nearly finished, lay a thread in the last shed with a long end hanging out at both sides. Push this upwards, and lay another thread in the same shed and push it downwards. Work the next row and bring both ends of the thread across in the new shed, one from left to right, and the other from right to left, so two threads lie in this second shed, as in Fig. 144(a). Continue thus for as many rows as required, always doing exactly the same in both upper and lower fabrics. Cut the threads after the final row and then knot the warp.

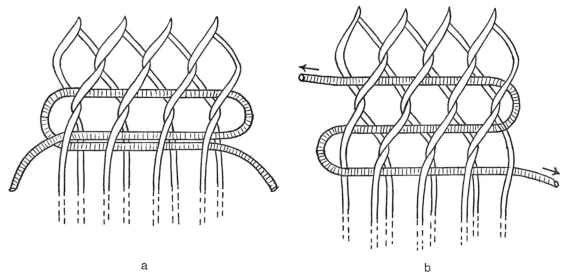

a b

Fig. 144. (a) Putting threads in the final sprang sheds of both fabrics, (b) putting the thread in final sprang sheds of both fabrics to narrow them

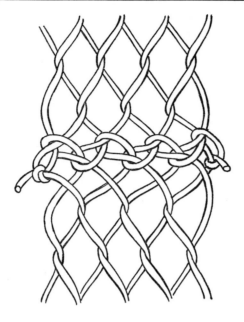

Fig. 145
Joining two half fabrics
into one

Sometimes it is desirable to narrow the fabric just before the fringe begins. So in the last three sheds, in both upper and lower fabric, lay a single continuous thread, as in Fig. 144(b). Pulling on the two ends of this thread exerts a drawstring action, see arrows. The same idea can be used many times across the width of the warp, gathering small groups of threads for making tassels.

(iii) PUTTING THREADS IN PLAIN WEAVE SHEDS

This method is described in connection with belt making in Guatemala (O'Neale, 1945). Before the sprang begins, a section of plain weave (labelled A in Fig. 146(a)) is woven at both ends of the warp, using a shed stick and leashes in the centre of the warp. The woven section begins some inches from each end to allow for a fringe. The leashes and stick are removed, and the warp between the two plain weave bands is worked in some sprang technique. Some distance from the centre, the stick and leashes are reintroduced and two more bands of a plain weave are woven, labelled B in Fig. 146(a). Two fringed belts are the result when the central unworked threads are cut; see the arrows in Fig. 146(a). The warp threads are knotted against the edges of the plain weave bands.

C. Method of securing the fabric which gives no fringes

The only historical example of this very elaborate method is the woollen stocking from Tegle, Norway (Hoffmann and Traetteberg, 1959).

As mentioned earlier, this stocking is only a tube of fabric, with no foot. Two narrow warps are set up stretching across the sprang frame at the same level as the final row of each fabric, as in Fig. 146(b). The warps have tablets (cards) threaded on them as shown or there could be some other type of shedding device.

The first two threads at the right are cut and the two cut ends put into the first shed of their respective warps. The tablets are then turned to give the next shed and the cut threads are carried back through this second shed. The next two warp threads are cut and are also put into the same shed. The tablets are again turned and the work continued. So in every shed, there are two pairs of threads entering from opposite sides. The threads can be trimmed short where they emerge from their second shed.

As described in section 5 of Chapter 4, the warp of the Tegle stocking was stretched between two tablet-woven bands, so each stocking had a tablet-woven border at both ends.

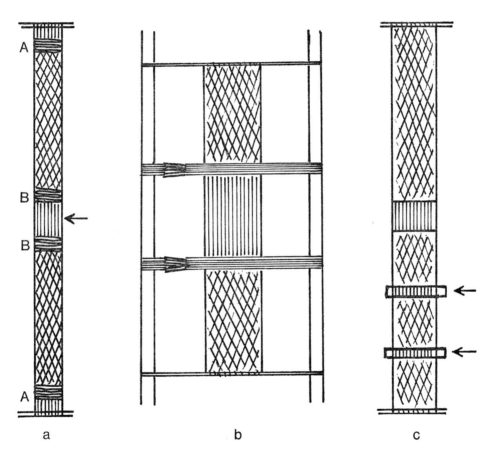

Fig. 146. (a) Making two sprang fabrics with woven ends, (b) finishing both fabrics with tablet-woven borders, (c) making several fabrics on one warp.

D. Making more than two fabrics

It is quite possible to make more than two fabrics from one warp, as shown in Fig. 146(c). One or more strips of wood or card, arrowed, are inserted into one half of the warp during the course of the work. Cutting all the unworked threads will give one long and several short pieces. If the pieces are to be hung, rods can be inserted together with the spacing strips. The threads when cut can then be knotted around the rods. This principle has many possibilities and applications.

E. Joining the two fabrics into one

This ingenious idea is found on a modern Czech table cloth. The two fabrics, separated by cutting across the warp centrally, are laid so that their starting edges are against each other. Then the end loops of warp are crocheted together, a loop being picked alternately from one fabric then from the other. The work proceeds from right to left as in Fig. 145. The right-hand end of warp is treated as the first loop and the left-hand warp end is used to secure the final loop. In this way a single fabric is produced with fringes at both ends and with a central feature not unlike a meeting line secured by chaining. If the same idea is applied to a one-piece sprang fabric, the result will naturally be a complete tube of fabric.

3. DEALING WITH THE END LOOPS OF WARP

A. Replacing warping cords or rods with finer yarn

It is unlikely that the heavy cords between which the warp was stretched will be wanted in the final fabric. But they cannot be pulled out, because the end loops have to be prevented from untwisting and thus loosening the two ends of the fabric. So the cords are usually replaced by a finer thread, perhaps one similar to the warp material. This is threaded on a needle, passed through the end loops with the cord still in place and then tied to the fabric at both sides. At what was the lower end of the warp, it can be tied to the beginning and ending thread of the warp. The cord is then pulled out.

A slight saving in time results from laying a piece of the fine yarn beside each cord at the warping stage so that the end loops of the finished fabric contain both the yarn and the cord. The latter is pulled out leaving the former in place.

Sometimes the thread in the end loops is left long and acts as a carrying handle for a bag. Naturally, in this case, a heavier material will be chosen, perhaps a many plied or braided thread.

The above remarks also apply to a fabric made between two rods, instead of cords. But if the fabric is intended as a hanging, the rods will probably be left in place.

B. Chaining the end loops

To make a more solid edge to the fabric, the end loops can be chained into each other using a crochet or latchet hook. See Plate 62. If the warping cord or rod is not too bulky,

it can be left in place and pulled out when the chaining is done. Otherwise it must be gradually withdrawn releasing loops, one by one, for the hook to pick up.

If the loops are dealt with singly, pulling one loop through one loop, the chained edge may be longer than the fabric is wide and so it will not lie flat. Two or more loops may therefore have to be taken as the unit, i.e., pulling two loops through two loops. By chaining many loops together the end of the fabric can be drawn in.

In the Coptic bags a special application of chaining is found. Some form of spacing strip was probably put in at one end of the warp to keep the first row of interlinking a certain distance from the warping cords. When the fabric was taken from the frame and the strip slid out, one end of the fabric was thus provided with long warp loops. These were chained in pairs and the ends of a heavy drawstring (spotted in Fig. 147) run in between the chaining and the fabric from opposite sides. The other end of the fabric, where the warp loops were of normal size, was sewn to a narrow woven strip (shaded in Fig. 147). The ends of this strip were tied to the two ends of the drawstring, as shown. So when the drawstring was tightened only one side of the bag was gathered in. Most of these features can be seen in Plate 26.

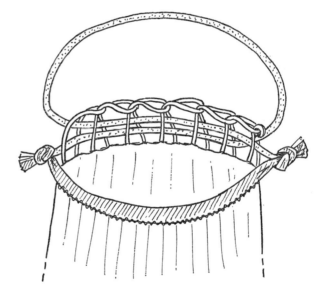

Fig. 147
Arrangement of drawstring,
chained warp loops and
woven strip at the opening
of a typical Coptic bag

In whatever way the end loops are treated, the two knots where the first and last warp threads were tied to the lower warping cord must be undone and the threads re-tied to the nearest end loop.

4. PRESSING

A piece of sprang fabric intended for a garment should be pressed to give some stability to its very elastic structure. It is stretched out to the required size on a board and pinned

in position. Then it is steam ironed or ironed under a damp cloth, and left pinned out until quite dry.

5. MOUNTING IN A FRAME

Mounting a sprang fabric slightly stretched in a rigid frame is not a traditional method, but it has advantages where the fabric is meant to be purely decorative. It overcomes any tendency of the fabric to twist or curl, so this effect does not have to be considered in the choice of yarn or technique. The pleasant meshwork of the various sprang structures can be well displayed and, if the fabric is mounted under some tension, it can be exaggerated. In this way, long slits in the fabric can be made to gape into dramatic holes.

But it is not easy to fit a fabric neatly and permanently into a well-made frame. This is partly a matter of dimensions. A sprang fabric off the frame can either be stretched lengthwise into a tall narrow fabric or sideways into a short wide fabric; so it has no absolute dimensions that the frame can be made to fit. The direction and degree of stretch have to be decided experimentally, perhaps by pinning the fabric to a board, and the frame made accordingly.

The frame can be of any material, metal, wood or plastic, that has sufficient rigidity, and the construction must be such that the constant tension does not cause buckling. Wood is the easiest material to work. The end pieces can be grooved so that rods holding the end loops of warp can be sunk out of sight. The side pieces can be drilled at the correct intervals so that a thread holding the fabric out sideways can be laced in and out. If the meeting line is secured by a rod, this can have its two ends fixed into the side pieces thus counteracting their tendency to bend inwards. (Description based on a frame designed by Heiner Stettler and seen in Plates 53 and 54.)

The fabric's elasticity means that non-rectangular frames can be used, such as six-sided or circular frames, and the fabric will still fill all the available space. Frames can be made with an intentional twist so that a curved surface is given to the fabric. There are other possibilities of making a three-dimensional form from the flat rectangle of fabric. See Plate 63.

Sprang fabrics can be held in a stretched-out state without a frame. Plate 64 shows a piece of double twist interlinked sprang, using nylon and horsehair, which has been sandwiched between sheets of fibre-glass and the whole fixed with resin. While this was being done the fabric was stretched on a temporary frame which was cut away when the resin had set.

Part Two

CIRCULAR WARP SPRANG

11 · Equipment, Warping and Technique in Circular Warp Sprang

INTRODUCTION

In circular warp sprang the continuous tube of warp is stretched between two bars, whose thickness makes it lie in two distinct planes, one behind the other, as in Fig. 148(a). For the purposes of description, the part nearest to the worker is called the *front half* of the warp, the part furthest from the worker the *back half*. The work takes place only in the *front half* of the warp, where front *layer* and back *layer* threads are manipulated normally, according to the technique being used. After the hands have completed each row, two sticks are put in the new shed. One is pushed up the warp, one down, and both are left in position. After several rows, when the working space becomes too cramped between the upper and lower sets of sticks, they are pushed over the top bar and under the lower bar respectively and into the back half of the warp. Here the sticks, coming from above and below, meet each other and are pulled out one by one, each leaving behind the row of thread twists it has carried to the back.

So the fabric begins to appear in the back half of the warp and the first part to appear is the meeting line between the two halves of the fabric. The fabric grows until eventually its two halves extend around the bars and on to the front half of the warp. Work usually stops when there is still a good length of unworked threads between the fell of the upper and lower halves of the fabric. These threads are cut centrally and knotted, giving the finished fabric a fringe at both ends.

Thus it will be seen that with a circular warp the fabric grows outwards from its central point towards its two ends, whereas with a flat warp it grows inwards from its two ends towards its central point.

The method has many variations, but the above general description includes the chief characteristics, which are now listed.

(i) The circular, tubular or ring form of the warp. It is not a single sheet of threads as in flat warp sprang.

(ii) The carrying of each successive shed to the back half of the warp by means of small sticks. It is the use of these sticks in circular warp sprang and of temporary warp sticks in flat warp sprang that has given rise to the German expression, *Stäbchen-flechterei*, and the Swedish expression, *Pinnbandsflätning*.

(iii) The appearance of the meeting line at the start as a direct result of the first row of interlinking being pushed round to the back.

(iv) If some threads are left unworked in the front half of the warp, there is no increased difficulty in the final stages of the work and the resulting fabric has a fringe at both ends.

(v) If the work is continued until both halves of the fabric meet at a second meeting line in the front, then the final stages are as difficult as in flat warp sprang and the resulting fabric is tubular in form.

The thread structures used with a circular warp are identical to those already described for a flat warp, but the presence of the sticks makes some techniques easier than others.

The method has been used wherever a stretch fabric, usually long and narrow, is wanted with a fringe at both ends. By leaving unworked threads at both ends of the warp, such a fabric can be made on a flat warp, but this has one obvious disadvantage. The warp and therefore the frame would have to be nearly twice as long, because the threads are worked in only one plane.

The circular warp method is not very suitable for wide fabrics because the warp is not anchored to the cross bars of the frame, as it is with a flat warp. So there is nothing to stop parts of it slipping and giving an uneven fell to the fabric. However this difficulty seems to have been overcome in the past as pieces up to 30 inches wide exist. The method is also unsuitable for use with rough or hairy yarns, due to the difficulty of pushing the sticks plus the threads twists through such a warp.

So circular and flat warp sprang are not just alternative methods of achieving the same result. They differ in specific ways and must be carefully selected according to the work on hand. A comparison of the two methods is shown in the following table.

	FLAT WARP SPRANG	CIRCULAR WARP SPRANG
Equipment	Usually a frame and a beater; temporary shed sticks may be used.	Either a frame or just two poles; set of small sticks; no beater.
Warping	Done on the frame.	On the frame or, where two poles are being used, on a warping board.
Work	Grows more difficult towards the end, unless diagonal interlinking used.	No increase in difficulty, unless a complete tube is made.
Meeting Line	Made by a separate process when work is finished.	Made as work starts, not a separate process.
Techniques	All possible.	All feasible, but when using two sticks in a shed some are difficult.
Fabric Produced	Typically a fringeless rectangle, i.e. having four selvages.	Typically a narrow band, fringed at both ends; can be a tube.

	FLAT WARP SPRANG	CIRCULAR WARP SPRANG
Size of Fabric	A little shorter than distance between warping cords; any width.	Can be nearly twice distance between bars of frame; wide fabric difficult to work.
Traditional Uses	Bags, head coverings, shirts, gloves, stockings, mittens, hammocks.	Belts, sashes, scarfs, ring slings.
Possible Survival Today	Guatemala, Mexico, Columbia	Pakistan, Afghanistan, Columbia, Hopi Indians.

It will be obvious that in descriptions of circular warp sprang it is inaccurate to refer to the production of *two fabrics*, as could be done with flat warp sprang right up to their meeting. From the very start, with a circular warp, there is only one piece of fabric. Accordingly, the two parts of this single fabric which lie on either side of the meeting line and show contrary twists will be referred to as the *two halves of the fabric*.

HISTORY

The fact that sprang could be made on two types of warp was not recognised when the technique was re-discovered in the 1890s. Louise Schinnerer in 1895 mentioned sashes made by the Ruthenians whose unusual meeting line and fringes puzzled her. Unlike the caps, she never saw these being made, but it is safe to say they were made on a circular warp; so this is an example of a culture where both types of warp existed side by side. In 1912, van Gennep published a translation of a Russian report of the Caucasian silk industry, which had been made in 1902. It includes a photograph of a narrow belt being made on a frame using a circular warp, which Gennep failed to understand. In the same year, he printed a French account of the making of belts for the *serwal* (baggy trousers) which with its mention of little bamboo sticks certainly sounds like circular warp sprang. This account referred to Algeria, and Gennep found these belts in use in other parts of N. Africa.

But the first accurate account did not appear till 1914, when Romulus Vuia published an excellent description of the method which he had seen being used by Rumanian women in Transylvania, for making long black woollen belts worn around their skirts. Other investigators have since written of these belts, whose production has survived until very recently (Treiber-Netoliczka, 1970; Secosanu, 1959). See Plate 65.

Two years later, in 1916, Walter Roth's very detailed account of the baby slings, or ring slings, made by the Guyana Indians proved that the technique was still alive in S. America.

Few pieces have survived from very early times, probably because the sort of fabrics made in this method (belts, garters) are even less likely to be preserved than those made on a flat warp, being purely utilitarian and generally unpatterned. A large linen piece with hole designs, probably made in Switzerland in the fifteenth century, may be the earliest European example (Bültzingslöwen). Its width of 30 inches is very unusual for this method and it is over three yards long. Another wide linen piece was found in a church at Hvalsoe, Denmark (Mygdal, 1917). Its date is certain as the figures 1707 are worked into the hole design together with some initials. A cotton fragment from a prehistoric site in Arizona is so similar in structure to the Hopi wedding sashes, that it seems reasonable to assume circular warp sprang was known in the S.W. United States before A.D. 1400 (Kent, 1972).

A large number of circular warp sprang fabrics survive in the form of military sashes. These date from about 1700 onwards when they were part of the officers' uniform in both European and American armies (Drost, 1972). They were generally made of silk and could measure up to 12 feet long by 30 inches wide. The majority show simple interlinking but some had hole designs, like those of George Washington and General Braddock, the latter bearing the date 1709 (*General Washington's Military Equipment*, 1963). See Plate 67. The British sashes were dark crimson, the Dutch orange (see Plate 68), the French striped in red, white and blue; green sashes were also made. Although they were obviously made in large numbers, nothing definite is known about their manufacture. An interesting point is that they all show an identical method of finishing; two or three wefts were laid in successive sheds, then two or three rows of normal interlinking, then two or three more wefts, then a long plied fringe (see Plate 67).

Today Pakistan women still use the method for making a trouser drawstring, called a *nara* (Lund, 1970). Its cotton warp may be striped, in which case it is interlinked with either single or double twist, or it may be of one colour and show complex hole designs (see Plates 66 and 69). Originally it was made of silk and had elaborate tassels bound with gold and silver thread. Its use suggests a long history, as trousers were first introduced into India with the Muhammadan conquest of about A.D. 710.

Similar belts or drawstrings are known from Persia and Afghanistan.

1. EQUIPMENT AND WARPING

The warp for circular warp sprang is stretched either on a frame with an adjustable bar, or between a pole hung from the ceiling and another tensioned by the feet. With a frame, the warp is wound directly between the two cross bars concerned; with the two pole method, the warp is made separately on a kind of primitive warping board.

A. Using two poles

This method has been described in India (Bühler-Oppenheim, 1947), Algeria (Gennep, 1912), and Rumania (Vuia, 1914). A strong pole is hung by two loops of cord from some

convenient point, such as a ceiling beam, see Fig. 148(a). The circular warp hangs between the centre of this pole and another pole inserted into its lower end. The lower pole may have one end resting on the floor in which case only one foot is put on it to tension the warp, see arrow in Fig. 148(a) and also Plate 65. Or both feet may be used, one on either side of the warp, so the lower pole hangs horizontally a few inches above the floor. This very simple arrangement works well for a narrow warp, but is unsuitable for a wide one.

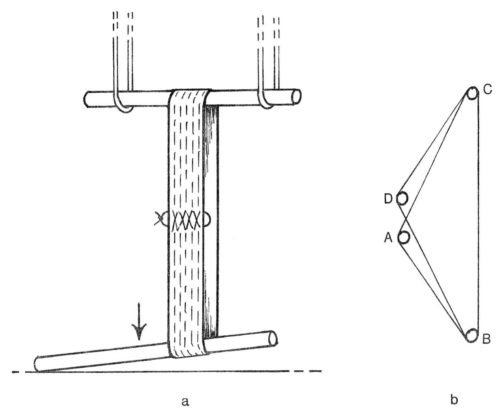

Fig. 148. Circular warp sprang. (a) Two pole method of suspending the warp, (b) making the warp on four pegs

The warp is made on four pegs arranged in the triangular manner shown in Fig. 148(b), and the method is as follows:

Starting from peg D, carry the warp thread around pegs B, C and A, missing out peg D this time around. Then carry the thread around pegs B, C and D, missing out peg A this time. Repeat this sequence, (B,C,A,B,C,D), until the correct number of threads have been warped. They can be easily counted between pegs A and D, where they form a one-and-one

cross. Cut the thread at peg D and tie it loosely to the beginning of the warp, leaving long ends to allow of later adjustment.

It will be seen that a completely circular warp has been made with one cross in it. Tie the latter between pegs A and D to keep it secure while the warp is transferred to the two poles. The top pole goes into the warp where peg C was and the lower pole where peg B was. The cross lies in the front half of the warp, facing the worker.

The only other equipment needed is a collection of small sticks. These are smooth and if possible made from a light wood. Their length and diameter are not critical, but could be 10 inches and $\frac{1}{4}$ inch. About thirty or forty are a convenient number to have. What happens next depends on which of the three methods of handling these sticks is to be used. These methods are described in section 2 below.

B. Using a frame

The frames for circular warp sprang are either fairly large and used vertically, or small and used horizontally.

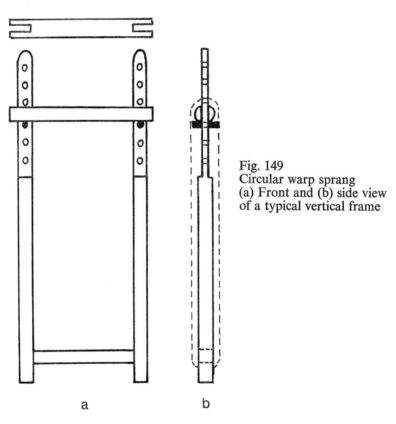

Fig. 149
Circular warp sprang
(a) Front and (b) side view
of a typical vertical frame

a b

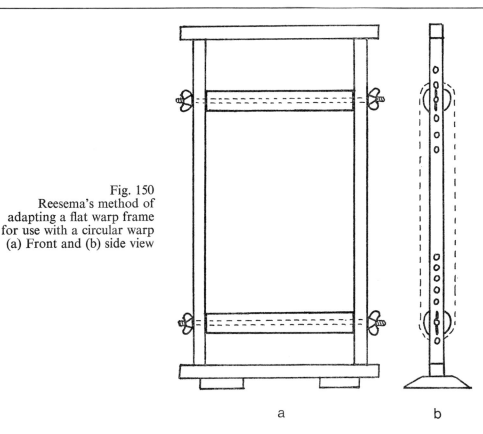

Fig. 150
Reesema's method of
adapting a flat warp frame
for use with a circular warp
(a) Front and (b) side view

a b

(i) VERTICAL FRAMES

Vertical frames have been described in Pakistan (Lund, 1970), Transylvania (Treiber-Netoliczka, 1970), and Afghanistan. Fig. 149(a) and (b) shows the front and side view of a typical design. The two uprights are connected by a fixed cross bar at the bottom. The upper cross bar has a slot at either end so that it can fit over the uprights which are here reduced in thickness, see Fig. 149(b). Holes in the uprights take pegs which fix the upper cross bar at the desired height. See Plate 66.

A free-standing frame as used for flat warp sprang can be adapted for a circular warp in the way described by Reesema (Reesema, n.d.). The uprights are drilled with holes to take screws which pass through the centres of two bars, see Fig. 150. The bars or rollers have a circular cross-section and can rotate on the screws. The importance of this will be seen later. If the holes for the upper roller are drilled $1\frac{1}{2}$ inches apart and those for the lower roller 1 inch apart, then the distance between them can be adjusted by $\frac{1}{2}$ inch increments.

The warp is wound directly around the cross bars or rollers in the following manner.

Starting towards the left-hand side, fix the end of the warp temporarily to the top cross bar. Then carry the thread over this bar, down to the lower cross bar, around this and up to the top cross bar again. The course taken by the thread is shown by a dotted line in Fig. 149(b) and Fig. 150(b). Keep working towards the right without overlapping any threads. Remember that each passage of the thread up and down the frame only adds one thread to the warp, because the work will be done on the front half of the warp only. Each such passage adds two threads to a flat warp.

Finish warping at the top bar and cut the thread. Tie this to the thread that lies next to it, and do the same for the starting end of the warp. These ties may have to be adjusted later. Alternatively, these two ends can be tied loosely to each other, as when making a warp on four pegs.

Pick up a one-and-one cross in the front half of the warp with the fingers and insert a stick or cord to secure it. Make sure that the right-hand thread passes over the stick.

The warp is now ready for the work to begin.

In the above method, the cross was picked up after the warping was done, but it can be made during the warping, as was done in Transylvania (Treiber-Netoliczka, 1970). Two sticks are tied to the left-hand upright of the frame so that they project horizontally across the frame a few inches apart. As each thread forming the front half of the warp is laid, it is slipped between these sticks at their unattached right-hand ends. Each succeeding thread takes an opposite course between the sticks, so that a normal one-and-one cross is made.

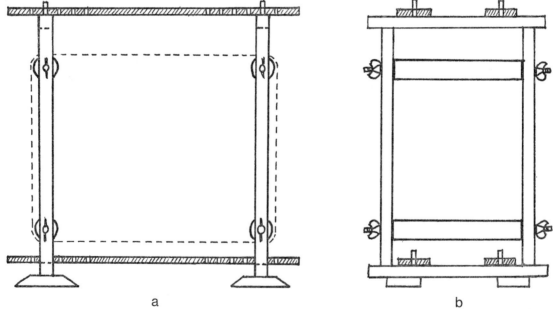

a b

Fig. 151. Reesema's method of joining two frames to accommodate a long warp. (a) Side and (b) front view

To accommodate a long warp the method originated by Reesema can be used. Two such frames, placed one behind the other, are joined with four lengths of wood, shaded in Fig. 151(a) and (b). At regular intervals, the latter are drilled with holes which fit over pins in the upper and lower cross pieces of the frames, so the distance between the frames can be adjusted to suit the length of warp. The warp passes round all four rollers as shown.

The idea of accommodating a long warp by zigzagging it between several closely set bars, as in the modern compact inkle loom, has not been tried but it might be successful.

(ii) SMALL FRAMES

The only traditional example of a small portable frame used for circular warp sprang comes from Guyana, S. America, where it is used for making a baby sling or ring sling (Roth, 1916–17). This is a complete tube of interlaced sprang with two meeting lines, one made at the start in the normal way, and one made at the finish when the two halves of fabric meet in the front half of the warp. The frame consists of two cross bars lashed to the ends of two diagonally crossed sticks, see Fig. 152, which shows the back view. One end of this very simple device rests in the lap, the other either on the worker's toes or a small support.

Fig. 152
Circular warp sprang. Small portable frame as used in Guyana

The sampling frame shown in Fig. 11(b) in Chapter 2 is suitable for a circular warp, but the latter has to be wound around the two wooden pieces to make it lie in two planes. The safety cord also changes position, passing from one side of the frame to the other between the two halves of the warp. It merely gives stability to the frame, as no safety cord is needed in circular warp sprang.

The Hopi Indian wedding sash is also made on a horizontal warp which is stretched between two poles, a few inches above floor level (Kent, 1940). One end of each pole is fitted into a hole in the wall and the other end into a hole in a large stone lying on the floor.

The warping of these three types of small frame is the same as for a vertical frame.

C. False Circular Warp

The false circular warp method, which is used in weaving in many parts of the world, can also be applied to sprang. The makers of interlaced hammocks in Columbia use it (Cardale-Schrimpff, 1972), and it may have been used in Guyana (Roth, 1916–17).

The method involves the use of a stick (shaded in Fig. 153), which is secured to one of the uprights of the frame during warping so that it lies horizontally, almost reaching across to the other upright. Loops of warp are passed alternately over the top cross bar and under the lower cross bar, and are threaded on to this stick. As Fig. 153 shows, no thread passes completely round the two cross bars in the normal circular way, hence the name of this method.

When the warping is finished, work begins on the front half of the warp in the usual way. The small sticks pushed round into the back half come up against the loop-holding stick,

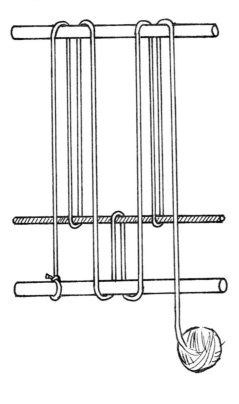

Fig. 153
Making a false circular
warp

which therefore lies where the meeting line between the two halves of fabric should be. Work continues until there is a meeting of the two halves of fabric in the front, which is secured by chaining or laying a weft in the last shed. The stick is then slid out from the warp loops, giving a simple rectangle of fabric with four selvages, which is of course the typical product of flat warp sprang. Indeed this method is best considered as a form of flat warp sprang specially adapted for long fabrics. The long rectangle of fabric can be thought of as having been doubled around the two cross bars during its making (the warp loops at its two ends being on one stick instead of on two separate warping cords), so that the frame need be only half as high as the fabric is long.

The presence of the loop-holding stick also means that a wide warp can easily be handled, because there is no tendency for the threads to slip around the cross bars giving an uneven fell, as may be found with a true circular warp. The Guajiro Indian hammocks from Columbia are up to $4\frac{1}{2}$ feet wide, probably the widest sprang fabrics made. Their interlaced structure is not pushed right up to the loop-holding stick, so both ends of the hammock have long warp loops which are used in its suspension.

2. BASIC TECHNIQUE

There are three ways the small sticks can be handled in circular warp sprang:

—One stick can be put in every shed and pushed *down* the warp, in which case the fabric appears on either side of the upper cross bar of the frame, as in Fig. 154(a).

—One stick can be put in every shed and pushed *up* the warp, in which case the fabric appears on either side of the lower cross bar, as in Fig. 154(b).

—Two sticks can be put in every shed and one pushed up, one pushed down, in which case the fabric appears in the middle of the back half of the warp, as in Fig. 154(c).

Note—The meeting line has been arrowed in Fig. 154(a), (b) and (c).

A. One Stick in a Shed

(i) WORKING AT UPPER END OF WARP

This is the easiest method to understand as it bears more relation to flat warp sprang than the two sticks in a shed method. It was used in Rumania (Vuia, 1914), and a variation of it was described by Reesema (Reesema, n.d.).

The warp can either be prepared on pegs and then suspended between two poles, or made directly on a frame, as already described.

(a) Using two poles

Put a stick in the warp in the opening above the cross and put the left hand in the opening below the cross. Remove the string securing the cross. If the warp was made exactly as described (see Fig. 148(b)), then the extreme right-hand thread will lie over the fingers.

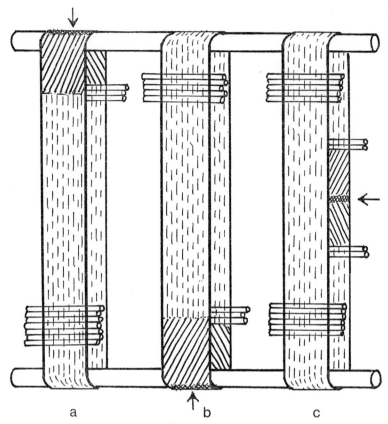

Fig. 154. Three methods of working circular warp sprang. (a) Pushing sticks down, (b) pushing sticks up, (c) pushing sticks both up and down

Work a normal plait row. Put a stick in the new shed and push it (plus the stick above it) to the top of the warp, then slide it down so that it lies in the shed just above the lower pole. Work a normal overplait row. Put in another stick. Push it up the warp to beat in the last row and then down the warp where it lies above the other stick.

As these two rows are repeated, one half of the fabric begins to grow downwards from the top pole, and the sticks, holding the contrary twists, begin to mount up from the lower pole.

When work becomes cramped between the fabric above and the sticks below, push the sticks round to the back. Start with the lowest stick (i.e. the one put in after the first row), and slide it under the lower pole, then up the back half of the warp, until it meets the single stick at the top pole. Pull it and this stick out of the warp. Now slide the other sticks round one by one and pull them out of the warp. Push each hard against the fabric which is beginning to appear behind the top pole, so that it is as well beaten as the fabric

already made in front. Do not pull out the last few sticks that are slid round, but leave them against the fell of the back half of the fabric to keep the rows well compressed, as shown in Fig. 154(a).

The two halves of the fabric now lie on either side of the top pole, stretching downwards from the meeting line which runs along the top of this pole. It will be understood why the Rumanians call the half in front, 'made by the fingers', and the half behind, 'made by the sticks'.

Note—That it is awkward to work at the level of the top pole, if a very long warp is used. In this case, the hands can work at any convenient level in the front half. But the sticks will have to be pushed under the lower pole, up the warp and then over the top pole to meet the fabric, both halves of which will initially be in the front half of the warp. See Plate 65, where the sticks have been pushed into the back half of the warp, but have not yet been pushed up and over the top pole.

—That putting in sticks quickly increases the warp tension, rather as a thick weft does in a warpface weave. The tension is reduced again when the sticks are pulled out. The two pole method allows for this perfectly, as the lower pole can rise and fall with the increase and decrease of tension.

THE MEETING LINE

The meeting line will have the structure shown in Fig. 155(a). This is the type most often found in old fabrics. The two halves of the fabric, one in S-twist and one in Z-twist interlinking, meet with a stripe of over two, under two interlacing. But the two halves can meet

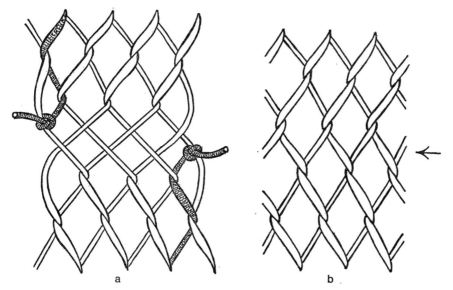

a b

Fig. 155. Meeting line in circular warp sprang. (a) Common type with over two, under two interlacing between the two halves of the fabric, (b) type with no interlacing

as in Fig. 155(b), without any interlacing between them. To achieve this, work a row by picking up each back layer thread in turn and dropping off each front layer thread in turn. The action is exactly as in an overplait row but, due to the position of the threads, it results in no interlinking. Follow this with a plait row and continue normally. This type of meeting line may have been less used because the sudden reversal of twist direction (at the level of the arrows in Fig. 155 (b)) tends to make the fabric curl at this point, especially if an elastic yarn is used.

It is interesting that with two types of interlaced sprang on a circular warp, over one, under one and over two, under two showing horizontal ribs, there is no structural irregularity at all at the meeting line. In fact it is only the presence of the two ends of warp (shaded in Fig. 155(a)) where the meeting line should be which shows that sprang (rather than braiding on a free hanging warp) was the method used.

DEALING WITH THE WARP ENDS

The two ends of the warp were knotted together, when the warp was made on the four pegs. When the sticks are pushed round and taken out, this knotted thread will stretch

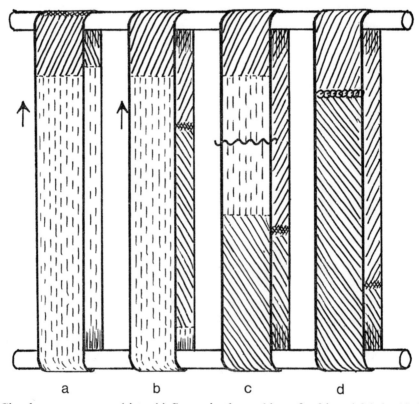

a b c d

Fig. 156. Circular warp sprang. (a) to (c) Stages in the making of a fringed fabric, (d) final stage in the making of a complete tube of fabric

from selvage to selvage across the fabric near the meeting line. The knot may have to be loosened to allow the first few rows to be well beaten. When the work is well established, the knot can be undone and the ends either darned into the fabric or each can be knotted to the nearest thread of the fabric, as shown in Fig. 155(a).

Similarly if a striped warp is used, the knots joining differently coloured threads should be made to lie near the meeting line. If placed anywhere else, they will be a nuisance and prevent the sticks sliding through the warp.

FINISHING

As the front half of the fabric grows downwards, the hands can be kept at the same convenient working height by gradually slipping the whole warp around the poles. Fig. 156 shows stages in this process, the arrows indicating the direction the warp has to be moved. Sticks have been omitted for clarity in this diagram. It will be seen that the fabric occupies more and more of the back half of the warp. Eventually it fills the back half and begins to appear at the lower end of the front half, as in Fig. 156(c).

The fabric is removed by cutting the unworked threads at their midpoint, marked by a wavy line in Fig. 156(c). But if a complete tube of fabric is wanted, then the work continues until the two halves of fabric meet and the meeting line is joined by chaining, as in Fig. 156(d).

(b) Using a vertical frame

In the following method described by Reesema, the warp is prepared as in section 1B(i) above. Two swords are used, but no small sticks.

Put the left hand into the picked-up shed. Work a plait row normally. Insert a sword and the safety cord into the new shed. Immediately push the sword down the warp, around the lower bar (or roller in the case of Reesema's frame) and up the back half of the warp to the top roller. Insert the second sword in the same shed in the front half. Push it upwards to meet the first sword at the top roller. Press the two swords together, so that the meeting line is well compacted between them.

Remove both swords and work the next row. Put a sword and the safety cord in the new shed and again slide the sword down the front half and up the back half of the warp. Insert the second sword as before to compress the first two rows.

Carry on in this way. After a few rows, the second sword need not be used, as the one sword first beats upwards on the front half of the fabric, then slides round the warp and beats upwards on the back half of the fabric.

Note—That the two knots at the ends of the warp may have to be retied to place them exactly at the meeting line. Or they may be untied and the free ends darned into the fabric.

—That it is much more difficult to push a sword than a small stick around the lower bar of the frame. This is why the bar is made as a roller, so that the sword can be carried round it, as it is slightly rotated.

—This is the only circular warp method that needs a safety cord, as there are no small sticks to preserve the sheds.

(ii) WORKING AT LOWER END OF WARP

As this method has only been described in connection with the horizontally stretched warp used by the Hopi and Guyana Indians, it is really working at the near, rather than the lower, end of the warp. If the false circular warp method is included, there is one example; that of the Guajiro Indians who work at the lower end of a warp stretched on a large vertical frame to make their hammocks. In all these three instances, the structure used is interlacing.

The process is the same as that described in section 2A(i) above, but in an inverted form, so it needs no detailed description. The work starts at the bottom of the warp instead of the top, the sticks are pushed upwards instead of downwards, and so on. It is obviously well suited to those accustomed to working flat warp sprang at the lower end of the warp or where a very large frame is being used.

B. Two sticks in a shed

This method is found in India and Pakistan, both with a warp suspended between poles and with a warp stretched on a frame.

(i) USING TWO POLES

The warp is made on four pegs as described in section 1A above, but with a slight difference. The warping is begun and finished halfway between pegs B and C. So the knot joining the two ends of the warp lies at this point, which is where the meeting line of the fabric is to be.

Hang the warp on the two poles with the cross to the front. Put a stick in the opening above the cross and another in the opening below it. Cut the string securing the cross. Push the two sticks to the top of the warp with the cross between them. Into the same opening as the lower stick, put a third stick and push it down to the lower end of the warp. Fig. 157(a) shows a diagrammatic side view of the warp with the three sticks in position. Note the knot lying centrally in the back half of the warp.

In the one stick in a shed method, the hand movements are identical with those used in flat warp sprang; the work is done in the normal position directly below (or above) the

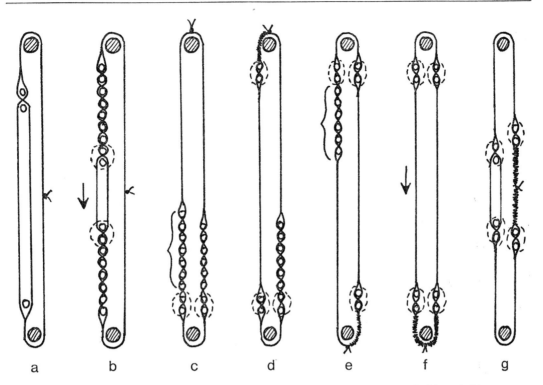

Fig. 157. Circular warp suspended between two poles, two sticks in a shed. (a) and (b) Beginning, (c) to (g) method of pushing sticks into back half of the warp

fell of the fabric. But here the hands are always working below a set of sticks. This alters the movements slightly, although the resulting thread structures remain the same.

Insert the fingers of the left hand into the opening occupied by the lower of the two sticks at the top of the warp. Begin a plait row thus, directly under this stick.

Pick up the first front layer thread on the back of the right thumb, carry it over towards the right, by twisting the wrist in a clockwise direction as in tightening a screw. This movement brings the right index towards the back layer threads. Pick up the first two back layer threads on the right index. Now release the front layer thread from the thumb and pass the remaining three right-hand fingers behind the two threads already on the index, so that these threads now lie in the right hand. Twist the wrist back in an anti-clockwise direction, and in so doing push the released front layer thread behind the right fingers.

Repeat the above sequence of movements for each subsequent interlinking, but of course only picking up one back layer thread. At the end of the row, pick up two front layer threads with the thumb.

When the row is finished, put two sticks into the new shed. Push one down to join the stick already there and push the other upwards to join the two already there.

In the next row, an overplait row, the thumb will pick up one front layer thread and the index pick up one back layer thread all across the warp.

Holding the hands well apart will automatically separate the next front layer thread from the bunch held in the left hand, and the thumb's carrying of this front layer thread over to the right will isolate the next back layer thread for the index to pick up. This means that with practice the work can go very fast and also that fine threads can be easily dealt with. If the threads stick to each other, the left thumb can help by separating the next front layer thread from the bunch.

Note—The stick will tend to fall out of the previous shed until the first few interlinkings are made.
 —It is easier to handle the threads if the warp tension is fairly light. When not working a row, increase the tension to stop the sticks slipping about.

Rows are worked, each followed by inserting two sticks, until there is insufficient space between the upper and lower sets of sticks, as in Fig. 157(b). Then an elastic band is slipped over the last two sticks inserted in each set, as shown in Fig. 158. The bands are represented by dotted circles in Fig. 157.

The sticks have now to be pushed round into the back half of the warp and pulled out. There is an ingenious way of doing this which avoids the awkward pushing of sticks plus the thread twists around the two poles. It also has the advantage of all the work being done in the front half of the warp.

Release the warp tension by taking the foot off the lower pole. Take hold of the front half of the warp and pull it downwards (see arrow in Fig. 157(b)), so that the whole warp plus sticks moves round. Regarding the warp as a circle, turn it a quarter of a revolution, so it now looks as in Fig. 157(c).

Now, with the the warp tight, slide the bracketed sticks (i.e. all except the two held with an elastic band) upwards one by one until the top one lies in the region of the knot in the warp. (Of course, the next time this is done, there will be a section of fabric here, against which to slide the sticks.) Remove the sticks one by one starting with the top stick, the one put in before the first row of interlinking. As each is removed, push it upwards to compress the gradually appearing fabric. Do not remove the last two sticks, but secure them in position against the fabric with an elastic band. Fig. 157(d) shows the position now reached.

Now release the warp tension and pull the warp round a half-revolution, so that what were the lower set of sticks now lie at the top of the front half of the warp, as in Fig.157(e). Tighten the warp and slide the bracketed sticks (all except the two held by a band) down

Fig. 158
Circular warp sprang.
Securing last four sticks
inserted with elastic bands

one by one, so that the lowest one is against the fabric already made. Remove the sticks one by one as before and again leave two in position held by a band. The two halves of the fabric will now be seen on either side of the lower pole, as in Fig. 157(f).

Give the warp another downwards pull so that the completed fabric is in the centre of the back half, as in Fig. 157(g). Push the two upper sticks to the top of the warp and the two lower sticks to the bottom to give the maximum space for the hands.

Insert the left hand into the opening occupied by the lower of the two top sticks and begin interlinking again.

Note—At this stage there are four pairs of sticks in the warp, each held by its own elastic band.

—Throughout the above operation, the warp is loosened when it is to be moved, but tightened when the sticks are to be moved.

—One advantage of the two sticks in a shed method is that the two halves of the fabric have their rows forced into position in the same efficient way, so that it is easy to ensure that their texture is both close and equal.

It might be thought that when the two sticks representing the first row of the work are pushed round to the back, the opposite twists they carry would cancel each other out and

so no fabric would be produced; and that the same would happen with all subsequent sticks. Indeed this would happen if the warp were made from many separate lengths of thread, each of which went round the two poles and then was tied to its own end. It is the fact that the warp lies in a spiral form, not as unconnected rings of thread, that ensures the locking together of the two sets of twists and so makes the method possible.

(ii) USING A VERTICAL FRAME

The two sticks in a shed method is worked in Pakistan on a frame similar to that in Fig. 149. The worker sits in a chair, resting her feet on the lower cross bar on either side of the warp. She keeps the frame upright by her grip on the front layer of the warp. Sometimes the frame has two legs supporting it, so that it is free-standing like an easel, as in Plate 66. The warp is kept fairly loose so that it can be easily pulled round when the sticks are to be moved. If the work is to be left, the top cross bar is fixed at a higher level to tighten the warp and thus keep the sticks in position.

 The warp can either be made on pegs and then put on the frame or be made on the frame. The method of work is exactly as described above in section 2B(i).

3. FINISHING

A. Making a single fabric with fringes at both ends

The commonest way to finish a circular warp sprang fabric is to cut across the centre of the unworked threads, which lie between the two halves of the fabric in the front half of the warp, see the wavy line in Fig. 156(c). The result is a long fabric with a fringe of warp threads at both ends. Any of the methods described for flat warp sprang in Chapter 10, sections 2A and B, can be used to treat the cut warp threads or the edge of the fabric before cutting. As the fabric produced is often worn as a belt or sash, the warp threads of the fringe can be treated decoratively with wrapping, added threads to make large tassels and complicated knotting.

B. Making a tubular fabric

Another method, already referred to, produces a complete tube of fabric by working until the two halves of fabric meet and are secured in the front, as in Fig. 156(d). It differs from the tubes made in flat warp sprang both in the fact that the warp runs round the circumference and not up the tube, and in its proportions. It obviously lends itself to the making of bags. A warp can be wound on a frame in such a way that the resulting tube has a twist in it, exactly as in a Moebius Strip. There are many possibilities in this method.

4. OTHER METHODS OF WORKING

In *Antike Handarbeiten*, Schinnerer mentioned the Spanish military sash, known as a *faja*, which was interlinked, had fringes at both ends but had no meeting line, i.e. the twist direction was the same throughout. If this report is true, such sashes were probably made on a circular warp, two at a time, as suggested by Reesema; though they could have been made on a hanging warp only fixed at its upper end (Reesema, 1920). Assuming the one stick in a shed method was used, when the sticks were first slid round they stopped well short of the fabric. In other words the two halves of the fabric never met, but were separated by a gap which could be easily maintained by a piece of card lying in the shed, see the dotted line in Fig. 159(a). When the work was finished the *two* sections of unworked threads were cut centrally (see arrows in Fig. 159(b)), giving *two* fringed half-fabrics, neither of which had a meeting line.

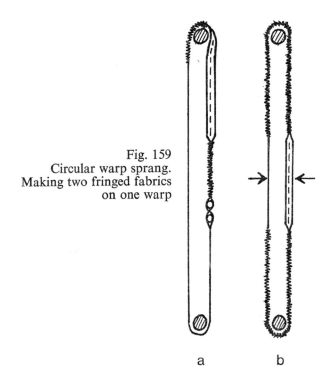

Fig. 159
Circular warp sprang.
Making two fringed fabrics
on one warp

a b

This sort of variation shows the difficulty of deciding whether a fabric was made in the sprang method or not. Although the presence of a meeting line, either of the flat warp or circular warp type, is a fairly sure indication of sprang, its absence definitely does not exclude it. There is also nothing to show from looking at a *faja* that it was not made on a flat warp, like the Guatemalan belts, see Fig. 146(a) in Chapter 10. It can only be said that the longer the fabric, the more likely it is that a circular warp was used.

To confuse the subject further, there is the strange method of belt making used by the Chippewa Indians (Densmore, 1929). A warp of cut threads was stretched between two posts. The threads were then interlinked, starting at the centre and working towards one end. The duplicated twists natural to sprang were combed out of the end of the warp when it was periodically untied from the post. Then beginning on the other side of the central line, the threads were interlinked towards the opposite end of the warp and again the duplicated twists were discarded. So the result was a fringed belt with a central meeting line of the circular warp type, yet the method was a repudiation of the sprang process and, moreover, used a flat warp.

5. TECHNICAL POSSIBILITIES WITH CIRCULAR WARP SPRANG

A. One stick in a shed

It will be obvious that when using the one stick in a shed method and working at either the top or the bottom of the warp, any of the techniques described for flat warp sprang are quite possible. The hands bear the same relation to the fell of the fabric as with a flat warp, so all the movements are identical. But there may be some difficulty in pushing complex twists around the cross bar and into the back half of the warp, especially if a rough yarn is being used.

Interlaced sprang has been made on a circular warp using one stick in a shed by both the Hopi and Guyanan Indians. The Hopi wedding sash is made from handspun undyed cotton and measures about 9 feet long by 9 inches wide (Kent, 1940). It has long braided fringes at both ends. Its structure is over three, under three interlacing, so worked that the floats appear as vertical ribs. The method used is that described for flat warp sprang (section 3B of Chapter 7), in which one row is worked from the right using certain finger movements, and the next row is worked from the left with the same movements, but with the hands reversing their roles.

Some of the Indian tribes in Guyana (late British Guiana) make a complete tube of interlaced sprang which is worn over one shoulder as a sling to carry a baby (Roth, 1916–1917). The ring sling, as Roth called it, is made from plain undyed cotton of which about three hundred threads are wound on the frame shown in Fig. 152. The method of work is as just described, one row being done from the right and the next from the left. The structure may be over one, under one interlacing using pairs of threads as the unit, or over two, under two interlacing (giving vertical ribs) using the threads singly. See sections 1 and 2B in Chapter 7. Often the two structures are combined as stripes in the same fabric. The work is continued until the two halves of the fabric meet in the front half of the warp, where they are secured with two or three heavy cords lying in the final sheds or in picked-up plain weave sheds. The cords are bound together at either side and may be decorated with tassels and feathers.

B. Two sticks in a shed

There are differences in technique associated with the two sticks in a shed method because here there is no fabric immediately above the hands to help guide their movements. So the position of some feature in the row being worked cannot be easily fixed by its relation to features in previous rows, as was done with flat warp sprang. The techniques traditional to the method are single and double twist interlinking on a striped warp, and hole designs on a warp of one colour.

(i) HOLE DESIGNS

The makers of the Pakistani drawstrings, or *nara*, use a special set of finger movements for hole designs (see Plate 69). Like the alternative method described for flat warp sprang (see section 2B(iii)(c) in Chapter 6), it untwists an interlinking made in the previous row and the hole so formed is closed in the following row. But the untwisting is not quite so simple because of the presence of the stick in the previous row. The manœuvre can be worked in either a plait or an overplait row, as long as it is worked in that row throughout.

Row 1
Where a hole is wanted, pick up the next front layer thread on the back of the right thumb and carry it to the right in the usual way. Pick up the following front layer thread by gripping it between the tips of the third and fourth fingers of the right hand. Carry it backward, then to the left behind the next back layer thread, then forward again and replace it on the left fingers. This movement untwists two threads interlinked in the previous row, but because of the presence of the stick in that row, no actual untwisting is seen. The movement also brings the back layer thread into the right hand where it stays. Now drop the front layer thread from the right thumb and let it lie behind the right fingers.

Note—The result of this manœuvre is to interlink the next front layer thread with the next back layer thread, but only after the latter has been released from an interlinking made in the last row.
 —The third and fourth fingers are used because the index is busy holding in place the threads already in the right hand.

The untwisting manœuvre is always followed by a normal interlinking. So if only one hole is wanted, the row continues with the thumb picking up the next front layer thread (the one the third and fourth fingers have just dealt with), the index picking up the next back layer thread, the thumb releasing its thread, and so on. But if a set of holes is wanted as close together as possible (as in Fig. 70), then the untwisting manœuvre and a normal interlinking must alternate regularly.

However the row is worked, it will be seen at its end that the threads are grouped in fours (two over the stick, two under it), wherever a hole is intended. Such a group is seen

centrally in Fig. 160 between sticks 2 and 3. The two threads that were untwisted are shaded and are only held in place by stick 2, just as a gauze or leno twist is locked in position by a weft. When stick 2 is eventually removed, these two threads will immediately separate, making a hole at this point.

Row 2
As with most hole techniques, the alternate rows are worked normally. The row closes the holes made in the last row, but this, of course, is not seen.

Row 3
The only problem in this row is placing the new holes in the correct relationship to those in Row 1. Assume a triangle of holes is wanted and that one hole was made in the centre of Row 1, as in Fig. 160. Then the moment to start the two holes in this row can be found by counting. If the single hole was 20 interlinkings in from the right selvage, the first of the two holes in this row will be 19 interlinkings in.

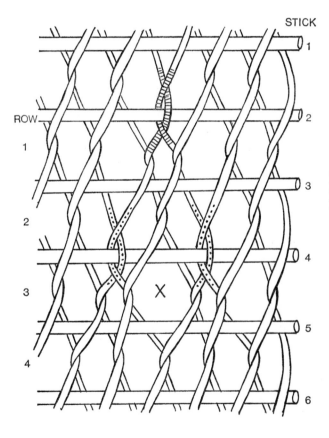

Fig. 160
Circular warp sprang.
Making a triangle of holes

Alternatively the moment can be judged visually. As the thumb picks up each front layer thread, look at the *following* front layer thread still held in the left hand. When the point is reached that this thread can be seen to run up into the group of four threads, make an untwisting manœuvre. Follow this with a normal interlinking and another untwisting to make the desired two holes, then interlink normally to the left selvage.

The result can be seen between sticks 4 and 5 in Fig. 160, where there are two groups of four threads. When stick 4 is removed, the dotted threads will separate to make two holes lying on either side of and below the first hole.

Note—The opening between these two groups, marked with an X in Fig. 160. Such openings between four-thread groups are only temporary and disappear when the sticks are removed.

Row 4
A normal row.

Row 5
There will be three holes in this row. The first hole will be 18 interlinkings from the selvage or its position can be judged visually. When the next-but-one front layer thread can be traced up to the right-hand of the two four-thread groups above, start the hole manœuvres.

Continuing thus, the triangle of holes will get wider and wider. To convert it into a diamond, the rule for decreasing the width must be learnt. This is very simple. The hole manœuvre is begun when the next-but-one front layer thread can be traced up, not to the right-hand of the four-thread groups above, but to the next one, i.e. the second from the right. The holes are started at this point and one less is made than in the previous hole-making row.

As with most techniques, it is important to practise with heavy yarn until the point to start making holes is easily recognised. Using two sticks in a shed, the work has to be very accurate as it is only when the sticks are pulled out that any mistake will be discovered and at that stage it will be very difficult to correct.

(ii) DOUBLE TWIST INTERLINKING

This method, worked on a striped warp to produce diagonal movements of the colours, presents no problems. Double twist interlinking is always slower than single twist, but the following set of movements will with practice speed up the process.

Pick up the next front layer thread with the thumb and the next back layer thread with the index in the usual way. Immediately extend the third finger across to the left (passing under the picked-up back layer thread), so that the thread which is now released from the

thumb falls on to it. Then bend the third finger, carrying this thread to the right under the thread on the index, which is at once dropped. Complete the movement by passing the other right-hand fingers behind the thread on the third finger.

(iii) COMBINING AREAS OF S- AND Z-TWIST INTERLINKING

Though not used traditionally, this very flexible technique works well on a circular warp. See the description for flat warp sprang in section 1C(ii) in Chapter 6.

The Z-twist stopping point is reached when the right-hand of the two threads lying together *behind* the stick has been included in the last interlinking. At this point, interlink the next two front layer threads, using S-twist if the S-twist area is to increase, and using Z-twist if the S-twist area is to decrease.

The S-twist stopping point is reached when the right-hand of the two threads lying together *over* the stick has been included in the last interlinking. At this point, interlink the next two back layer threads, using S-twist if the S-twist area is to increase, and using Z-twist if the area is to decrease.

The above few examples show how techniques may have to be slightly modified or adapted when the two sticks in a shed method of circular warp sprang is used.

Appendix 1 · Notes on the Identification of Sprang Fabrics

A reading of the relevant parts of this book shows that there is no one typical product of the sprang process whose existence would make the process easy to identify. Sprang fabrics can have several forms and show several thread structures, many of which are also found in non-sprang fabrics. As a result, sprang fabrics are still inaccurately described and named in many textile collections. The following notes try to show a few safe landmarks in this difficult and controversial field.

A sprang fabric relies for its structures solely on the manipulation of the parallel threads of a warp that is fixed at both ends. From this it follows that it is a completely *weftless* fabric and that *all its threads are of equal length*, because this initial condition of the warp is not altered by whatever thread structure is employed. Also it will be clear that the *thread movements involved in these structures must be of a type consistent with a warp fixed at both ends*, i.e. they must not necessitate the manipulation of a free end of thread, as in knotting.

The three basic thread structures used in sprang fabrics are *interlinking*, *interlacing* and *intertwining*, as shown in Fig. 1. A fabric may show one of these structures throughout its length either used in its simplest form or incorporating any of the many possible variations, or it may combine two or three of the structures in the same piece.

Whatever structure is used, there are several other reasons why a sprang fabric may present a rather confusing appearance. It may be attached to another fabric made by quite another process, e.g. weaving. Though typically a flat rectangle, it is often converted into a three-dimensional object (e.g. a carrying bag, an article of clothing) through the use of various shaping methods both during and after its making, as described in Chapters 9 and 10. Also the fabric may itself be used as a ground for other thread work, such as embroidery.

Sprang can either be worked on a flat or a circular warp. The typical *flat* warp sprang fabric either has warp loops at both ends or, if it has been cut in two, it has loops at one end and a fringe at the other. The typical *circular* warp sprang fabric either has a fringe at both ends or is in the form of a complete tube of fabric. The following more detailed analysis uses these characteristics as a means of classification.

1. FABRIC WITH WARP LOOPS AT BOTH ENDS

A. With a meeting line

The presence of a meeting line at or near the centre of such a fabric is proof of sprang. The meeting line may be secured by chaining or by the laying of weft-like elements in the

final shed or sheds, as described in section 1 of Chapter 10. If the structure used is *inter-linking* or *intertwining*, the fabric on either side of the meeting line will show contrary twists. Whatever structure is used, there will be a mirror-imaging of the design and a duplication of any mistakes on either side of the meeting line.

B. Without a meeting line

The absence of a meeting line means the method of manufacture cannot have been sprang but that the fabric was made by the *linking* method, see Fig. 3 in Chapter 1. Linking is worked with a single thread whose free end is passed through loops in the growing edge of the fabric. The thread moves in this way from one end of the fabric to the other where, having been caught round some end support, it starts the return journey and passes through loops made in the previous row. Periodically a new length of thread has to be joined on either by knotting or by a nearly invisible splicing of the two ends. The structures used in sprang which are also produced by linking are simple 1/1 *interlinking* (see Fig. 1), *lattice sprang* (see Fig. 61) and combinations of the two (see Fig. 62). So where these structures are found in a fringeless fabric it is essential to discover whether or not there is a meeting line.

Neither *interlacing* nor *intertwining* can be worked in this way, as the general course of the threads is at an angle to, not parallel with, the selvage of the fabric.

2. FABRIC WITH WARP LOOPS AT ONE END AND WARP FRINGE AT THE OTHER END

This is the other typical product of flat warp sprang and is most often associated with *interlinking*. The work is stopped before the centre of the warp is reached and the threads are cut between the two fabrics, as described in section 2 of Chapter 10. Obviously no meeting line is present as the two fabrics never meet. These two fabrics, originating from one warp, may be found joined face to face (see Fig. 140), or they may be found side by side sewn as a decorative border to another textile, or they may be found as a pair of gloves, stockings or sleeves. In these cases, the two fabrics showing contrary twists still exist together and so there is a strong supposition that they were made by the sprang method.

But sometimes each of the two fabrics is made into a separate object, such as a cap (see Fig. 138), and it is unlikely that the two caps coming from the one warp will both be found, or be found together. Here a decision has to be influenced by vaguer arguments based on the complexity of the design, the similarity to other objects with a known method of manufacture and so on.

A narrow fabric of this type but with an *interlaced* structure can be made quite differently. *Diagonal interlacing* or plaiting is often worked on a set of threads which have been doubled over some support so that the ends hang down freely. But here the warp loops at the upper

end of the fabric are likely to be disordered and not in the strict sequence which results from the warping method used for sprang. A fabric can also be *diagonally interlinked* on a freely hanging warp in this way.

3. FABRIC WITH FRINGES AT BOTH ENDS

Such a fabric has usually to be distinguished from one of like structure made on a freely hanging warp, as the latter can also be fringed at both ends.

A. With a meeting line of the circular warp type

Here even the presence of a meeting line of the *circular* warp type (see Fig. 155(a) and (b)) is not sufficient evidence for sprang. For a fabric made on a hanging warp can be *diagonally interlaced* (and even *interlinked*) by starting at the middle of a set of cut threads and first working to one end and then to the other. This method, often used to overcome the difficulty of working with very long threads, leads to irregularities of structure at the centre of the fabric similar or identical to a meeting line. The confusion is increased by the fact that a circular warp meeting line is often associated with disordered threads due to the difficulties involved in this method.

The following three features, which will only be found in a sprang fabric, should there-fore be looked for:

(i) THE PRESENCE OF THE BEGINNING AND THE END OF THE WARP THREAD, IN THE REGION OF THE MEETING LINE

These two threads lie at opposite selvages and come from opposite directions; see the shaded threads shown in Fig. 155(a). They may be either knotted to a nearby thread as in Fig. 155(a) or still knotted to each other and lying across the fabric (in the case of very narrow fabrics) or simply darned into the fabric.

(ii) IF THE WARP IS STRIPED, THE PRESENCE OF KNOTS OR FLOATING THREADS IN THE REGION OF THE MEETING LINE

A knot is the join, made at the warping stage, between two threads of different colour. A floating thread shows that another method has been used during warping, in which a thread is not cut at the end of its stripe but floats over intervening stripes to the beginning of the next stripe of its colour. Knots and floats can be found in the same fabric, the latter usually associated with narrow stripes.

(iii) THE MIRROR-IMAGING OF ANY DESIGN AND THE DUPLICATION OF ANY
 MISTAKE ON EITHER SIDE OF THE MEETING LINE

B. With a meeting line of the flat warp type

The presence of a meeting line of the *flat* warp type confirms the method as sprang and means that the first rows were kept at a distance from the two ends of the warp by the insertion of sticks or some other spacing device. Withdrawing the latter from the finished fabric leaves long loops of warp, which may or may not be cut.

C. Without a meeting line

The absence of a meeting line or any structural irregularity at the centre of the fabric can have several implications.

If the structure is *interlinking*, it can mean that the fabric is one of a pair of fabrics either made on a flat warp as in Fig. 146(a), or made on a circular warp as in Fig. 159(a). But, again, such a fabric can also be made on a hanging warp by working from one end to the other. The only guide here is the complexity of the design, as it is easier to carry out an intricate design on stretched threads (i.e. using the sprang method) than on freely hanging threads. However these are dangerous grounds on which to base a firm decision. If the fabric is very long, it is more likely that the circular warp than the flat warp method was used.

If the structure is *interlacing*, it is important to realise that, in two types of interlacing worked on a circular warp, there is no structural change at all to show where the actual meeting place of the two half fabrics lies. These two types are over one, under one interlacing and over two, under two interlacing showing horizontal ribs, which are described in sections 1 and 2A of Chapter 7. So these fabrics look very like diagonally interlaced fabrics made on a hanging warp. However, the three features described in section A above can again be used to sort out the sprang from the non-sprang fabrics. In the latter the warp threads will run from one end of the fabric to the other without any knots at the centre.

All other types of *interlacing* made on a circular warp show some structural irregularity at the meeting line which, together with the three features described in section A, indicate sprang as being the method of production. In the absence of these signs, such a fabric could be one of a pair of sprang fabrics made as in Fig. 146(a) or as in Fig. 159(a), or it could be *diagonally interlaced* on a hanging warp. One possible help in distinguishing the two is that a sprang fabric typically begins and ends with a straight fell at right angles to the selvage, whereas a diagonally interlaced fabric typically ends with a point though it begins with a straight line. But these are generalisations with many exceptions and so are not very reliable.

4. TUBE OF FABRIC WITH TWO MEETING LINES

A tubular fabric with warp running round the tube and with one meeting line of the flat warp type and one of the circular warp type is bound to be made by the sprang method. See section 3B in Chapter 11. The meeting lines will be diametrically opposite each other and, if the structure is interlinking, will separate the tube into two halves showing opposite twist.

5. FRAGMENTS

With older or more damaged fabrics, only odd fragments may be found. Here it is very important to preserve all the pieces, because if examination shows some are in S-twist interlinking and some in Z-twist, it is likely they all came from one sprang fabric. Obviously a fragment showing a definite meeting line or a reversal of twist along a horizontal line is even better evidence.

Little mention has been made of *intertwined* sprang in the above analysis, because there is no evidence to suggest that the structure was ever made by any other method. Practically it is very difficult to work it on a freely hanging warp, but if the threads are weighted and lie over some support, as in bobbin lace, it does become possible. There is a structure used in the latter which is very similar to intertwining; however, the type of design found in bobbin lace is completely different from that found in intertwined sprang. The Japanese, using some special equipment, produce the intertwined structure for narrow braids, but they are so tightly compressed as to make that structure barely recognisable.

It has been shown above that certain thread structures can be produced equally well by the sprang method as by two other methods, namely, linking and working a set of freely hanging threads. Though this is true, it avoids consideration of the relative ease with which the different methods produce the same structure. Some structures, especially complex ones, come far more easily and naturally to one method than to another, so it might be assumed that a certain fabric was necessarily made by the easier method. This argument carries some weight, but it does not clinch matters, as a worker may well make a fabric in a slow and tedious way, being quite ignorant of an alternative and more suitable method.

On the other hand, two different methods may even coexist in the same culture, as do *linking* and *interlinked* sprang in some S. American tribes. Here it is a matter of tradition which method is used for which particular fabric. There is also the strange practice reported from Slovakia in which the selvage of an *interlinked* sprang girdle is used as the starting edge for the *linking* of a similar girdle with a needle and thread (Markova, 1957). The interlinked and linked girdles are finally separated by pulling out the first thread used in the linking process.

Appendix 2 · A feature of Sprang found in Weaving

It is interesting that although one of the features of sprang, the simultaneous production of two mirror-imaged fabrics, can sometimes be applied to the weaving process, this has only infrequently happened. Not surprisingly the few reported instances relate to tablet weaving, in which, as in sprang, a set of contrary twists build up naturally at the far end of the warp and so suggest their utilisation for a second fabric. A long warp is threaded with tablets at its centre and two wefts are used. At each turning of the tablets, one weft is inserted into the shed at the near end of the warp and one into the corresponding shed at the far end (Bolland, 1972; Schuette, 1956).

In ordinary weaving the use of a rigid heddle or two sets of leashes would make it possible to weave at both ends of a warp at once. But with the more usual primitive shedding device of leashes and shed stick, the latter prevents the sheds made by the leashes reaching the far end of the warp. So where weaving is found at both ends of a warp shedded in this way, it is not a matter of the simultaneous production of two fabrics but of weaving *first* at one end of the warp, repositioning the shed stick and *then* weaving at the other end. Of two examples from Guatemala, one is the interlinked belt with woven end borders, described in section 2B(iii) of Chapter 10 (O'Neale, 1945). The other is a saddlebag. A flat warp is woven for some distance in this manner so that a piece of cloth is made at both ends. Then the unworked threads between these two woven pieces are interlaced to a meeting line, using several threads as the unit for this area of sprang. When off the frame, each woven part is folded over and sewn at the selvages to make a pocket at each end. The connecting piece of interlaced sprang, which is narrower than the woven part, is slung across the saddle.

Another example comes from the Ucayali region of N. Peru, where the principle is used on a warp stretched on a small frame. The structure is a combination of over two, under two weaving and the twining of warp threads in pairs, the latter forming diagonal surface ridges. Apparently as each shed is picked up by the fingers, a weft is put in at one end of the warp and a stick at the other end. Later the sticks are pulled out one by one and a weft substituted. The two half fabrics meet at the centre (Schmidt, 1907).

Bibliography

Note—That the few references *without* a short description in brackets have not been consulted, but they have been included for the sake of completeness.

Atwater, Mary Meigs, 1954. *Byways in Hand Weaving*. Macmillan, New York (Chapter on Plaiting deals with six types of sprang)

Bake, Door B., 'Egyptisch Vlechtwerk. Ter Nagedachtenis van Elisabeth Siewertsz van Reesema, gestoren 31 Aug. 1922', *Nederlandsche Ambachts-en Nijverheidskunst* 1922, Rotterdam (Short account of Reesema's life and work with sprang)

La Baume, Wolfgang, 1955. *Die Entwicklung des Textilhandwerks in Alteuropa*

Birrel, Verla, 1959. *The Textile Arts*, New York (Few pages on sprang, called mesh-work)

Bolland, Rita, 1972. 'Three Looms for Tablet Weaving', *Tropical Man*, Vol. III, 1970. Leiden (Describes the simultaneous production of two fabrics using tablets)

Branting, Agnes, 1907. 'Knytning, Knippling och Sprangning', in *Fataburen*, Nordiska Museet, Stockholm (Mainly on bobbin-lace and embroidery; several plates incorrectly labelled sprang)

Brekke-Vasbotn, Helga, 1929. *Bregding*, Oslo

Broholm, Hans Christian, and Hald, Margrethe, 1935. 'To Sprangede Textilarbejder i danske Oldfund', *Aarboger for Nordisk Oldkyndighed og Historie*, Copenhagen (Detailed description of Borum Eshöj and Haraldskar hair-nets; review of Scandinavian sprang; many references)

1939. 'Skrydstrupfundet', *Nordiske Fortisminder*, III (1939), 2, Copenhagen.

1940. *Costumes of the Bronze Age in Denmark*, Contributions to the Archaeology and Textile History of the Bronze Age, Copenhagen (Good account of historical sprang fabrics)

1948. *Bronze Age Fashion*, Copenhagen

Bucher, Bruno, 1895. *Geschichte der technischen Künste*, Stuttgart (Volume 3 contains article by A. Riegl on textiles, with pictures of Coptic sprang)

Bühler-Oppenheim, Kristin and Alfred, 1948. *Die Textiliensammlung Fritz Iklé-Huber im Museum für Völkerkunde und Schweizerischen Museum für Volkskunde, Basel*. Denkschriften der Schweizerischen Naturforschenden Gesellschaft, Vol. LXXVIII, 2, Zürich (Complete and illuminating classification of all fabric structures; diagrams, photographs, many references)

1948. 'Basic Textile Techniques', *Ciba Review*, No. 63, Basel (Based on the above)

von Bültzingslöwen, Regina, 1953. *Nichtgewebte Textilien vor 1400*, unpublished (Description and catalogue of sprang, vantsöm, looped and knitted fabrics made in Europe before 1400; a great deal of detailed and unique information)

Cardale-Schrimpff, Marianne, 1972. *Textiles of Columbia*, an unpublished manuscript

Collingwood, Peter, 1964. 'Sprang; Revival of an Ancient Technique', in *Handweaver and Craftsman*, Spring, New York

 1970, 'A Sample in Sprang', in *Threads in Action*, Vol. 2, No. 1, Winter, 1970–71 (Detailed description of simple hole design)

Collins, Maria, 1915. 'Gammalskånska Band', in *Fataburen* No. 1, Part I and No. 4, Part II, Nordiska Museet, Stockholm (All techniques used for making narrow bands, including sprang)

 1922. 'Den Äldste Kända Flätningen', in *Fataburen* No. 1, Nordiska Musseet, Stockholm (Good article on sprang, photographs of Coptic and Norwegian work)

 1928. 'Gamle Vävnader och deras Mönster', *Natur och Kultur*, 88, Stockholm (Well-illustrated short history of textiles)

Cosgrove, C.B., 1947. 'Caves of the Upper Gila and Hueco Areas in New Mexico and Texas', *Papers of the Peabody Museum of American Archaeology and Ethnology*, Harvard University, Vol. XXIV, No. 2, Cambridge, Mass. (Picture and diagram of a hole design piece)

Dedekam, Hans, 1914. *Hvitsöm fra Nordmör*, Nordenfjelska Kunstindustrimusem, Trondheim (Half a page on sprang; five photographs)

 1925. 'Et tekstilfund i myr fra Romersk Jernalder', *Stavanger Museums årbok*, Stavanger (Describes sprang stocking found at Tegle; picture of old Norwegian frame)

Densmore, Frances, 1929. *Chippewa Customs*, Bureau of American Ethnology, Bulletin 86, Washington (Describes an interlinked sash made by a non-sprang method)

Dohrenburg, Thyra, 1936. 'Sprang, eine dreitausandjährige Handarbeit', in *Frauen-Kultur*, 9, Ausgabe A, September 1936, Leipzig (Excellent well-illustrated summary of history of sprang; includes short account of sprang in E. Prussia by E. Dethlessen)

Dress Regulations, 1846, The Uniform of the British Army at the beginning of the Crimean War, London, 1971 (Frequent references to military sashes)

Drost, Henriette A., 1972. 'Een unieke gevlochten orangezijden sjerp', in *Antiek*, 7th year, No. 3, Lochem, Holland (Well-illustrated article on a very large sash made on a circular warp)

Emery, Irene, 1966. *The Primary Structure of Fabrics*, Textile Museum, Washington (Good discussion on nomenclature of sprang; includes all three structures)

Engel, Frederic, 1963. 'A Pre-Ceramic Settlement on the Central Coast of Peru', in *Transactions of the American Philosophical Society*, New Series, Vol. 53, Part 3, Philadelphia (Several diagrams and photographs of sprang)

Ensslin, Mathilde, 1933. 'Koptische Flechttechnik,' in *Die Frauenarbeitsschule*, Vol. 8, September–October

Eriksson, Gölin, 1961. 'Pinnbandsspetsar', in *Svensk Slojdtidning*, No. 5–6.

Errera, Isabella, 1907. *Catalogue d'étoffes anciennes et modernes*, Musées Royaux des arts decoratifs de Bruxelles, Brussels
 1916, *Collection d'anciennes étoffes Égyptiennes*, Musées Royaux des arts decoratifs de Bruxelles, Brussels (Both describe and illustrate Coptic sprang very briefly)

Falk, Hjalmar, 1919. *Altwestnordische Kleiderkunde*, Kristianis (Mentions use of sprang in Middle Ages, quoting contemporary sources)

Frauberger, Tina, 1893. *Kunstgewerbeblatt, No. 4*, January 1893 (Describes linking technique)
 1894. *Handbuch der Spitzenkunde*, Vienna (Expresses opinion that Coptic sprang was made by linking)

Gabric, Paula, 1962. 'Jalbu u selu Trg kod Ozlja', in *Zbornik za Narodni Zivot i Obicaje*, Vol. 40, Zagreb (Account of the making of sprang head-dresses in Yugoslav villages)

Geijer, Agnes, 1938. 'Birka III: Die Textilfunde aus den Gräbern', *Kungl. Vitterhets Historie och Antikvitets Akademien*, Uppsala (Describes two eighth-century interlinked fragments)

General Washington's Military Equipment, 1963. Mount Vernon Ladies Association of the Union, Virginia (Illustrates and describes two military sashes)

van Gennep, A., 1909. 'Netting without a knot' in *Man*, No. 20.
 1912, 'Neueres über Brettchenweberei', and 'Brettchenweberei oder Flechterei', in *Zeitschrift für Ethnologie* (Articles containing some information about sprang which was little understood by author)

Grieg, Sigurd, 1928. See Osebergfundet

Grostøl, Anna, 1932. *Sprang*, Oslo (Instruction book, only describes hole designs; many illustrations with drafts)

Haberlandt, Arthur, 1926. 'Die volkstümliche Kultur Europas in ihrer geschichtlichen Entwicklung', in *Illustrierte Völkerkunde*, Vol. II, Part 2, Stuttgart

Hailey, O. S., 1904. 'Silk Industry in the Punjab', in *The Journal of Indian Art*, Vol. X, Nos. 81–88, London (A paragraph and a sketch about making silk pyjama drawstrings, here called azarbands, on circular warp)

Hald, Margrethe, 1936. Three articles on sprang in *Berlingske Tidende*, Copenhagen, (25 May, 7 June, 12 July) (Very detailed, well-illustrated articles)
 1946. 'Ancient Textile Techniques in Egypt and Scandinavia, a Comparative Study', in *Acta Archaeologica*, Vol. 17, fasc. 1–3, Copenhagen (Occurrence and types of sprang in the two countries discussed)
 1950. *Olddanske Tekstiler*, Copenhagen (The best world survey of sprang; many pictures and references; detailed analyses of Coptic sprang pieces; English summary)

d'Harcourt, Raoul, 1935. *Les Textils Anciens du Pérou et Leurs Techniques*, Paris. English edition, University of Washington Press, 1962 (Several photographs and clear diagrams of sprang)

Harvey, Virginia, 1969. 'Sprang,' in *Threads in Action*, Vol. I, No. 1, September, 1969 (Short introductory article on sprang technique)

Heiden, Max, 1904. *Handwörterbuch der Textilkunde*, Stuttgart (Few pictures of Coptic sprang)

Henshall, Audrey, 1951. 'Note on an early stocking in "Sprang" technique found near Micklegate Bar, York', *Transactions of the Yorkshire Philosophical Society* (Photograph, diagram and description)

Hoffmann, Marta, 1964. *The Warp-weighted Loom*, Studia Norvegica No. 14, Oslo.

Hoffmann, Marta, and Traetteberg, Ragnhild, 1959. 'Teglefunnet', in *Stavanger Museum's årbok*, Stavanger (Both the above deal with the stocking found at Tegle)

Hundt, Hans-Jürgen, 1968. 'Die verkohlten Reste von Geweben, Geflechten, Seilen, Schnüren und Holzgeräten aus Grab 200 von El Cigarralejo', *Madrider Mitteilungen* 9, Heidelberg (Carbonised scraps of interlinked fabric from the Iron Age)

Jelles, B. C., 1971. *Het Grote Handwerkboek*, Leiden (12th and somewhat altered edition of a book previously called *Ik kan handwerken*) (Chapter called 'Het Vlechten' deals with sprang; much information derived from Reesema and other sources)

Johnson, Irmgard Weitlaner, 1950. *Twine-Plaiting: a Historical, Technical and Comparative Study*. Thesis filed at University of California, Berkeley (A full well-illustrated account from which the following entry is extracted)

 1958. 'Twine-plaiting in the New World', in *Proceedings of the 32nd International Congress of Americanists*, Copenhagen, 1956 (Very good survey of sprang in the Americas; pictures of Mexican work; good bibliography)

de Jong, Jo, 1933. *Weef-en Bordurekunst*, Rotterdam (Brief account of sprang; photographs of recent work and of Indian circular warp sprang)

Kendrick, A. F., 1921. *Catalogue of textiles from the burying-grounds in Egypt*, Vol. 2, Victoria and Albert Museum, London (Descriptions and pictures of Coptic work, called 'plaited')

Kent, Kate Peck, 1940. 'The Braiding of the Hopi Wedding Sash,' in *Plateau*, January 1940, Museum of Northern Arizona, Flagstaff, Arizona (The definitive account of the circular warp Hopi sash; very detailed)

 1957. 'The Cultivation and Weaving of Cotton in the Prehistoric Southwestern United States', in *American Philosophical Society Transactions*, New Series, Vol. 47, Part 3, Philadelphia (Three pages on sprang, called twine-plaiting)

 1972. Private letter.

Kurrik, H. 1935. *Villased meestevööd*, Eesti Rahva Muuseumi Aastaraamat XI (Mentions occurrence of sprang in Estonia)

Lang, Margarete, 1908. *Die Bestimmung des Onos oder Epinetron*, Berlin (Touches on Greek vase paintings of ? sprang frames; considers them embroidery frames)

Lehmann, Edgar, 1954. 'Nichtgewebte Textilien vor 1400', in *Wirkerei- und Strickerei-Technik*, Nos. 5, 7 and 8, Coburg (Chiefly concerned with recognition and history of sprang; based on researches of Regina von Bültzingslöwen)

Ljungblom, Erik and Ingeborg (n.d.). *Pinnbandsspets*, Jämtslöjds Försäljningsförening, Sweden (Recent and practical pamphlet, only dealing with hole designs; good

historical summary and bibliography; gives address of supplier of sprang
frames)

Lorenzen, Erna, 1932. *Gamle danske Haandarbejder* (Chapter on sprang)

Lund, Jeanette, 1970 'Sprang', in *Threads in Action*, Vol. 2, No. 1 (Article on the making
of *nara* in Pakistan)

Mackeprang, Mogens B., 1936. 'Om et Traeskrin med Amuletter', *Nationalmuseets Arbejds-
mark*, Copenhagen (Mentions an interlinked piece from Roman Iron Age)

Magnus, Olaus, 1555. *Historia de Gentibus Septentrionalibus*, Rome (Mentions 'spraangn-
ing')

Markova, Ema, 1954. 'Pletenie na Krosienkach na Moravé' (Frame plaiting in Moravia),
in *Věci a Lidé*, VI/7–8, Prague (Detailed account of the making of head-dresses in
sprang; good photographs)

1957. 'Po stopách krosienok' (On the track of the plaiting frame), in *Slovensky Narodopis*,
V/1, Bratislava. (Important and very detailed investigation into sprang; many illus-
trations; very good bibliography especially of E. European sources)

Merisalo, Viivi, 1966. *Nauhoja*, Finland (Very short account of the making of a narrow
sprang braid)

Mikkelsen, P. Helweg, 1938. *Blidegngraven* (Hald describes the textiles in this find, includ-
ing piece of sprang)

Moszynski, K., 1929. *Kultura Ludowa Slowian*, Krakow (Mentions occurrence of sprang,
called 'branie', in Slav countries)

Müller, Sophus, 1891. Article in *Aarbok for Nordisk Oldkyndighed*, Copenhagen (Has
picture of Godskesen's copy of Borum Eshöj hair-net; microscopical analyses of all
fibres used in Bronze Age costumes; technical diagrams)

1897. *Vor Oldtid*, Copenhagen (Shortened and more popular version of above)

Mygdal, Elna, 1917. 'Sprang, en Haandarbejdsteknik', in *Vore Damer*, 10 May (Good
general account of sprang in Scandinavia)

1931. 'Danske Folketekstiler', *Nordens Husflidsforbund*, VI

Nilsson, Karin, 1928. *Mönster till Pinnbandsspetsar*, Östersund (Simple instruction book;
diagrams and many photographs of hole designs, some extremely complicated; all
pieces have fringes)

Nordenskiöld, Erland, 1919. 'An Ethnographical Analysis of the Material Culture of Two
Indian Tribes in the Gran Chaco', *Comp. ethnograph. stud* I. Göteborg

Nylen, Anna-Maja, 1968. *Hemslöjd*, Lund (Contains short section on sprang, well illus-
trated)

Nyman, Fenny, 1972. 'Egyptisch Vlechtwerk', in *Bijvoorbeeld*, No. 2, Ijmuiden, Holland
(Short article with pictures of three pieces of contemporary Dutch work. No. 4 also
has one colour photograph)

O'Neale, Lila M., 1932. 'Tejidos del periodo primitivo de Paracas', in *Revista del Museo
National de Lima*, Vol. I, No. 2, Lima (Describes two sprang head-dressses with hole
designs)

1937. *Textiles of the Early Nazca Period*, Field Museum of Natural History, Vol. II, No. 3, Chicago (Quotes in English part of above description; illustrations may show intertwined sprang)

1942. *Textile Periods in Ancient Peru; II, Paracas Caverns and the Grand Necropolis*, Univ. of Calif. Publications in American Archaeology and Ethnology, Vol. 39, No. 2, Berkeley (Mentions and illustrates above head-dresses)

1945. *Textiles of Highland Guatemala*, Washington (Reprinted 1966) (Description and photographs of sprang belts)

Osebergfundet II, 1928, Oslo (Contains section by Sigurd Grieg on wooden frame, ? for sprang)

Palotay, Gertrud and Ferencz, Cornelia, 1934. 'Magyar adatok a fanással készült csipke fökötökhöz' (Production of Hungarian plaited head-dresses) in *Népraszi Ertesitö*, 1933, Vol. 3–4, Budapest

Paulis, L., 1930. 'Le Point de Dentelle', in *Bulletin des Musées Royaux d'Art et d'Histoire*, 3rd Series, No. 6, November 1930, Brussels (Describes and illustrates collection of 100 sprang pieces)

1933. 'Le Point de Dentelle', in *Bulletin des Musées Royaux d'Art et d'Histoire*, No. 1, Brussels (Discusses picture by Devos showing a ? sprang frame)

Proceedings of Society of Antiquaries of Scotland, XVII (Details of impression in Viking brooch, ? sprang)

Rackow, Ernst, 1943. 'Das Beduinenkostüm in Tripolitanien,' in *Baessler-Archiv*, Vol. XXV, No. 1, Berlin (Describes the *asaba*, a woollen sprang fabric wound around the head; good diagrams; one photograph; did not see it being made nor know it was sprang)

van Reesema, Elisabeth Siewertsz, 1908. 'Oud-Egyptisch Vlechtwerk', in *Onze Kunst*, Vol. 7 (Reesema's first article about sprang, illustrated by her own work and diagrams from Schinnerer. Other pictures of her work appeared in same magazine in 1919 and 1921, but with no text)

1920. 'Old Egyptian Lace', *Needle and Bobbin Club*, Vol. 4, No. 1, New York (Short account of sprang and Reesema's involvement in it; describes her invention of double sprang)

1920–21. Four articles in *De Vrouw en har Huis*, Amsterdam (Later published together, see following entry)

n.d. *Egyptisch Vlechtwerk*, Amsterdam (The best instruction book of its time; meticulous descriptions of technique, including double sprang; many photographs of sprang pieces)

n.d. 'Een Oud-Egyptische Muts', in *Elseviers Maandschrift*, LXIII (Describes a Coptic cap and the making of a copy; photographs including a turban)

1926. *Contributions to the early history of textile techniques* (edited by E. Nierstrasz), Verhandelingen der Koniklijke Akademie van Wetenschappen te Amsterdam, Afdeeling Letterkunde, New Series, Vol. 26, No. 2, Amsterdam (Shows Egyptian

design motifs could be much more accurately worked in double sprang than in tablet weaving, as had been suggested; much information and many illustrations)

Ricard, P., 1925–26. 'Les arts indigens tripolitains', in *Rivista della Tripolitania* (Short description of the *asaba*; mentions possibility that the technique could be used for modern fabrics!)

Riegl, A., 1889. *Die ägyptischen Textil Funde im K. K. Osterreich Museum*, Vienna (Mentions several Coptic pieces, thinking them a kind of lace or knitting)

Roth, Walter, 1916–17. *An Introductory Study of the Arts, Crafts and Customs of the Guiana Indians*, 38th Annual Report of the Bureau of American Ethnology. Reprinted 1970, New York (Detailed row by row account of making a ring sling)

Sandvold, Astrid and Arneberg, Halfdan, 1927. *Sprang, en gammel Knipleteknikk*, Oslo (Simple instruction book, only deals with simple hole designs of which there are many pictures; all fabrics have fringes)

Schimmelmann, A., 1954. *Volkstümliche Handwebtechniken*, Stuttgart

Schinnerer, Louise, 1895. 'Textile Volkskunst bei den Rutenen', *Zeitschrift für österreichische Volkskunde*, Vol. I (Describes the sprang head-dress and its making by Ruthenian women; picture of frame)

n.d. *Antike Handarbeiten*, Vienna (The earliest technical account of sprang with excellent diagrams; covers hole designs, S- and Z-twist, multiple thread interlinking, extra twining threads)

Schlabow, Karl, 1960. 'Abdrücke von Textilien an Tongefässen der Jungsteinzeit', *Jahresschrift für mitteldeutsche Vorgeschichte*, Vol. 44, Halle (Considers that some impressions on bases of neolithic pots prove the latter were laid on sprang fabrics while drying)

Schmidt, Max, 1907. 'Besondere Geflechtsart der Indianer im Ucayaligebiet', in *Archiv für Anthropologie*, neue Folge, Vol. VI, Braunschweig (Account of technique combining weaving and twisted warp threads)

Schuchard, Wolfgang, 1941. *Weibliche Handwerkskunst im deutschen Mittelalter*, Berlin 1941. *Weben und Wirken*, Staatliche Museum für Deutsche Volkskunde, Berlin

Schuette, Marie, 1914. *Alte Spitzen*, Berlin (Has one picture of Coptic sprang, whose technique the author thought might be a forerunner of lace)

1956. 'Tablet Weaving', in *Ciba Review*, No. 117, Basel (Describes the simultaneous production of two fabrics, using tablets)

Schweizer, W. F., 1966. 'Textile Making Methods depicted in Frescos in Slovene Textiles', in *Ciba Review* 1966, No. 1, Basel (Two reproduced frescos may show sprang being made)

Schwetter, Bertha, 1930. *Lehrbuch der weiblichen Handarbeiten*, 2 vols., Leipzig (One chapter, called 'Ägyptische Flechttechnik', has excellent instructions and superb diagrams of warping, simple interlinking, hole designs, methods of finishing and actual projects)

Scott, Nora, 1939. 'Three Egyptian turbans of the late Roman period', in *Bulletin of the*

Metropolitan Museum of Art, Vol. 34, No. 10, New York (Short but factual account of the making of sprang turbans)

Secosanu, Elena, 1959. A manuscript describing belt making in Transylvania, deposited in Bruckenthalmuseum, Hermannstadt, Rumania

Shetelig, 1940. *Viking Antiquities in Great Britain and Ireland*, Oslo

Sirelius, U. T., 1932. *Suomen Kansanomaista Kultturia* II, Finlands Folkliga Kultur (Describes Finnish sprang)

Six, J., 1920. 'Altgriechische "durchbrochene Arbeit"', *Jahrshefte des österreichischen archäologischen Institutes in Wien*, XIX–XX, Vienna (An effort to prove that the frames shown on Greek vase paintings were for sprang; includes a photograph of a reconstructed Greek frame being used)

Skowronski, Hella, 1969. 'Experiments with sprang', in *Handweaver and Craftsman*, Vol. 20, No. 1, New York (Illustrates some modern interpretations of the technique)

Smolkova, M. A., 1904. 'O Starobylém Pleteni na Krosienkách u Lidu Uhersko-Sloven-ského', in *Narodopisny Sbornik*, X, Prague (Picture of vertical frame and fabric with hole design; six pages text)

Solberg, Thor, 1967. 'Bregding- en gammel kunst på mote igjen?', in *Kvinner og Klaer*, No. 22, 31 May

Speiser, Noemi, 1971. 'Neue Entwicklungen der Sprang-Technik', in *Heimatwerk*, No. 3, 1971, Zürich (Short but excellent account of sprang, giving the author's developments of the technique, chiefly in intertwining; photographs of sixteen of her works from a recent exhibition)

Staňkova, Jilká, 1972. 'Les techniques textiles de la culture populaire tchecoslovaque', in *Bulletin de Liaison du Centre International d'Etude des Textiles Anciens*, No. 36, 1972-11, Lyon (includes a detailed account of the use of sprang for bonnets and sashes)

Treiber-Netoliczka, Luise, 1970. 'Das Nachleben der bronzezeitlichen Frauenhäubchen und der Stäbchenflechterei in Siebenburgen', in *Festschrift für Hans Reinerth*, Singen am Hohentwiel (Very well illustrated account of the survival in Transylvania of sprang, both with flat and circular warp, for the making of caps and belts; much technical and historical information; good bibliography covering E. European sources)

Trotzig, Liv and Axelsson, Astrid, 1958. *Band*, Västerås, Sweden (Short account of making a narrow sprang braid, called Pinnband)

Underhill, Ruth, 1944. *Pueblo Crafts*, US Department of the Interior, Washington (Short illustrated account of Hopi wedding sash)

Urbachova, Eva and others, 1963. 'Práce na Rámu a její dnešní využití', in *Uměni a Řemesla*, 2, 1963, Prague (History and description of technique, photographs of caps, belts, collars)

Vogt, Emil, 1947. 'Basketry and Woven Fabrics of the European Stone and Bronze Age', *Ciba Review* No. 54 (Short account of sprang with one of Hald's diagrams)

Vuia, Romulus, 1914. 'Flechterei mit Stäbchen bei den Rumänen', in *Zeitschrift für Ethnologie*, Vol. 46 (A clear account of belt making in Rumania by the circular warp method)

Vydra, Josef, 1926. 'Ribbons and braids of popular culture in Slovakia', *Narodopisny Věstník českoslovansky*, XIX.

Vydra, Josef, 1930. 'Dentellerie en Tchécoslovaque'. *Státni ústav pro Učehné Pomucky škol Premyslových a Odborných*, Prague

von Walterstorff, Emilie, 1925. *Swedish Textiles*, Nordiska Museet, Stockholm (Short section called Språngning; two pictures)

Whiting, Gertrude, 1928. *Tools and Toys of Stitchery*, New York (Reprinted 1971, New York, as *Old-time Tools and Toys of Needlework*) (Picture of sprang frame with work on it, no source given)

Wild, J. P., 1970. *Textile Manufacture in the Northern Roman Provinces*, Cambridge (Picture and description of one piece of sprang, dating from A.D. 100)

Index

PLATES

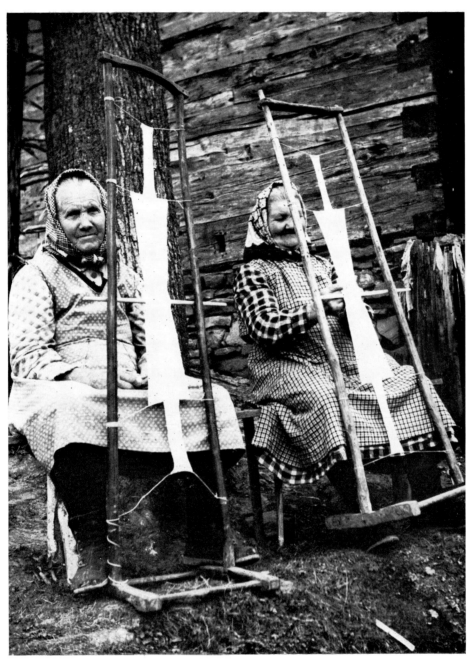

1. Making shaped head-dresses on free-standing frames, Moravia, 1954 (see page 47)

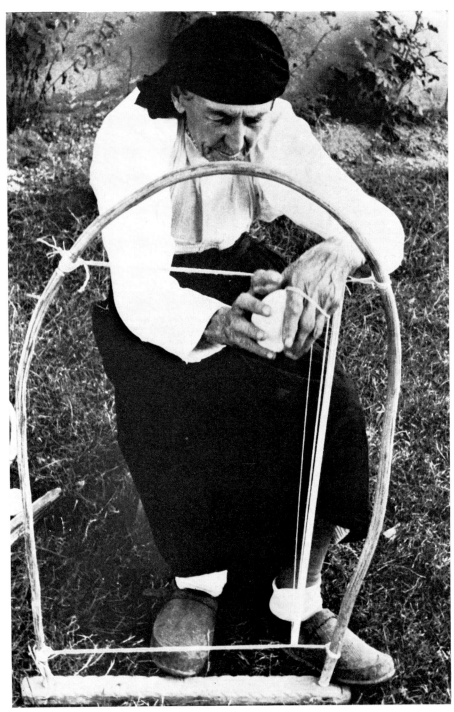

2. Putting warp in figure of eight formation on a portable frame, Yugoslavia, 1958 (see page 51)

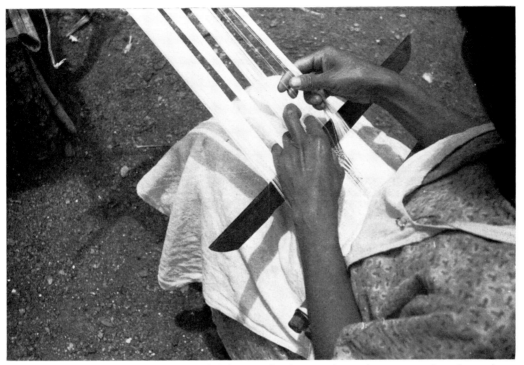

3. Nahua woman working a sprang fabric on a back-strap loom (weaver-tensioned warp), Ichcateopan, Guerrero, Mexico, 1948 (see page 54)

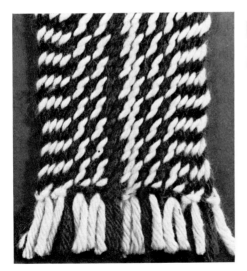

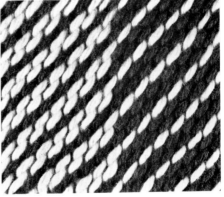

5. Interlinked sprang with a warp colour sequence of (A, A, B) and (A, B, B) (see page 93)

4. Interlinked sprang with warp colour sequences of (A, B, A, B), (A, A, B, B) and (A, A, A, A, B, B, B, B) (see page 95)

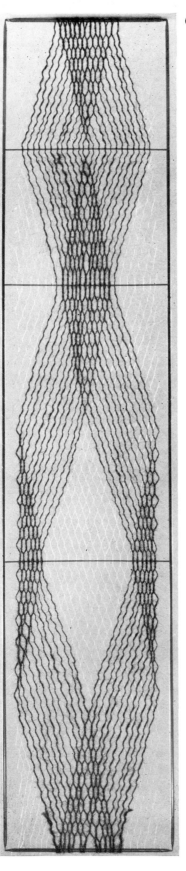

6. Double twist interlinking. Screen made from horsehair and nylon (see page 97)

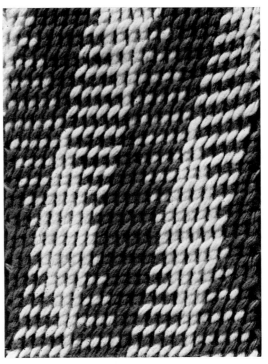

7. Double twist interlinking using a striped warp (see page 98)

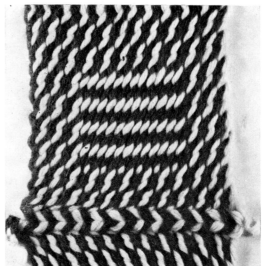

8. Double twist interlinking used selectively to give a block of cross stripes on a background of diagonal lines. Chained meeting line (see page 100)

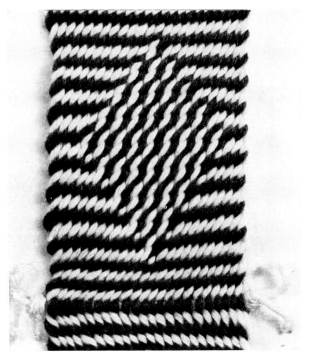

9. Double twist interlinking used selectively to give a diamond of diagonal lines on a background of cross stripes. Meeting line secured by a thread in the final shed (see page 100)

11. Double twist interlinking used selectively to give two different central areas (see page 100)

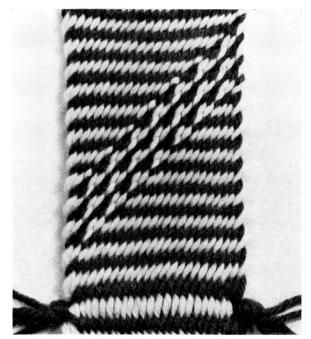

10 Double twist interlinking used selectively to give a diagonal band of interlocking triangles on a background of cross stripes. Meeting line secured with wefts in the three final sheds (see page 100)

12. Horizontal stripes of S- and Z-twist interlinking (see page 105)

13. Areas of S- and Z-twist interlinking with angled boundaries showing the three-dimensional effect (see pages 107, 115)

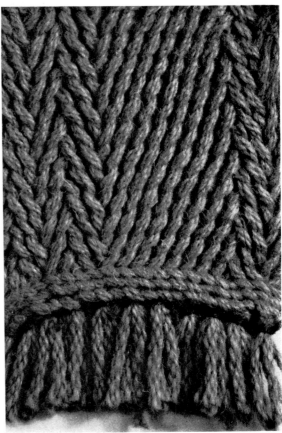

15. Vertical stripes of S- and Z-twist interlinking. Three rows of chaining at bottom edge (see page 120)

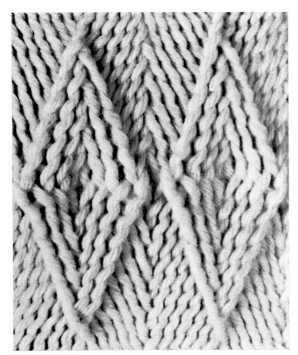

14. S- and Z-twist interlinking used so that every edge of a diamond stands above the background (see page 115)

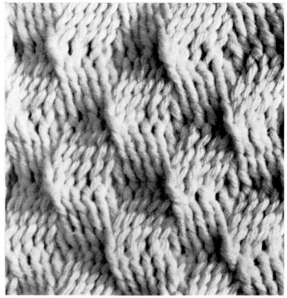

16. Alternating blocks of S- and Z-twist interlinking giving an undulating surface (see page 120)

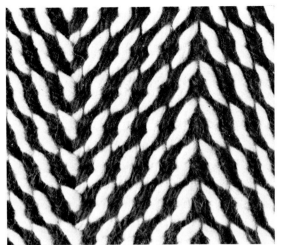

17. Vertical stripes of S- and Z-twist interlinking on a warp with an (A, A, B, B) colour sequence (see page 121)

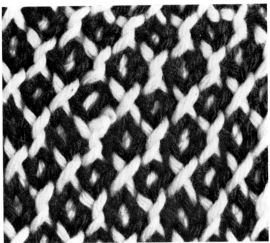

19. Combination of S- and Z-twist interlinking using a warp with an (A, A, B, B) colour sequence (see page 122)

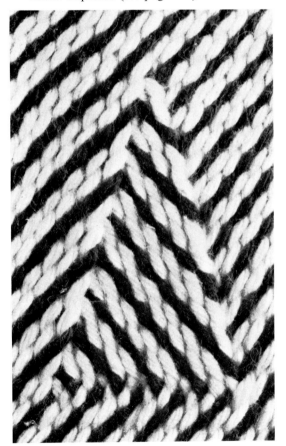

18. Triangle of S-twist on a background of Z-twist interlinking, using a warp with an (A, A, B) colour sequence (see page 122)

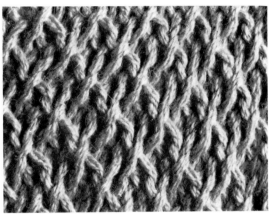

20. Same structure as in plate 19, but using a warp of one colour to show the textured surface (see page 122)

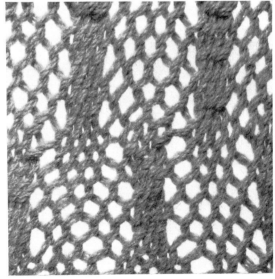

21. Inserting extra rows of interlinking in selected places (see page 127)

22. Omitting rows of interlinking in selected places on a nylon warp: detail of a hanging by Noemi Speiser (see page 128)

23. Alternate rows of 2/2 and 1/1 inter-linking used all across warp to give holes (see page 134)

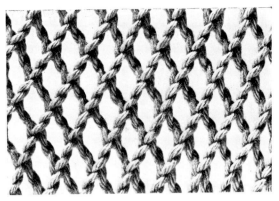

24. Long holes separated by two threads: detail of a bag by Noemi Speiser (see page 145)

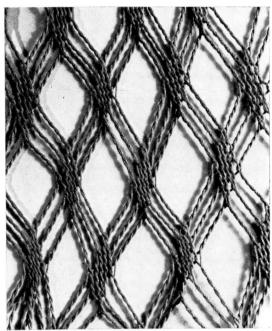

25. Combination of holes with warp transposition to give a three-dimensional fabric (see page 153)

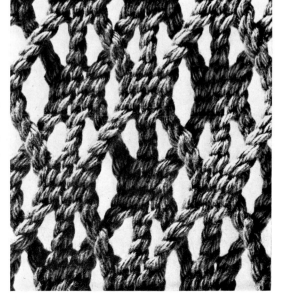

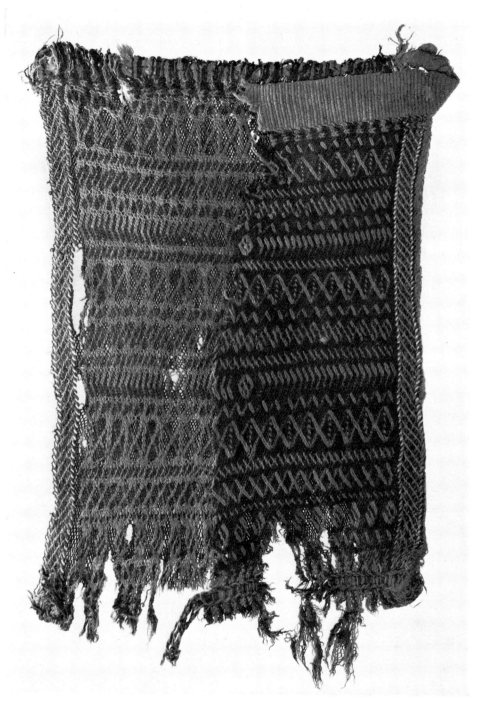

26. Woollen Coptic bag with red extra twining threads on a blue interlinked background. Partly destroyed so both inside and outside can be seen. Woven band of red wool at top to which the ends of the drawstring are tied. Meeting line secured with a continuous line of chaining on outside and inside of bag. Side panels in orange, green, red and white (see page 153)

27. Sample showing three typical Coptic motifs produced by extra threads twining on the interlinked background (see page 154)

29. Sample showing a Coptic design in which threads change regularly from inter- linking to twining and back again (see page 161)

30. Three sets of extra threads twining vertically. At intervals the central and left-hand sets float at the back so that spots are formed, the right-hand set forms a continuous vertical stripe (see page 156, 163)

28. Threads changing from twining to inter- linking along a diagonal line (see page 160)

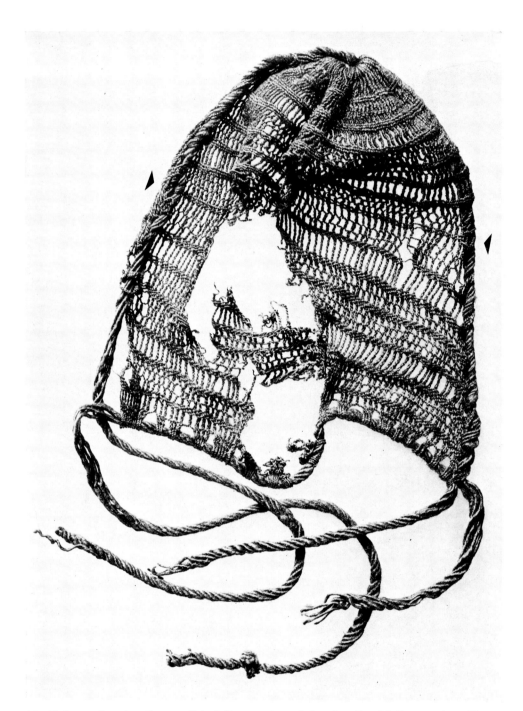

31. Hair-net found at Borum-Eshöj, Denmark, and dated to Danish Bronze Age. Shows multiple twists, chained ridges and a chained meeting line (arrowed) (see pages 38, 165)

32. Single, double and triple chained ridges (see page 165)

33. Twisted and chained ridge (see page 166)

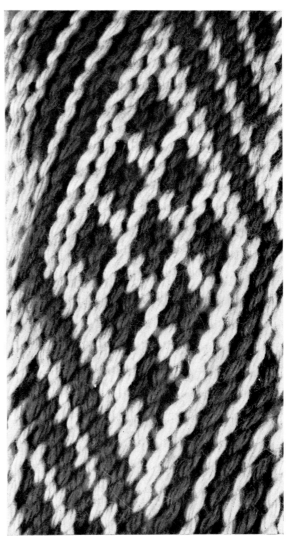

34. Double interlinked sprang (see page 175)

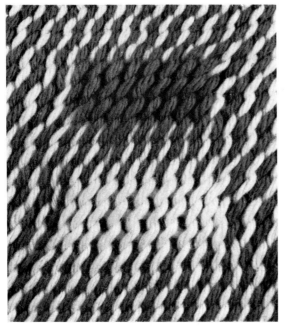

35. Two areas of double interlinked sprang on a background of single interlinked sprang (see page 178)

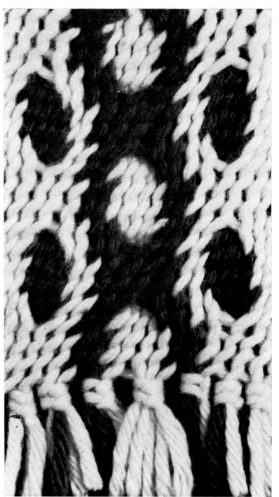

36. Converting the back fabric of double interlinked sprang into a stripe (see page 180)

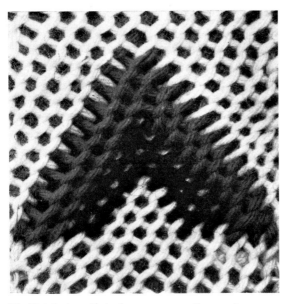

37. Triple interlinked sprang: small sample stretched to show structure (see page 183)

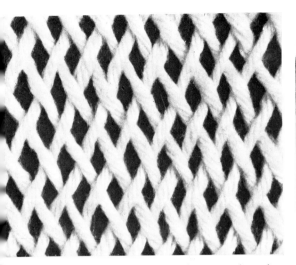

38. Over one, under one interlaced sprang: loosely made sample to show structure (see page 184)

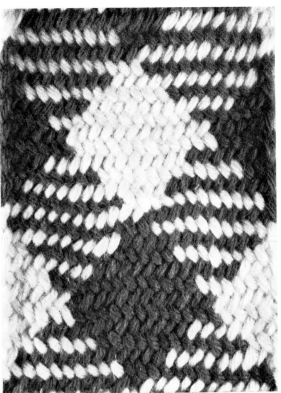

39. Over two, under two interlaced sprang with horizontal ribs (see page 187)

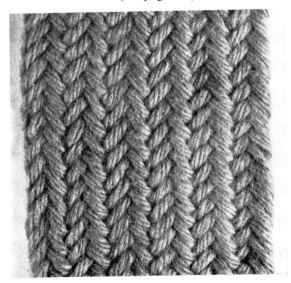

40. Over three, under three interlaced sprang with vertical ribs (see page 191)

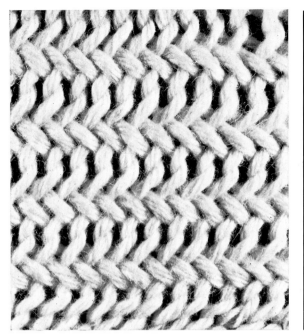

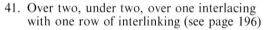

41. Over two, under two, over one interlacing with one row of interlinking (see page 196)

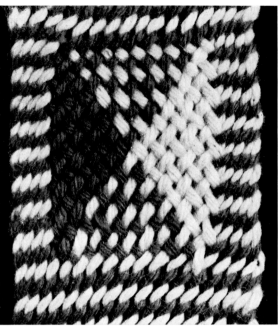

42. Area of over one, under one interlacing on a background of 1/1 interlinking (see page 197)

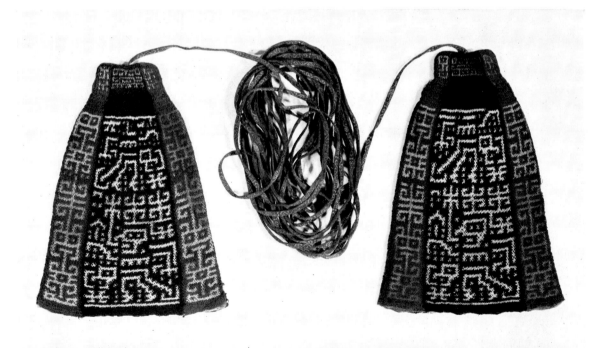

43. Double intertwined sprang. Two woollen tassels connected by long woven cord. Outer panels red and yellow, central panel blue and white. Each piece folded in half along the meeting line and the sides then sewn up. Near the meeting line, an area of cross knit loop stitch. Peru, probably Nazca valley, before 900 A.D. (see page 217)

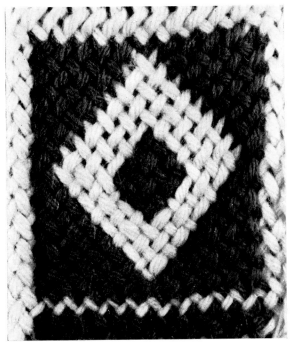

44. Double over one, under one interlaced sprang
 (see page 199)

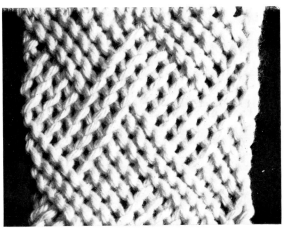

46. Intertwined sprang: combining the two types
 of crossing on a warp of one colour to give a
 zig-zag stripe (see page 206)

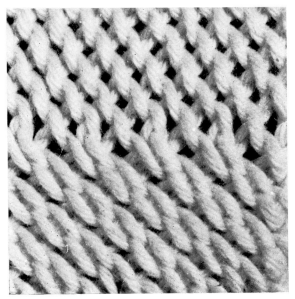

45. Intertwined sprang. In upper half a single
 pair of threads is the unit, in the lower half
 two pairs are the unit (see pages 203, 210)

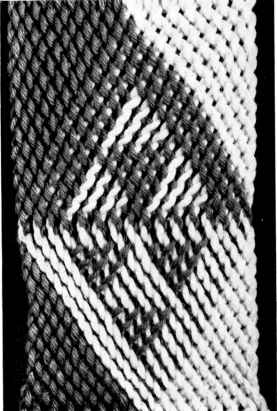

47. Intertwined sprang: combining the two
 types of crossing on a warp of two colours
 (see page 206)

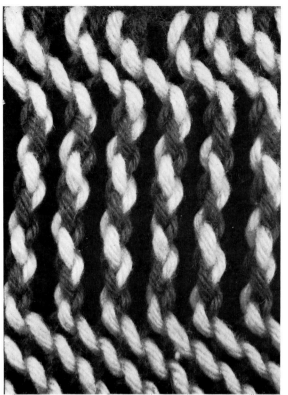

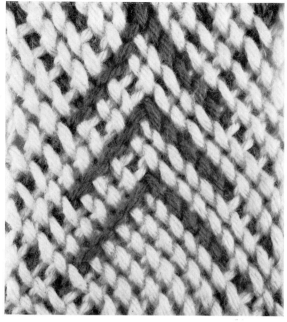

49. Intertwined sprang: extra twining threads coming to the surface to form three chevrons (see page 211)

48. Intertwined sprang: braids made by repeating a row several times (see page 208)

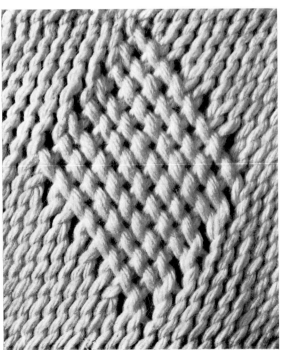

50. Diamond of intertwined on a background of interlinked sprang (see page 214)

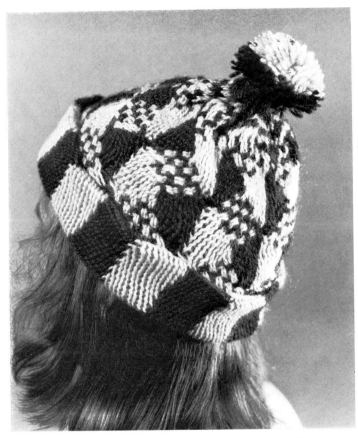

51. Woollen cap made by Noemi Speiser which combines intertwined and interlinked sprang (see page 217)

52. Interlinked fabric with narrow diagonal stripes of inter-
twining (see page 217)

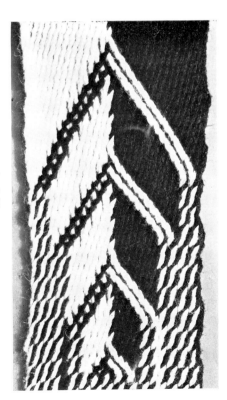

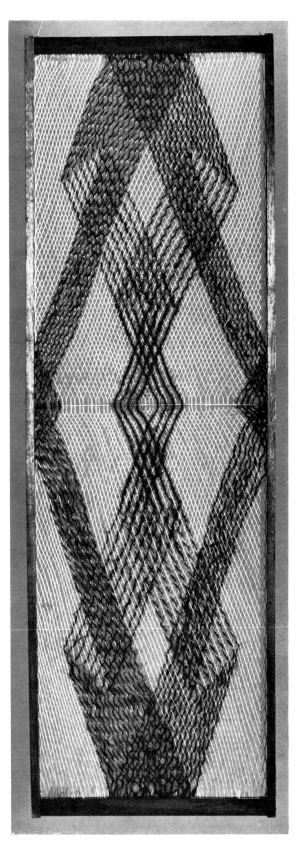

53. Intertwined fabric by Noemi Speiser, made of horsehair and nylon and mounted in a frame (see pages 202, 244)

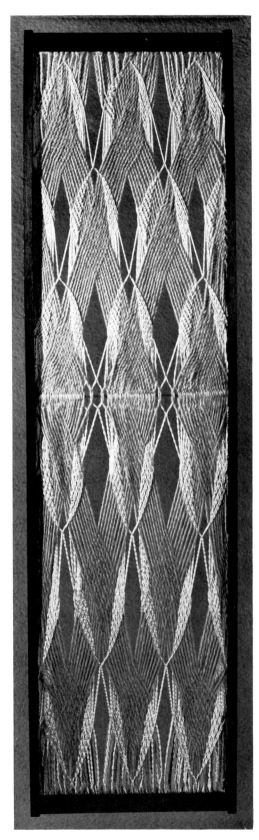

54. Intertwined fabric made of grey wool and white synthetic by Noemi Speiser (see pages 202, 244)

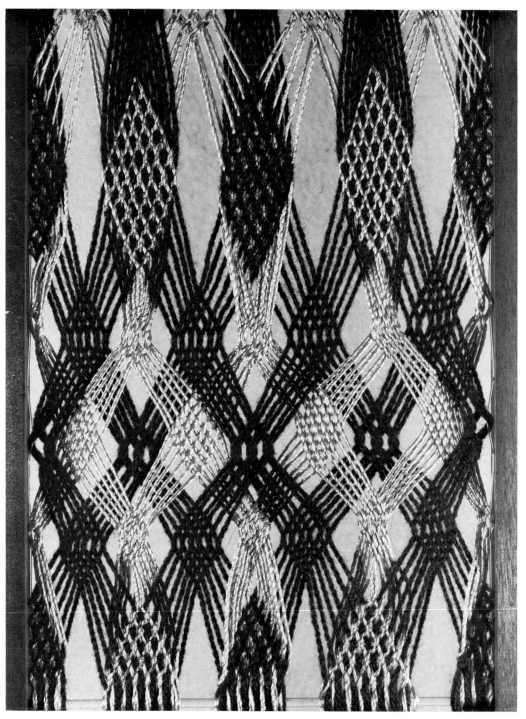

55. Detail of an intertwined fabric made by Noemi Speiser of grey synthetic and dark wools
Note rod securing the meeting line (see page 202)

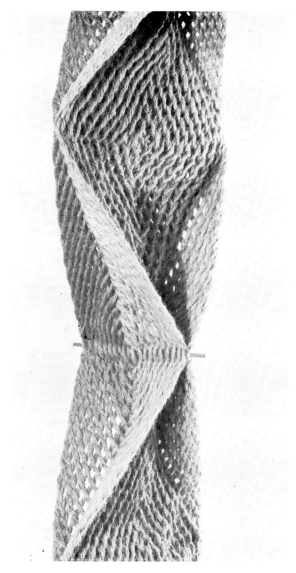

56. Double intertwined sprang: part of a three-dimensional hanging made of sisal (see page 217)

57. Securing the meeting line with a single row of chaining (see page 225)

58. Securing the meeting line with two rows of chaining (see page 227)

59. Securing the meeting line with a row of two-through-one chaining (see page 227)

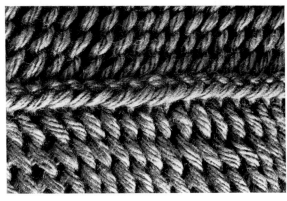

60. Securing the meeting line with a row of twisted chaining (see page 228)

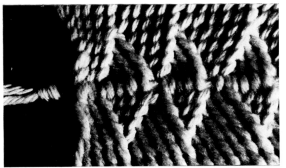

61. Securing the meeting line with a single thread in the final shed. S- and Z-twist interlinking worked diagonally in the final stages (see page 230)

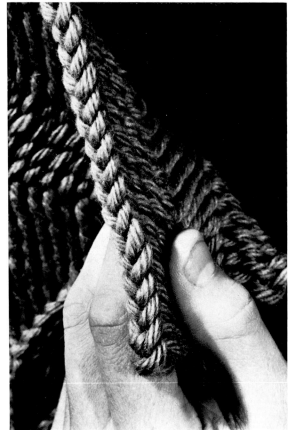

62. Top edge of sprang fabric to show chaining of the warp loops (see page 242)

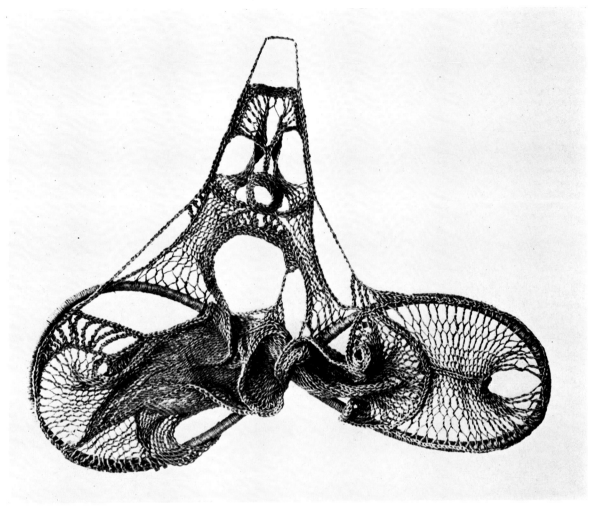

63. Construction in jute by Susan W. Gilmurray. Four pieces of S- and Z-twist interlinked sprang joined with crochet (see page 244)

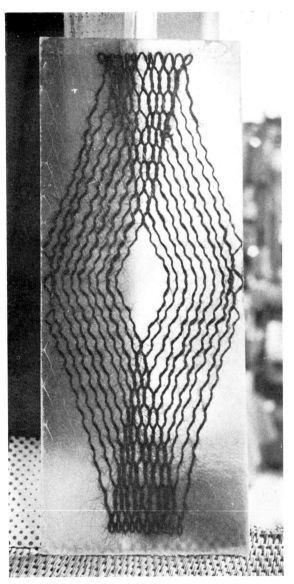

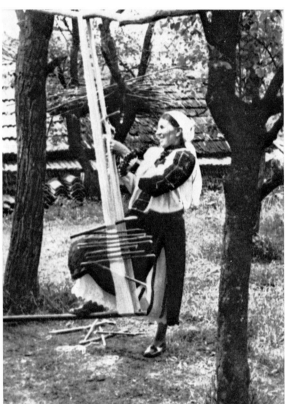

65. Circular warp sprang. Woman making woollen belt on a warp stretched between two poles. Cerbal, Rumania, 1958 (see page 249)

64. Double twist interlinked fabric, made from horsehair and nylon and laminated with fibre-glass and resin (see page 244)

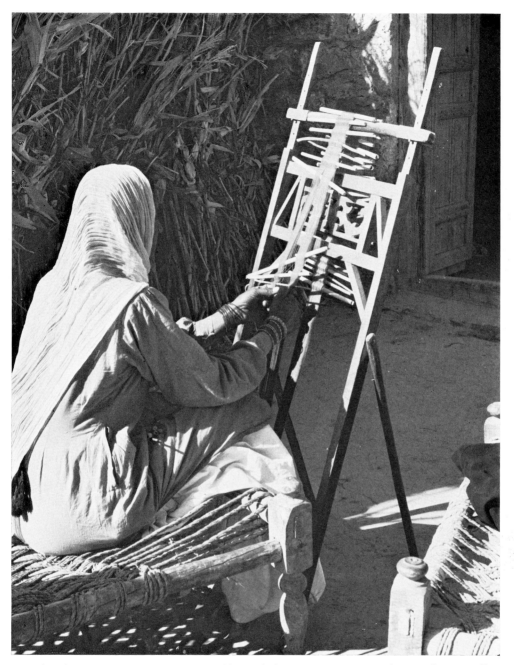

66. Circular warp sprang. Woman making a belt on a warp mounted on a free-standing
frame, Pakistan (see page 253)

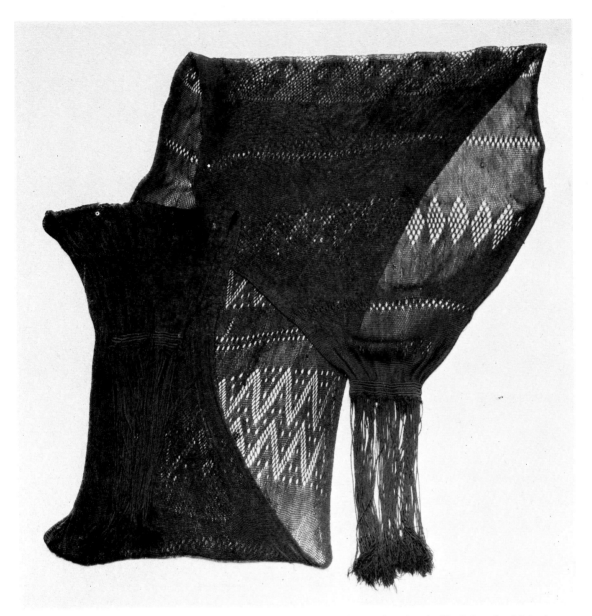

67. Circular warp sprang. George Washington's military sash, made of red silk, 8 feet by 28 inches. Simple hole designs, long plied fringe. About 1779 (see page 250)

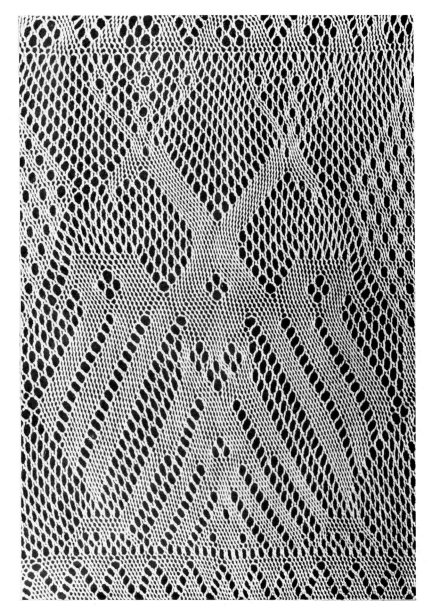

68. Circular warp sprang. Two-headed eagle worked in 1/1 interlinking on a background of holes. Detail from a very large orange silk sash, 10½ feet by 4 feet. About 1700, Dutch (see page 250)

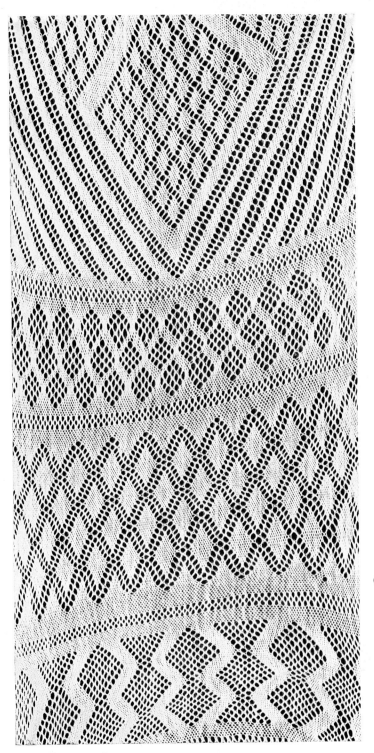

69. Circular warp sprang. Detail of a contemporary Pakistani cotton belt (*nara*) showing simple hole designs (see pages 250, 269)